IN SEARCH OF ALBION

IN SEARCH OF ALBION

From Cornwall to Cumbria:
A Ride Through England's
Hidden Soul

Colin Irwin

André Deutsch

First published in 2005 by

André Deutsch
an imprint of the
Carlton Publishing Group
20 Mortimer Street
London W1T 3JW

The publishers would like to thank the following sources for their kind
permission to reproduce the pictures in this book:
page 6: (top) Topfoto.co.uk/Gary Roberts; (bottom) Collections/Brian Shuel;
page 7: (top) Getty Images/Scott Barbour; (bottom) Liz King Media;
page 8: (top) Getty Images/Jon Furniss; (bottom) Collections/Brian Shuel.
Other photos belong to the author. Every effort has been made to
acknowledge correctly and contact the source and/or copyright holder of each
picture and Carlton Books Limited apologises for any unintentional errors or
omissions that will be corrected in future editions of this book.

A catalogue record for this book is available from the British Library

ISBN 0-23300-116-6

Typeset by e-type, Liverpool
Printed and bound in Great Britain by
Mackays of Chatham

Contents

Acknowledgments

Thanks to all those who contributed to the journey:

Val – dodgy map-reader, brilliant co-conspirator

Christy, Kevin, Don and Gabriel Irwin

Ian Gittins, Christine Collister, Bob Pegg, Martin Carthy, Norma Waterson, Jim Moray, Seth Lakeman, Auntie Pat, Ian Anderson, Harriet Sims, Scott Watson, Nic and Julia Jones, Isle of Man Tourist Board, Chris and Rachel Heard, Cyril and Rosemary Tawney, Mike and Kathryn Tickell, Jackie Beaney, Chris Morpeth, Richard Thompson, Francis Shergold, Sophie and Viv Legg, Jez Lowe, Paul Wilson, Robert Harker, John Douglas Spencer Wheeler, Robert Wyatt, Vinty Kneale, Dave McLean, David Kilgallon, Philly Gawne, Mark Kermode, Maggie Holland.

And, most important of all … Alberta, the bold Cavalier.

Dedicated to Bill and Gwen Irwin, the finest English folk
I know, in memory of Egbert the clock

A Place Called England

I rode out on a bright May morning, like a hero in a song
Looking for a place called England, trying to find where I came from
Couldn't find the old flood meadow, or the post that I once knew
No trace of the little river, or the garden where I grew

I saw town and I saw country, motorway and sink estate
Rich man in his rolling acres, poor man still outside the gate
Retail park and burger kingdom, prairie field and factory farm
Run by men who think that England's only a place to park their car

But as the train pulled from the station, through the wastelands of
 despair
From the corner of my eye, a brightness filled the filthy air
Someone's grown a batch of sunflowers, though the soil is sooty black
Marigolds and a few tomatoes, right beside the railway track

Down behind the terraced houses, in between the concrete towers
Compost heaps and scarlet runners, secret gardens full of flowers
Meeta grows the scent of roses, right beneath the big jet's path
Bid a fortune for her garden, Eileen turns away and laughs

So rise up George and wake up Arthur, time to rouse out from your
 sleep
Deck the horse in sea green ribbons, drag the old sword from the deep
Hold the line for Dave and Daniel, as they tunnel through the clay
While the oak in all its glory, lives to thrive for one more day

And come all you at home with freedom, whatever the land that gave
 you birth
There's room for you both root and branch, as long as you love the
 English earth
Room for vole and room for orchid, room for all to grow and thrive
Just less room for the fat landowner, on his arse in his four-wheel drive

England is not flag or empire, it is not money, it is not blood
It's limestone gorge and granite fell, it's Wealden clay and Severn
mud
It's blackbird singing from the may tree, lark ascending through the
scales
Robin watching from your spade and English earth beneath your nails
So here's two cheers for a place called England, badly used but not yet
dead
A Mr Harding sort of England, hanging in there by a thread
Here's two cheers for the crazy Diggers, now their hour shall come
around
We shall plant the seed they gave us, common wealth and common
ground

Maggie Holland

© Maggie Holland 1998, published by Moose Music.
Reprinted by kind permission of Maggie Holland. The song features on her
1999 album *Getting There* (Irregular). It has also been recorded by June Tabor
on her album *A Quiet Eye* (Topic, 1999).

Introduction

'England?'

Yes.

'I mean ... *England*?!'

Yes, England.

'You seriously want to write a book about England?'

That's the general idea, yes.

'But it's full of English! The English are the most boring people in the world!'

Ah, but that's exactly the sort of misapprehension I want to destroy ...

'Nah, mate, forget it. Go to Cuba. Write about dusky maidens in short skirts doing the samba.'

Samba's not Cuba. Samba's Brazil. Rumba is Cuba. Cubans rumba, Brazilians samba.

'*Whatever*. Cuba, Brazil, Fiji, Outer Mongolia ... I'd buy a book about that. But England? Who wants a book about England? I'll tell you this ... I'm not buying a book about *bloody England*.'

Forthright as ever, my mate Dave – born and bred in Lewisham – marched to the bar, snorting with derision. Bristling with indignation, I set off to prove him wrong.

Which is why, at 9am on Christmas Day, I found myself shivering alongside the Serpentine in Hyde Park, central London, watching a curious trail of sheepishly grinning loopies dressed in all manner of colourful swimming costumes being urged to leap in the water by a middle-aged bloke in a Santa hat loudly singing '*... In the dunce school, that's what we do, come on in the water's fine/You are in my heart for ever, oh my darling Serpentine ...*' to the tune of "Oh My Darling Clementine". My December 25 had never been like this before.

'Stop posing and get on the board!' he'd yelled, with such authority that the 40 or so foolhardy heroes had obeyed instantly and filed dutifully to the small pier in their goggles, goose bumps and fetching stripy one-pieces. The MC bullied them into singing along with his "... Serpentine" song and then, in a curious handicapping system that only an advanced mathematician or nuclear physicist could possibly

decipher, had them diving into the water at seemingly random inter-
vals to splash along with a frantic cross between doggy paddle and
drowning, wounded butterflies. After 100 yards of desperate thrashing
around they crawled out at the other end yelping pitifully, grabbed the
wine and whisky proffered as reward and gave us permission to shoot
them if we ever saw them planning a repeat performance next year.

A strapping fellow in a purple cap and serious Speedos watched
impassively from the other end, patiently crouching at the starting
point ready for the nod to launch himself into the icy maelstrom of
cavorting limbs and gyrating water. When it came, he was off like a
submarine, but as half the swimmers had already finished by this time,
it seemed a particularly fierce handicap. 'I don't fancy his chances
much,' I observed, noting the delirious celebrations and whisky
gulping already going on at the other end as he dived in. 'Oh, I don't
know,' said a woman-in-the-know next to me. 'That guy swam the
Channel.' What? He's already swum the Channel this morning? Poor
bloke must be knackered; you'd think they'd at least let him start with
the others …

All inhibitions were discarded in the cold as swimsuits were ripped
off and the participants raced to get into something a little more likely
to make them resemble human beings. Totally baffled by it all, I asked
a kindly-looking grey-haired gent, snug in a big warm scarf, if he knew
who'd won the race. 'Actually,' he said, a tad abashed, '*I* did.' His name
was Alan Lacy, he was 80 years old, and he'd competed in this race
every year since 1954. 'There weren't so many swimmers in those
days,' he added, gazing mournfully at the crowds gathering for the
presentation ceremony.

Alan was duly presented with the Peter Pan Cup, a trophy donated
by a prominent Serpentine Swimming Club member, J. M. Barrie, in
honour of the stage debut of his new play *Peter Pan* at the Duke of York
Theatre in 1904. One of Barrie's descendants was there to present Alan
with the cup. 'He got the idea of a little boy who wouldn't grow up
while he was walking through Kensington Gardens and Hyde Park …
we've got a few people here today who won't grow up,' he said. And
when Alan Lacy stepped forward to accept the Peter Pan Cup, it
inspired an impromptu song from the "Serpentine" guy, improvising a
theme using the same tune: '*Alan Lacy isn't crazy, in fact he's bloody slow,
but he's steady when it matters, as Hitler got to know …*'

You've got to respect an octogenarian who goes swimming on
Christmas morn and gets a song in his honour. And you've got to
respect the bloke who makes that song up. Is this what they call folk
music? Is this the genesis of traditional song? I asked Alan Lacy why
he'd done this for the last 50 years: getting up at the crack of dawn on

Christmas morn to swim 100 yards up the Serpentine. I mean, there must be easier ways to get a glass of whisky. He looked at me rather pitifully. '*Why*? It's what being English is all about …'

I left the scene of the crime musing over the odd characters who had participated in the Peter Pan Cup. 'It's what being English is all about …' The words spun around my head like a mantra as I put on my stockings, suspenders and alluring headscarf to participate in our own sacred family Christmas Day tradition. It involves the menfolk dressing up as women to pipe in the Christmas pudding with a tasteful selection of carols and, bizarrely, croon the show tune "Anchors Aweigh" for the arrival of the Nestles milk. I fondly imagined other families up and down the country doing the exact same thing, but have never actually encountered any of them. So it's just us, then …

But I felt strangely proud of all those who'd turned up at the Serpentine in their daft costumes to swim 100 yards in the freezing cold, particularly the guy who'd turned up late, but still swam it, even though there was no longer whisky greeting him at the end of it – you wouldn't catch Paula Radcliffe doing that. 'It's what being English is all about …' Alan Lacy had said. I wondered if he was right. I *hoped* he was right …

See, I have a funny relationship with England. I lived there for a while. Well, all of my life, as it happens. I used to think that it was the best country in the world, thoroughly seduced by all those stories they feed you at school of English fair play and manners and pageantry and sportsmanship and swashbuckling adventures of ruling waves and running empires. They seduced us with heroic tales of kings, queens and brave deeds … of Boadicea, Nelson, Drake, Robin Hood, Florence Nightingale, W. G. Grace, Stanley Matthews, Fred Perry, Lord Montgomery and Winston Churchill, and we didn't even question darker deeds in America, Australia, Africa, India, Ireland or Scotland.

My first memory is of hearing Nat King Cole sing "On The Sunny Side Of The Street" on our old gramophone, and my musical upbringing was almost exclusively a diet of jazz, jazz and jazz, specifically Basie, Ellington and Satchmo. No bad thing that, and you can still reduce me to a quivering wreck by playing Lena Horne singing "Frankie And Johnny" and "Love Me Or Leave Me" with a sensuality and simmering passion that frankly should have been outlawed. But at school even the cheesy English folk songs they made us sing, "Dashing Away With The Smoothing Iron", "Early One Morning", "The Lincolnshire Poacher" and all, struck a distant chord of recognition.

When the Beatles arrived, English culture turned several somersaults. The country realised in shock that its population included something called 'young people' and the class system creaked as the

old duffers humphed and spluttered as the boys grew their hair and the girls savaged their hemlines. In our house Thursdays meant *Melody Maker* and the whole family descended on it, avariciously devouring its contents; rock pages, pop pages, jazz, folk and all. One Thursday it carried the immortal headline BEATLES DIG DYLAN. It didn't mean much at the time. Why were the Beatles discussing Dylan Thomas, I wondered? But the times they were a-changin', and the article triggered a whole new assessment of cultural differences. Once we'd explored Bob Dylan it was a short hop into his main reference point – Woody Guthrie – and all the sub-texts of blues, American country and union songs that galvanised him.

A further leap took us into the repercussions on our side of the Atlantic. The ashes of the short-lived Fifties skiffle boom left a scattering of young UK musicians with an interest in the roots of American music that led them back home to its British origins, and the network of folk clubs that sprang up around the country to accommodate them. The suffocating incursion of American culture has perhaps validated the controversial dictum of one of its most prominent movers and shakers, Ewan MacColl, who specified that anyone performing at his folk club should only play music of their own heritage. No such restrictions were imposed at Guildford's Star Folk Club where my friend John Douglas Spencer Wheeler first dragged me several years later to absorb this alternative culture at first hand, initially introducing me to the likes of Tony Rose, Robin and Barry Dransfield, Dick Gaughan and, er, the Spinners.

But the real *knock-yer-socks-off-strike-me-down-with-a-feather* revelatory recognition of a truly profound English tradition, with which you could trace history, social attitudes, war, politics and working-class heroes, occurred for me at Loughborough Folk Festival at the start of the Seventies. There were two very different-looking characters on stage. One was a stocky middle-aged man with silvery hair, wearing a tweed jacket, white shirt and tie. The other looked barely out of his teens, was skinny as a rake, wore ridiculous loon pants and a tie-dye t-shirt, had a dour expression and hair down to his waist. They were the oddest of odd couples.

You couldn't imagine any remote common ground between them at all. Not when it came to music. Then they faffed around a bit, mumbled between themselves, opened a huge book with delicate, loving care, fiddled with a tuning fork and, unaccompanied, began to sing "Spencer The Rover". The harmonies were exquisite and the rapport between the two singers telepathic. They were demonstrating such love and respect for the song about a rakish rambler who belatedly discovers family values that the whole thing was almost spiritual.

By the time they sang "Claudy Banks" – *War And Peace* with a tuning fork, I was an emotional wreck.

The older man was Bob Copper, and the hippy lad singing the bass lines was his son, John. They were a living embodiment of the English tradition. I felt proud to be part of the same heritage, and never quite understood why others not only didn't feel the same way, but even actively rejected their own culture with some hostility. It was to be another 30 years before Bob Copper – caretaker of English traditional singing all his life – was officially recognised with an MBE. He died in 2004, three days after receiving it from Prince Charles.

Then again, by the Eighties I was ashamed and sickened to be English. There were two reasons: Margaret Thatcher and football hooligans. For two pins I would have given up on England there and then and joined the Foreign Legion, except that by then I was an editor of *Melody Maker*, holding down a dream job that offered me liberal licence to go trolling off to all parts of the globe with degenerates and mavericks. There again, that's enough about the Dagenham Girl Pipers.

Since then, of course, England has changed enormously. The days of the Empire seem like something out of some sad, rather repugnant ancient history book. Superficially, at least, the class system is but an apologetic relic of an absurd social hierarchy long devalued and discarded by most right-minded people. England is now a richly multi-cultural nation embracing musicians, sports personalities, designers and chefs of far distant roots and adopting them as their own.

Which is all fine and dandy, and on a good day I think positively of England as a thrusting twenty-first-century European nation with a fantastic heritage rich in folklore and a colourful multi-cultural society. Then some revolting politician pops up bleating about law-and-order and defence budgets, or a BNP candidate gets elected in Burnley, or racists go on the rampage, or the *Daily Mail* witters on about asylum seekers, or Chinese immigrants are drowned picking cockles in Morecambe, or fox-hunters march on London, or the odious Simon Cowell returns to contaminate our culture and destroy the music industry with another of his wretched self-promotional 'talent' shows … and that one-way ticket to Siberia looks very tempting again.

It's a bewildering time to be English. I mean, personally, I love it that England has become so multi-cultural. How else could I pop next door for a pint of milk on a Monday night, had the Asian community not bought up the old local corner shops? Personally, I can't get upset about the suggestion of abandoning the old English pound in favour of a bright new euro. I was in Ireland when the euro came in there, and it didn't seem to faze them one bit. But suggest that we get rid of the

pound in Britain and new political parties are formed, the press stirs up frenzy, and we're accused of selling our native soul.

So the dichotomy is, how do you equate inclusiveness and globalisation with a long and deep love of traditional culture and old customs? Does the advance of The New automatically need to sweep away The Old? Is a love and respect for the old music, ceremonies and rituals of England reconcilable with a passionate welcome to a modern, forward-thinking, enlightened twenty-first-century England? When cultures collide and merge, is the inevitable consequence a loss of purity and custom?

This is an argument that has taken place in most countries of the world where the music and traditions have been joyously uncovered, and often subsequently purloined and mixed and matched with those of the people doing the discovering. How is tradition preserved if it is exposed to the international community, with all the ills and viruses this inevitably brings?

England has become such an international community that this becomes a natural, organic process. The Notting Hill Carnival may have been conceived in homage to a famously West Indian custom, but it's over half a century since the *Windrush* sailed in with the first wave of West Indian immigrants, and Carnival is now practically an English institution. As blood mixes, so does the culture. In the next century, will bhangra be seen as part of the English tradition? Roast beef, stiff upper-lip, red phone boxes, Morecambe and Wise and cricket on the village green are the popular stereotypes of Englishness, but the national dish now apparently is chicken tikka masala, the phone boxes are grey shells, and the last cricket captain of England was born in India, so where does that leave us? Dazed and confused, that's where.

The soulless wretches in charge of the media, popular entertainment, the record industry and, in fact, almost all aspects of mainstream modern life wouldn't have a clue about this, but England has always had some of the world's most powerful, emotional and exotic cultures. There are traditional songs of such graphic storytelling about love, death, murder, sex and incest that they would make your average Norwegian death metal band blush. Not to mention colourful dances of joyous exuberance and brazen symbolism, and ancient rituals so oddly unnerving you can barely begin to understand their origins.

In more rural times, these ceremonies expressed the everyday lifestyles, superstitions and entertainment values of working-class folk. Those days are largely gone ... and expressing any sort of interest in them now is tantamount to putting a 'PRAT' sign on your forehead and ascending a stage to let the masses pound you with metaphorical rotting fruit. It's understandable, really, given the hideous

connotations now widely associated with the Union Jack and any form of nationalism. I'm with the singer Billy Bragg on this one – take down the Union Jack; we don't need it any more. *And* the flag of St George, while we're at it.

There have been too many sores. Too many images of skinheads rampaging through Europe with their veins bulging. Too many BNP bastards trying to hijack Tower Hamlets and Burnley. Too many horrific history lessons, and misguided souls harping back to the days of the Empire, and Britannia ruling the waves. The Scots, Welsh and Irish promote their own culture *ad nauseam*, but everyone hates the English. Especially the English, apparently.

One glimpse of a morris dancer and the comedians sharpen their one-liners and the good decent middle classes guffaw and mock heartily. Sod all this weird dancing and bizarre ritualistic, ceremonial stuff, the assumption runs: let's build a few more burger chains and grab ourselves some proper, transatlantic music. I still can't get my head round the fact that the English reject their own dramatic culture with such disdain, while hungrily devouring all manner of blandness from the States.

So how *are* the old customs surviving in the nooks and crannies of the country, faced with this onslaught of hostility, ridicule and blind indifference? Is King Arthur ready to rise from the earth in Glastonbury, or wherever the hell it is he's meant to be buried, to come and save the nation? Doesn't England have a soul any more? Are its roots still showing? And is there a perfect pint with my name on it?

This was always going to be an inexact journey. I've conceived it as a single circuit of the country for the sake of the narrative, although targeting specific customs and traditions means a certain licence with the timelines. It's not a guide to English folklore and custom – there are many better equipped to write such things, and some of them have – but a purely personal exploration of Englishness.

I'd always thought that all was well with Mother England as long as we still had the Shipping Forecast, and *Test Match Special* and *The Archers* on the radio, and James Alexander Gordon reading the football results at 5pm every Saturday. But now I wasn't so sure. So I set off to see for myself. From Cornwall to Cumbria, Northumberland to Norfolk, Lincoln to London, trying to find a place called England ...

CHAPTER ONE

Unite and Unite

'*Unite and unite, let us all unite ... for summer is a-come unto day ...*'

"Padstow May Song", traditional

*A*pril 30, a million years ago. Well, a different century anyway ...
The train to Cornwall had been so slow I'd seriously
wondered about sending the driver a cup of coffee to wake him up a
bit, and we'd stopped on Bodmin Moor so long I thought he'd either
become engrossed in a good book or devoured by some hideous crea-
ture of the night. When the train finally staggered into St Austell, I
leaped off it fretting that I'd missed the last bus to Padstow – after all,
they went only once every three weeks – and would be stuck here and
miss all the fun. First, though, I had to *find* the bus to Padstow. If he
was any relation to Locomotive Man, the bus driver would be fast
asleep on the No 37 parked on the beach somewhere.

And then I started seeing The Others. The German identical twin
brothers, with their laughable moustaches, their hyena-squeals of
laughter, and their impossibly huge backpacks with kettles and saucepans
sticking out of the top. And the busker with the bass drum on his back,
cymbals all over his head and a battered guitar with a sticker saying
'THIS MACHINE KILLS FASCISTS' slung around his shoulder.

There was also an old guy in full clown make-up; a couple of
giggling girls trying to sing Pink Floyd songs; hippies of all shapes,
sizes and indeterminate sex; a gaggle of students armed to the hilt with
Party Seven cases of beer; a fortune teller dripping in garish jewellery;
and three posh young blokes in full evening dress offering to perform
the complete works of Shakespeare in exactly ten minutes.

Naturally, I joined this bizarre procession: a hapless young journo
from the badlands of Surrey, with eyes on stalks, seeking the truth ...
or a few beers, whichever came first. The German twins were telling
each other jokes and laughing with ever more frenzied hysteria at the

end of them; the busker was singing Don Partridge's "Rosie"; the girls were struggling with the 20-minute instrumental interlude in *Dark Side Of The Moon;* and the posh boys were arguing about who made the best murderer in the Scottish play.

I followed them out of the station, straight on to a bus that could have been going to the dark side of the moon itself for all I knew, and watched in wonder as more people with surreal haircuts, mad accents and frankly certifiable fashion sense appeared from nowhere to clamber on board. They just kept on a-coming, cramming on to the seats, hanging from the luggage racks and jam-packed along the aisles as the bus appeared to take on the ever-expanding characteristics of Dr Who's Tardis.

A rotund, red-faced driver watched impassively as we all squeezed on, offering no reaction as the first chorus of "Give Peace A Chance" took hold. 'Everyone for Padstow, then?' he yelled eventually, and the groaning bus rolled into the night, grumbling all the way, as we headed for the north Cornwall coast. The beers went round, the singing got more raucous, the Germans started swapping jokes in Esperanto, the posh boys were halfway through *Hamlet* and the clown was in the middle of telling me a sad story about the circus, his flighty young wife and an evil tightrope walker, when the driver slammed on his brakes.

We peered through the windows, wondering if the Cornish vice squad had caught wind of the dodgy-smelling cigarettes that had been lit by the bad boys at the back, but all we could see was a pub. All eyes were turned quizzically towards the driver. Had he finally snapped and decided to throw us off his bus and abandon us in the middle of nowhere? Were we all unwitting extras in some fiendish Fellini movie? Or had it gone a bit *Wicker Man* and we were all to be sacrificed to the gods, as part of some strange Cornish May Day ritual?

The driver pulled on the handbrake, rose from his seat, turned to face us and uttered the most magical phrase in the English language: 'Anyone fancy a pint, then?'

Why, yes, kind driver, we certainly did. And so all of us jugglers, poets, clowns, conjurers, fortune tellers, Shakespeareans, Germans and professional drinkers tumbled off the bus in the wilds of Cornwall into the welcoming arms of a loving hostelry. We drank and sang and hugged and swapped life stories and told each other we'd be best friends for ever and ever amen and became one big, mad, ugly, raucous, drunken family. And that was just the bus driver.

'S'pose we'd best be on our way,' he said after an hour or so of concentrated quaffing, and rounded up the troops. 'Anyone fancy driving the bus, then? I'm a bit rat-arsed ...' We hadn't even made it as far as Padstow, but I was hooked. I never saw the German twins again,

though I fondly imagine there's a village in Cornwall entirely popu-
lated by Germans who all look exactly the same ...

But that was then, and this is now, and I hadn't been back to Padstow
on May Day for a good 20 years. Yet somehow it seemed the right and
proper place to begin a journey into the underbelly of Englishness.

The English have been rising at the crack of dawn to welcome the
May since medieval times, decorating their homes with flowers,
crowning May queens, dancing round maypoles, leaping through
bonfires and taking to the streets to share their joy, drink themselves
senseless and, frequently, behave very badly indeed. It's a symbol of the
arrival of summer, an unbridled celebration of the end of winter, better
weather, better crops, and better times ahead. And not just in England
either. In truth, they've done it for centuries all over the world.

But nobody, *nobody* celebrates May Day like a Padstonian.

Padstow's unique ceremony is shrouded in mystique and wonder.
There are a million theories, but precious few factual explanations, as
to how this remote coastal town came to welcome in May with the
canonisation of a peculiar, startlingly ugly man-made beast known to
all as an Obby Oss, despite the fact that it bears almost nil resemblance
to a horse, or indeed any other creature, real or mythical. Two Osses,
representing rival factions of the town, are paraded though the streets,
accompanied by dancers and musicians playing just one, sweetly
haunting song that you hear virtually non-stop throughout May Day,
but rarely anywhere but Padstow, or any other time of the year.

Nobody is sure why, but it's a ceremony that holds almost sacred
importance to the people of Padstow. They dress in white – with the
red or blue ribbons, and sashes, of their favoured Oss – and fight their
way through the tourists to mark the day in a unique, time-honoured
fashion. Its images of pagan symbolism, mystery, sense of community,
history and celebration make it England's oldest and most virulent
living tradition and it's the *only* time and place to start my journey
round England.

Well, that's the theory, anyway.

'We'll bomb down to Cornwall on April 30, join the May Day cele-
brations in Padstow, pop off down to Land's End and that's it, we're off
on a tour of England,' I'd fearlessly told a doubtful Mrs Colin. Sitting
motionless in a jam-packed car park just outside Bristol – it's called the
M5 – a few days later, it doesn't seem such a good idea.

Some guy's been on the radio talking about a book he's written
about the M5. Apparently the book makes a study of all the sights and
buildings you can see while driving along the M5. 'It's the most beau-
tiful motorway in the country,' he'd insisted rather pompously. 'No, it's

not,' argued one suitably indignant caller on the inevitable, subsequent phone-in. 'Nothing can beat that stretch of the M6 passing the Lake District.' Claims for the M50, M42, M20 and M40 followed thick and fast, and I stared at the radio in wonder – the world had clearly taken leave of its senses. Trapped in a fog of metal, fumes and concrete, the words 'beauty', 'cars' and 'motorway' somehow failed to compute.

We phone the guest house just outside Padstow. *Again.* The cheery landlord who'd been telling us not to worry – 'We Cornish be night owls, it don't matter 'bout the time, we won't go to bed' – appeared to have done just that, and been replaced by his much sterner wife. 'So you're still in Bristol,' she says, a little coldly, I feel. 'That's a good three hours away…' It's now 9.30pm. 'Will you still be up?' 'It looks like I'll have to be,' she says with undisguised menace, and I'm not sure if the crackle is interference on the line or some medieval weapon of torture being retrieved from the basement.

Eight phone calls, nine wrong turnings and three and a half hours later we make it to Padstow. Another three phone calls, six wrong turnings and a further half hour after *that* we find the guest house. We bombard our landlady with apologies and explanations, promise her a trip on the London Eye if she's ever in our neck of the woods, and tell her we'll name our next cat after her. She yawns ostentatiously, drops in the fact that she has to be up at 5am, and says breakfast will be served at 8am. There is the clear inference that if we arrive at 8.01am, we'll get it over our heads. Plans to go back into town to catch the pre-May Day night singing that traditionally has Padstonians pouring out of the pubs serenading the homes of selected residents after the stroke of midnight are put on hold …

We report for breakfast on the stroke of 8am as instructed, endure a tirade of meaningful yawns and sighs from the kitchen, enthuse a bit too vociferously about the *divine* eggs and the *cooked-to-perfection* bacon, and scuttle off into Padstow to welcome the May. I park Alberta, my brave Vauxhall Cavalier, at the top of the hill, promising her a quiet day after yesterday's tortuous journey west, and start clambering down into the small town of Padstow. Already the sound of drums faintly seeps through the morning haze, and the distant sight of streets festooned with flags brings an unreasonable flutter to the heart.

Then, in the distance, you catch the first, almost ghostly strains of *that tune*. It acts like an electric shock to the system, sending me leaping dangerously down the hill towards the throng already massing on the narrow streets.

'Unite and unite, let us all unite …'

It's getting louder now, and we get the first glimpse of the musicians, singers and dancers in their gleaming white shirts and trousers, and blue sashes, parading down the centre of the road.

'*Summer is a-come unto day …*'

I manhandle my way to the front of the crowd and gawp in wonder as the procession approaches, radiating joyous vibrancy as it weaves in and out of the drums and melodeons picking out the incessantly infectious tune that'll envelop the town for the whole day.

'*And whither we are going, we will all unite, in the merry merry morning of May.*'

They used to say terrible things would befall anyone who sang this song anywhere else but Padstow, or indeed on any other day of the year. I used to go round telling people about this wondrous song I'd heard there on May Day, adding that I couldn't even hum it or I'd have to kill them. I well remember the sense of shock – and what I fancied were sharp, horrified intakes of breath around the concert hall – when Maddy Prior sang it in London one subsequent Christmas.

'*Where are the young men that here now should dance, for summer is a-come unto day …,*'

They are directly in front of me now, a surprisingly young group, making their way towards the Institute, blue sashes twirling, excitement so palpable on their faces you can almost touch it.

'*Some they are in England and some they are in France in the merry morning of May …*'

The crowd follows them, packing together outside the Institute, cameras flashing, small children hoisted on shoulders, all eyes glued to the Institute steps. As the clock strikes ten, there are chants of 'Oss Oss, Wee Oss!', a massive cheer reverberates and, peering through the throng, you can just catch tantalising glimpses of a strange black swirl jerking erratically into the street. The Blue Ribbon Obby Oss has landed. The mass is on the move again and the whole street now seems to be singing with ever more vigour.

'*The young men of Padstow might if they would, for summer is a-come unto day …*'

A couple of shoulder charges, a duck here, a dive there and I'm miraculously at the front of the crowd, among the throng of dancers in their whites, blues and cowslips who've formed a circle around the Oss. This is just plain weird. A guy inside a cumbersome hoop draped in an unbecoming heavy black plastic skirt, topped off by a fairly grotesquely painted mask-cum-hat-cum-helmet. The sight of this thing leaping around in front of you would give you nightmares for weeks.

'They might have built a ship and gilded her with gold in the merry
morning of May …'

A 'teaser' dances in front of the Oss, goading it with a small paddle that you imagine is used for the rest of the year for swatting flies, or maybe the odd impromptu game of ping-pong. Suddenly, dramatically, the Oss 'dies', sinking in an untidy heap to the floor, and the music briefly stops. The teaser is on his hands and knees over it as the crowd lurches into song again, but it's a different tune now, a mournful dirge.

'O where is St George? O where is he O?'

They sing quietly and solemnly, staring at the still figure of the Oss still slumped on the floor.

'He is out in his long boat all on the salt sea O, up flies the kite and
down falls the lark O …'

The whole motley congregation of Padstonians, visitors, puzzled Japanese bystanders and teens having a sly cider stare at the bizarre street theatre unfolding before us, scarcely comprehending, but nevertheless gripped by an unworldly, indefinable emotion.

'Aunt Ursula Birdhood she had an old ewe and she died in her own
park O …'

There is a brief but poignant pause, the whole street apparently in suspended animation staring at the still black figure on the floor. Then the melodeons and drums spark into life again …

'With the merry ring, adieu the merry spring, for summer is a-come
unto day …'

The teaser is up instantly, leaping, goading, imploring, and the Oss is swiftly back on its feet too, dancing with renewed fervour.

'How happy is the little bird that merrily doth sing, in the merry morning of May ...'

And they're bounding away up South Quay boisterously continuing a journey that will last all day ... and, in my head, for many weeks afterwards. I start to follow this raucous, animated, yet oddly dignified procession, but feel an unfamiliar wetness on my face. Tears? *Tears?*

I'm in a town I haven't visited for 20 years, watching a bunch of strangers singing and dancing with another bloke dressed up in a bewilderingly ugly costume in a colourful but unfathomable ritual so ancient and obscure that even those performing the bloody thing don't really have a clue about its origins, and for God's sake I'm *crying!* How does that work, then?

And, in truth, the Blue Ribbon Oss isn't even the main event. He's the new guy in town, a mere young upstart who arrived at the turn of the twentieth century as the 'Temperance' alternative to the licentious cavorting of the Old Oss. After the Great War, the Temperance Oss was reinvented as the Peace Oss, taking round the collecting tin for charity. There are stories of other Osses – notably a strange white one – appearing and disappearing through the ages, but now there's just the bluey and the ol' feller.

And so I plough back through the crowds already thick outside the Golden Lion pub, awaiting the 11am entrance of the reprobate Old Oss. The Oss police are already fighting their corner, attempting to keep the pub forecourt clear while a guy with a ruddy face and a red bandana on his head is keeping the troops entertained, educating them in the ways of the west and urging them to buy song sheets.

'Where you from?' he asks one guy in a flat cap. 'Me? I'm from London,' says the bloke. 'Ah, then you'll have to pay a bit more.' 'Why?' asks the visitor. 'Well, if you're from London then you'll be used to paying over the odds ...' 'Oh I see,' says the visitor, grappling with West Country logic, but still digging into his pockets.

Meanwhile, our jolly MC is starting to sound like the warm-up act at a *Smash Hits* Pollwinners' Party. 'Are you ready for the best day of the year?' he yells. 'Yeeeahhhhh!' 'Are you gonna have FUN?' 'YEEAHHHHH!' 'What's the best Oss?' 'The RED Oss!' 'You gonna sing with the music?' 'YEEAAHHHH!' 'You learned all the words?' 'Er ... erm ... shuffle shuffle ... mumble mumble ...'

But the crowd at the back is starting to surge forward, ever encroaching on the space outside the Golden Lion. 'What we're going to do now is do the moonwalk,' shouts Bandana Man. 'Everybody take one step back with your right foot, then a step back with your left foot,

then one more back with the right and one back with your left and hey, you're doing the *moonwalk*.' Nobody moves.

A man in whites with a red sash moves purposefully into the throng, trying to get them to retreat with the offer of something rather more persuasive than a moonwalk – his shoulder. A portly American instantly takes umbrage, fearing one of the 18 cameras hanging round his neck might get tarnished, and rounds on the Padstonian. He, in turn, is in no mood for niceties and offers a firm push to assist his journey to a place where he might cause less interference. 'But I'm a visitor!' yelps the American, indignantly. '*Quite*,' mutters the Padstonian under his breath, and quickly moves on.

It's only a mini-flashpoint, and is but a short, sharp cameo in a long day, but it says plenty about Cornish tradition and the attitude of the locals who treasure it and preserve it so lovingly. You watch Padstonians in their ribbons and garlands hugging each other and wishing one another 'Happy May Day', eagerly greeting the returning prodigals who left the town years ago but return without fail to be with their families on an occasion that's plainly special to all of them.

Any visitor would have to be insensitive not to feel like the prover-bial spare wotsit at a wedding, as an essentially private ritual is played out through the streets. May Day consumes Padstow, and all its resi-dents, and they may not be able or willing to explain why they do it, but they know it's important. Apart from the odd collection box and people selling song sheets, there is no commercial undercurrent to it, and this alone makes it something to be cherished. Sure, local busi-nesses make a killing, but that's just seen as rightful compensation for hordes of strangers trampling through the town and the tradition. Tourists are tolerated – *barely* – but only if they don't get in the way.

May Day pictures from the early 1900s suggest a relatively pathetic affair, maintained by a few old fishermen and a smattering of raggedy musicians using anything they could lay their hands on to bang out the tune. Clearly the ritual was in steep decline and, fearing for its future after the Great War, Padstonians did what they could to generate interest, including several away-day excursions for the Oss to appear at festivals and concerts.

They succeeded in spreading the word rather more spectacularly than they could ever have imagined. Come the folk revival of the Sixties and the explosion of mass media, and Padstow became an annual pilgrimage for the folk movement ... and an excuse for hordes of drinkers to invade the town, get legless, fall over in the streets and cause bother. By the mid-Seventies television cameras were effectively banned from Padstow and, since then, all areas of the media have been give the sort of welcome normally reserved for an invading plague of diseased locusts.

But back to the town, and at 11am there's a huge roar as the doors of the Golden Lion fly open and the Old Oss finally bursts out, gambolling around the street in a manner that suggests the guy inside is shouting, 'Who's the daddy?' He's all over the place, mirroring the leaps of the teaser, dancing into the crowd, a fury of exciting energy.

'Unite and unite, let us all unite ...'

The circle of supporters in their whites and red ribbons are singing beautifully and, despite the faintly comical grotesqueness of the Oss's visage and its ungainly movement, there's a deeply emotional grace about the whole thing and ... and ... oh dear sweet Jesus, I'm crying again.

We follow the Old Oss as best we can on its constant journey through the town. Past Rick Stein's ever-growing empire of restaurants – come back in 20 years, and Padstow will be one huge Rick Stein eating orgy – *that* song is played and sung over and over again, but each verse seems to put an extra bounce in your step, a broader smile on your lips.

As they head up towards Prideaux Place, I try a short cut along a back street to beat the crowds. This swiftly leads to another side road, a back alley here and a little lane there, and before long I'm hopelessly lost. I see a young group of lads and lasses, dressed in Old Oss colours, and approach them for directions ... but back off as a volley of Cornish expletives cuts through the air. An ugly altercation is clearly in progress. Voices are raised, there's swearing and pushing and squaring up, a bottle smashes on the roadside and one of the lads is throwing up. Another guy is trying to pick a fight.

'You don't know how hard it is carrying that Oss,' he blethers, lurching into a car. 'It's *bloody hard* ... that bloody thing cuts right into your shoulders.' He's waving his arms around and nearly stumbles into me. A passing middle-aged woman catches my eye. 'He's drunk, y'know,' she says, conspiratorially. Yes, I say, that thought had occurred to me too. She nods: 'It's a rite of passage if you're brought up here ...' Well, the kid has apparently carried the Oss, got paralytic and tried to take out his mates and it's not even midday. That's some rite of passage.

In the grounds of Prideaux Place the Oss has 'died' again and the crowd is singing the dirge that'll revive it. A slightly overweight man with a red face and bushy beard rips the Oss mask/helmet off and, drenched in sweat and panting heavily, frees himself from the black skirt. Another slightly overweight man with a red face and bushy beard puts the mask/helmet on and clambers into the black skirt in his place.

'Aunt Ursula Birdhood she had an old ewe and she died in her own Park O ...'

The 'Unite unite' tune breaks out again, and the 'new' Old Oss leaps into action.

There is no shortage of theories about the origins of the Oss, from the re-enactment of a Cornish dragon killing to it being a fertility symbol. One of the bushy beards spends most of his spell inside the Oss licentiously pursuing women, the legend being that any female caught under its black skirts will be pregnant within the year. But the most romantic and popular theory is wound up in those strange song lyrics that centre on 'Aunt Ursula Birdhood'.

It is said that this dates back to when the men of Padstow were all away at war, fighting the French, in the fourteenth century. When a French ship was spotted approaching the coast, there was widespread panic in the town. One of the townsfolk, Ursula Birdhood, came up with the idea of the women dressing in red cloaks, beating drums and marching to the top of the cliff behind the visage of a scampering horse to replicate an army on the march. The French, who were either very stupid or had appalling eyesight, took one look at the Oss, turned tail and fled back to Calais pronto.

Down at the harbour they're flogging pasties of all shapes, sizes and ingredients, while I take refuge listening to John the Busker singing about the evils of working life and why we should all give up mammon and denounce worldly goods and take to the streets. 'I'm here every year,' he tells me. 'One year I didn't make it down and they thought I must be dead!' John sings Maggie Holland's magnificent alternative national anthem, "A Place Called England", which inspires an elongated debate about Maggie's references in the song. Who's Mr Harding? Who's Daniel and Dave? Meeta? Eileen? The crazy Diggers? It's getting like a Dylan convention out there on the sea front as the crowd gathers, trying to figure it all out.

Further along the quay, two hippies who look as if they took John's advice about taking to the streets a long time ago are playing Marc Bolan interpretations of Buddy Holly songs, which somehow segue into "Streets Of London" … except they're singing "Streets Of Baghdad". I stand and watch, anticipating some caustic and radical reworking of Ralph McTell's entire lyric, but … that's it. They've changed London to Baghdad, and then got bored. Politics is alive and well, but in need of inspiration at the harbour in Padstow.

The day skips by in a delirious blur. I wander around the town but don't get far without hearing the drums and the swirling May tune and, as if dragged by some magic magnet, I'm back in the throng of it again, pursuing the merry band as they head through the narrow streets. By careful pre-arrangement the blue and red teams manage to avoid meeting at any time during their all-day processions, but finally come

together at the maypole in the tiny town square around 6pm. I get there early, but already the crowds are packed tight in anticipation of this clash of the titans.

There's a hubbub among the massed spectators at the entrance to the market square, and people are staring and pointing. The first policeman of the day is spotted and we are agog to discover what all the excitement is about. A third Oss? Somebody from the blue team been caught transferring to the reds? Has a Cornish pasty sprouted legs and tried to escape from the bakery?

Then we see what all the fuss is about ... it's only a frigging *car*! This is the only day of the year, and possibly the only place too, where a car seems to belong to a different age, another universe entirely. So we gasp and point as if it's some alien being, and jeer and whistle and laugh as its embarrassed occupants painstakingly thread it inch by inch through the crowds, until it eventually emerges at the other end of the square to roar off into the night.

There's even more excitement as medics lead a guy with blood streaming down his face through the crowd. Nobody has a clue what happened to him, but there is no shortage of theories. 'There was a group of lads round the corner who looked like wrong 'uns,' one cove volunteers. 'They'd had too much to drink and they were looking for trouble. Outsiders they were. Probably came from St Austell. I reckon it's them. We're best without those sort of hooligans.' My own theory that the guy was one of the blue team caught trying to infiltrate the red team and kidnap the Old Oss doesn't seem to attract much support.

Nobody can tell me how Padstonians come to be divided between the red and blue Oss, but it seems to be a decree from the same sort of family history that dictates whether you support Liverpool or Everton, or Manchester United or City, or Rangers or Celtic. Not that the blue and red teams have *that* level of intense rivalry, obviously ...

'Oh yes, *they do* ...' says a woman next to me. 'There are *huge* rivalries between the two teams. Pride, jealousy, family disputes ... you don't know the half of it.'

I don't, but I want to, and suddenly this coming together of the two teams seems like the showdown at the OK Corral. The red Oss advance party are already out in force, pressing the crowds to the sides. A large party of Germans arrives, presumably in good time to place their blanket on the beach for the morning, but the red Oss troops are quickly among them forcing them back off the road. I do the moon-walk backwards and crash into an elderly couple who are desperately trying to hang on to their stroppy outsize granddaughter, who continually demands chocolate in a horrible whiney voice. Grandma searches in her bag and produces enough chocolate to keep Cadbury's in

20

business for the rest of May and the girl chomps happily away for several minutes as I'm given the inside gen on life in Padstow.

'Have you noticed everybody in the town wears cowslips?' I hadn't. I mean, flowers are flowers, you've seen one you've seen 'em all, right? 'Yeah, they're cowslips, everyone wears cowslips on May Day. But the thing is ...' She looks around to make sure no one's watching and leans forward to whisper. 'They're *illegal!*' What are? 'Cowslips!' Cowslips are illegal? I'm wondering if cowslips are Cornwall's equivalent of magic mushrooms. 'Yes! I mean, no. See, what it is, it's illegal to *pick* cowslips.' 'Why?' 'I don't know why, but it is. Except you can pick them in Padstow, but only for May Day. It's a special dispensation from Prince Charles. Or is it the Queen? Or.... somebody, anyway ...' Rick Stein, probably ...

I'm still absorbing this bombshell when there's a worrying disturbance behind me. The annoying fat kid has eaten all the chocolate and is whining that she can't see. Grandad tries to pick her up to put her on his shoulders but nearly has a coronary in the process, and settles for the ledge of a shop window behind them. But it doesn't keep the girl happy for long, and the next time I look she is hanging precariously from a groaning drainpipe outside the shop. As the sounds of the two bands arriving from opposite directions reach the square, there's an almighty crash as the drainpipe snaps and the girl lands in a heap at my feet with a bloodcurdling yelp.

'Oh,' says Grandad to the girl, by now sobbing heartily, 'are you all right, my lovely?' He glares accusingly at me. I clearly stand accused of dragging her off the drainpipe and flinging her cruelly to the floor. Luckily, his wife is prepared to be a defence witness, and quickly identifies the real villain in all this. 'The drainpipe broke,' she says with some melodrama. 'You wouldn't think the drainpipe would just snap like that, would you?' 'Well, you would if a baby elephant was climbing up it, missus,' I reply.

Or I *might* have done, were it not for the tumultuous roar as the two Osses arrive in the square. I peer through the backs of people's heads as the Osses and their teasers joust around the maypole, anticipating this final head-to-head will conclude only with a lot of carnage and when just one of them is left standing. There is a bit of frenzy as the melodeons go into overdrive and the Osses pout and pose and posture and eyeball each other. But it's all a bit handbags, and in due course the Peace Oss makes a tactical withdrawal and heads back to Padstow Institute to rest for the next 364 days. The red Oss continues its journey through the town in triumphant mood before, flanked by newly invigorated banks of supporters, it reaches the Golden Lion.

In the words of Herman's Hermits there's a kind of a hush (all over

the world). The drums halt, melodeons cease, dancing stops, chatter abates, mobile phones are silenced and an almost ghostly chorus fills the dark streets of Padstow.

> '*Farewell, farewell, my own true love ... farewell, farewell, my own true love ...*'

The singing is eerily mournful, a new mood of melancholia engulfing us.

> '*How can I bear to leave you, one parting kiss I'll give you ... I'll go whate'ere befalls me, I'll go where duty calls me ...*'

No! No tears! Whatever happens now, I WILL NOT CRY.

> '*I think of thee with longing, think though while tears are thronging, that with my last faint sighing, I whispered soft whilst dying ...*'

No tears! There WILL BE NO MORE TEARS IN THIS BOOK!

> '*Farewell, farewell, my own true love, farewell, farewell, my own true love ...*'

Oh, sod it, here we go again. Blubbing like a baby. But then so is everyone else.

The Old Oss has disappeared into the bowels of the Golden Lion for another year, while the visitors quietly file back up the hill to the car park, and blue and red sashes swell the pubs. I was thinking about joining them in the Golden Lion but somehow it doesn't seem right. We'd all encroached too much already in what is (give or take thousands of visitors) an essentially private party. It will retain all its magic and mystery for as long as it stays that way.

So, out of respect, I turn my back on the Golden Lion and walk away. Well, it's so crammed you can't get near the bar anyway. John the Busker had mentioned a pub out of town, which he promised would be singing the night away, but the emotional rigours of the day have taken their toll.

We crawl back to the guest house, and try not to disturb the landlady.

It's a crack of dawn job next morning as we contemplate the route to Land's End, sing the Padstow May song, and tell the landlady how wonderful her breakfast is. Almost tame by this time, the landlady –

who'd previously told us that wild boars wouldn't drag her into Padstow on May 1 – says, 'Why don't you go to Minehead?'

As it happens, this isn't a bad question. Most references to Padstow Obby Oss come with a PS about a similar Obby Oss that appears at the same time in Minehead, some hundred miles or so north along the coast in Somerset. One popular theory involves a shipwreck and a dead cow with its tail chopped off; another has the heroic creature repelling marauding Vikings from the shores of Minehead in the first or second century. In Padstow they pooh-pooh this, insisting the Minehead Oss is but a pale imitation of the Cornish version ... but oddly enough, Minehead insists it is the other way round, and the Padstow Osses are just fey show ponies. One Minehead-friendly guy even tells me the Minehead Oss – shaped like a boat and covered in ribbons and feathers – has perfected its own camp little dance sending up the more populist Padstow superstars, and is much feistier and much more fun.

It's not easy to find though, he warns. The Minehead Oss takes pride in its unpredictability. It's up at sunrise and there are certain landmarks it is sworn to bless at given times, but otherwise it follows no programme or established route. It's a feisty, multi-coloured beast, charging randomly into onlookers and knocking on people's doors, goaded on by 'gullivers' in flash costumes and a couple of musicians playing, among other things, "Soldier's Joy". 'When you least expect it, *that's* when it'll strike,' he says, a tad melodramatically. 'But make sure you get the right Oss, though ...'

Waddya mean, the *right* Oss? Is there more than one? 'Oh yeah, one year there were five. They're always having rows and splitting up and setting up rival sides. There's only one proper one, though. The others don't count.'

Unlike in Padstow, the Minehead Oss actually shows its face the day before May Day and – the big attraction for our purposes – hangs around to dance among the good folk of Minehead for a couple of days afterwards. So I have a quiet word with Alberta the bold Cavalier and we scrap the masterplan and head north through Devon. Just north of Clovelly, we pause at Buck's Mills in anticipation of discovering a cute little pub overlooking Bideford Bay where we can enjoy a sumptuous lunch at a giveaway price. We scramble down a steep lane around a disused quarry and stumble on to a small, pebbly beach. It's pretty, but there's no pub. A huge disappointment, obviously, that threatens to taint my feelings towards Buck's Mills – but there are a few quirks here to make it oddly fascinating.

There's the Braund Society, for one thing. Apparently seven brothers, all called Braund, crawled ashore here after Franny Drake's

lads gave their Spanish ships one hell of a beating during the Spanish Armada. They settled in Buck's Mills, won over the natives and, seemingly in no time at all, they'd populated the whole village with little Braunds.

I'm in the middle of writing a sitcom about a Devon village entirely populated by Spaniards called Braund, when another fascinating titbit of information about Buck's Mills springs from the ether. Somewhere beneath the sea are the ruins of a harbour that was built here in 1598 by a certain Richard Cole. This turns out to be not the other one in the Communards but, according to the sign on the beach at least, Old King Cole of merry old soul fame. He was apparently from up the road in Woolfardisworthy and was Something Very Important in the area at the time. Sadly there's no explanation why he was such a merry old soul, or what he was doing with those dodgy fiddlers three ...

We leave Buck's Mills and the Braunds and Old King Cole and the drowned harbour to wallow in their mysteries and push on up the coast to Lynmouth. It looks sedate enough now, an attractive village, with a sweet little river flowing through the centre; but even over fifty years later, the place is still overshadowed by its own tragedy.

In a torrential storm in August 1952, floods roared in off Exmoor at 200mph and turned this dainty river into a raging monster. It burst its banks in ferocious fashion, spraying rocks, trees, mud, cars, bridges, boats, walls, telegraph poles and houses as it thundered through the village, flattening everything in its path. At the end of it all the list of 35 victims included boy scouts, a postman on his rounds, hikers, holidaymakers and locals alike ... and Lynmouth lay flattened, desolate and devastated.

A small museum opposite the quay details the catalogue of human disaster and people wander through it looking at photographs of the carnage, silently reading the letters and newspaper cuttings with a sense of disbelief. You see them coming out, blinking in the sunshine, hollow expressions on their faces, gazing uncomprehendingly across at the innocent banks of the West and East Lyn rivers.

We join the genteel set enjoying cream teas in the garden of the Rock House and watch them file silently from the museum. It's a salutary reminder that here at least nature is king. There were conspiracy theories about the Lynmouth disaster, including suggestions that the freak storm was a result of scientists propelling salt into the clouds in a rainmaking experiment that went horribly wrong. Official denials swiftly followed these claims, but there remains something unworldly about Lynmouth.

Even the bikers who barge into the Rock House in their leathers and skull caps to rather surreally share biking banter and cream teas

seem to feel it, looking up in wonder at the Tors Hotel towering in the hills above us. You see tourists and holidaymakers and artists and houses claiming to be where Shelley spent his honeymoon with his child bride and R. D. Blackmore wrote *Lorna Doone* … but mostly you see ghosts.

We make it to Minehead by early evening, check in at the Old Ship Aground right on the harbour front and start looking for the local Obby Oss. There are no crowds thronging the streets, there is no distant sound of drums, melodeons or singing, no bunting or flags or maypoles. Not much of anything, in fact. Just a couple of Hell's Angels revving up their bikes, the odd fisherman – *very* odd in fact – with armfuls of maggots, and a random vicar looking decidedly shifty.

But it's blindingly obvious where the search for the Minehead Oss should start – the Hobby Horse public house, of course. This, clearly, is where he's hiding out and after two days gallivanting around the town and surrounding areas, who can blame him? The Hobby Horse has a disconcertingly grand exterior and a long pathway to the entrance that gives it the air of an old Victorian hotel that's beginning to look a bit dishevelled around the ears. In fact, it's at great pains to disassociate itself from such an illusion with a big sign outside announcing: 'THIS IS NOT A HOTEL, IT'S A PUB.'

Suitably encouraged by this information, I march confidently inside and look around, searching for the Oss and its handlers propping up the bar and a blinding session of fiddles, accordions and mandolins at full tilt in the corner. Instead, I get a freeze-frame image of five identical middle-aged blokes with ruddy round faces, spectacles and funny little caps swivelling round at the exact same moment from their stools at the bar to stare at the intruder.

If there was any conversation, it stops dead as I walk to the bar. The barmaid – a female version of the blokes, without the funny little cap – eyes me warily, a black labrador dog bares its teeth, and a little girl pokes her tongue out. I'm taking bets on which one of them will shoot me first.

'A pint of bitter please,' I say nervously to the barmaid. Somebody presses a button, the volume is switched on and movement resumes. The quintuplets avert their stares, a guy hammers a ball on the pool table with meaningful aggression, Michael Jackson sings "Thriller" on the jukebox, the labrador goes to sleep and *Coronation Street* starts wittering away on the telly in the corner. Encouraged, I turn my attention to the object of the visit …

'Is the Obby Oss around then?'

Coronation Street stops mid-sentence, Michael Jackson turns into a ghoul, a miscued shot sends a pool ball flying off the table, the little

girl shrieks, the dog jumps up and howls, the barmaid drops the glass she'd picked up to pour my pint and the faces of the quintuplets spin round at me in grotesque masks of shock and horror. The only sound is my pint shattering on the floor.

'I don't know nuthin' 'bout that ...' the barmaid mutters eventually, staring at the floor. But I thought, you know ... your pub being called the Hobby Horse, this would be like the home pub for the Minehead Obby Oss ...

'T'ain't nuthin' to do with us ... we got *nuthin' to do with it.*'

She's getting a bit tetchy now.

'You wouldn't happen to know where ... you know, where I might *find* the Obby Oss?'

There's a collective inward sucking of breath and the whole congregation winces in pain at the mention of the OO words.

'No, I don't know NUTHIN' 'BOUT THAT,' she says, splashing beer into another pint and sending it spinning towards me across the bar. She then turns on her heel and disappears into the innards of the pub, doubtless to send a coded message to Mr Big that there's a stranger in town asking awkward questions about the creature that dare not speak its name.

Suspiciously looking for signs of secreted hemlock, I sup my pint – *quickly* – watch the worst pool players in history grind out a 0-0 draw, listen to "Thriller" five times on a loop and leave, pulling my collar up in defence against the eyes drilling into the back of my head, expecting to be mown down at any moment.

A brisk stroll around Minehead reveals not the remotest sign of an Obby Oss, or indeed any other sort of life. Enquiries are met with a puzzled shake of the head and I get more sense talking to the strange sculpture depicting two giant hands holding what appears to be a metal map of Somerset along the promenade. I stare at it, baffled, for several minutes, absorbing the information that it was designed by a local student, Sarah Ward, sculpted by Owen Cunningham, and officially opened in 2001. Which leaves only one question to be answered. *Why???*

But there are no answers and certainly no Obby Oss so I wander on ... to be halted by an absurdly deep voice behind me. 'You're going the wrong way!' it booms. I turn to find the tallest man in Somerset beaming at me.

'Sorry?'

'You're going the wrong way. A lot of people do that. They get here, look at the sculpture, march off and what they don't realise is ...' He pauses for comic effect, his eyes already twinkling in anticipation of the punchline: 'They don't realise they're walking *the wrong way!!!*'

Clearly it always tickles him, this one, and he rocks backwards and forwards as he guffaws so vigorously I fear the logical conclusion may be a coronary.

Eventually he realises I'm still there, staring back at him in total bemusement. 'You're here to do the South West Coastal Path, right?' I'm here to do the *what*? 'You start here and you walk right round the south-west coast down through Devon and Cornwall to St Ives, then back round the other coast up to Penzance and all the way up to Poole in Dorset. It's 630 miles in all. That's what you're doing isn't it?'

I look at my tatty trainers, t-shirt, thin jacket, the complete absence of even a cheese-and-tomato sandwich, and think, 'Do I really *look* as if I'm about to go on a six-hundred-mile hike around the craggiest, most treacherous, wildest, rockiest landscape in England?' My friend the giant is dismayed to discover the South West Coastal Path walk isn't on the agenda.

'You should do it, you know, it's an experience you'll never forget,' he says, frowning. But then he remembers all those who arrive at the sculpture intent on doing that six-hundred-mile walk and set off in the wrong direction and he's chortling again. 'They come from all over the world, you know. You see them gathering here with their rucksacks and their walking shoes and their maps and all their equipment and they set off and ... they're going in the wrong direction!' Uh-oh, he's howling with laughter again ...

He indicates shapes of feet on the ground at the foot of the sculpture, showing us the official route begins not in the logical direction along the sea front, but up a hill across the road. He clearly spends his days hiding behind the sculpture just so he can hoot at the hapless hikers taking the low road when they should be taking the high road, and I'm guessing he's possibly a single man.

But now we're such good chums I ask him if he knows anything about the Minehead Obby Oss. '*Eh?*' I try and explain but he just stares at me in a manner that suggests a call to the men in white coats may be in order, and without a word, he wanders away, chuckling heartily to himself.

Everything else seems to be closed so we're forced to do battle with a bunch of inmates on day release from the West Wing at the Butlin's Holiday Camp up the road in the queue for that good old staple of the English seaside, fish and chips. One guy in a Manchester United shirt (so he's obviously from Kent) has about eighteen kids with him in various advanced states of hysteria. As they strew the promenade with vinegar and smelly paper, he invents a new game to keep them quiet. Every time he sees a car approaching he marches into the centre of the road and, roaring with laughter, he holds up his hand to make the car

screech to a halt and beckons the kids, all eighteen of them, to cross
the road in single file. As soon as another vehicle approaches, he
marches them back again. They certainly know how to have fun in
Minehead.

Even back at the Old Ship Aground, they're hazy about the Obby
Oss. 'Try the Hobby Horse pub up the road ...' somebody suggests
helpfully. No, I explain, been there, done that, didn't get the t-shirt.
Word of my enquiry goes round and I am directed to Marie, a dear grey-
haired lady sitting in the corner rather worryingly cradling a set of darts.
'Oh the Obby Oss,' says Marie, beaming. 'It's great fun, isn't it?'

I wouldn't actually know, I haven't met anyone who knows where it is.

'Oh it's been here, doing the, you know, the *dancing* and all that. I
think it was here at lunchtime. Or maybe it was yesterday. It was here
though. Sometimes they all go to Dunster, that's probably where it is.
Or if you'd been at Whitecross at six in the morning you'd have seen
it there.'

I explain I was in Padstow but that goes down badly. 'Why d'you
want to go there? Ours are better.'

At least you can find them at Padstow. She goes on to explain some
of the internal politics that split the Sailor's Oss and the Town Oss,
complete with tales of jealousy, betrayal, drunken fights, accusations of
breaking tradition and even a threatened court case over rightful
ownership of the ritual. But she's starting to slur and as she's waving
the darts around in dangerous fashion as she speaks, I'm beginning to
wonder if she's a reliable witness.

Even the tourist office next morning seems clueless about the
whereabouts of the missing Oss. 'There's a bit of paper here some-
where about that,' says our would-be tour guide, scrabbling about
among the leaflets about scenic bicycle rides, homes for orphaned
otters, ghost walks and go-kart rides. 'I remember seeing it, now where
would it be ...?'

Where indeed? An elusive beast, the Minehead Oss is clearly among
the lower echelons of the Ryman's League when it comes to tourist
attractions. And it's not as if Minehead is wildly blessed on that score
– those lost souls incarcerated at Butlin's excepted, obviously.

'Ah, here it is!' says the woman in the tourist office, scrabbling on
the floor and raising a scruffy piece of paper triumphantly. She
smoothes it out, holds it up to the light and I expect her to declare
peace in our time. 'Now, let me see ... they'll be in Dunster later on
today and then they have a break and ... ah! They'll be back in
Minehead tonight!'

Frankly I'd rather stick pins in my eyes than spend another day in
Minehead ... 'Oh, well there's always next year!' she says brightly.

Yeah, there is, and I'll be in Padstow. We tramp back to the Old Ship Aground, speeding up as we pass the Hobby Horse pub, take one long, last lingering look at Butlin's looming out of the sea in the distance, saddle up Alberta and head south west back to Cornwall ...

CHAPTER TWO

'Straw Dogs' and Land's End

'If I had the strength to lead an army
Or the wit to argue well and win the day
I would place a silver net about my country
And let her children take their own again'

"Silver Net", Richard Gendall

So this American mathematician marries a flirty Cornish girl and they arrive in Cornwall – all loved-up – to live in a farmhouse in her remote village. The young blonde wife soon gets frustrated with the well-meaning but deadly dull American, and the sinister locals – including her ex-boyfriend – come sniffing around and messing with both their minds. And then it all goes sleazily pear-shaped. The wife is brutally raped, a lynch mob chases a suspected paedophile, the American flips and there's complete carnage in the village ...

Well, that's how *I* remember Dustin Hoffman and Susan George in *Straw Dogs*, and I've been scared of Cornwall ever since. 'Narrow roads,' I say enigmatically, when people ask me why I'm scared of Cornwall. 'Narrow roads equal narrow minds ...' and they nod thoughtfully without having a clue what I'm on about. But really it's *Straw Dogs*. Well, *Straw Dogs* and caravans.

What *is* it with caravans? If there's one thing everyone knows about Cornwall, it's that it has quaint villages, steep hills and narrow country lanes. So what does everyone do? They drag a dirty great caravan down there with them to clog it all up.

See, the way it goes is this: you hit a narrow, country lane in Cornwall and you're pootling along, admiring the rural countryside, the cows in the fields and the interesting smells, basking in the splendid isolation and magnificent tranquillity. Then a tractor comes trundling along in the opposite direction. So you squeeze into a hedge to allow it to pass, waving your apologies for entering his domain

because you know he's a working farmer who must detest all the Fancy
Dans coming down from London in their M-reg Vauxhall Cavaliers,
and he was probably an extra in *Straw Dogs* anyway so you really don't
want to cross him.

You resume the idyllic, leisurely drive around the back lanes ... but
quickly have to dive into a ditch as some young buck comes roaring
past, splashing mud over you at 70mph in a Range Rover with barely a
sideways glance. You take a deep breath, stop making rude signs and
attempt to recapture the mood of serenity you'd felt pulling into the
lane a few minutes earlier. And, just as the lane narrows even more, you
see it – a huge brute sashaying erratically around the road over the
brow of a hill ... the Devil's Ride, the *caravan*.

There's no room to pass so you both stop, giving each other glassy-
eyed stares. He looks behind, shrugs his shoulders, indicating the
caravan's not for turning. So you have to hit reverse, scraping the wing
mirror on that stone wall in the process, until you find the hedge where
the Range Rover dumped you. You suck your breath in and glower as
the caravan wobbles past, the driver offering you a cheery wave,
snotty-nosed kids sticking their tongues out in the back.

What goes on in these people's heads? Caravans are always driven
by middle-class, middle-aged men with annoying moustaches who
wear Val Doonican cardies, have stickers from Brittany all over their
windscreens, do bad impersonations of scenes from *Star Wars* and
listen to Phil Collins and Lighthouse Family CDs all day. Their main
purpose in life, clearly, is to bugger up Cornwall.

During the many hours I spend sitting alone in pubs, finalising my
list of entries for items to put in TV's "Room 101" when Paul Merton
comes a-knocking, caravans always feature prominently. In fact, the
up-to-date Top 10, finalised over last orders in the Old Ship Aground
last night, reads:

1. Caravans
2. Umbrellas
3. Golf
4. Portsmouth
5. Football agents
6. Radio playlists
7. The flag of St George
8. All these trendy modern bars playing deafening dance music
 and full of squealing teenagers drinking alcopops
9. Simon Cowell
10. = Blokes with pony tails
10. = Traffic wardens.

Historically, spiritually, geographically and emotionally, Cornwall is like no other county in England. Cross the River Tamar that marks the great divide with Devon, and this extreme south-westerly corner of England instantly feels like the foreign country that many of its brethren would still like it to be.

It has its own customs, its own myths and legends (millions of 'em), its own flag (a rather fetching white cross on a black background), its own political party (Mebyon Kernow – Sons of Cornwall) and its own language. Mebyon Kernow scored just 1.3 per cent of the Cornish vote at the 2001 general election and the last native Kernewek speaker, John Davey of Zennor – also a traditional singer – died in 1891, but you cross the Tamar and try saying Cornwall's just another county and you'll end up in one of their pasties.

They're not slow to tell you that Cornwall is a Celtic nation and has more in common with fellow Celts in Ireland, Wales, Scotland, Isle of Man, Galicia and especially Brittany than the rest of England. The last independent king of Cornwall was a guy called Hywel, defeated in battle in AD936 by Athelstan, the king of Wessex, who systematically set about eradicating all traces of Celtic culture from the area. Indeed, until the late seventeenth century Cornwall was demeaningly marked on maps as 'West Wales'.

Yet its Celtic connections died hard and, full of associations with the mystical legends surrounding King Arthur and any number of strange myths and beguiling folklore, there's something of the night about Cornwall. It may be groaning under the weight of tourism and absentee landlords these days, but in spirit at least it's very much a foreign land. So the drive back there from Somerset is long, slow and cautious, with Mrs Colin on permanent red alert looking for rampaging farmers, careering caravans, men in moustaches and extras from *Straw Dogs*.

Romantic, historic names drift past. Tintagel, notable for the dark ruins of a Norman castle and a Celtic monastery, but most famous as the birthplace of King Arthur. Possibly – about three hundred other places make the same claim. And there's Boscastle, home of the great dance tune "Boscastle Breakdown" and where, in a mirror image of the Lynmouth disaster, floods wreak havoc in 2004. Thankfully nobody dies in the Boscastle floods, but the damage is catastrophic.

The Museum of Witchcraft is one of the buildings hit. Originally located on the Isle of Man, it opened in Boscastle in 1960, and for many years its star attraction was the skeleton of Joan Wytte, 'the fighting fairy woman'. A clairvoyant and healer, she ended up in Bodmin Gaol on a charge of grievous bodily harm and died there of pneumonia in 1813. When Graham King took over the museum he

felt uneasy about the skeleton in his cupboard, and in 1998 Joan Wytte belatedly got a proper burial in a local wood at a spot now marked by a memorial stone.

We call in at Wadebridge, which houses the splendid Cornwall Folk Festival, and watch in wonder an evocative musical dramatisation of *The Lost Gardens of Heligan*. Like the nearby Eden Project, the restoration of Heligan at Mevagissey is one of Cornwall's proudest achievements. The Tremayne family had occupied Heligan House since the sixteenth century, developing the gardens into a national treasure, proudly tended by local gardeners, until the Great War dragged them all away. The neglected gardens fell into ruin and stayed that way for a century, used only for teenage bonking and unofficial treasure hunts.

The havoc caused by the great storm of 1987 appeared to mark its final destruction, but the following Easter a small group of enthusiasts clambered over the ruins to see if they couldn't stick it all together again. They decided they could and Heligan is a horticulturist's delight once more, not only a thriving visitors' attraction, but a vindication of dreamers, idealists and natural pleasure seekers in a mad, bad world. A vindication, in fact, of Maggie Holland's place called England.

We really should go to Helston. Just a week after the Obby Oss shenanigans at Padstow, local attention turns up the road to Helston and its Furry Dance celebrations. In theory, this is a fine idea. Parish bells peeling across the town at the crack of dawn; dancing outside the Corn Exchange from 7am; processions; skipping through shops, streets and houses; men in morning dress; women in full-length gowns; the famously rowdy *Hal-an-Tow* play; booming bass drums; brass bands; a great tune played over and over; flowers a-go-go and non-stop bevvying. Sounds good, doesn't it?

The problem is ... Terry Wogan.

The Brighouse and Rastrick Brass Band had a No 2 hit single in 1977 with an instrumental version of the Helston tune. No gripes about that (nor even their corruption of the title to "The Floral Dance" and the fact that they're not from Cornwall at all but the West Riding of Yorkshire). Brass bands are good, and there's no merit in being ultra-precious about tradition or trying to seal it off from the big, bad commercial world.

But then Terry Wogan, high BBC priest of Irish charm, started adding jokey voiceovers to the record on his Radio 2 breakfast show, his version followed Brighouse and Rastrick into the charts, and I couldn't take Helston seriously again. I mean, Oysterband recorded a thrilling version of the *Hal-an-Tow* song in the Eighties, with its oblique references to St George, Robin Hood and Spaniards; now why

couldn't *that* have been a hit single? Uncle Terry's contribution became another strand in a long line of media muggings that encourage the cringe element that so undermines the public perception of English traditions.

And if you *really* want to get into the pedantry of it, the tune that Brighouse and Rastrick took into the charts in 1977 isn't actually the real deal. A trained musician and singer, Katie Moss, wrote the lyrics on a train back to London after a visit to Helston in 1911. She set it to the tune she'd been listening to all day, Chappell's published it, and the Furry Dance achieved worldwide popularity. Roger Barsotti then published a brass arrangement in 1948 which was adopted by virtually every brass band in the country, Brighouse and Rastrick included. But Katie Moss's memory of the tune was flawed, and when you hear the Helston town band play the traditional dance, it varies sharply from the one you hear by Brighouse and Rastrick, Terry Wogan or indeed virtually everyone else you hear play it.

Helston is also the birthplace (in 1863) of one Bob Fitzsimmons who, until Mr Lewis came along, was Britain's only world heavyweight boxing champion. Not that Cornwall ever saw much of him. His family emigrated to New Zealand when he was nine, and he worked there as a blacksmith before moving to Australia to launch his fighting career in the days of bare-knuckle bouts and unruly crowds.

Fitzsimmons was an unlikely champion; bald and skinny, he looked like the sort of guy you'd imagine having sand kicked in his face on the beach. His natural weight was middle, but he had a punch that chopped his opponents in half, and it was a talent that took him to America to claim the middleweight title before taking on the big boys. In Carson City, Nevada he fought the legendary Tom Sharkey, but in a bout refereed by Wyatt Earp (yep, *that* Wyatt Earp), he was disqualified for hitting Sharkey when he was down. Fitzsimmons went on to win the heavyweight title in 1897, knocking out Gentleman Jim Corbett in the fourteenth round, then losing it two years later in a cloak-and-dagger fight in New York, where boxing was banned.

But he kept fighting well into his forties (at one stage he claimed to have had 350 bouts) and beat George Gardner to win the light-heavyweight title and complete a unique triple crown. He was also a huge celebrity and an amazing character, keeping lions as pets and appearing on Broadway. Sadly, though, there was no emotional furry dancing homecoming, and he died of pneumonia in Chicago in 1917. There's a statue of him in Timaru, New Zealand, but alas not in Helston.

Helston's a perfectly fine old Cornish market town with a proud tin-mining history, and I'm tempted to stop and raise a glass to Bob

Fitzsimmons and the furry dancers. But last night I had a deeply unsettling dream about Terry Wogan in sexual congress with Susan George and today Alberta, Mrs Colin and I whizz on through it without a second glance. Nope, it's Land's End or bust for us, and I'm eagerly looking forward to the rugged, ragged wilderness and spiritual enlightenment that surely awaits us at this far-flung precipice of England.

But first there's Penzance, the 'gateway to the Scillies'. I make a mental note to return for Golowan, the ancient midsummer feast of St John. Everyone tells me what a wonderful, colourful festival it is, full of Celtic traditions, parades, singing, dancing and celebrations that absorb the whole town. It sounds amazing but today Penzance just seems, well, a bit *seedy*. There's a rugby team in one pub in the early stages of what would appear to be a quest to drink Penzance dry – and deafen it in the process singing, er, *rugby songs*. I thought modern rugby was all about mineral water and ice-cold baths after matches, but no, here we are on the third call for Dinah, Dinah to show us her leg.

The next pub is little better. There's a hopeless singer in front of a hopeless band, bellowing out hopeless songs at deafening volume. The third pub is more promising ... but the presence in the toilet of a waste-disposal unit full of used syringes sends me scurrying back into the arms of Mrs Colin, Alberta and the road to nowhere.

Or, at least, Mousehole. Every December 23, Mousehole (and pronounce it *Mowz-all* or be damned for ever) becomes an all-singing, all-dancing, all-drinking, all-eating madhouse to celebrate the munificence of Tom Bawcock.

A local fisherman and widower, Tom had, centuries earlier, risked his life to go out to sea in ferocious gales, to return with a huge catch of fish which were baked into a local delicacy, stargazy pie, to save the villagers from starvation. It's a fine thing to celebrate, although old-timers mutter low about the volume of visitors now descending on Mousehole on the great day and hi-jacking their local custom. It's to become a familiar complaint ...

Alberta says sod this for a game of soldiers, totally disregards both map and signposts, and suddenly we find ourselves across on the north coast (Cornwall and Devon are the only English counties with two different coastlines). We pause at an old tin-mining town, St Agnes, meander down the long and winding road to Trevaunance Cove, and check in at the Driftwood Spars Hotel, where I'm unfeasibly excited to discover that husky-voiced, spiky-haired lesbian *Fame Academy* winner Alex Parks used to be a barmaid.

It's an anomaly, I know. I loathe Simon Cowell (the Devil's spawn) and all the other imbecilic wretches involved in these shows helping to destroy the music industry, yet I'm hopelessly hooked on reality TV –

there's no sleep in our house when *Big Brother* is on. See, the way I figure it is actors spend years and fortunes going to RADA studying and training so they can impersonate real people. Why not just cut out the middlemen and women and watch *real people*?

Well, it seems a logical line of thought in my scrambled head as I clamber over the bar in the Driftwood Spars to quiz the current incumbent of the bar attendant position about her predecessor. 'No, I never met Alex Parks,' she says wearily, trying to memorise the order of a mountain of scrumpy and whisky chasers that's just been hurled at her by a raucous visiting rugby team. 'I think she's from Mount Hawke, isn't she?' Is she? 'Yeah, you know, near Truro.'

I *didn't* know. 'She used to play in the pubs around here, I think she was in a folk group.' Really? What were they like? 'Oh, I never saw them, I'm more into house music, like.' Still, you must have felt proud when she won *Fame Academy*? 'Didn't watch it actually, but good luck to her. She's cool. And from what I hear she's good behind the bar ...' Ah, it's good she's got something to fall back on.

I head into St Agnes in search of adventures. One of the pubs in town had offered a vague promise of live music and if that doesn't happen, there's bound to be a pub quiz going on. I'll just stand at the bar, nodding confidently as the questions start rolling out. Capital of St Kitts? 'Scarborough, mate,' I'll whisper. Last Labour prime minister before Blair? 'Callaghan,' I'll nonchalantly mouth. FA Cup winners in 1976? 'Southampton!' I'll yell triumphantly. One of the teams is bound to sign me up.

I walk up the hill from the Driftwood Spars and try to be smart, bounding along a narrow lane that's *obviously* a short cut into the town. An unnaturally large Irish wolfhound eyes me suspiciously as I plough on, refusing to be deflated by the lane's rapid deterioration into a muddy overgrown track. Peering through the hedgerows I can see the backs of a series of enormous houses but, still convinced of my bearings, I march resolutely on. And on. And on. That's the bloke code, isn't it? Never believe you could possibly get it wrong in matters of route planning, never consult the natives for directions and never, *ever*, retrace your steps.

An hour later, it's pitch-black, I'm groping my way through brambles and briars, and the only life I've seen are a series of cats, foxes, hares and various weird unidentifiable leaping creatures darting in and out of the undergrowth at my approach and scaring me witless. I take a right turn intent on correcting what I've now conceded to be navigational malfunction and get more and more lost.

There's no road, no lights, no moon, no indication of life apart from the shining eyes of increasingly werewolf-like creatures of the night

that look as if they're getting ready for one big collective howl at the moon. And then I remember *Straw Dogs* and every shadow, every rustle, every whistle of the wind becomes my assassin. I walk ever faster, fantasising about my slow, lingering death at the hands of shadowy devil worshippers and mad-eyed druids sacrificing me to some Cornish god. I wonder if I might get to hear an ancient tribal chant before they disembowel me.

And then I see a road and quickly clamber over fences, barbed wire and ditches to reach it. There are no signs, no cars: no indication at all that I haven't passed into some murky netherworld. It's pouring with rain and I'm cold, disorientated and, frankly, petrified. I try to sing songs to cheer myself up but end up repeating and repeating the chorus of Richard Thompson's classic death song, "Meet On The Ledge". Right song, wrong place.

Then a huge shadow envelops me. There is no sound of footsteps, no breathing – just the odd feeling of a *presence*. The shape of the shadow suggests that it is holding a dangerous implement. The evidence is stacking up in favour of the Grim Reaper. I swivel round, holding my breath, barely daring to look …

'You lost, my lovely?' says a little old lady, smiling at me while her cocker spaniel attempts to make love to my ankle. At 300mph I gabble my impossibly complicated explanation, including my irrational fear of being chopped up by devil worshippers and devoured by druids. She smiles indulgently: 'No, there's not much call for druids or devil worshippers round these parts …'

My guardian angel gently coaxes me back to civilisation and I crawl back to the Driftwood Spars dripping wet, covered in cuts and bruises, my ego in tatters. Mrs Colin sleepily opens one eye … and closes it again quickly. 'Did you have a nice time? Did you find any music?' 'Um, not exactly,' I say, and Richard Thompson's "Meet On The Ledge" and gruesome scenes from *Straw Dogs* dance round my head as I crawl into bed and shut away the nightmare.

Next morning we head deeper into the moody inner recesses of Cornwall, beating a path between the wild Atlantic and the bleak moors that lead to St Just-in-Penwith, the last town before Land's End. Once driven by the tin and copper industry, today St Just gently goes about its business, with a scattering of visitors meandering quietly around the market square, peering into art galleries, tiny cafes and curiosity-shop windows and contemplating a cheeky pint in the Star Inn, where John Wesley stayed in 1777 but which now hosts Monday-night folk music sessions.

Suddenly, cars start arriving from all directions and excitable young things come tumbling out of them in their glad rags, armed with silver

wrapping paper and shoes that look good but will make their toes fall off several hours later. They are in search of a wedding, and are clearly so determined to have a good time that I contemplate trying to gate-crash the party. However, I am distracted by the strains of a strange medieval music filtering through from beyond the town.

Further investigation reveals an open-air theatre, the Plen-an-Gwary, and peering through a crack in the fence, you can just catch sight of a group of people in varying states of panic running around the circular amphitheatre with amps and ladders and colourful costumes. Outside the audience has already begun to queue.

They are here to see *Ordinalia*, a rare staging of the Cornish miracle plays, originally written in the Cornish language at Glasney College in Penryn in the fifteenth century as a means of conveying the stories of the Bible to common folk in a similar way to the *York Mysteries*. They were translated in the nineteenth century, but hadn't been performed for 500 years until Mavis Spargo formed the Ordinalia Trust and, with a mixture of local actors and enthusiastic residents, staged the first of the plays, *The Creation*, in 2000. St Just was a natural venue as it is one of only two towns that still has one of these old medieval 'playing places', where processional plays like *Ordinalia* would in the old days have been performed to working folk in the community. The other is Perranzabuloe's St Piran's Round, north of Redruth. It's tempting to join the *Ordinalia* queue, but it's starting to rain and, after a traumatic night in St Agnes, I don't think I can cope with the beginning of the world, the birth of religion, the death of Christ *and* the Resurrection in three and a half hours.

We wander back to the market square and browse in a persuasive little shop called Just Cornish. This turns out to be a veritable treasure chest of Cornish culture; in fact it sells *only* Cornish produce. There are black-and-white Cornish flags of all shapes and sizes, t-shirts, endless paraphernalia about the Cornish language, and hundreds and hundreds of books about Cornwall. Perhaps significantly the shop's bestsellers are *Holyewgh An Lergh* (*Cornish for Beginners*), a t-shirt with the Cornish flag, and a car aerial flag. But a slim volume catches my attention: *Pantomime Stew: Poems by Brenda Wootton*.

Brenda Wootton was the first Cornish person I ever met. She was amazing. A big, *big* woman with an even bigger personality, she'd bound into a room in one of her colourful, voluminous gowns and dominate it with warmth, strength of character, loud rings on all her fingers, an outrageous laugh and the enviable ability to talk you all the way to the Scillies. Her softly engaging voice and the gentle, sensitive and humorous songs she favoured belied a fiercely passionate pride in her Cornish heritage.

Originally born in Newlyn in 1928, she was steeped in the local culture with an unshakeable commitment to family values and good food. And as the folk club movement began to gather momentum in the Sixties, she became a fixture just up the road from St Just at the Botallack Counthouse, a regular haunt for the burgeoning scene. Apart from a spell at St Buryan Village Hall when the Counthouse owners decided they'd make a few extra bob running a disco, the tiny outpost of Botallack became a key port of call of the folk music movement. Many of the finest young artists of the day – Wizz Jones, Al Stewart, John Renbourn, Bert Jansch, Michael Chapman, Billy Connolly and Jasper Carrott among them – were regulars, and Ralph McTell was even a resident for a while.

And it wasn't too lo .fore Brenda Wootton's passion for music and status as a natural centre of attention transported her from singing chorus in the audience to the main attraction front of house. She teamed up with guitarist John the Fish in a duo that soon became popular around the folk clubs and festivals. In 1974 she linked up with another guitarist, Robert Bartlett, adopted Crowdy Crawn – a Cornish drum equivalent of the Irish bodhran – as a surrogate band name and, at the grand old age of 46, became a professional singer.

She subsequently performed all over the world; she sang in schools, prisons, for aborigines, Native Americans, and various heads of state and celebrities and, in France especially, she became something of a legend: the singing granny who could talk you under a table, then coax you out again with a voice of such tender sweetness you felt as if you were being massaged with a feather. She occasionally threw in a curved ball and sang "House Of The Rising Sun" or "Brown Sugar" or "Somewhere Over The Rainbow". But mostly she sang the songs of Cornwall.

Brenda sang of the bell-ringers of Egloshayle, near Wadebridge; of Tom Bawcock's Eve in Mousehole; of smugglers and drinking and the mermaid legend of Matthew Trewells in Zennor; of Humphrey Davy of Ludgvan, who invented the miner's lamp; and of James Ruse of Launceston, who was transported from England for theft but found celebrity as Australia's first farmer. She also sang a deeply moving tribute to the great accordion player Charlie Bate, a fixture at Padstow on May Day and still one of Cornwall's most revered traditional musicians. 'He was a symbol of all musicians,' said Brenda. 'When people needed music, he was there.'

The only professional performer singing in the Kernewek language, Brenda found a formidable ally and collaborator on her journey into Cornish culture – Richard Gendall. A teacher, bird-watcher, boat enthusiast, forester, Cornish bard and reclusive character, Gendall

wrote hundreds of songs in English, French and Cornish, and the best of them were popularised by Brenda Wootton.

Gendall became a leading authority on all matters Kernewek, although the recent revival of the Cornish language has not been without controversy. Morton Nance published a Cornish–English dictionary in 1935, and the corpse of Kernewek really began to stir after the Second World War. Gendall launched a Cornish-language magazine *An Lef* in 1952, local schools began providing language classes, and regional identity became a serious matter.

Founded in Redruth in 1951, Mebyon Kernow consequently developed from a pressure group to a fully-fledged political party, winning its first county council election in 1967 and campaigning for more self-government. A splinter group, the Cornish National Party, went one step further to demand full independence.

There were divisions among the language revivalists too. Morton Nance's *Unified Cornish* was adapted from literature of the fourteenth and fifteenth centuries, but criticisms about purity, authenticity and indeterminate pronunciation resulted, in 1987, in Breton speaker Dr Ken George's *Common Cornish* alternative. The language buffs were still in dispute about this when Richard Gendall popped up again with a *third* alternative, *Traditional Cornish*, based on his studies of the vernacular language at the point it effectively died in the eighteenth century.

You pays your money and you takes your choice. I mean, I was all set to get down the evening institute and knock this chapter out in Cornish, but which *form* of Cornish? A study in 1995 concluded that all the revivalists' efforts were flawed, but that Robert Morton Nance's original *Unified Cornish* was the best bet. It's an ongoing debate, with Cornish a kind of linguistic equivalent of boxing's varying governing bodies. I decide to take up Esperanto instead.

So when I see Brenda Wootton's book of poetry in this little shop in St Just, I know I must buy it. 'I wrote that,' says the kindly-looking woman behind the counter, when I proffer book and money. 'Brenda Wootton was my mother.'

Sue Ellery tells me how sad she was that she was unable to complete the book before her mother's death in March 1994. 'You're right, she *was* larger than life,' says Sue. 'At her peak she was phenomenal. She'd go on and *seduce* audiences, whether it was in front of a couple of thousand people at the Olympia in Paris, or the pub up the road. She did have a big ego, but there's no way she could have got up on stage and do what she did without it.'

We talk at length of Brenda and Cornwall and Richard Gendall and the thorny question of tourists: 'They can be a pain in the arse and I

like driving around uncluttered roads as much as the next one, but I have no patience with people who lambast tourists all the time. I don't know what state Cornwall would be in without them.

'Where I do get agitated is the whole housing issue. Mother used to sing this song, "Silver Net", which is about wanting to throw a silver net over all the people who've had to leave Cornwall looking for work. Living in Cornwall means you are earning significantly less than you would do in Manchester or London. There aren't jobs or affordable housing here, so people are always leaving. So people come down here, buy up a farmer's barn, turn it into something wonderful and use it for two weeks a year, while locals can't afford to live here. That's something that should be dealt with.'

So did Brenda Wootton's passion for Cornwall make her anti-English? 'She wasn't very happy about the concept of being English, but quite happy to be European,' says Sue. 'I am, too. I have a sense of unease about being English but I feel a kinship with Bretons. I do know people who refuse to write English as their nationality on forms and put Cornish instead, but I don't go that far. I mean; it only delays things ...'

I remember the news bulletin that's just come through about 40 people who've stripped off at Alton Towers to break the world record for nude rollercoaster-riding, and wonder why anybody could possibly not want to be English.

I later ask Rick Williams, a local postman and clarinettist with Hayle band Bagas Degol, what he thinks about all this, and he muses for a while.

'Well, we do have a long, ambiguous history with England and successive English governments have done nothing to clarify it. Basically they ignore you to death ... and it's hard not to believe it's on purpose.'

In fact, Bagas Degol (it means 'Feast Day Band') are one of Cornwall's most intriguing outfits. They are big on Cornish tradition, liberally littering their music with Cornish-language material, yet have no qualms about David Twomlow playing Scottish bagpipes for all his worth, or chucking dubs and samples into a very modern, dance-y interpretation of Cornish music. Certainly their album has an inspired title: *Party Like It's 1399*.

'Hmmm,' says Rick, '1399 was a bad year ... in fact, the fourteenth century was a bad century.' Why? What happened? '*Bad* things.' Rick doesn't elaborate, so I decide to google it. I type '1399' into the computer, only to be confronted by a fierce-looking site announcing itself as 'The Society for Information Security Vulnerability Names'. When the computer sternly informs me 'THIS IS A CANDIDATE

IN THE CVE LIST' with a clanging siren and the sound of shadowy internet secret agents reaching for their sten guns, I immediately think *Straw Dogs*, switch off and return to Rick Williams and Bagas Degol.

'People have said that if this band is going to do anything at all, we'd have to leave Cornwall,' he's saying. 'It's a bit like taking a vow of poverty to stay here. The wages are so low and the price of property so high ... a lot of rich people are coming in who don't give a damn about the place.'

You want home rule for Cornwall then? 'Well, more money goes out of Cornwall than comes in, and if we had a chance to do things in our own way I'm sure it would be better. It couldn't be any worse. People say we're away with the fairies when we talk about it, but Cornwall is the size of Luxembourg ...'

Do you hate all tourists? 'Every single individual is welcome, but as a phenomenon, tourism is unwelcome. You can taste the pollution in Penzance in August, and it's hard then not to scratch your head and wonder what good this is doing us.' Rick's campaign subsequently receives an unexpected boost in high places – *The Simpsons'* alternative Christmas message features Lisa Simpson demanding home rule for Cornwall.

Still, this isn't getting us to Land's End so, after a quick look at the delights of Cape Cornwall, we plough on into the wilderness, somewhat alarmingly discovering an agitated queue of cars battling to get into the small fishing village of Sennen. Aye aye, we think, summat's up here, and join the throng tussling for ice creams and car parking space.

For several minutes I sit there swearing at a man who's returned to the swish camper van occupying a prime spot in the small harbour-side car park and is just sitting and staring into space, oblivious of my urgent pleas to get his show on the road to vacate the spot and let me in. 'About bloody time too,' I mutter, swinging broadside across the space to prevent the dodgy opportunist in the Volvo from sneaking in as the van finally edges out.

Camper Van man slams on his handbrake and is out of the vehicle like a shot, waving his arms around in what I assume to be a confrontational manner. I brace myself. The guy can clearly lip-read and is ready for a showdown. What is it to be? The old 'I no understand, me from Barcelona' trick, or do we brazen this one out and pretend I'd merely been admiring his clutch work?

Before I can say a word he thrusts a ticket in my hand. 'D'you want my parking ticket? There's three hours left on it. No point in giving money to these bastards, eh?' Ah, the brotherhood of the beleaguered motorist. I thank him effusively and proudly stick the ticket in my

window, feeling strangely rejuvenated at this unexpected victory over the System. Not to mention saving two whole English pounds.

I explore Sennen with a new spring in my step and discover why there are so many people here – it's Lifeboat Open Day. Among the ice creams, art galleries and stalls flogging I Heart Cornwall mugs and old Biggles books for 30p, I meet coastguard Dave Jackson. He's standing outside a bunch of newspaper cuttings relating the story of the shipwreck of RMS *Mulheim*, which ran aground close by here in 2003.

It appears the officer on watch caught his trousers on a lever, fell forward and was knocked unconscious. The rest of the Polish crew were asleep at the time, totally oblivious as the *Mulheim* plunged into the rocks nearby. The incident caused an outcry when it was revealed the cargo liberated in the shipwreck included large, sharp-edged lumps of black plastic waste, later found strewn along local beaches and washed up as far afield as Newquay. The surfers were outraged, forming a pressure group Surfers Against Sewage to campaign for more stringent governmental protection of Cornwall's coastline.

'Oh yes, that *Mulheim* incident was a big one,' says Dave Jackson. 'We got the call at 5am and it was one of the most ambitious things we've ever had to do, with the rescue and the cargo involved.'

As I tell Dave, getting a call to go out at 5am would be shock enough for me without having to climb around on cliffs hauling jagged lumps of plastic out of the sea. Does he get scared? He looks at me as if I'm King Loopy: 'Scared? *Scared?* What's that? No, I've been doing it for thirty years, and I've never felt scared once.'

What was the worst incident you've had as a coastguard? 'Penlee,' he says without hesitation, recalling the lifeboat smashed to pieces in appalling conditions while attempting to rescue a boat wrecked on the rocks off Mousehole in 1981. Eight people died on the *Union Star*, and another eight died on the Penlee lifeboat trying to save them. 'The conditions were so horrendous,' says Dave. 'The weather was terrible: hurricane gales, massive waves against huge cliffs, impossible circumstances. Not that cliffs worry me; I go abseiling down cliffs for fun.'

I stare at him in awe. How do you get through the day after an experience like that? How do you raise the strength to answer another call? 'You can never ever take it home with you. I'd have to wear a rubber suit if I did. You just get on with it, and the truth is I love it. Mind you, I've never had to deal with the death of a child, I'm not sure I could cope with that …'

Land's End is just a mile up the road from Sennen Cove, but cranking Alberta into action, it seems a long, ominous haul. The cheery bustle of Sennen's fishing community and coastguard stories is soon replaced by clear signs that the real Land's End is a far cry from

the Land's End in my head. We're out in the rugged wilds looking at oddly shaped stone sculptures mapping the route: look, there's the First and Last Inn in England, and the wartime telegraph museum, and Seaview Holiday Park and, then, up ahead, the end of the road.

It feels like the end of a dream. There is a bouncy castle, preening coaches, caravans breeding, a great big car park with a jolly man in a black t-shirt relieving you of £3. All here for what, exactly? To see a big, ugly hotel perched on the end of England, apparently. A spiritual wilderness this isn't. Wandering through the yellow gorse (being careful to avoid treading on the empty bottles of Jacob's Creek neatly secreted within) I watch the crowds milling round the small animals farm, the crafts and pottery shop, stroke the two cats asleep on the counter, walk to the edge of the cliffs and look for Lyonesse.

The story goes that Lyonesse was a prosperous kingdom between Land's End and the Scilly Isles, which was ruled by the lovers Tristram and Iseult after some distinctly odd behaviour with a love potion. Lyonesse – supposed to have sunk into the sea at the end of the eleventh century – inspired Tennyson to poetry, Jack Vance and Matthew Arnold to literature, Wagner to music and a thousand legends, often involving King Arthur and Camelot. All of which, obviously, are true.

So I stare out at the waves lapping around like an angry beagle, listening for the bells the storytellers still claim you can occasionally hear from the lost city beneath the ocean. But all I can see is the wreck of the *Mulheim*, and two young Australians in ludicrous shorts precariously wrapped around each other on the very precipice of the cliff trying to swallow each other's faces. I wonder for a second if it's a suicide pact and clamber across to talk them out of it, but at the sound of my approach, they manage to winch their jaws apart. With a brisk 'G'day, mate', they manhandle one another to safety, maybe taking my advice to get a room. Or, at least, a new pair of shorts.

I take a closer look at the Land's End Hotel guarding England. One sight of this great white monstrosity and any would-be invaders would turn on their heels and flee. The real reason Lyonesse sank without trace was probably because old Tristram built a hotel like this on it.

They say that in 1957 all that was here were just a few cottages and a modest gift shop. Now they're queueing, *queueing* mind, to have their photos taken underneath the famous Land's End signpost pointing to New York (3,147 miles), John o'Groats (874 miles) and, er, Ripon (431 miles). The grinning couple in matching yellow sweaters (clearly wearing them for a bet) are replaced by the Addams family. The Ripon sign is unceremoniously dismantled, new letters are inserted, a book of mileages is consulted, and the Addams family

are now posing under a sign magically transformed to announce Basingstoke – 248 miles.

I'm tempted; I'm really tempted. There's nothing wrong with a bit of good old English tack and, rather taken with the owner's explanation that the signpost thing has been run here as a family business since 1957, I'm halfway to having them take my picture under a sign saying ALBION – 1,000,000 miles. Sadly, the ever-pragmatic Mrs Colin won't hear of it: '£9.50 for a 7x5, £12 for a 10x7? They're having a laugh ...' and I am steered away from temptation to explore the plethora of fun things lurking alongside the Land's End Hotel.

There are adventure playgrounds, fast-food outlets, boats to clamber on, red telephone boxes and film shows on everything from local wildlife to the exclusive circle of people who've made the journey from Land's End to John o'Groats or vice versa. Well, not *that* exclusive. The road from LE to Jo'G is apparently so busy with jolly japesters with collecting buckets following the route in daffy costumes and bizarre modes of transport that they have a sign up informing End-to-Enders where to report to when they finish.

The first guy who made the End-to-End trek was a Cornishman, Robert Carlyle, in 1879. For reasons best known to himself, he decided to take a wheelbarrow with him. He was so pleased with himself he later did it again. And again. Robert and wheelbarrow were still walking at 79, and from the tip of Cornwall to the top of Scotland End-to-Enders have been at it ever since.

With one last swift glance at the tacky end of England we flee to the hills.

There have been nude cyclists, Ian Botham, some bloke parcelled up as a first-class letter, Ian Botham, horse riders, three-legged runners, farmers on tractors, Ian Botham, small children, aged grannies, families and their dogs and Ian Botham. Oh, and someone pushing a pea along the ground with his nose ... except that he gave up after a mile.

After one last lingering survey of the squealing kids, the empty bottles of Jacob's Creek, the fast-food outlets and the Basingstoke family handing over £12 for a photograph under a pretend road sign, I think that I know exactly how he feels ...

CHAPTER THREE

One Night on the Moors

'Never guessed unto her cold end,
Call the Devil her only friend,
Never guessed it with his bare hands,
Call the Devil the mark of man.'

"Kitty Jay", Seth Lakeman

*I*t feels like clambering across the roof of England. Not that I've ever clambered across the roof of England, of course – I'd get lost trying to find it. But as the wind howls, the cold rips through flesh and the mist descends, a strangely mystic disorientation manifests itself. I have this inescapable image of wandering into a black-and-white movie from the Thirties, and at any moment I expect to see a hunchback trundling across the moor to devour the golden-haired virgin while a pack of werewolves howl at the moon.

Even Alberta the bold Cavalier winces and groans as we rumble up another sharp incline and the grey bleakness stretches to infinity, hovering alongside the road threatening to pounce and swallow us whole any second. We haven't seen another soul for hours, and there's little indication that we will *ever* do so again. All we have is a horizon of emptiness to fuel an increasingly rampant imagination and leave a disturbing chill of doubt during the struggle to identify the strange dark shapes scuttling around in the bracken.

'It'd be great if we found a pub round this next bend,' I tell Mrs Colin, who's currently knee-deep in a map of Devon that appears to have no more clue than we do, about our current location. We round the next bend and ... yep, there *is* a pub there. Which is even spookier.

We stare at it for several minutes, just to make sure it's not a mirage or some elaborate Jeremy Beadle jape, then assemble our pennies and enter. The pub is a rather grand white affair called the Warren House Inn and has a big log fire on the go, with a huddle of hikers draped

around it. My admiration for them is boundless. It's hard enough driving, but to *walk* to such a remote spot is heroic. I sometimes feel I'd like to do this hiking lark myself, but I just couldn't stand wearing those knee-length red socks they've all got on.

'Nice fire, that ...' I observe in a hearty hiker kind of way, and I quickly hear the story of the eternal flame. The pub used to be on the opposite side of the road until, over 150 years ago, it burned to the ground. The publican rescued some smouldering embers from the ruin, took them to kindle a fire in the hearth of the building opposite ... and that fire hasn't been extinguished since. Allegedly.

Back in the day, the Warren would have been mostly frequented by a handful of farmers and tin miners and the occasional visitor to the Huccaby races held regularly up here in the early part of the century. But today it's just hikers in red socks, and an animated platoon of bikers who order piping-hot lunches and talk about chrome and horsepower. Mrs Colin and I sit outside to watch the frisky Dartmoor ponies romping through the heather (is that what they call that purple stuff?), suck in the weird atmosphere that pervades this extraordinary place, and see how long it takes to get hypothermia.

Not long, as it happens. So we head for Princetown.

More inspirationally barren landscapes, more frisky ponies, more skies the colour of coal ... and then you see it. An ugly, menacing brute of a building, grey, charmless and disconsolate: Dartmoor Prison.

Close up, it looks even more ancient, friendless and unforgiving. I stand under the huge arch gazing at those big ol' gates and a shiver runs through me. The Latin inscription reads '*Parcere Subjectis*' – spare the vanquished – but you wouldn't want to be vanquished in this place.

It was built during the Napoleonic Wars, originally to accommodate French prisoners who'd previously been held on diseased, groaningly overcrowded hulks anchored off Plymouth. It was at the behest of local MP, Sir Thomas Tyrwhitt, for many years private secretary to the Prince of Wales, who owned most of Dartmoor.

Tyrwhitt laid the first stone in 1802 and the prison officially opened seven years later, very quickly establishing its reputation as a hell on earth with horrific stories of overcrowding and appalling treatment. By 1813, over ten thousand – including a large number of American prisoners captured during the US War of Independence – were crammed into the windowless, unheated gaol, riddled with typhoid, measles, smallpox and other epidemics.

Gradually, convicts replaced prisoners-of-war. Previously, the way of things had been to transport convicts to America, Australia and other ends of the earth, but oddly enough some of the local residents took a dim view of England dumping its human flotsam in this

fashion, and the government eyed the old prisoner-of-war camps as an alternative.

The most violent, dangerous and craziest characters of Victorian England subsequently found themselves herded down to Devon and locked behind these murky walls at Princetown, and Dartmoor's infamous reputation began in earnest. Ball-and-chains, arrowed uniforms, rigid discipline, hard labour, tiny cells, wooden beds, ruthless gaolers, revolting conditions, enforced silence, cruel punishments, cat-o'-nine-tails thrashings, the birch and a freezing climate … all became synonymous with Dartmoor.

The toughest criminals all herded together in the toughest prison … it was a recipe for disaster, and the legends of Dartmoor Prison are legion. The Irish Republic's first leader, Eamon de Valera, was held here after the 1916 Dublin Easter Rising, and over a thousand conscientious objectors were dumped during the Great War to be reviled by their fellow inmates and treated abominably by their gaolers. In 1917, so many socialist conscientious objectors were incarcerated there that on May Day they held their own celebration and sang "The Red Flag".

There were various riots and plentiful escape attempts along the way. The chiming of the large bell that still hangs under the arch sounded the alert for an escape, summoning off-duty warders to duty, though the bell hasn't actually been rung since 1931. Getting over the wall was one thing, but surviving the fierce hazards on the moor outside was another. Many prisoners perished in the bid for freedom, one recaptured convict returned to his cell missing two toes as a result of frostbite.

A Princetown dog-breeder was on permanent alert with a pack of bloodhounds to lead the pursuit of fugitives across the moor. Arrows nailed to the soles of their boots usually left a trail, and the need to break into local houses for fresh clothes and sustenance also made them vulnerable.

Some, however, were successful. Like Frank 'the Mad Axeman' Mitchell.

Frank was a huge man. I've seen descriptions of him as 'a gentle giant', but when you look at Frank's CV you think that whoever said it must have been on some pretty potent mind-bending drugs. The product of a south London 'school for backward children', his track record included housebreaking, office breaking and robbery with violence … and he was still in his teens.

He was given fifteen lashes of the cat-o'-nine-tails for attacking three warders at Pentonville Prison in 1954, and had fifteen strokes of the birch for doing the same thing at Hull Prison a few years later. When he escaped from Broadmoor, a prison for the criminally insane,

and broke into the nearby home of an elderly couple while wielding an axe, he became popularly known as the Mad Axeman.

Eventually, Frank wound up in Dartmoor, where everyone – other inmates and warders alike – was terrified of him. He was serving a life sentence with little prospect of release any day soon when, one fierce December in 1966, he joined a work party building fences on the moor. The weather was so bad that the work party sheltered in a hut, and by the time the minibus came to take them back to the prison Frank had gone.

The nation was in uproar. How was it possible for one of the country's most notorious and dangerous criminals to just *disappear*? Especially a man-mountain like Frank, whose elevator clearly didn't quite reach the top floor? One of the biggest manhunts the country had ever seen combed Dartmoor and surrounding areas, questions were asked in the House, the press had a field day, and even the RAF and the army were called in to join the hunt. But they never found him.

Not surprising really, considering he was propping up a bridge on the M1 ...

Frank was big chums with the infamous Kray twins and, according to evidence presented at their own trial later, it was they who spirited him away from Dartmoor in a pre-arranged escape in a big grey Rover and then, for reasons unknown, killed him just over a week later. Ronnie Kray's autobiography disputes this, claiming they paid an associate to get Frank out of the country, but he simply took the money and bumped Frank off.

His body was never found and nobody was ever convicted of his murder, but the popular myth is that he was dumped in a mix of concrete used for one of the pillars holding up a bridge on the motorway. So at least he got his own statue.

A bloke I know was a reporter on a local paper down here years ago. Sent to cover a mundane meeting, he was driving past the prison when a warder came running out in front of him waving his arms around. The guy stopped and the warder jumped in the car, breathlessly telling him a prisoner had escaped and instructed him to head for the moors.

Eventually they saw the convict in the distance, chased after him and, after a bit of a struggle, overpowered him, dragged him into the car and dumped him back at the prison. Understandably feeling rather chuffed to be accidentally centre-stage in such a dramatic breaking news story, the reporter dashed back to his office to impart the news.

Before he had the chance to say a word he was hauled into the editor's office, loudly berated for missing the meeting to which he'd been sent, and sacked on the spot. In a daze he headed straight for the opposition paper, wrote up his exclusive, and wished he could have

seen his old editor's face when his dramatic story of thwarting an escape appeared as the front-page lead.

That's what he tells me, anyway.

So when I'm looking up at that bell and those big arches and those bulky gates, I think of Frank 'the Mad Axeman' Mitchell and 'Rubber Bones' Webb, who wriggled to freedom through the heating viaducts beneath his cell and Eamon de Valera and Michael Davitt and the acid bath murderer John Haigh ... and I feel oddly humble. 'I wouldn't want to be inside those gates,' I mumble to a passing caterpillar, but that is exactly what is about to happen. I'm going inside Dartmoor Prison and there's a uniformed bloke with loud, jangly keys dangling off his belt to prove it.

It's a purely social visit. Devon singer Seth Lakeman, who lives round these parts, knows one of the prison officers – they don't call them warders any more – and when Seth mentioned he was looking for somewhere to launch his new album, *Kitty Jay*, he suggested the prison. Now, I've no way of knowing this, but I have my suspicions that alcohol may have been involved in the hatching of this cunning plan. It's the sort of idea that sounds great as they call last orders ... only to be quietly flushed down the toilet next morning. But this was one mad idea that hung around for breakfast.

Dartmoor had recently appointed a progressive young governor, Claudia Sturt, intent on transforming the image of a prison still widely associated with the 'cesspit of humanity' quote once used to describe it. In 2002, Inspector of Prisons Anne Owens called it 'the prison that time forgot' amid stories of abuse and degradation and suicidal prisoners being locked in iron mesh cages. In 2003, it was named as one of the worst three prisons in England, and was under grave threat of privatisation. But, now a category C prison, its image is being transformed by Claudia Sturt, who warmly welcomed the idea of a concert. The Stranglers were the last people to play a concert here 12 years ago and nobody rioted then, so why the hell not?

I meet Seth before the concert and he jabbers away at such a pace that he is clearly scared witless. 'I ... you know ... I've no idea what to expect ... this is uncharted territory ... I'm looking forward to it but yeah, a bit nervous too. I mean, I could look at someone the wrong way ... they're probably all into hard rock and hip-hop ... that's a long way from what I do and they may all hate me and start a riot or something ... I mean, you never *know*, do you?'

Bouncy and effervescent, Seth's a likeable guy with a healthily laconic view of music forged by some bittersweet experiences in the music world. He and his brothers Sam and Sean were kids when they first played in public with their parents' band and were students at uni

when they started performing as the Lakeman Brothers in the early Nineties and released their first album, *Three Piece Suite*.

Things then took a dramatic turn. Kathryn Roberts, a terrific young singer from Barnsley who'd sung on *Three Piece Suite*, had started gigging as a duo with her mate, Kate Rusby. They made one sublime duo album together, which made it all the way to be *fROOTS* magazine's critics' album of the year. When they were invited to tour Portugal, Rusby and Roberts asked the three Lakeman boys to go on the road with them as a backing band. It worked so well that they decided to form a permanent band together: Equation.

Well, that was their *official* name. Fuelled by the arrogance of youth and the first taste of life on the road, they became known in some circles as the folk brat pack. In no time at all, a major label came knocking at their door talking contracts and hits and world tours. This scared the pants off Kate Rusby, who went fleeing home to Barnsley – and a glittering solo career tugging at the heartstrings of folk song – but the others took the bait.

The next few years proved to be an enlightening, if frustrating, insight into the workings of the mainstream music industry. With the might of Warner Brothers behind them, their lives became one long round of hotels, photo shoots, meetings, shaking hands with important people, writing sessions, recording sessions, costume fittings, video shoots and even the occasional gig.

The Corrs were big at the time, and the perception on the folk scene was that Equation were being groomed in the same mould, with all the blanding-out sessions that money could buy to take them there. They made a subtle, whimsical album, *Return to Me*, that various executives tossed from pillar to post before rejecting it (it was to be nearly eight years before it was finally released by independent label Rough Trade in 2003).

Sam Lakeman had teamed up with Cara Dillon, the winsome singer recruited from Derry as Kate Rusby's replacement in the band, and while all the faffing around was going on, Sam and Cara jumped ship from Equation. It wasn't a total escape – Warners apparently still saw folk-pop as a lucrative cult-in-waiting, and there were a couple more years of pumping hands, demos, discussions with producers and hit songwriting attempts before they retreated to acoustic traditional roots and, like Kate Rusby before them, made a big success of it.

In fairness Equation survived too and did well enough in America, though Kathryn Roberts and Sean Lakeman also eventually followed the acoustic duo route and won popularity back on the British folk scene where they'd started. Which left Seth. The one who didn't get the girl. 'I do feel a bit like that, sometimes,' he laughs. 'I never ever

thought of myself as a solo artist. I kept thinking, "I need a girl singer!"'

A fine fiddle player, cellist and guitarist, he worked regularly with both Roberts-Lakeman and Dillon-Lakeman before working out his own solo repertoire mixing traditional material with his own songs, mostly inspired by his Devon surroundings. The local legends of murderer John Lomas, Plymouth shipbuilder Henry Clark and the desperate servant girl Kitty Jay have proved particularly telling inspirations.

So I've filled in all the forms, signed my life away and got clearance to join a few other hacks who've gone through the same process to witness Seth and his band strut their stuff in front of a hundred or so guests at Her Majesty's Pleasure. In a small office at the edge of the prison itself, we get our instructions from Man with Clipboard. No identifying the prisoners, no photos of prisoners, no smuggling in files hidden in cakes to slip to the prisoners ...

They escort us to the chapel where the concert is to take place, and the governor Claudia Sturt welcomes us. A tall, elegant, thirty some-thing, she talks impressively of the changes she's instituted at Dartmoor and her campaign to modernise and rid it of those old 'prison that time forgot' shackles. It's one reason why she was keen to allow Seth Lakeman to play his Devon songs to her, er, clients, who'd applied for 'tickets' in response to an announcement on the notice board, and ultimately been selected as a reward for good behaviour.

One of the hacks swiftly reveals his true colours and is keen to dig the dirt. 'Tell me, Ms Sturt ... Claudia ... how do the prisoners react to having a *woman* governor ...' 'The same as they'd react to a *male* governor,' she answers coolly. 'But, if I might say so, you're young and attractive, you must get some, er, *comments* ...' 'I think they're more inter-ested in how I govern than what I look like ...' She's good. *Very* good.

We civvies are perched on a balcony at the back of the chapel, watching as small gaggles of prisoners are brought in. They're a fear-some-looking bunch. It's tattoos a-go-go and I'm not sure what it says about the prison barber, but – the odd mohawk and radical short-back-and-sides apart – it feels as if you've wandered into a convention of the Shaved Head Society. The hardest-looking cases have tattooed shaved heads.

I study them closely. The Notorious B.I.G., Slayer and Old Dirty Bastard would appear to be more their musical tipple than Seth's elegiac story songs of Devon folklore, and I start to wonder if his fears of inciting a riot may not be as paranoid as I'd imagined. I mean, they seem calm enough, chattering quietly among themselves, occasionally swapping high fives or swivelling round to stare suspiciously at the alien contingent observing them from the balcony.

Inevitably you think of Johnny Cash and his famous gigs at Folsom Prison and San Quentin. '*San Quentin, may you rot and burn in hell …*' he sang to a standing ovation, while the prison officers gripped their truncheons that little bit tighter. '*May your walls fall and may I live to tell …*' On that live 1969 recording you can hear the prisoners reaching a frenzy. '*May all the world forget you ever stood … and may all the world regret you did no good.*'

He was some dude, Johnny Cash. He even had the nerve to ask the warders to bring him a glass of water after that inflammatory song. 'Noooooo! Are you mad?' yelps an appalled Seth Lakeman, when asked if he's penned a similarly emotive paean to Dartmoor Prison for the occasion. 'I just want to get out of there alive!'

Eventually Claudia Sturt appears on the makeshift stage to introduce Seth and his band. 'It's a good opportunity for you to hear someone from outside,' she tells the audience. 'I know there's not always much to look forward to if you're in gaol and I hope you show Seth and his band a lot of appreciation. I heard them rehearsing and they sounded great …'

And, grinning sheepishly, Seth and his chums nervously sidle on to sing about Devon. The first song is greeted with warm applause and everyone relaxes. Seth is no Johnny Cash though. 'I live near here and often pass so, er, it's a … great … pleasure … to, er, be here.' Later on he asks if there's anyone from Scotland and, encouraged by a few stifled cheers, he talks about the anguish of being away from home. 'So this is for anyone away from home … well, that's all of you, I suppose … silly thing to say … er, what I mean is….'

Shut up and play the song, Seth. He shuts up and plays the song.

And then he introduces Charlie. Seth had told me about Charlie earlier. On one of his exploratory visits to the prison, they'd told Seth that one of the long-term prisoners was a mean guitarist and singer. Seth asked if he could meet him and they ended up jamming together. Seth decided he'd get Charlie up on stage with him during the gig, but Man with Clipboard had said this now looked unlikely. I assumed he'd been a bad boy and privileges had been removed, but Clipboard said 'No, he's just scared shitless.' Why? 'He thinks the other prisoners will take the piss out of him …'

But when the moment comes and Seth says, 'And now I want you all to welcome on stage someone you all know well …' Charlie's up there next to him in a single bound. He's a giant of a man, swamped in muscles and tattoos, smiling gratefully as the cons rise to their feet to welcome him. As soon as he launches into a gritty blues stomper, "Stormy Monday", they're whooping and hollering, and by the end of the song Charlie seems quite overcome. The gig ends in raucous

cheers and while I'm still waiting for the band to re-emerge and play a knock-'em-dead version of "Jailhouse Rock", the officers sidle alongside their charges, the applause quickly dissipates and they all shuffle back to their cells.

I nip downstairs and have a quick word with a couple of prisoners, who joke that it's the best gig they've been to in years. 'That guy's good,' says a small blond lad who looks like a choirboy. I wouldn't mind betting his gaol nickname *is* the Choirboy. 'I don't know anything about folk music, and I'd never have listened to it on the outside, I'm more into hard rock, know what I mean? But I like the way he tells the stories in the songs. He's cool.'

He was terrified you'd hate him and riot. 'He thought we'd *riot?*' The Choirboy laughs uproariously at the very idea. We seem to be getting along so well I wonder if I dare ask what he's in for. That's the thing. As good as Seth Lakeman is, I'd spent the whole concert staring at the prisoners, my imagination running riot at the thought of what dastardly crimes they'd committed.

So what are you in … I mean, what's it like in here then?

'It's OK. Better than it used to be.' What do you think of the governor?

'She's cool. It's got a lot better here; they treat you better. They treat you with more respect.'

I'm still dying to know his crime. When will you get out?

'Next year I hope …'

Oh …

'Arson.'

Sorry?

'I'm in for arson. People always want to know what you're in for…'

Oh no … I wasn't … I mean, it never occurred to me …

Charlie, the hero of the hour, is also hanging around, so I wander over and congratulate him on his performance. 'Thanks, man,' he mumbles, but I can't stop staring at the tattoos all over his neck and face.

He's a shy boy, but we end up having a nice chat. He's in his late twenties, talks knowledgeably of old blues greats like Robert Johnson, Muddy Waters and Sonny Boy Williamson, and appears to be very taken with Seth Lakeman. 'That's one of my favourite CDs,' he says. 'I play it all the time.'

In *here*? He gives me an old-fashioned look and I know he wants to say something like, 'No actually, I go down to the coast on a Friday night with me mates when we go clubbing and I play it before we go out, numskull!' but he's painstakingly polite and respectful and explains that yes, they can hear CDs at Dartmoor these days.

Did you play before you got inside?

'Not much. I never wrote a song before. I'm practising guitar a lot now.'

Will you play when you get out?

'I'd like to. Seth said we could maybe do some stuff together.'

When do you get out?

'Next year, hopefully ...'

Again, I'm dying to know what he's done, but every enquiry along these lines to the prison staff is met with the stock line of 'there are victim issues'. So we'll never know. Unless, of course, you happen to be in a local pub getting bladdered later, and happen to mention you'd seen this guy Charlie playing the blues in the prison and he seemed like a nice guy and this bloke you've never met in your life before but may or may not work at the prison, leans over, shakes his head and says, 'Oh no he's *not* ...' and proceeds to inform you that Charlie actually kicked a man to death in a drugs dispute.

By this time Seth Lakeman is feeling no pain, flushed on the success of not causing a riot, and talks some more about Charlie: 'It was the gym instructor who said, "You want to get Charlie on board", and he took me into his cell to meet him, which was a bit weird. I wasn't expecting much but he started to play, and then he suddenly burst out with this big booming voice and I thought "Wow!" He's written a couple of great songs too, about his experiences in prison and his feelings about what he's done. It'd be great to help him, maybe go in and arrange them in a slightly different way, and hopefully that'll inspire him to write some more.'

He leans back in his seat, takes another gulp from his pint and laughs. 'It's been a surreal day all right. I'm glad I went into the prison beforehand and met Charlie and a couple of the others. Meeting them first made a big difference. I got a snippet of their lifestyle and it made me feel I could play the music in the way I wanted them to perceive it, which is in quite a passionate, dramatic way. I was still nervous though. Did you see the guy whistle when the soundman came to the front of the stage? He wolf-whistled right in front of him. At a normal gig you wouldn't worry about that sort of thing, but here ... I mean, it only needs one to kick off.'

But you had Charlie onside ...

'Yep, I had Charlie onside. Imagine what A and B wing is like tonight. When we left, Charlie said, "I'm gonna have a drink now!" Imagine! They're gonna have a party in there!'

In fairness we have our own party, too, discussing Devon, its funny little ways and its grand tradition of music, dancing and village fairs. In the old days they'd have pony racing, greasy poles, pig-skittling and all manner of sideshows, but the highlight was always the step-dancing

competition. Such an environment has produced many great musicians, but perhaps none greater than melodeon player supreme, Bob Cann from South Tawton, long dead but still a legend in these parts and an inspiration to many Devon musicians since. Local music traditions faded fast in Devon when the new broom came in after the Second World War, and would almost certainly have disappeared completely were it not for Cann keeping the tunes alive as well as composing some new ones.

His playing and singing at Saturday dances was the one constant in village life around Dartmoor; he maintained an unbroken link with the old traditions and continued to play right up to his death in 1990. His legacy is maintained in fine style in the area by his grandson Mark Bazeley and Jason Rice, grandson of another renowned local musician and step-dancer, Jack Rice from Chagford, who often accompanied Bob Cann on mouth organ and played with him in his Dartmoor Pixie Band.

So with thoughts of Bob Cann intermingling with Seth's songs of weird Devon legends swirling around my head amid images of Charlie's tattoos and mad axemen running across the moors, I feel a bit queasy as I stumble back to my nearby B&B. It's then I notice the room. Bibles. Everywhere there are Bibles. *Everywhere*. Big ones, small ones, red ones, black ones. Everywhere you look there are books on religion. Just sitting there, staring at you from every angle like a disapproving governess.

The walls are strewn with religious posters and pictures and I swear that Jesus is climbing off the cross hanging on the wall and coming towards me with a disapproving look on His face. I really shouldn't have had that last pint of scrumpy. I've just spent a night in a prison and a pub ... and I'm being silently bombarded by Christianity. No wonder the Devil gets all the best songs.

In desperation, I switch on the telly, hoping for a re-run of *One Foot in the Grave* or *To the Manor Born* to help me make it through the night. A fuzzy screen eventually chokes into focus to show an American preacher ranting about the evils of carnal lust, the demon alcohol and the corrupting influence of mammon ... and then asking for donations to help him spread the word.

I frantically press knobs and smack the telly a few times before the penny drops ... this telly is jammed into the God channel and hell will freeze over before it'll allow me to watch *To the Manor Born*. Jeezus ... if I'm not saved by the end of this long night, I never will be. I drift off into a troubled sleep interrupted at regular intervals by a grinning horned creature in a red cape, cackling and dancing through a torrent of flames while screaming 'You're going to *hell*, heathen' in a bloodcurdling voice.

Feeling faint next morning, I wade through the crosses and piles of *Jesus Saves* (but Satan nets the rebound) magazines for a holy breakfast and eye the chirpy Cockney landlord suspiciously. He ushers me to my

table with extravagant warmth and I brace myself, awaiting the conversion speech. 'Would you like the full English ...?' I'm thinking it's going to be loaves and fishes. 'I do pride myself on my breakfasts ... most important meal of the day, good hearty breakfast, sets you up, don't you think? I do a good proper English breakfast.'

So a proper English breakfast it is – a real coronary special piled high with eggs, bacon, beans, fried tomatoes, mushrooms, black pudding, the lot – before I make my excuses and make a dash for it as a group of men in black suits, pudding-bowl haircuts and VIP brief cases march through the door.

I flee into the arms of Mrs Colin, who has been on a map-reading course at Plymouth, and we decide her newfound skills should be put to the test right away with a visit to Kitty Jay's grave. 'Where's that then?' she asks. I've no idea, but pixies come each day to put fresh flowers on the grave so we should be able to find it. She pores over the map uncertainly.

Seth Lakeman's song about Kitty Jay has fired my imagination. Over a frenetic fiddle, he tells a particularly woeful tale, detailing the sorrows of an orphan girl sent to live with a farming family at Manaton. The farmer's son took a bit of a shine to her, as farmers' sons do, and impregnated her. This being Devon in the 1700s, the news didn't play well in the local community, least of all the farmer's son's family.

There was to be no shotgun wedding here. Kitty was thrown out of the farm, ostracised in the community, disowned by the church and ended up hanging herself. As suicides weren't allowed to be buried on consecrated ground for fear their souls would return as ghosts, Kitty was buried in no-man's land at a crossroads in the middle of nowhere between the parishes of Manaton and Widecombe.

Now this may all sound like cock-and-bull, and that's what they thought in south Devon too. A certain Mr Bryant, who owned Hedge Barton adjoining the burial site in the mid-nineteenth century, was so sick of all the stories that he decided to resolve the issue once and for all and, convinced there was nothing inside, dug up the grave. He found the skull and bones of a young woman.

Thus authenticated, the legend found a new impetus, and Kitty's grave has become a symbolic shrine, an unknown soldier for victims, waifs and strays. It is said that persons unknown lay fresh flowers at her grave every day. They say that at midnight the mists descend on Hound Tor and, when it clears, fresh flowers magically appear. Every day. Winter and summer. Snowstorm or hail. Tempest or storm. Every day, fresh flowers.

'It's the pixies,' Seth Lakeman had insisted last night. '*They* put the

flowers on Kitty's grave – I've seen 'em!' However, his evidence is deemed inadmissible on the grounds that he was three sheets to the wind at the time. Even more oddly it's even said to have become a focal point for pagans and, cripes, *devil worshippers*. A local group called the Torbay Investigators of the Paranormal have been making a study of the Kitty Jay mystery, camping out on Hound Tor at midnight and looking for pixies, but their results are inconclusive. Hang on, I'll just rewind here. The *Torbay Investigators of the Paranormal?*

This sounds like something out of a *Little Britain* sketch, but straight up, there really *is* a Torbay Investigators of the Paranormal. They meet on Monday nights at the Churston Court Hotel in Torbay, because it's supposedly one of the most haunted places in Devon. A disembodied monk's habit is regularly seen gliding through their gatherings, candles go out and relight at will, and all sorts of ghosts pop along to join in the fun as the heroic souls of the Torbay Investigators of the Paranormal plot their next ghost-busting party. It beats line dancing, I guess. I want to meet them and find out what they look like. What uniforms do they wear? What music do they listen to? Who irons their sheets? And is that really Jesus in that B&B I stayed in last night? Oddly enough, they don't return my calls.

But none of this is finding Kitty Jay's grave. And this is no easy task: a stern test of Mrs Colin's new map-reading talents. There are two schools of thought about the Kitty Jay suicide. The Torbay Investigators of the Paranormal insist she took her own life in the barn at the back of Barracott Farm where she lived, but my new best mates, the prison officers at Princetown, reckon she did the deed at a local pub, the Ring o'Bells.

And that's where we're heading. Maybe.

We pass through the impossibly cute village of Widecombe with Uncle Tom Cobley and all. They still hold a fair here on the second Tuesday in September, but mostly it's just for the tourists. We sing the Widecombe Fair song and realise what a ghastly story it is, telling of seven oiks 'borrowing' Tom Pearce's old grey mare and getting tanked up as they rode her over the moors until she keeled over and died. It's a true story too. *Ish.* Tom Cobley was certainly a real person, who died in 1844; you can see his grave at Spreyton. His descendants still live there, while the ghost of the old grey mare – the poor grey mare who isn't even given the courtesy of having her name remembered in the song, dammit! – is said to haunt the moors. And so it bloody should.

Arriving at the even more impossibly cute village of North Bovey we stop the car, take our shoes off and push Alberta up the hill lest we disturb the precious tranquillity of the place. We talk in whispers,

although there's nobody around. Like, there's *nobody* around. It's so spooky I'm on the point of calling in the Torbay Investigators of the Paranormal. Then we spot the Ring o'Bells.

This is it! This is the pub where Kitty Jay killed herself: I can *sense* it. So we skip across the small village green, past the water pump and granite trough, past the parade of whitewashed thatched cottages and the gorgeous fifteenth-century church, and dive into the big old rambling bar. The Ring o'Bells is a lovely, spacious thirteenth-century inn with a 1993 Egon Ronay certificate proudly mounted outside, but this afternoon at least it's totally deserted and looks very shut.

But hey, the door creaks open and we tiptoe nervously into the darkness inside, me with one hand in my pocket ready to dial Torbay Investigators of the Paranormal. We edge round the corner, half expecting to find Kitty still hanging in the closet, but joy of joys, it leads into a bar. An empty bar, but still a bar with drinks and every-thing. In a matter of, ooh, *minutes*, we're even joined by a barmaid.

Drinks are ordered, seats are discovered and I decide to cut to the chase. Kitty Jay, then... The young barmaid looks at me sharply, perhaps thinking I'm a member of Torbay Investigators of the Paranormal in disguise. 'What *about* Kitty Jay?'

Is it true she killed herself in this pub? There's a brief flicker of panic across the girl's face followed by a long pause. 'I believe, er ... well I don't rightly know but ... yes, I did hear that story, yes.'

She scuttles off and we're left gazing at posters about the forth-coming quiz night (every second Sunday). But I bide my time, wait for her to come and see if we've left yet, and then ... *pounce*.

So *where* did she do it?

'What?'

Kitty. Where in the pub did she kill herself?

She looks as if she's going to cry. 'I, er, I really couldn't ... I er, I really couldn't tell you.' She's polishing the bar at a rate of knots now ...

How did she do it?

'What?'

Was it a hanging? I mean, there's a few beams here that she could have used ...

'Look, I really don't know anything about it, OK?'

OK.

The struggle to find Kitty Jay's grave goes on. We eventually break the habit of a lifetime and ask for directions. It's pointless, really; I always tune out at the bit where they say, 'Turn left at the end of this road', start tinkering with my Greatest English Strikers of the Last 35 Years list, and wake up to thank them profusely only when they get to the bit where they say, 'You can't miss it.' My favourite was the time in

Oxford when I asked a guy if he knew where the football ground was. 'Yes I do, thank you,' he said, and marched off.

So there follows an excruciating hour or so following steep, meandering lanes, reaching dead ends, doing three-point turns in muddy ditches and having intelligent conversations with a couple of bored cows about whether Lineker was better than Shearer as darkness begins to fall, and the mist descends from Hound Tor. It's getting scary now, and I can well imagine the local legend of the phantom hounds racing across the moor to hurl themselves against the tomb of an evil squire in the seventeenth century inspiring Conan Doyle to write *The Hound of the Baskervilles*.

These are tense moments in our search for Albion, and with Mrs Colin demanding a refund on that map-reading course, we decide it's all been an elaborate Seth Lakeman hoax and Kitty Jay's grave doesn't exist. That's it, we're off, project abandoned. Let's go home and have some fish and chips and watch *One Foot in the Grave* on the God Channel.

And then we find it.

There are farms, a lay-by, and … a small mound strewn with flowers. Right there, along the side of the road. And that's it. No headstone. No other marking. But it feels like finding the Holy Grail.

Closer up, the plot thickens. Literally. There's a key, a few candles, 42p in small change and lots of fresh flowers, so the pixies *have* been busy. One of the bunches carries a cryptic message … '*Kitty, it's been two hundred years or more, and Sam Hain's come again. You're ever liked and ever loved. Your death was not in vain. So rest in peace where you lay and sleep the deep sleep after this day. From two friends.*'

It's dated October 31. Which is, of course, Halloween. Or, alternatively, the Celtic New Year, when bonfires were lit to ward off evil spirits. Several centuries before Christ, the people even offered sacrifices – some of them human – to the God of Death. The God of Death was called Sam Hain.

Almost imperceptibly the mist has tumbled off Hound Tor, swallowing up everything around. Darkness has fallen, it's suddenly freezing cold, and Mrs Colin has already fled to Alberta's loving seat belt. I stare at Kitty Jay's grave one more time and realise I'm shivering.

I decide not to hang around to say hello to the pixies …

CHAPTER FOUR

Avalon, Tenpole Tudor and the Man They Couldn't Hang

'Come all you false young men, do not leave me here to complain
For the grass that have been oftentimes trampled under foot
Give it time it will rise up again, give it time it will rise up again'

"The Seeds Of Love", traditional

The plan is an early night, and a swift exit from Devon next morning. It doesn't happen. A swift nightcap had turned into a serious session pondering a subject threatening to match Items for "Room 101" in my Top 10 of crucial matters for discussion in public houses: Songs for My Funeral.

It's the ultimate mix-tape, your valedictory statement to the world: a grandstanding conclusion on The Meaning of Life and all who sail in her. You're going to get only one crack at it, so you'd better get it right. And that's why you'll frequently find me alone in dark corners of pubs with furrowed brow, silently mouthing lyrics, quaffing ale, and scribbling frantically. People look quizzically out of the corners of their eyes, mutter 'nutter' to each other, and pass my table trying to scrutinise my notes. A few ales down the line, they crumble and ask if I'm writing a book. 'A book?' I say in astonishment. 'Me, writing a book? Perish the thought! Good gracious, *no* …'

'Then what *are* you doing?' they implore. 'I'm writing the soundtrack to my funeral …'

That usually shuts them up and they sidle off, muttering 'nutter' again. But more often than not they're soon back, asking if they can play too. See, there is something irresistible about Songs for My Funeral. It's a great chat-up line, especially if you're an undertaker. And it's revealing, too. If you want an instant insight into someone's character, ask 'em what they want played at their funeral.

If they go for "My Way", then just turn around and walk away –

they have an ego the size of Exeter. If they choose "The Wind Beneath My Wings", then approach with caution – they're probably an emotional wreck. If it's "The End" by the Doors, they probably have issues. If it's Edith Piaf's "*Je Ne Regrette Rien*", you won't get a word in edgeways, and if it's "Somewhere Over The Rainbow" they're probably gay. If it's The Seekers' "The Carnival Is Over", they're taking the piss. If they go for "Days", then you might want to buy them a drink … but check first whether they mean the version by the Kinks or Kirsty MacColl. If it's Kirsty, you might want to make it a double.

It's a debate still raging in my head as we pass a sign for Torquay. 'I'm really not sure,' I'm saying to Mrs Colin. 'I've got Ewan MacColl's "Joy Of Living", Bob Marley's "No Woman No Cry" and Christy Moore's "Ride On", but I'm stuck between Cyril Tawney's "Sammy's Bar" and John Tams's "Pull Down Lads" and I almost forgot about Roy Harper's "When An Old Cricketer Leaves The Crease" … oh and Richard Thompson's "Meet On The Ledge" as a closer? And you know what? I'm even contemplating Billy Bragg's "Between The Wars". What do you think?'

'Shut up.'

'Fair enough …'

The sight of Torquay excites endless approximations of Basil Fawlty's best lines and hearty cries of 'Morning Major, Morning Fawlty', 'Don't mention the war' and 'It's Torquay, madam. What do you expect to see outside a Torquay hotel window – the hanging gardens of Babylon?' It's legally compulsory to do this if you're in a car and you see a sign to Torquay. If you're on foot, you must do the funny walk.

And then, hey, there's the sign to Babbacombe, and that evokes a whole new flood of images. Babbacombe, the self-styled 'jewel in the crown of the English Riviera', with its two beaches and the splendid Cary Arms overlooking the sea. Ah yes, Babbacombe; my favourite murder.

It happened in the early hours of November 14, 1884. A fire was spotted at the Glen, a big house on the sea front, and people from the Cary Arms and other surrounding houses rushed to help put out the flames. But when the dust settled they went inside and, in the dining room, discovered the lady of the house, 68-year-old Emma Keyse, a personal friend of Queen Victoria. Her throat was cut, her head smashed in and she was doused in paraffin.

All eyes turned to John Lee, the tall, thin, sallow-faced, hollow-cheeked, slightly shady 19-year-old from the gorgeous Devon village of Abbotskerswell, who'd done time for theft and was now employed as a servant by Emma Keyse. When questioned, he failed to come up with the right answers, totally unable or unwilling to explain how he'd

cut his arm. It wasn't much to go on, but it was enough apparently to send him to Exeter Assizes. There he was convicted of murder, despite a distinct lack of hard evidence, and no motive apart from revenge on Emma Keyse for cutting his wages in half to two shillings per week. His pleas of innocence fell on deaf ears, and he was duly sentenced to hang by his neck until he was dead.

The execution was set for Exeter Prison on February 23, 1885 ... and that's when the fun started. With a chaplain at his side, they stood John Lee on the trap door, strapped his legs together, placed a white hood over his head, tied the noose round his neck, pulled the lever and watched for his lifeless body to dangle and twitch at the end of the rope. Except it didn't. Nothing happened. The trap door didn't budge and John Lee lived. He stood and watched while they tested the trap door, jumping up and down on it, and it snapped open each time. There was nowt wrong with it. So the wretched Lee was marched back and the process repeated. The hangman pulled the lever again and ... the trap door didn't budge.

Lee was taken back to his cell while workmen were called to investigate the fault.

You imagine there was then a long delay while they waited for the workmen, who were late because they had to do another quick scaffold job in Dartmoor on the way. And, of course, when they arrived they didn't have the right tools and had to pop out to B&Q to pick up a screwdriver. But they didn't have the right one in stock, so they had to order one from Plymouth, and then of course it was lunchtime.

When they did finally arrive, they spent an hour or so, circling and prodding the rogue trap door, digging into their tool bag for a tape measure, shaking their heads, asking if a cuppa was out of the question, tutting a bit, getting on their hands and knees to study it all from different angles, muttering among themselves and scratching their heads a lot.

Then, sighing deeply, they finally address the hangman: 'Sorry mate, this is gonna cost. It's yer dry rot, see. Come here, have a look at that trap door, it's bowed, see. Needs a sliver shaved off the side, see, so we'll have to take it right off and then sink it back into the hole. That's a major job that is. I mean, the labour on that is, well, £150 an hour, then there's the materials and the cost of hiring a saw and dry cleaning for me boiler suit 'cos I got me knees dirty, see, and I've got a bit of dust on my head, so that means a haircut at the fancy new salon up the road. So work it out for yourself. I could do you a whole new scaffold for a couple of grand. Quality job. No bullshit. There's a lot of cowboys around, y'know. No? OK. Shall we call it £950, then? And I'm robbing myself.'

The trap door was tested and retested using a sandbag the same weight as the condemned man, and found to be in perfect working order. The sandbag was stone dead in seconds. So the chaplain was recalled, John Lee was marched back to the scaffold, his legs strapped together, the hood placed over his head and the noose around his neck. The hangman, a Yorkshire ex-policeman called James Berry, was understandably tense. He was, after all, on 21 guineas per dangling corpse.

He jerked the lever. Nothing happened.

Exeter Gaol was in uproar. The chaplain is said to have fainted, the assembled press were running around in circles with excitement, James Berry was stunned and the prison authorities argued furiously among themselves about what should be done. A messenger was despatched to London to inform the Home Secretary of this unprecedented turn of events. John Lee went back to his cell to eat an unexpectedly hearty lunch.

When the messenger returned to Exeter, it was to inform the powers-that-be that the condemned man clearly had God on his side, and the sentence was to be commuted to life imprisonment. He ultimately served twenty years and was released in 1905, still protesting his innocence, to marry a childhood sweetheart and move to America where they lived happily ever after. Ish …

I only know all this because, in 1971, Fairport Convention made a concept album called *Babbacombe Lee*, which documented the whole story in a passionate song cycle. It was pretty much a commercial failure and rarely gets mentioned these days, even among Fairport enthusiasts. The perception seems to be that by this time the golden groundbreaking era of Fairport Convention – and perhaps the whole folk rock movement – had already disappeared with the departure of its three central characters, Ashley Hutchings, Sandy Denny and Richard Thompson. They'd marched into further adventures with Steeleye Span, Fotheringay and solo careers, while Fairport hobbled on as best they could.

But cometh the hour, cometh the man and Dave Swarbrick, the brilliant fiddle player introduced to add folk flair and traditional music pedigree to Fairport, responded to the challenge. Stumbling on the story of the man they couldn't hang in an old magazine article while rummaging around in a junk shop, Swarb was so fascinated by the story that he wrote a whole album devoted to it. Even more amazingly, he took on the unenviable role of replacing the great Sandy Denny as lead singer, and became the band's driving force. He made a pretty good fist of it, too. And while its lavish gatefold sleeve got up a lot of people's noses because it rejected the traditional track listing in favour of a thematic scene-setting format, the much-maligned,

grossly underrated *Babbacombe Lee* album may still even stand as Swarbrick's finest hour.

It certainly triggered much more interest in the John Lee case. All sorts of supplementary evidence, new suspects, fresh motives, conspiracy theories and sub-plot mysteries emerged. There was the vision Lee reportedly experienced the night before his planned execution, when visited by an angel who told him not to worry – they wouldn't be able to kill him because he was innocent. Poor old James Berry, the hangman, is also said to have had a premonition the night before that something would go horribly wrong the next day and he wouldn't get his 21 guineas.

When Lee emerged from prison 22 years later, still protesting his innocence before disappearing to a new life in America, he made oblique references to an unnamed killer he refused to name. With no sign of any forced entry into the house, one theory is that he was protecting his step-sister, Elizabeth Harris, who was Emma Keyse's cook.

An investigation by a Torquay newspaper floated an even darker theory. It revealed that Elizabeth Harris was pregnant at the time of the murder, and although the name of the father was never revealed, it pointed the finger at a prominent and well-to-do young solicitor, Gwynne Templer. There were claims of a party in the servants' quarters on the fateful night involving Templer, Harris, Lee and another girl, and that when Emma Keyse was awoken by the noise and came to investigate, the trouble kicked off. A puritanical Christian, Miss Keyse was outraged by the salacious scene that confronted her, and in the ensuing row Templer took an axe to her head and a knife to her throat. In the blood-splattered kitchen, John Lee and the others hastily concocted a panicky plan to burn the whole darn shooting match and run for their lives.

Gwynne Templer, never connected with the crime during his lifetime, represented John Lee at his trial, but by all accounts was totally useless, becoming so mentally unstable that he was taken off the case before the verdict was announced. He subsequently went mad – driven crazy by guilt, according to the theorists – and died aged 29 from 'general paralysis of the insane' at Holloway Sanatorium in Egham, Surrey, just two years after the murder.

There is no shortage of alternative theories involving deathbed confessions, shadowy intruders, lurking fishermen, long-lost relatives, bribing the hangman and secret lovers to keep the yarns boiling over, with a 2005 book, *The Man They Couldn't Hang*, offering yet further revelations and theories to the improbable tale unearthed by Dave Swarbrick. Even the ultimate fate of John Lee after his release from prison is shrouded in mystery.

He abandoned Jessie, the girl from Newton Abbot he'd married after getting out of gaol, teamed up with a certain Adelina Gibbs, and they made a new life in America, where Lee survived the Depression working as a shipping clerk in Milwaukee. Yet his life was still touched by tragedy – Evelyn, his 19-year-old daughter with Adelina, died in 1933 of fumes inhaled while she was using naphtha to clean drapes at a house where she was employed in service. John Lee, who became an American citizen in 1939, finally died at the age of 81 – a full 60 years after poor old James Berry had tried to hang him in Exeter. Lee's partner Adelina went on to survive for many more years, and was 94 when she eventually died in 1969.

Emma Keyse's old house, the Glen, no longer overlooks the beach at Babbacombe, long since flattened for a car park, though you wouldn't know it as there's no outward memorial or acknowledgment that anything untoward ever happened here. But you can still have a pint in the Cary Arms nearby, where John Lee ran to raise the alarm, and, if you're lucky, get to hear a few more theories. Sadly, my only souvenir of the murder – a rather natty Man They Couldn't Hang tankard depicting the scene of the crime, purchased from the Cary Arms – has also expired, cruelly murdered by my cat Frank in his own moment of madness, leaping from the window sill to the kitchen table.

Dave Swarbrick, the man who originally revived interest in all this with the *Babbacombe Lee* album, famously went on to have his own phantom death when, in 1999, some idiot prematurely wrote his obituary in the *Daily Telegraph*. Well, when I say *some* idiot …

The *Telegraph* had called me on a Friday night, told me Dave was seriously ill in hospital with a lung problem, wasn't expected to survive the weekend, and could I please prepare an obituary? It is, of course, standard practice for newspapers to write obituaries in advance, and I'd done a few before, although it always made me uneasy. Don't know why. It's not as if an obit could somehow inexplicably find its way into the paper before the subject is dead, is it? *Is* it?

I'd been paranoid about a similar call years earlier from *The Times* asking me to write an urgent Lonnie Donegan obit when he was rushed to hospital for major heart surgery. I immediately called my friend Wally Whyton, the broadcaster and one-time leader of the skiffle band the Vipers. Donegan and the Vipers had been dual spearheads of the brief skiffle boom of 1957 which, effectively, became the catalyst of the British folk revival that followed, and I figured Wally – a lovely, warm-spirited man with nary a bad word to say about *anyone* – would offer valuable insight and a warm tribute. 'Lonnie Donegan?' said Wally, rather animatedly, when I called him. 'Yes, I can tell you about Lonnie Donegan. He stole my songs, he stole my band and he

stole my girlfriend ... he's an absolute *bastard* and yes, you can quote me on that. Anything else you want to know?'

I wrote the obituary – minus Wally's quotes – and spent the next few days living in abject terror worrying about whether it would somehow get printed in *The Times* before the time was right. It didn't, and Lonnie went on to live for another 15 years or so – outliving Wally Whyton, incidentally – at which point, *The Times* dug out my obituary, blew off the cobwebs, added a bit about his last few years and printed it. So when I emailed the *Daily Telegraph* my Dave Swarbrick obituary that weekend in 1999, I enclosed a note that read, 'I SINCERELY HOPE YOU WON'T HAVE THE NEED TO USE THIS FOR A VERY LONG TIME.'

On the Monday, I made my own enquiries about Swarb's state of health and was relieved to discover that, while he'd been seriously ill over the weekend, he was now recovering. The next day somebody called me to say he'd died – it must be true, his obituary was in the *Telegraph*. A shiver went through me. The phone was suddenly red-hot with confused people wondering what had happened overnight to cause this tragic turn of events, and how did the *Telegraph* get the news in so quickly anyway? The answer, of course, was that Swarb was not well, exactly, but he was certainly alive.

Then I took a call from the *Guardian*.

'We were wondering if you could write an obituary on Dave Swarbrick ...'

He's not dead.

'Yes he is.'

Trust me, he's not dead.

'Yes he is, he *must* be.'

Why must he be?

'It's in the *Telegraph*.'

I didn't know whether to laugh or cry. What I did was curl into a ball and hide under the table for a while.

I was mortified by the whole business. The mistake was entirely the *Telegraph*'s – they had acted on bum information, and got their lines crossed. Luckily the *Telegraph* doesn't have bylines on its obituaries, so I didn't actually have to change my name by deed poll, but it still turned my stomach over every time I thought about it and I'd flee from a room whenever anyone mentioned it. 'Wonder who wrote that Swarb obituary?' they'd say. 'I *wonder* ...' I'd say, and retire to the little boys' room for another agony session.

At least it gave Swarb a good line ('It's not the first time I've died in Coventry') and he didn't cast any aspersions on the actual content of his obit. But here we are riding through Babbacombe, and for the first time I manage to raise a smile about the whole wretched affair.

Dave Swarbrick has continued to battle with emphysema since then, still playing fiddle beautifully but requiring a wheelchair and an oxygen cylinder to get him through it. Honoured with a lifetime achievement award at the BBC Folk Awards in January 2004, he was too ill to attend and Martin Carthy received it on his behalf. But there was a positive development in the autumn when he had a successful double lung transplant, and the rest of us now allow ourselves a cautious celebration and the hope that one of the best-loved characters and finest musicians to grace this land will once more lay his irrepressible bow on fiddle.

That *Babbacombe Lee* album is reaching its dramatic finale as we hit Teignmouth (and that's pronounced *Tin-muth* if you don't want to upset the natives). Muse, an extreme rock band who douse themselves in flamboyant gestures and a garish pomp that takes them teetering to the precipice of Planet Ludicrous without quite toppling them over it, are from Teignmouth. I know this because I hear someone on the radio slagging them off. Frankly anyone who started out calling themselves Gothic Plague deserve all that's coming to them in later life, but Muse's strained relationship with their home town is a bit more personal. They said Teignmouth was crap, basically.

'A boring little town with nothing to offer,' is how Muse singer Matt Bellamy described it. 'The only time it came to life was in the summer when it turned into a vacation spot for visiting Londoners. When the summer ended, they left and took all the life with them.' Muse even slagged it off in their press biog, saying Teignmouth was 'barely breathing in summer, stone cold dead in winter ... and for anyone between 13 and 18, a living hell the whole year round'. The *South Devon Herald Express* was incandescent with rage, and that marble statue and freedom of the town award may be on hold for a while yet.

But Muse's damnation of Teignmouth might also justifiably be applied to several towns along this coast. Not least to Sidmouth.

Usually I'm here in the first week in August, when the streets are teeming with dancers, musicians, artists, stallholders and free spirits who annually congregate for the oldest festival of its kind in Europe and yep, probably the best too. You can have a fine old time spending the whole day and evening wandering along the esplanade ducking and diving through morris and sword dancers, listening to the buskers, chatting to the winos about the meaning of life and watching the daily parades.

You can have an even better time sitting in the pubs all day and evening, absorbing the bottomless sessions that seem to carry on all week without a break. Alternatively, you can dart around the town, taking in the astonishing range of workshops, lectures and concerts occupying the place. If you're really energetic you can trek up the hill

to the Knowle Arena, where international dance teams from all over the world have performed. In recent times, it has witnessed unforgettable performances from Rolf Harris (Godlike), Lonnie Donegan (one of his last), Incredible String Band (unspeakably awful) and Blue Murder (wondrous).

I was here one midweek afternoon in 2001 for the most emotional concert I have ever witnessed, when the entire audience was reduced to a gibbering emotional wreck by two blokes who weren't even on the bill.

Tony Rose was one of the first singers I ever saw in a folk club. He looked a bit of a rebel then, with his long flowing hair, loud shirts and the hint of a swagger in his step. In a warm, rich, tender, unfussy manner, accompanying himself on guitar and concertina, he sang ballads of such graphic, descriptive detail that each one felt like a full-blooded movie. Songs like "Young Hunting", "Lord Randall", "The Bonny Hind", "Sheaf And Knife" … gripping tales of love, lost love, deceit, murder, treachery, tragedy, disaster, incest. He balanced these with some rousing West Country chorus songs like "Tavistock Goosey Fair" and "The Bellringing".

Born in Exeter, Tony discovered folk music at Oxford University in the Sixties, where he saw some of the more colourful pioneers of the folk club movement, such as the great Geordie singer Louis Killen, Sussex Rose Shirley Collins, and the larger than life Scots entertainer Alex Campbell. He was also profoundly influenced by another West Country singer, former navy man Cyril Tawney, and went on to become a leading light at his local folk club, the Jolly Porter in Exeter. He subsequently emerged on the very front line of the second wave of Brit folk revivalists, aligned with the likes of Martin Carthy, Dave Burland, Dick Gaughan and Nic Jones. At one point he even formed a 'supergroup' of sorts – Bandoggs – with Nic Jones and the popular duo Pete and Christine Coe.

Tony had a rewardingly simplistic approach. He mostly sang traditional songs because they were what moved him most and he felt they deserved to be heard, and he avoided the sexier folk rock band route many of his contemporaries were taking – although he did do a mean version of "The Three Bells" *in French*. It never remotely threatened to make him rich or famous, and eventually he returned to his original job of teaching, but it did make him one of the greatest singers, as well as one of the most admirable characters, that I have ever met.

I can't remember who told me he had cancer, but I well remember the immediate queue for tickets as well as the queue of headline artists wanting to appear when they announced a special fund-raising concert would be held for Tony Rose at that 2001 Sidmouth Festival. Tony was there, smiling broadly throughout, as his peers lined up to pay their

tributes and to try and provide the moral support and spiritual fibre that would help him beat the disease. His old compadre Nic Jones was also there, making his first real foray into the folk world since a horrific car crash had ended his career 20 years earlier. Like two wounded old soldiers, Tony Rose and Nic Jones linked arms and joined the throng on stage singing the chorus of ... I dunno, "Wild Mountain Thyme" or some such. Like everyone else, I was blinded by tears at the time.

Tony looked in pretty good shape that day, all things considered, and spoke philosophically but optimistically of his chances of recovery. During a period of remission he even attempted a couple of comeback gigs, renewed his season ticket to Bath Rugby Club and accepted an invitation to appear at Sidmouth Festival the following year.

A remarkably unassuming man, he was astonished by the waves of support and affection the folk scene had heaped on him, and spoke at length of the privilege he felt about being involved in a grassroots movement that generally eschewed bullshit, hype, ego, greed, ambition and all the other ugly ills that clog up the mainstream music industry. He was certainly looking forward to making a triumphant return to the 2002 Sidmouth Festival. Sadly, he didn't make it. Tony died in June of that year.

I'd like to say his music lives on, but for the moment a lot of it doesn't. Like much great British folk music of the Seventies, his classic albums are largely unavailable and have never been issued on CD, because somebody apparently believes they're better off gathering dust in a cupboard than out in the shops. So Sidmouth holds lots of memories, but today it makes me angry.

During festival week it's a frenetic, joyous celebration of music and dance that consumes the entire town. A folk festival in every traditional sense of the expression, it's a throwback almost to the true essence of folk music when it really did represent the self-expression and essential spirit of working people. A time when communities gathered to sing and play and talk and dance and drink together, with a special respect reserved for the musicians and singers providing the entertainment.

From 1949, a Whit Monday morris dancing tour of south Devon became a popular feature of the calendar in Sidmouth, attracting large audiences, and there was a history of traditional songs and dances being collected in the locality. So that when the English Folk Dance and Song Society sought somewhere to host a festival to promote dance in 1954, Sidmouth was a logical choice.

It was run by Nibs Matthews and Margaret Grant, and tickets for that first official Sidmouth Festival in 1955 were £2.50 (for men) and £2 (women) or £4 per double ticket. About a hundred people – mostly in their twenties – came to that first festival, highlighted by a Saturday

night at the Girl Guide hut with various processional dances along the promenade and informal sessions at the Volunteer Inn and the Marine Bar throughout what turned out to be a sunny and highly successful week. Anthony Eden was at No 10, ITV had just been launched, the Aldermaston marches were in full swing and Bill Haley, Dicky Valentine, Slim Whitman and Jimmy Young were the heart-throbs of the day as teddy boys roamed the land. But social and ritual dance displays proved to be more appealing in this small seaside town than anyone had ever imagined.

Under the stewardship of the redoubtable Bill Rutter, the festival went from strength to strength, eventually attracting dance teams not just from all parts of Britain, but the rest of the world. Apart from a two-year exile in the larger resort of Exmouth, where the grass briefly looked greener, Sidmouth became a focal point for the British folk revival. In time it brought in traditional dance teams from China, Ghana, Zimbabwe, Korea, Sierra Leone, New Zealand, Trinidad, Uganda, Tibet ... every country imaginable, as well as workshops, heated debates, quizzes, plays, silly games, youth events, alternative dances, impromptu bands and sessions, firework displays, torchlight processions and attempts to get in the *Guinness Book of World Records* for the biggest ceilidh ever. Virtually everyone who ever sang or played a note on the UK folk scene has appeared in Sidmouth at some stage, either officially or unofficially, plus a lot of people who haven't. It's a teeming, vibrant festival that's engendered its own self-propelling lifestyle and affected roots music trends in profound ways.

A recent upsurge of thrilling young English dance bands like Whapweasel, Hekety, Jabadaw and Bellowhead is a direct result of Sidmouth's raucous late-night sessions. The Shooting Roots youth fringe has produced an inventive new generation of artists intent on pursuing their own musical heritage, with the impressive likes of Kate Rusby, Kathryn Roberts, Nancy Kerr, Bill Jones, Benji Kirkpatrick, Jim Moray and Laurel Swift all emerging directly or indirectly from the inspiration of Sidmouth.

In 1997 it poured virtually all week, flooding much of Knowle Arena and other parts of the town, turning the festival into a mudbath and decimating attendance figures. It drained the coffers and concentrated minds at Mrs Casey, the company which had run the festival so successfully for so long and now sought more support from local businesses. It didn't happen. In 2004 Mrs Casey announced that unless a fund could be set up as a guarantee against the sort of losses that almost wrecked its business in 1997, it was pulling out. This also didn't happen, and Mrs Casey went through with its threat to pull out, though others have stepped in to fill the void.

Passing through Sidmouth now, I'm reminded of Muse talking about the visitors taking all the life with them when they left Teignmouth. What was it Matt Bellamy said? 'Barely breathing in summer, stone cold dead in winter ...' Sidmouth isn't so very different; so quiet and listless you can't imagine how it could possibly survive without the influx of people in folk week, when it can hike up prices and, you imagine, subsidise hibernation during the other 51 weeks of the year. 'Running Sidmouth for 20 years was the best thing I ever did ... and not running it is the best thing I ever did,' Steve Heap tells me.

'Pull your finger out, Sidmouth!' I yell, and grab the coat tails of Cecil Sharp. In one stately bound Alberta is whisking us into Somerset, through the Saxon market town of Axminster (disappointingly the roads aren't carpeted), high up into Chard (home of the first woman cabinet minister Margaret Bondfield) and Crewkerne (where Nelson's chum Hardy, of 'kiss me Hardy' fame, went to school) and into the baffling maze of country lanes where Sharp used to ride his bike.

There are various schools of thought about Cecil Sharp. Born in London, he was a privately educated Cambridge graduate who spent most of his twenties living in Australia. On his return he became a teacher, and in 1895 was appointed principal at Hampstead Conservatory. But he was irresistibly drawn to Somerset, where his life's defining work as the country's most important collector of traditional songs and dances was largely acted out.

Cecil Sharp collected over 500 songs from singers in Somerset and north Devon alone, and then extended his work to Cornwall, Gloucester, Oxfordshire and ultimately to the south Appalachians in America. The received wisdom is that without his vision and enterprise in notating this oral tradition, these songs – and with them a way of life and a vital snapshot of cultural history – are likely to have been lost for ever. There were English collectors both before and after him – Lucy Broadwood, Frank Kidson and Sabine Baring-Gould among them – but none assembled anything like the same volume of material with such painstaking commitment. Unlike prominent earlier ballad collectors like Francis Child, Sharp notated the tunes as well as the words. A part-time musician, composer and private music tutor, he was to become a dominant force in the embryonic English Folk Song Society at the turn of the twentieth century, and appears to have put a few noses out of joint there with the urgent passion with which he went about trying to get the music recognised, and his frustration at the inertia of others in helping to achieve it.

Two famous events came to define Sharp's role as the saviour of folk music. The first came on Boxing Day 1899 when he accidentally discovered morris dancing at Headington in Oxfordshire, leading him

to notate the music played for the dancers by William Kimber on the concertina.

Kimber had listened to morris tunes from the cradle – his father played the tunes to him on concertina, fiddle and tin whistle, so the young William was born to the role, initially as dancer and then as concertina player. He made his debut as a dancer with the Headington Quarry side at Queen Victoria's Jubilee celebrations in 1877.

Cecil Sharp spent the white Christmas of 1899 in the area, and looked out of his window on Boxing Day to see the morris side dancing along the street, led by the 17-year-old Kimber playing "Laudanum Bunches". Sharp was beside himself with excitement watching this strange sight, and went out to talk to the dancers. They rather shame-facedly said they were really meant to dance at Whitsuntide, not Christmas, but times were so hard in the great freeze that they thought they'd see if they could earn a few pennies.

Sharp noted down five dances and later described the meeting as the turning point in his life. He and Kimber subsequently became close friends (though Kimber always called him 'Mr Sharp' and Sharp called him 'Kimber'); Sharp described Kimber as 'a bricklayer by trade, but a dancer by profession.' The concertina he played on that first meeting with Sharp was presented to Cecil Sharp House, the headquarters of the English Folk Dance and Song Society in London, but was destroyed when the building was hit in a bombing raid during the Second World War. Kimber died on Boxing Day, 1961 – 62 years to the day after his first meeting with Sharp.

Sharp's second epiphany arrived during the summer of 1903, when he came to Somerset to visit the Rev. Charles Marson, a friend he'd first met in Australia. It was at Marson's vicarage in the village of Hambridge that he heard Marson's gardener, John England, singing "The Seeds Of Love". This, seemingly, was Sharp's blinding light on the road to Damascus. He carefully wrote down the words and notes England was singing and arranged it on piano. It was the first song he collected, and it triggered the subsequent annotation of a large stock of England's living song tradition.

So our first job is to find Hambridge. It's not as easy as you might think. There are any number of Somerset villages around these parts, so tiny and so unfettered by signs of life that you whip through them with nary a second glance. As far as we can make out, these villages consist of, well, just signs really. A few cows, the odd pub, occasional tractor and fields, fields, fields flash by in a blur. Then there's a sign for Hambridge, a few cows, a tractor, a big white pub called the Lamb and Lion and fields, fields, fields. And a church ... with a graveyard and everything.

Some people find it hard to pass a pub or a betting shop without going in. I'm currently having the same problem with graveyards. Every gravestone tells a story. You look at the inscriptions and wonder what secrets they guard. Once I spent Saturday afternoons doing something healthy with my life, like screaming abuse at referees of football matches; now I wander around graveyards, my imagination rampantly constructing life stories from the shreds of information on the headstone.

ADAM DALRYMPLE
b. Newcastle Jan 8 1880. d. 1963
Beloved husband of Ann and father of Toby, Thomas,
Taylor, Thelma, Tamarind, Travis

A further inscription reveals that Ann was 25 years younger than her husband. By the time I've finished with him, Adam Dalrymple is a Geordie lothario. Carousing the West Country obsessed by the letter T, he meets his match with a local nymphet. This throws up more questions. I mean, what sort of a parent names a child *Tamarind*?

St James's Church has a maroon door, and a sign on it announcing: 'Regretfully this church is locked. Following the theft of articles from this church, the vicar and PCC have regretfully decided to keep it locked for the time being.' It's a bleak indictment on society when things are nicked from such a tranquil church in a beautiful hamlet like this.

Behind the church there's a veritable orgy of headstones, and I plough through them in search of some clues to Cecil Sharp's visits and the local singing tradition. Right at the back, I strike gold. A grand, slightly overgrown grave with a round headstone reads:

To the dear memory of Charles Latimer Marson
For 19 years the much loving and beloved vicar of this parish
Born May 16, 1859. Died March 3, 1914, aged 54 years

Charles Marson seems to have been an amazing man. The eldest son of a parish priest from Clevedon, Somerset, he studied classics and history at Oxford and became an ardent radical. He decided to get his hands dirty working with the impoverished, downtrodden souls in the East End of London, helped to found the Christian Socialist League, and became editor of the Christian Socialist magazine. He moved to Australia, where he became a founder of the Adelaide Labor Party and that's where he met Cecil Sharp.

On his return to England he continued his work in the London slums, but he was a man of poor health who suffered from chronic asthma, and in 1895 he came home to Somerset to be the Hambridge parish priest. So it was at the vicarage here that Sharp came to visit Rev. Marson on the fateful occasion he heard the gardener John England singing "The Seeds Of Love", which set him off on his epic voyage of discovery into traditional song. Indeed, Marson was to introduce Sharp to many other local traditional singers in the area.

So there, standing all alone by Charles Marson's grave on a chilly Saturday afternoon, Mrs Colin and I raise an imaginary glass to the good reverend and Cecil Sharp and John England, and sing the beautiful, evocative song, "The Seeds Of Love" ... *'My garden was planted well with flowers everywhere ... But I had not the liberty to choose for myself, of the flowers that I love so dear ... of the flowers that I loved so dear.'* Well, in truth, Mrs Colin just hums a bit and I get completely lost at the end of the second verse, but for a couple of moments there we feel we're connecting profoundly with a small part of England's soul.

It also sets us off on a further chase round Somerset villages. I've invested in a terrific book called *Still Growing: English Traditional Songs and Singers from the Cecil Sharp Collection*. Apart from an absorbing essay on Sharp, in which the learned Vic Gammon questions some widely held assumptions about the great collector, particularly querying Sharp's eschewal of the newfangled phonograph – used by Percy Grainger and other researchers to record the old singers and musicians – in favour of the tried-and-trusted pen-and-paper collecting technique. Sharp, an opinionated man at the best of times, argued that singers felt self-conscious and tense when singing into cylinder recordings, but his critics felt he misrepresented working people. He certainly put a few noses out of joint at the English Folk Song Society and ultimately also fell out with Rev. Marson, though nobody seems to know why.

Hambridge certainly seems to have been a hotbed of traditional song. Two sisters, Lucy White and Louisa Hooper, supplied Sharp with over a hundred songs that had been in the family for several generations and talked of some merry old music sessions with Sharp and Rev. Marson at the Vicarage. Louie Hooper, whose big song was "Foggy Dew", was even recorded by the BBC for a broadcast on the World Service, and it's high fives all round when we find her grave in the Hambridge churchyard.

I'm quite keen to find out more about another Hambridge singer, cowman Tom Spracklan, who sang "High Germany" and "Brennan on the Moor" and once bit a man's thumb off. Sadly, there's no sign of his grave, nor indeed any memorial to John England, who

emigrated to Canada some time after Cecil Sharp heard him singing "The Seeds Of Love".

Along the road from Hambridge is Curry Rivel, another tiny village, where Sharp collected, from a local stone quarry worker Harry Richards, one of the most famous songs in the English tradition, the desperately sad "The Trees They Do Grow High", about a girl forced by her father to marry a 16-year-old lad, who fathers a son and is dead by the time he's 18.

We're lured into the relative metropolis of Langport by the splendid story of Mary Overd. A 67-year-old mother of nine, she lived in the 'mean street' of Knapps Lane, and when Sharp came calling, she was off down the pub. When Cecil eventually found her she apparently threw her arms around him and danced him round the pub, much, you fondly imagine, to his supreme embarrassment. Accounts of her singing songs like "Bruton Town" and "King George" describe an extrovert performer, pumping her fist in the air and thumping tables in excitement.

She sounds wonderful, and with houses lurching around at a disorientating array of jaunty angles, Langport conveys the rather appealing impression of a town that's permanently ratted. Sadly, I don't get to discover the veracity of this, as our attempt to locate the home of Mary Overd in Knapps Lane founders miserably in a succession of badly executed three-point turns and a lot of cussing from people in Land Rovers and an ugly face-off with a caravan. Tails between legs, we scarper to North Petherton.

North Petherton is another small Somerset town that you imagine spends most of its life quietly minding its own business and carefully avoiding saying boo to a goose. Not that we see any geese. They'd soon have been frightened off by the squawking kids, the roar of coaches and the clunk of tinnies being snapped open as the tourist crowds pour in.

Geoffrey Chaucer was once Deputy Forester here, but otherwise North Petherton's main claim to fame was as the biggest village in England. It must have been a mixed blessing when it was officially upgraded to a town not too long ago. No more mentions in pub quizzes or *Trivial Pursuit*, no more answering to the clichés 'quaint' or 'charming', no more being patronised by brassy American tourists. Cranleigh, on the Surrey edge of the Sussex border, now lays claim to the 'largest village in England' title, and North Petherton is just another small town which, I suspect, now bitterly regrets losing its status as a big fish in a small pond. Now people called it 'Pethy', worry about kids taking drugs, and commute to work in Taunton or Bridgwater.

Tonight, though, North Petherton rolls back the years and once more reigns as the king of Somerset villages. Tonight it's a thriving local community once more lauding its own identity with fierce local pride and a rare old swagger in its step. Tonight, it's *carnival*.

Coaches have been arriving all afternoon from Wales and various parts of the Midlands, and claim their plum spot on the roadside for what everyone assures me is the best show in the west. 'You been before?' the old ladies ask as they erect their fold-up chairs, carefully arrange blankets on their laps and dig out their flasks for the first hot chocolate of the night. 'You're in for a treat, a real *treat*,' they beam. 'All the floats, all lit up, all decorated, beautiful they are, just *beautiful*.'

I reckon a pre-procession snifter is in order at the Compass Tavern, but the way appears to be blocked by a one-woman picket, outraged because the pub has locked its toilets. 'Look at that queue,' she says, pointing to the long, static line sneaking from the Portaloos past the burgers. 'You could die of old age in a queue like that.'

But you can see the Compass Tavern's point of view. They'd have the whole of Pethy marching in and out of here all night just to use their loo, you can't blame them for locking it. 'Yeah, but I was having a drink in there! I've had to come outside to spend a penny, have you heard anything like it? I've left a drink in there but do you think I'm going back in to finish it?' Er, possibly not. '*Definitely* not. I'll die of thirst rather than drink another drop in there again.'

Out on the roadside things are hotting up as the announcer, who clearly fancies himself as some kind of great lost Dimbleby, gives chapter and verse on the long history of the carnival, its relationship with the other carnivals being held in the locality over the next week, a detailed description of the route, and regular updates on the progress of the carnival through the other end of town. The guys snap open their cans of lager, swallow heartily and slap each other across the back, and the vendors patrolling the road furnish the kiddies and wacky aunties with sparkly light-up headdresses. Who would have thought you could have had so much fun by a roadside in North Petherton after dark?

It takes for ever for the floats to reach us in the Portaloo queue – 'hang on in there, only 390 people in front of us now' – and a rather mediocre samba band at the head doesn't inspire confidence. But I have to admit when they do start arriving in a blaze of light, exotic costumes and rampaging music, it's like Las Vegas on wheels.

My night is certainly made complete by the sight of two, count 'em, *two*, separate floats full of people dressed up like Long John Silver for a *Pirates of the Caribbean* theme, leaping around and waving cutlasses to the booming sounds of Tenpole Tudor playing "Swords Of A

Thousand Men". Clearly this is one of the greatest records ever made, and I doff my cap to North Petherton for restoring it to the forefront of popular culture. Secretly, though, I'm quite glad Mrs Colin talked me out of calling our first-born Tenpole in its honour.

The downside to the unexpected delight of hearing Tenpole Tudor blasting out – twice – is that we also get a couple of floats full of people dressed up as burgers dancing to the kiddie pop band the Fast Food Rockers. There's also an overdose of the "Only Fools And Horses" theme, "Copacabana", "Dancing Queen", "Who Let The Dogs Out" and any number of Disney-related song-and-dance teams. Later on a float full of camp cowboys leap around in chaparajos to the Osmonds singing "Crazy Horses". In the pub later, someone insists this float cost a cool £35,000 to construct.

Surreptitiously passing around hip flasks, the old boys at the side of the road are having a grand old time while their families wave and shout at the ever more colourful procession ... scenes from *Chitty Chitty Bang Bang*, *Les Misérables*, *Wizard of Oz*, *Fantasia*, *Arachnophobia*, *Platoon*, *From Russia with Love*, *Midnight Express*, *Mary Poppins*, *Cats*, *Platoon*, *Noddy*, *Flipper* ... It gets more and more surreal by the second, and the floats just keep on coming. There's a gap in the traffic and Pethy's Dimbleby clone is beside himself with worry. 'Please don't go, there's plenty more floats to come, some of them prize-winners, but there's been a hold-up further down the road. I'll try and find out what's happened and get back to you ...'

After a couple of hours some of the generators are capsizing, plunging their floats into darkness and silence. With kids getting fractious, old ladies whingeing about frostbite and the lads getting alarmingly pissed, the night is starting to lose its magic. I mean, you can take only so many brightly decorated lorries full of people dressed in fantasy costumes singing dodgy Eighties hits. A bar, I think. But obviously not the one where they don't let you go to the toilet.

Heading north, there's just one more stop to make before leaving Somerset. But it's an important stop: a place dripping in such a welter of myth and folklore, it's an irresistible magnet for an endless stream of spiritual souls pursuing every strand of alternative lifestyle known to Albion. A place where one legend insists Christ visited; where Joseph of Arimathea supposedly buried the chalice used at the Last Supper and thrust his thorn staff into the ground, giving root to the thorn tree that still flowers in winter.

It's the birthplace of Christianity in Britain, on which some say William Blake based "Jerusalem" and where Queen Guinevere was imprisoned. It's a place where King Arthur is said still to reside, awaiting England's call to duty once more. A place once entirely covered in water,

apart from an island they called Avalon; a place where you feel naked without your sandals and magic crystals. Welcome to Glastonbury.

I've been coming to Glastonbury Festival for several years, but rarely ventured into the town. Partly because the festival isn't at Glastonbury at all, but on Michael Eavis's farm at the village of Pilton, a few rambling, rolling miles out of Glastonbury. And while the festival is a jaw-dropping carnival of sights and sounds, the old market town itself is positively peculiar, embedded with a hippy heart and a sense that every outsider who ever thrust two fingers up at the day job, the commuter runs, the wage slavery, the grey suit and polite society's banal conventions will find a welcome here.

The first thing I see is a couple entwined on the pavement. He has long matted hair and pink loon pants; she has pigtails, orange hair and a black bin liner round her waist. They are just sitting in the street trying to eat each other's faces off. Nobody takes a blind bit of notice of them.

Wandering around Glastonbury feels as if you've died and gone somewhere floaty. Shops with names like the Psychic Piglet, Pixie Taylor and Man, Myth and Magik abound, and posters offer everything from shamanic practitioners training to hedgewitchery, esoteric soul healing, tarot reading, Tibetan arts, tai chi and, my favourite, a course to build your own geodisic dome. I quite fancy the idea of a geodisic dome in my back garden, as it happens. Whatever it might be.

Wind chimes jangle daintily as you tiptoe across thresholds into darkly lit emporiums that immediately make you woozy with the whiff of joss sticks, and perfumed assistants who glide around amid beatific smiles and flowing garments. It's crystal city here, and followers of every cult, religion and alternative lifestyle are accommodated in the intriguing array of herbs, natural remedies and literature about finding yourself and the Meaning of Life.

I always feel guilty in these places; me with my drinking habits, fondness for raucous Pogues' records, habit of screaming profanities at football referees and the odd impure thought about Kylie Minogue. I sense that the woman in the Maharishi hairdo serenely blowing bubbles between the scented candles and Eastern imagery knows about the incident with the Rémy Martin back in North Petherton, and that awkward business in Cornwall. Not to mention Dartmoor. This is how Catholics must feel all the time.

To be honest, the town is freaking me out a bit. There's only so much peace and love that can be exuded in a market town without it giving you the willies. The bowls of water labelled 'For Dogs' strategically placed along the walkways are a nice touch, though, and it *is* impressive that dogs in this part of the world can read.

But as I'm here, I decide to embrace the complete Glastonbury experience and climb to the top of Glastonbury Tor. The tor is the area's ultimate symbol of an unrivalled spiritual heritage, visible from miles away rising above the horizon like a sinisterly protective father. It's an impressive sight all right, and looking at it towering above the town, you'd think it would be impossible not to find the path leading to the top. You'd certainly *think* that ...

Never mind climbing the tor, I'm soon knackered in the back streets trying to find it. It's just sort of ... *disappeared*. Like a good Englishman I pretend to be an American tourist and ask a policeman. He looks at me with glazed eyes and points upwards. 'It's just *there*.' The fifteenth-century St Michael's Church tower atop the tor is suddenly plainly visible again. Clearly, somebody stole it as a joke and put it back again when I wasn't looking. I thank him, and march briskly on.

I turn the corner in the road leading to the tor ... and stop in my tracks. The wreckage of two cars is strewn across the road making it impossible to pass, and the next 45 minutes are spent watching Somerset's equivalent of Laurel and Hardy trying to load the wreckage on to their pick-up trucks. They view the twisted metal from every conceivable angle and after each viewing, scratch their heads a bit, have a long chat, slap each other on the back, move the pick-up truck to a different spot, shift the crane around, nudge the mangled wreck a bit, discover the truck is at completely the wrong angle to fit it on ... and go through the whole process again. All this goes on in front of an increasingly abusive audience.

'Oi, you,' yells a well-to-do man in a suit. 'Ever heard the phrase piss-up in a brewery?' 'No,' says Mr Laurel. 'Well you couldn't organise one!' The group of winos on the other side of the road, who clearly haven't had such free entertainment in years, cackle raucously, shouting their own advice in that charmingly incomprehensible way of theirs.

Suddenly the bloke in the suit is over the cordon and in the truck, trying to show them how to do it. Laurel and Hardy are deeply unim-pressed by this turn of events, and as they drag him away the whole thing threatens to turn very ugly. A couple of enterprising kids have also decided to take matters into their own hands, ducking under the cordon and climbing over the wreckage to the other side, pausing only to dance an unsteady jig on the top and flick V-signs at the men with the truck shouting at them to get the hell down.

They make it to the other side and the floodgates are open. Mothers and toddlers, old men walking their dogs, hippies, more winos and possibly even King Arthur himself break ranks and clamber over the dead cars. In the end I'm the only one left on the other side. Not any

sense of propriety, I'm just genuinely enthralled to discover how exactly Olly will get out of another fine mess that Stanley's gotten him into. It's another half hour before they successfully load the wreckage on their trucks, warmly congratulating each other at the end of it, and I start the ascent of Glastonbury Tor.

It's all a bit of an anti-climax, really. The climb is steep and tiring, yet not too exacting and I'm feeling quite fresh until two young lads come sprinting past on their own personal challenge race to the top. Halfway up I meet a priest, looking likely to keel over at any moment, puffing and panting, his face crimson. 'You all right, Father?' I ask. 'Uh ... oh ...' he gasps in a wheezy Irish voice. 'Oh yes ...' he's spluttering now, 'grand, yes ... grand.' Right, I say, doubtfully, watching him gulping air. I'll be on my way to the top then ...

'OK,' he says, 'I'll see you at the top. I do this climb every week, you know ... keeps me fit.' His face is scarlet now and I momentarily wonder what colour he goes when he's unfit.

At the top, two young lads are having a sly cigarette, a bloke in shorts surveys the surrounding sights of Wiltshire and Dorset through the biggest pair of binoculars known to man, and two Japanese tourists take 320 photos of each other grinning madly.

An earnest mother is explaining to her daughter the origins of the nursery rhyme "Little Jack Horner"; the chap who sat in the corner eating his pie, stuck in his thumb, pulled out a plum, and said, '*What a good boy am I!*' Little Jack Horner, she explains, was actually Thomas Horner, a steward to the abbot of Glastonbury during the reign of Henry VIII. Henry apparently had designs on Glastonbury Abbey – the wealthiest in all of England – and Horner was dispatched to visit the king with the deeds to a dozen manor houses as a bribe to keep his hands off the abbey. The deeds were hidden in a pie – a common practice at the time to thwart the threat of theft by highwaymen, The bribe didn't work and, Henry being Henry, he took the manor house and the abbey *and* ate all the pies.

I'm fascinated, but there are no fairies, no evidence, physical or spiritual, of King Arthur's presence, and none of the mystical ambience that's apparently dragged people up here for centuries to absorb the ley-lines, get close to the gods and achieve oneness with the natural world. The biggest miracle is the city of tents that appears to have appeared overnight on Michael Eavis's 700-acre dairy farm at Pilton, reminding me that it's high time I got on down to join them.

In the best traditions of the festival, it's pissing down and, totally unprepared in my flimsy trainers and thin jacket, I'm drenched and caked in mud long before I've completed the long trek from the car park through the formidable labyrinth of security that flanks the £1m

'ring of steel' which now protects the festival. But it wasn't always like this.

When I came here in 2000, it was like a free festival. People openly clambered over the shabby perimeter fencing all weekend as stewards initially made token efforts to stop them before giving up, and by Sunday it was open house as large sections of the fence were smashed down completely and people wandered in and out at will. The result was that, despite a crowd safety limit of 100,000, there were more than twice as many people inside and it got pretty scary. I was rapidly dispossessed of wallet, phone and dictaphone in the mass surge forward at the outset of Chemical Brothers' Friday-night headlining set, and a visit to the lost property office next day revealed an enormous queue and horrific stories not only of pickpockets, but of tents being raided and even physical assaults. Lowlife had hijacked the hippy festival's ideals, and it was no surprise when the local police and Mendip Council stamped their feet and the 2001 festival was cancelled while Michael Eavis got his house in order.

When it returned in 2002, a co-promoting deal had been struck with the ultra-professional London-based Mean Fiddler organisation and the security was so aggressively water-tight that seasoned Glastonbury campaigners were up in arms. For so long the biggest contemporary music event in the English calendar, it had resiliently clung to the spiritual heart that Michael Eavis had created when he first ran the festival for 2,000 fans in 1970, after being inspired by a visit to the Bath Blues Festival.

T. Rex headlined that first event – Marc Bolan turning up in a velvet-covered Buick – and apart from Hell's Angels setting fire to a hay wagon and stealing the ox from the roast, all passed smoothly. A pyramid stage was introduced the following year when the festival assumed all the essential characteristics of the cultural underground, including appearances by a nascent David Bowie, Hawkwind, Pink Fairies, Arthur Brown, Edgar Broughton and Quintessence, and the pious outrage of the national press writing lurid stories about naked hippies having orgies in the mud and rampant drug-taking.

Things are very different now, and the new security measures breed much resentment, not least because of the farcical ticketing arrangements, involving ordering on a phone line that's constantly engaged or a website so overloaded it constantly crashes. The organisers seemed totally overwhelmed by ticket demand, and you imagine the resultant bad publicity hurt the kindly Michael Eavis, who – amid asides about the Iraq war and 'flaky leaders' – makes a fulsome apology for the ticketing problems in his programme notes.

It doesn't appease some of the festival old-timers, who for so long

have seen free entry as a divine right. 'Very few of those who scrambled over the fence with me in 2000 and on five previous occasions will ever be able to come back again,' writes a self-righteous contributor to *Festival Eye* magazine, complaining that the UK's biggest free festival has been 'stolen' by capitalism. 'The random bunkers and blaggers gave Glastonbury its unique edge and were in many respects its life and soul. It seems the organisers have had to destroy the festival in order to "save" it.'

Jake, the bongo player from Planet Maraccas whom I encounter in the Green Fields later, certainly seems to agree. 'I've been coming here for 15 years; nobody asked me to pay before, this festival would be nothing without people like me. They've ruined it. It's all too corporate now. They've sold out. You don't get the characters any more.' Well, *you're* here Jake ... 'Yeah, I'm a legend.' I try to find out how he managed to get in, but he's away on a 20-minute bongo solo with a vacant expression, and I leave him to it.

The festival may have lost a few of Jake's mates and some of its character with them, but the gentle farmer Michael Eavis is a reassuring presence, wandering around backstage like a benevolent uncle. There were genuine fears the festival would not have survived without dramatic action over security, and while Eavis is in control you instinctively know it will never jettison its original spirit entirely. It's certainly an orgy of recycling, eco-consciousness and alternative values, and it's a bonus to know that every other person who gives you a second glance isn't likely to be a mugger.

It's hard to imagine the hugeness of it all. The endless avenues of outlets with inventive, multi-coloured signs sell food from every conceivable part of the world, and stalls provide countless strange and wonderful delights, including an exotic range of teepees, 'mantra doorbells' and the opportunity to build your own spaceship. I spend an inordinate amount of time fending off a mobile magic mushroom salesman, observing the eco toilets, and studying the baffling multitude of causes I'm asked to sign my name to. Drop the Third World Debt, *get in*. Troops out of Iraq, *right on*. Oh hang on, I've just signed up for a course in Tibetan Sacred Earth and Healing Arts.

It's tempting to spend all weekend at the stone circle right at the top of the festival, where everyone lies around with contented, glazed expressions and giggles a lot – the invitation to stay up here to watch sunrise with them all is very tempting indeed, I can tell you. But there are people to see, places to go. The new memorial at the Joe Strummer Field; the yoga workout at the Croissant Neuf venue; Tony Benn conducting a debate at Leftfield; poetry and organic tea in the Green Fields; mime in the Theatre Fields; weddings being conducted in the

Lost Vagueness Field; fruit juggling at the Cabaret Marquee; Japanese juggling at the big top; *The Wicker Man* being shown at the Open Air Cinema; not to mention the usual barrage of stilt walkers, Naked Liberation protesters and men in ballgowns you are always likely to bump into this weekend.

There's also the small matter of seven main stages and lots of smaller ones spread around the festival, providing music for every taste from the Godlike Morrissey blessing his flock on the main Pyramid Stage to the English National Opera getting Sunday's proceedings under way with a slab of Wagner's "Ride Of The Valkyries".

But in this weather, in this mud, in these trainers, wading anywhere is a major operation. Jumping up to register approval of a heart-warming set of old Beatles singalongs by Uncle Paul McCartney from the hill overlooking the Pyramid Stage, I land on my backside and go sledding down the hill at 30mph, taking a surprised hippy, a couple of tanked-up students, a magic mushroom salesman and a family of four from Widnes with me.

Worse is to come. I'm actually working this weekend, writing reports to be screened on Teletext throughout the weekend. I've had a phobia about tents since a spectacular incident at Cambridge Folk Festival involving a gas lamp cylinder, a box of matches, a small explosion and a short but dramatic canvas ball of flames. So the good news is Teletext have booked me into a hotel to carry out my duties. The bad news is that it's in Bridgwater. The even worse news is that I've absolutely no idea in which field I've left the trusty Alberta to take me there.

In pitch darkness at the dead of night, one mudbath field full of cars is very much like another one, and I spend two hours knee-deep in mud asking shivering nonplussed stewards whether they've seen my car. It's 2.15am and I'm about to bale out and build a mud hut to take refuge in for the rest of the weekend and wait for everyone else to go home, when Alberta will be the only motor car left on the farm and we will be reunited. I suddenly hear a car horn from the middle of a cluster of vehicles. It seems to be calling me and, rejuvenated, I plough towards it. Maybe there's something in this spiritual stuff after all, because exactly on the spot where I heard the horn, there's my beloved Alberta.

Yet the travails are not over yet. Somebody's moved Bridgwater, for one thing. The long battle to get through the Pilton fields and avoid the hordes of paralytic pedestrians erratically appearing in front of the car at regular intervals on the dark narrow road out of the festival is elongated by long pit stops peering at maps and road signs. Never mind Albion, this book could well end up as *In Search of Bridgwater.*

I visit Shepton Mallet three times, Street four times, Somerton

twice and even catch a glimpse of my old mate North Petherton in repeated excursions across the Polden Hills before Bridgwater eventually hoves into view. I swear it's laughing at me. I find the hotel, ring the doorbell for 20 minutes and grab the room key from a hotel porter who emerges so breathless from a room at the back I daren't imagine what he's been doing.

A quick shower to get the circulation going again, and it's time to fire the laptop into action and knock out a series of astutely penetrating insights into the day's events at Glastonbury Festival. Now, all that needs to be done is plug the laptop into the phone line, get online, send it through to the Teletext system and I'll be rewarded with a warm bed and the promise of sunshine and a stress-free day tomorrow. It's a good plan with one small problem. There's no phone in the room. Or phone *line*. It's hard to get online without a phone connection.

I go downstairs and rouse the night porter again. He doesn't seem best pleased to see me, and is oddly unsympathetic to my problems. 'None of the rooms have phone lines in them,' he says with a finality that suggests that whatever he's got in the back room – a good book, porn channel, bottle of brandy or Rebecca Loos – he's desperate to get back to it without further delay. But I'm a member of Her Majesty's Press, I tell him and OK, so it may be four o'clock in the morning, but there's a nation out there glued to their telly screens waiting to see how Oasis performed on the Pyramid Stage.

'Oasis, eh?' he says, feigning interest. 'Any good?'

Nah, they were rubbish.

'I like Motörhead myself ...'

So what about my report?

'What?'

I need a phone connection to send my report through.

'None of the rooms have phones.'

I beg, threaten, plead and try to bribe the guy to let me use the phone line in the reception area – or indeed, that mystery room at the back – to get online and access the button I need to press to send my words of wisdom to central office and release me from this nightmare. 'It'll only take five minutes,' I say. '*Five minutes.* All I need to do is press a button and we're out of here.' But he won't relent. More than his job's worth, apparently. I suddenly hear a volley of foul expletives, wonder who on earth can be using such filthy language, and realise with a sudden jolt that it's me. The night porter turns on his heel and marches into the back room, slamming the door without a second glance.

There's no signal on my mobile phone, so I unplug the laptop, carry it out into the street, find a phone box, pour small change into the phone and sweet talk the duty editor into taking the report down over

the phone. But the nightmare is not over yet. The phone box is so dark that it's hard to read my copy off the laptop. Then the laptop batteries go and it's impossible to read it at all, and when my money runs out and the duty editor tries to call me back, I discover the phone won't take incoming calls.

Cap-in-hand I return to the glowering hotel porter I'd so roundly abused half an hour earlier, apologise profusely for my outburst, tell him I'm writing a book and he'll have the starring role, and ask if there's any chance of raiding the piggy bank for change for the phone. Strangely enough he's not keen and I end up back on the streets of Bridgwater, eventually finding an understanding newsagent awaiting delivery of the morning papers and willing to give me a handful of change.

So it's back to the phone box, more money shovelled in and, with the carefully crafted reviews lost with the death of the laptop battery, I garble my impromptu and, I imagine, entirely incomprehensible report down the line to a duty editor who must have been wondering what she'd done to deserve *this*. I return to the hotel a gibbering wreck, just as the night porter goes off duty to be replaced by a fresh-faced young woman in a crisp, freshly starched blue suit, gleaming white teeth, a fixed smile and a name tag that says 'IRENE'.

'Good morning sir,' she says brightly. 'Can I get you anything?'

'Let me see,' I say, '… a pint of arsenic, the head of that bloody night porter and a one-way ticket out of this hell-hole …'

'Certainly sir, she says sweetly. 'What would you like first, the arsenic or the night porter's head?'

Goodnight, Irene …

CHAPTER FIVE

Flag Day in Dorset

'Britannia she's half-English, She speaks Latin at home
St George was born in the Lebanon/How he got here I don't know
And those three lions on your shirt/They never sprang from England's dirt
Them lions are half-English/And I'm half-English too'

"England Half-English", Billy Bragg

Another day, another dilemma. Heading south again, I stick on a tape. It's "Rainy Night In Soho", one of the finest songs of all by the Godlike Shane MacGowan, though this heartbreakingly beautiful version is by the sublime Mary McPartlan. I realise instantly that it's a MUST for my funeral song list.

'This is it ... just before they all start filing out at the end of the ceremony, play this. It'll knock 'em, well, dead!' I tell a doubtful Mrs Colin triumphantly. Then on comes the Fugees' version of "Killing Me Softly" and I hesitate again ... I'd never considered it as a funeral song before but it *could* work. It'd certainly wake them up when Wyclef started wailing 'one time, two time' behind Lauryn Hill. The song was inspired by someone listening to Don McLean singing "Empty Chairs", and that sets me off again. "Empty Chairs" ... how would that sound in the crematorium? Not bad, I reckon ...

This fascinating reverie is rudely interrupted by a shocking sight as we cross into Dorset. Flags. Everywhere. The flags of St George. Flying on cars, dangling out of bedroom windows, plastered all over shops. 'Tis the season to be patriotic, apparently. England are in a big football tournament in Europe, so we are implored to nail our colours to the mast and get our flags out for the lads.

It makes me feel a bit queasy, this. The Union Jack, the flag of St George ... for me, they have too many implications. Too many visions of imperial might and old school bullies; too many images of tattooed skinheads rampaging through Europe; too many right-wing affiliations; too many bellicose Tories; too many racist connotations.

86

It's a recurring argument in our household. 'That's just your gener-
ation; my generation doesn't have those connections, we're *reclaiming*
the flag from the racists,' says my eldest son Kevin, never short of an
opinion. Especially when he knows it winds up the old man. 'It wasn't
my generation who murdered Stephen Lawrence,' I mutter, re-
affirming that there'll be no flags of St George flying from *my* car.

At least the *Guardian* understands. It presents its readers with a
paper flag of St George for its readers to stick on their windows, with
an asterisk indicating an important proviso ...

> * *By flying this flag I would like to show my support for the England*
> *team but ...*
> 1. *Wholeheartedly reject any connotations of xenophobic nationalism*
> 2. *Dissociate myself from anyone who removes his shirt in public*
> 3. *Salute the rich contribution made by my Celtic cousins to British life*
> 4. *Reaffirm my commitment to the European Social Chapter.*

Amen to that, Mr *Guardian*.

The whole thing seems to strike at the heart of my dichotomy over
nationalism. The Scots and the Welsh don't have any problem
waving their identities at the world and, let's face it, they're rubbish
at football. But they don't have the same political baggage, and their
flags seem to carry a sub-text announcing, 'Yep, we're rubbish at
football and we'll never win the World Cup, but AT LEAST WE'RE
NOT ENGLISH!'

I figure that if all these people proudly waving the flag of St George
really want to lay it on the line, why don't they stop listening to
homogenised rubbish from America and get into English traditional
song? Then they'd *really* know about their national identity ...

'You talk about the English not being aware or respecting their
own traditions, but I think most people here *are* aware,' the young
singer Jim Moray tells me, when I go to him seeking answers. 'It's just
not the same culture you think they should be respecting. It may be
your culture and *your* tradition, but football and pubs and going to
work as management consultants may represent more about
Englishness to them than the Straw Bear or Green Man or morris
dancers. Once you take traditions out of the villages where they orig-
inated, you're taking them into entertainment ... and that is
something very different.'

The sight of a caravan – a *caravan*, mark you! – careering out of a
side street in front of me festooned in flags is an abrupt reminder of my
original disquiet about the flag of St George. Anyone know when St
George's Day is? Anyone *care*? Each year the *Daily Mail* or someone

tries to manufacture national fervour from shallow pride, and each year there's rank indifference.

It's hardly surprising. What do we know, what do we *really* know about St George? Apart from that funny business with the dragon, I mean. It transpires St George was born in Cappadocia. *Where the hell is Cappadocia?* Some leafy suburb of Birmingham, maybe? A little-known resort on the coast of Lincolnshire? An alternative name for Glastonbury?

Cappadocia was in Asia Minor. *Where the hell is Asia Minor?* 'Asia Minor? Turkey way, wasn't it?' reckons my friend the pub quiz champion, after much contemplation and several lagers. George, in fact, lived much of his early life in Palestine, was a Roman soldier, did his trick with the dragon in Libya, and never set foot in England during his *entire life*. At least Elvis touched down in Scotland once. St George didn't get closer than Rome, apparently.

His campaigns for Christian rights were rewarded with a beheading, but he did subsequently make an appearance to a seemingly hallucinating Richard the Lionheart during the Crusades. In 1222, the Council of Oxford decreed April 23 as George's Feast Day, and in the fourteenth century he was duly promoted to patron saint of England. Hardly an original choice, considering he'd long been venerated in Libya, Greece, Syria, Georgia, Portugal and goodness knows where else, but a bit like Sven, we now claimed him as our own. Forgive me if I don't jump up and down and wave my knickers in the air.

Meanwhile, before we know it, we're deep into west Dorset. Soft, rolling hills ... pleasant, languid countryside ... small, sedate villages and inviting country pubs ... To all intents and purposes, Dorset represents the quintessential England's green and pleasant land of popular myth. Driving through in the early-summer sun, happily untroubled by caravan hell with just the odd crazed biker and ranting inbred on the roadside to disturb the idyllic calm, you almost believe the picture postcards. Dorset *is* beautiful, as local folkies the Yetties used to sing ad nauseum on the radio.

In such an atmosphere of dreamy, undisturbed serenity, it would take a particularly rampant and tortured imagination to picture this as a place seething in protest and rebellion. Was this really a place of such infamy that it became a *cause célèbre*, sent shock waves throughout the land, and effectively changed England for ever?

Even as you enter the neat, small village of Tolpuddle, there is little activity to suggest its place in history. Compact rows of houses lie back from the road, there's an attractive pub, a tiny green, barely any shops, and but a few locals going about their business stopping to chat, you fondly imagine, about the size of Bert-up-the-road's marrow and Kenton's latest mishap in *The Archers*.

And then you see the pink elephant.

It wafts around in the breeze, like a fluffy King Kong, enticing you to stop even if you don't want to. It leads you into the Tolpuddle Martyrs' Festival, an annual jamboree held in a field awash with tents, stalls, stages, animated debate … and a story that, over 170 years later, still deserves to be told.

It concerns George Loveless, a swarthy Tolpuddle farm labourer and self-educated Methodist lay preacher with a clear vision of right and wrong. It was tough enough in the 1830s feeding his family on nine shillings a week, but when the local landowners reduced this salary to eight – and then to a meagre seven shillings a week – they were at starvation level.

This was hardly exclusive to Dorset, but it was here that the rumblings of dissent grew into a roar and the peasants started revolting with a series of threats and attacks on the squires' property, hiding behind the generic name 'Captain Swing'. The squires reacted to this crisis in a heartwarming spirit of fair play – they announced they were reducing the workers' wages to *six* shillings a week …

George Loveless decided he had to do something about it. He duly organised the farm labourers into a trade union, and in 1833 the Tolpuddle Friendly Society of Agricultural Labourers was inaugurated with a meeting of 40 workers at the cottage of another farm worker in the village, Thomas Standfield. There was nothing illegal about this – trade unionism had been permitted by law for ten years – so they had nothing to fret about. *In theory*.

Enter the villain of the piece, Dorset magistrate James Frampton. Like many landowners and gentry, he was alarmed by the prospect of the plebs getting organised and thinking for themselves, and felt he had to take a stand. He put up placards throughout the area threatening seven years' transportation for anybody who joined the new union … and then sought ways to convict them. The result was that on February 24, 1834, George Loveless was arrested on his way to work. He was marched off to Dorchester Gaol with his younger brother James, 20-year-old James Brine, 44-year-old Thomas Standfield, his son John, and James Hammett.

The case against the six Tolpuddle Martyrs effectively hung on the evidence of two other farm labourers admitted to the union, Edward Legg and John Lock. Opinions widely vary as to whether Legg and Lock were bribed by the magistrate, were simpletons bamboozled by the legal process or were simply bloody-minded. In any case, they testified to being initiated into the union through a secret oath.

Membership of a union wasn't a crime, but taking a secret oath was … and Legg and Lock duly pointed the finger at the Lovelesses, the

Standfields, Brine and Hammett. After a shoddy trial – 'the greater part of the evidence against us was put into the mouths of the witnesses by the judge', George Loveless was to write later – all six defendants were duly sentenced to seven years' imprisonment in Australia. George Loveless wrote his defiant "Song Of Freedom" as he waited for the sentence to be carried out …

> *'God is our guide! No swords we draw.*
> *We kindle not war's battle fires:*
> *By reason, union, justice, law.*
> *We claim the birthright of our sires:*
> *We raise the watchword, liberty:*
> *We will, we will, we will be free!'*

The six Martyrs were duly dumped in Australia, where further horrors awaited. Manacled in squalid, unhygienic conditions on an over-crowded boat riddled with disease, it was a minor miracle they survived the journey at all. Especially George Loveless, who'd fallen ill at Dorchester Gaol and, transported after the others, was sent to Van Diemen's Land – Tasmania.

The others were all assigned hard labour in the Blue Mountains and each of them had a tale of woe. James Brine was attacked by bandits soon after arrival and for the first six months had no shoes or change of clothing and slept on bare ground without cover. Thomas Standfield also had to sleep rough, and was seemingly a broken man close to death when his son John accidentally chanced upon him one day. James Loveless had to walk 300 miles in 14 days to reach his designated work, and James Hammett got into a fracas and was given a further 18 months' sentence for assault. As for George Loveless, he narrowly avoided flogging after nine wild cattle escaped from his charge.

What they didn't know, however, was that back at home their plight had become a symbol of working-class oppression, and a campaign for their pardon was gathering relentless momentum. There were marches and demonstrations and other unions showed solidarity with a massive gathering in London's Copenhagen Fields – where King's Cross now stands – armed with a petition of over a quarter of a million signatures demanding the Martyrs be returned to England. Even the press rallied behind them, embarrassing the aristocracy by suggesting that if Loveless and the others were guilty of swearing secret oaths, then so was the king's brother, the Duke of Cumberland, in his role as Grand Master of the Orange Lodge.

With the weight of public feeling clearly with the Martyrs, an energetic new MP, Thomas Wakley, fighting their corner in the corridors of power, and with the shadow of a messy court case involving the king's brother looming, the establishment capitulated. The Tolpuddle Martyrs duly received their pardons, and George Loveless was the first back in London to a hero's reception in June 1837. He returned to Tolpuddle to await the others and wrote a passionate account of his ordeal, *The Victims of Whiggery*.

If they'd dreamed of returning to a life of tranquil obscurity, they didn't get it. A second rally was held at London's Copenhagen Fields in their honour, and in front of six thousand enthusiastic supporters, they rode in an open carriage along the streets to a celebration dinner. There was more to come. A fund had been launched, and with the proceeds the Martyrs were gifted a seven-year lease on two farms at Greensted, near Ongar in Essex, to run as they saw fit.

It wasn't a universally popular act of generosity, and the vicar and other Greensted residents weren't happy at all about the new arrivals and refused to accept them into the community. Ultimately, the Lovelesses, Standfords and Brine (who'd since married Thomas Standfield's daughter Elizabeth) all emigrated to Canada, working farms in London, Ontario, where their past as 'convicts' remained a closely guarded secret and they finally found the peace they craved. The only Martyr to return to Tolpuddle was James Hammett.

In many ways Hammett was the most interesting of them all. He was the odd one out, an outsider, a loner. Apart from Hammett, the Martyrs were all Methodists, and the case was perceived by many to be as much an attack on Methodism as on trade unionism. Hammett was the only one with a previous criminal record (for stealing some iron), the only one arrested in Australia, the only one who never wrote about his experiences, the only one who didn't emigrate to Canada. And the only one who *wasn't* at the fateful meeting at Thomas Standfield's cottage when the infamous secret oath was taken.

Hammett took the rap for his brother John, whose young wife was about to give birth when the arrests were made. As a result of that little local difficulty in Oz, his return to England came two years after the others and he missed all the gala celebrations and the triumphal parade through London. He did briefly join the others on their tenant farm in Essex, but soon returned quietly to Tolpuddle, worked as a builder's labourer, and rarely discussed his youth as a reluctant Martyr.

He went on to live until he was 80, and his grave remains in the small parish church. He is being honoured at this year's Tolpuddle Martyrs' Festival, so Mrs Colin and I troop down there for a service of remembrance, gathering around the headstone:

JAMES HAMMETT – Tolpuddle Martyr
Pioneer of Trades Unionism
Champion of Freedom
Born 11 December, 1811
Died 21 November, 1891

Hilary Benn, MP, is there presenting a wreath on behalf of the Labour Party, and a song is sung in a short, dignified ceremony.

We gawp at Thomas Standfield's cottage nearby, wander around the small Martyrs museum at the TUC Memorial Cottages, look at the inscription outside the Methodist Chapel, sit on the bench next to the stump of the sycamore tree on the green where the Martyrs are said to have held some of their meetings, have a drink at the attractive Martyrs Inn, and wonder again how such a gentle little village became a symbol of working-class defiance and a landmark of social history.

Every year they hold the Martyrs' Festival here; an enticing mix of radicalism and music. You could drown in leaflets urging you to spend the rest of the year signing petitions, going on protest marches, campaigning against social injustices from Burma to Birkenhead, buying mags and papers plotting the revolution, and generally immersing yourself in every counter-culture known to mankind. You feel dizzy lurching from stall to stall; from War on Want to the horror of workers allegedly murdered by major corporations in Colombia.

There's a musical play, *Tolpuddle Man*, largely written by Graham Moore, which tells the tale in front of a lively audience. In panto style, they roundly jeer the appearance of the baddies, magistrate James Frampton and the witless dupes used to frame the Martyrs; and cheer wildly as George Loveless takes on the establishment and eventually brings his boys home in triumph.

The music Moore has assembled – largely his own, with a sprinkling of traditional songs – is excellent, full of telling lyrics, and big, emotive choruses. It would need a bit of a brush-up and a spruce around the ears, but shouldn't this sort of thing be given a national stage? A major event in English social history full of human drama and provocative political content, delivered in accessible, entertaining fashion using the country's own folk song … well, why not? If people flock to see Ben Elton knocking up some ludicrous story as a means of hanging together a load of songs by the execrable Queen – or, indeed, the even more execrable Rod Stewart – then surely there has to be a place in the theatre for *Tolpuddle Man*. Graham Moore writes better lyrics than Tim Rice, that's for sure.

Peter Bellamy's esteemed folk opera *The Transports*, about the

emotional wreckage caused by the early transportations to Australia, had a bit of success, but scarcely made a dent outside the folk music scene which launched it. So will Cameron Macintosh be prepared to take a punt on *Tolpuddle Man* as a dramatic West End presentation of an all-singing all-dancing examination of English history? Very possibly not ...

We spend the night in a criminally overpriced pub a couple of miles from Tolpuddle, and return to the village the next day to find a two-mile tailback. Hearing Billy Bragg singing in the distance I apologise to Alberta, park in a hedge and make haste.

Today, Billy is in epic, ranting form. Spawned by the Clash, he once asked me to shoot him if I ever saw him on stage with an acoustic guitar. But when it happened – at a Roy Bailey concert at London's Royal Albert Hall – I was too busy clapping my hands while the rest just rattled their jewellery to do his bidding. Today, he's thrashing the acoustic without a trace of self-consciousness as he turns "Waiting For The Great Leap Forwards" into an diatribe against Iraq, capitalism, America ('stick it up yer jacksee!') and, from my vantage point behind a man with a beehive hairdo selling copies of the *Socialist Worker*, an attack on caravanners. But that may have been wishful thinking.

> '*Mixing pop and politics he asks what the use is/I offer him embarrass-ment and the usual excuses ... here comes the future and you can't run from it/If you've got a blacklist I want to be on it ... so join the struggle while you may/the revolution is just an ethical t-shirt away ...*'

Queueing for an ice cream afterwards, I'm approached by a young lad looking at me imploringly, proffering a pen and an autograph book. I'm a tad confused by this. I'm not often asked for my autograph. In fact, I've *never* been asked for my autograph before. 'Er, to be honest, I'm not really famous ... well, to be honest, I'm not famous at all ...'

The boy glances back at his mum, who nods at him encouragingly and he presses the autograph book forward more urgently. I try to explain that I'm a complete nonentity and that he'd be better off asking the ice cream salesman, who looks a dead ringer for Engelbert Humperdinck and probably does a bit of karaoke at his local pub on a Saturday night, but the boy just carries on staring. 'He thinks you're Billy Bragg,' whispers Mrs Colin helpfully. People are sniggering, I'm now at the front of the ice cream queue and tears are welling in the boy's eyes.

I ask him his name, grab the book, sign it 'To Daniel, good luck from Billy Bragg' with a series of impenetrable squiggles that hopefully won't stand up in a court of law, hum a line from "Between The Wars",

pat him on the head and grab two 99 ice creams. I steal a glance at the boy showing his mum my Billy Bragg forgery and catch her staring at me, looking angry. About to be exposed as a Bragg impersonator, I leave the scene of the crime at a brisk trot ...

Then I bump into Billy Bragg. It's a local gig for him. The bard of Barking left London for idyllic Dorset a few years ago, but he didn't abandon his political conscience. In the 2001 general election he hit on an ingenious method of getting rid of his Tory MP, by setting up a website to encourage Labour and Liberal Democrat supporters to unite against the common enemy, the sitting Tory MPs holding slim majorities in the neighbouring West Dorset and South Dorset constituencies.

It half worked, too. Labour kicked out the Tories in South Dorset, and the Liberal Democrats came close to doing the same in West Dorset; while there was a knock-on effect in nearby Mid-Dorset, too, where the Lib Dems overturned the Tories.

So we chit and we chat and I'm on the point of confessing I'm wanted by the Tolpuddle Mothers' Union for impersonating him when he asks what I'm doing here. Me? Oh, I'm writing a book.

'Really?' says Billy, 'so am I!'

Yeah? What's yours about?

'England. It's about England. What's yours about?'

Erm ... well, *England*.

We compare notes. 'I think,' says Billy, eyes twinkling, 'mine will be a bit more political than yours. There won't be any bloody morris dancers in *my* book, that's for sure ...'

We break for speeches. Tony Benn is up there talking in characteristically eloquent style about unionism and martyrdom: 'George Loveless's great-great-great-granddaughter Edna Loveless was secretary of the Labour Party in Bristol while I was there, and the great-great-granddaughter of Squire Frampton who sent them all to Australia was the Speaker's secretary ... she terrified me ... when I put up a flag in the broom cupboard at the House of Commons, my God, there she was ... screwing it up ...'

Anecdotes, dates, names, figures, morals, conclusions, asides fly at you thick and fast with an animated energy that would put to shame blokes a third of his age. 'Today there isn't much democracy on a global scale,' he says. 'We don't elect the International Monetary Fund, we don't elect the World Trade Organisation, we don't elect Rupert Murdoch ... the truth is this generation faces on a global scale the problems the Tolpuddle Martyrs faced 170 years ago. We have to build a democratic world ...'

He's preaching to the converted and the converted are suitably

adoring, but it's still vintage Benn. *Writing on the Wall*, his compelling words and music anthology of dissent with Roy Bailey, won him Best Live Act at the BBC Folk Awards a couple of years ago, a decision that caused great merriment in the mainstream music industry. A left-wing politician, in his late seventies, being voted best live act of the year? What are those folkies *like*, eh?

Well, actually they're pretty clued in. Benn is a magical performer. I tell him as much when I ambush him as he leaves the Tolpuddle stage. 'Mr Benn, you are a magical performer,' I inform him. Several times. All the while pumping his hand in a manner reminiscent of Mr Shaky Hand Man, the spoof *Banzai* TV character who approaches celebs with the sole intention of determining how long he can shake hands with them before either their arms drop off or they punch him. I had a similar experience with Pele at a Simply Red concert in the south of France a few years earlier. Except then I was too much in awe to get any words out. Just did the open-mouthed staring and incessant shaking hands bit. Possibly as alarmed as he was encountering Squire Frampton's great-great-granddaughter in the broom cupboard at the House of Commons, Tony Benn thanks me nervously, and is whisked away by his son Hilary. It's OK; he probably thinks I'm Billy Bragg.

By this time the banners are out and the congregation lines up for a march through Tolpuddle. Numerous unions are represented, along with the Wessex Pensioners' Convention, the Dhol Foundation, the Isle of Wight Labour Party, the Stop the War Coalition, the Communist Party of Great Britain and numerous others. They march off down the road to chants of 'Stop the war' and the odd chorus of "The Red Flag", which sounds rather good to the background of the Dhol drummers. Fatboy Slim could do a lot worse than get down here and sample it pronto.

The locals make hay while the sun shines, flogging roadside lucky dips, teas and facsimiles of newspaper reports of the Tolpuddle story and there's standing room only at the Martyrs Inn. I can't get to the bar but I end up in conversation with a man who tells me it's all very well Hilary Benn, Billy Bragg and all the polite trade unions coming here to honour the Tolpuddle Martyrs, but what we really want is revolution, right? 'New Labour is anti-working class,' he tells me intently, 'it's all capitalism; we need to get rid of the lot of them. What do you think?'

I tell him I'd love to stay here and chat, but I've left Alberta unattended in a ditch somewhere and I really must see if she's all right, so he thrusts a lime-green Socialist Party of Great Britain pamphlet in my hand. *'Would it not be a fitting gesture to the memory of the Tolpuddle martyrs,'* it asks, *'to reject the Labour Party and the capitalist left who feed*

off their misery and become Socialists working for the establishment of the common ownership and democratic control of the means of production by all of society? Would it not show a growth in political maturity not to have leaders but for workers to think and act for themselves?'

Phew. Ask the easy questions first, why don't you? I suddenly feel a headache coming on and tell the pamphlet I'll get back to it later with my answer. Meanwhile, as the strains of "The Red Flag" disappear the other side of James Hammett's grave, I set off on the biggest task of the day.

I'm sure I left Alberta around here somewhere ...

CHAPTER SIX

Incest and Morris Dancing

'Try everything once – except incest and morris dancing'
Sir Thomas Beecham

'What's wrong with incest?'
Anonymous

*A*nd now for something completely different ...

Q: *Why do you never see Jewish morris dancers?*
A: *Because you have to be a* complete *prick to be a morris dancer.*

'Yeah, yeah. Heard them all. Water off a duck's back, mate,' says the bloke in bells and flowers in a pub in Chippenham.

Oh, I'm not dissing morris dancers, I tell him earnestly. I don't usually confess this in public, but I used to be in a morris side myself.

Well, it wasn't exactly *morris* and it wasn't really a *side* ... it was just a joke really, put together as a southern softie alternative to *The Full Monty*, to make the local school fete go with a leap. We misinterpreted the hysterical reaction from startled loved ones and small children as frantic encouragement and, high on applause, accepted an offer to do the same thing at another local function. And then another. And before we knew it, we were dancing our summers away.

The euphoria of it all and the appeal of the intense 15-minute weekly practices followed by 20 pints of performance analysis and team building tended to cloud the fact that we were actually crap. Folk music icon John Kirkpatrick told me once that when you knew all the steps and moves so well you didn't even have to think about it and went on autopilot, morris could whisk you to another plane. Sadly we never even made it up the gangplank.

Our sticks kept breaking – as did the occasional hand when the stick clashing got particularly wild on the fifth pub forecourt of one Saturday afternoon – and I still can't show my face in Twickenham since performing two choruses of "Constant Billy" before realising the hankie I was proudly waving above my head was actually a pair of Mrs Colin's knickers.

It was all great fun but totally knackering, and reality set in when members of a *real* morris side came along to view the opposition and completely baffled us by asking which tradition we danced. 'We sort of invented our own tradition,' I blethered, as he burbled on about Cotswold this and Headington Quarry that. They ended up in convulsions of laughter watching our ineptitude, but we got revenge when a stray stick dance accidentally burst one of their children's balloons and he ran off sobbing. Now *that's* the spirit of morris.

Chippenham is a likeable Wiltshire town, bustling around with a skip in its step and a twinkle in the eye. For 33 years it's been home to one of the country's better folk festivals, with a myriad of intriguing events scattered around the place. There are workshops in everything from circus skills to clog, busking, storytelling, Northumbrian pipes and belly dancing, in addition to a generous round of informal sessions, dances and concerts.

Like a mini-Sidmouth, it consumes much of the town and you trip over morris dancers on every corner, chugging away in their sweaty whites and chirpy expressions. We find ourselves gravitating to the local sports hall and perching atop what feels like a particularly scary climbing frame to experience the new adventures of Mr Ashley Hutchings.

As the driving force of numerous, inventive incarnations of the Albion Band across three decades, the dapper character in the natty hat and stylish jacket might be considered the fairy godfather of this book. A founder member of the three Seventies folk rock bands with enduring impact – Fairport Convention, Steeleye Span and the Albion Country Band – Ashley's influence down the years has been profound, going way, *way* beyond his role as linchpin bass player.

A BBC poll a couple of years ago named Fairport Convention's 1969 album *Liege and Lief* as the greatest folk album of them all. I'm not sure I'd go along with that – within the folk rock genre, I'd back the Shirley Collins/Albions' *No Roses*, Steeleye Span's *Please to See the King* or even the Albion Band's *Battle of the Field* ahead of it, but *Liege and Lief* was certainly the first of the crop. Hutchings was in the engine room each time, on his own journey of enlightenment from his original spiritual land of milk and honey on the West Coast of America to an ever-increasing obsession with the roots of English music.

Fairport started as a British version of Jefferson Airplane and they played the London underground scene supporting the likes of Pink Floyd, until producer/manager Joe Boyd spotted them playing at a strip club in Soho in 1967. Sandy Denny was already a popular figure on the folk club scene after working with the likes of Alex Campbell, Johnny Silvo and the Strawbs when she was recruited to replace Judy Dyble as singer, and the band began to turn away from California to look backwards at the English tradition as a means of going forwards. Richard Thompson was already developing as one of the most brilliant and challenging songwriters of his generation with his classic "Meet On The Ledge" – a must for any self-respecting funeral – appearing on the band's second album, *What We Did on Our Holidays*.

But it was their epic reworking of the traditional song "A Sailor's Life" for next album *Unhalfbricking*, completed with the loan signing of fiddle maestro Dave Swarbrick from Martin Carthy, which really provided the key to rocking the English tradition. Swarb, already a bit of a legend through his work with Carthy and the Ian Campbell Folk Group, was initially sceptical about linking up with Fairport: 'What do I want to play with a rock band for? I bloody *hate* rock music!' But he soon changed his tune, and the times they were a'changing.

The tragedy that followed might easily have finished it all there and then and made "Meet On The Ledge" their epitaph. Returning from a gig in Birmingham in the early hours of the morning, their van skidded off the M1. Nineteen-year-old drummer Martin Lamble died along with Richard Thompson's girlfriend Jeannie Franklyn, while the rest of the band – apart from Sandy Denny, travelling independently with future husband Trevor Lucas – suffered various injuries.

While the crash provoked debate in the House of Commons about the need for compulsory seat belts and benefit concerts were held, Island decided to go ahead with the scheduled release of the *Unhalfbricking* album, with its gently pastoral sleeve showing Sandy Denny's parents posing in front of a church while the band had a tea party on the back sleeve. The inclusion of the melancholy Sandy Denny song that became her calling card – "Who Knows Where The Time Goes?" – added to the poignancy. It even spawned a hit single, the jokey "*Si Tu Dois Partir*", the French-language cover of Bob Dylan's "If You Gotta Go Go Now", also a hit for Manfred Mann. But nobody knew at the time – least of all the surviving members – if the band would continue.

It was in such a mood of heavy reflection and self-examination that they reconvened at Farley Chamberlayne in rural Hampshire ... and to all intents and purposes emerged with something called folk rock. It didn't meet unanimous approval. The folkies were iffy, as folkies

tended to be about most innovations, and their old rock audiences wondered what the hell they were doing. The critics got their knives out and *Rolling Stone* even dismissed *Liege and Lief* as 'boring'.

Not that we should condemn *Rolling Stone* for that, oh no. You get a new LP in, give it a couple of swift plays, but you can't concentrate properly because people keep talking to you or phoning you up to remind you about picking up a bottle of wine from the off licence because you're going to dinner with those people you don't remember meeting though you've-met-them-a-hundred-times-and-you-really-should-see-a-doctor-about-this-memory-loss-thing. And then you have to knock out a review.

So *Rolling Stone* got it wrong with *Liege and Lief*. We've all been there. At dinner parties people-I-don't-remember-though-we've-met-hundreds-of-times constantly chortle as they remind me of the kicking I once gave the Eagles' album *Hotel California*, which regularly crops up in the higher reaches of those daft 'Best Albums of All Time' lists strangling the life out of music magazines. And I even get the occasional wise guy recalling my time as a hapless *Melody Maker* singles reviewer when I predicted Rod Stewart's "Sailing" would be a big fat MISS in the charts. It was No 1 two weeks later and I was sacked from the singles reviews. Oddly enough, I was never invited on *Juke Box Jury*, either.

In truth, *Liege and Lief* didn't set the world on fire. Not at first. People just didn't understand why a respected rock band was messing around with folk songs. But Dave Swarbrick, by now installed as a permanent member of Fairport, soon put them right. 'The thing is,' he said, 'if you're singing about a bloke having his head chopped off or a girl screwing her brother and having a baby and the brother cutting her guts open, stamping on the baby and killing his sister, that's a fantastic story by anybody's standards.'

You've got to admit he has a point.

Play me the intro of "Matty Groves" now and I'll stay rooted to the spot, listening to the whole sorry saga of the unrepentant, adulterous noble lady and her young lover being cut down by the insanely jealous Lord Donald after her quisling servant has done his Duncan Goodhew impression to spill the beans. I won't budge an inch until Matty gasps his last breath. Only if it's the Sandy Denny version, mind …

It all went a bit skiddly-do for Fairport after *Liege and Lief* as they argued about future directions. Sandy wanted to do her own stuff and went off to form Fotheringay, Ashley wanted to take a deeper leap into traditional song and founded Steeleye Span, and Richard Thompson wandered off into a solo album and then a rewarding duo act with his wife Linda.

There was much talk that Fairport's new singer would be the vener-able Albert Lancaster Lloyd. Now this, I'd love to have seen. A. Lloyd was a seminal figure in the British folk revival of the Fifties and Sixties. Born in Sussex and orphaned at 15, he became a sheep man in Australia, where he became hooked on the bush songs of Banjo Patterson, the man who wrote "Waltzing Matilda". He also lived in South Africa for a while, but on his return to Blighty he became a communist and found a new obsession with the traditional singing of Phil Tanner. In 1944, he published his first book, *The Singing Englishman*, a social analysis of folk song.

He was also a whaler in the Antarctic, a journalist during the Spanish Civil War, a BBC producer, a vigorous critic of Hitler when others counselled appeasement, and a song collector and musicologist par excellence. His folk song collections were massively influential and, along with Ewan MacColl, he was the burgeoning young folk club scene's strongest voice. Indeed, the title of Lloyd's pioneering radio series *Ballads and Blues* was adopted by MacColl for the London club which became a blueprint for the folk club movement.

Bert Lloyd died in 1983, but I met him a couple of times. He was a mischievous small bundle of a man whose warmth, charm and vitality were in marked contrast to the haughty austerity of the slightly intim-idating MacColl. What's often overlooked is that Lloyd was also a fabulous singer, with a buoyantly informal style, almost acting out the stories with facial expressions and expressive eyes as he wrung every last lyrical nuance and storytelling trick in the book from the songs.

The single, best live performance I ever heard in my life was Bert Lloyd singing "Tam Lin" in front of a dozen people in one corner of an unprepossessing field somewhere in Reading about a million years ago. I mean, we're talking the lord of all ballads here.

A Scottish song collected in the mid-nineteenth century by the American Francis Child, "Tam Lin" is a stunning story steeped in witchcraft, fertility symbols, superstition and evil deeds as Janet defies her father, the king, to brave the magical horrors that lie in store at Carterhaugh, where Tam Lin lays in wait claiming maidenheads.

Janet ends up pregnant and is resigned to aborting the child. But returning to Carterhaugh to do so, she encounters Tam Lim and unmasks the secret of his former life as a knight who's fallen under the spell of the Fairy Queen. His only route to freedom, apparently, involves an ambush from the startlingly heroic Janet, who has to pull Tam Lin from his white horse at a crossroads at Halloween and hang on to him for dear life while the fairies change his body into an alarming array of different creatures.

Listening to Lloyd delivering the exciting denouement felt like

watching an all-action movie as Janet clings to Tam Lin while enraged fairies turn him into a poisonous snake, a roaring lion, a red-hot bar of iron, burning lead and then … a naked knight. Harry Potter has nothing on Tam Lin …

Sadly, Bert Lloyd didn't join Fairport in the end, and we'll never know what wonders would have transpired had he done so. The great Sandy Denny's erratic solo career ended with her death after a fall in 1978, and her Australian husband Trevor Lucas – also briefly with Fairport – died of heart failure two years later. But the other leading players in the Fairport story survived to tell the tale, reuniting for an annual summer reunion beano at the village of Cropredy in Oxfordshire.

It's that continuing story that brings us to Chippenham now. Apart from more folk rocking with Steeleye Span and the Albion Band, plus various adventures with theatre and the spoken word (a show about the life of Cecil Sharp, for one), Ashley Hutchings became deeply immersed in morris dancing.

It was quite a revelation when Ashley and John Kirkpatrick put together the *Morris On* album in the early Seventies, embracing many of the leading movers and shakers of the time and imposing folk rock values on the morris tradition. The Albion Band even co-opted their own morris side from Chingford who were known, on particularly barmy occasions, to dance to Ian Dury's "Sex And Drugs And Rock'n'Roll". The old tradition was alive and well and kicking for England.

Kirkpatrick himself ploughed even further into the dancing tradition with subsequent albums *The Compleat Dancing Master* and *Plain Capers*, while Hutchings is now on to this fourth collection of morris tunes – the faintly embarrassingly titled *Great Grandson of Morris On*. So, high up in the sports hall in Chippenham, Mrs Colin and I watch Ashley further exploring his own journeys through morris music.

It turns out to be quite a show. Morris tunes are splendidly invigorating, with or without dancers at the front, and are certainly strong enough to withstand the powerhouse of instruments Ashley has put behind them over the years. He's got a good band around him, highlighted by the all-singing, all-dancing Simon Care. He frequently demonstrates his own expertise, dancing in front of the stage with an impressive array of leaps and bounds without missing a note as he continues to play melodeon and concertina.

He's a great character, Simon Care. The son of a morris man, he's played in a variety of trailblazing bands, notably the multi-cultural outfit E2, and is all for kicking out the jams and putting a few firecrackers up the bottom of dance music. 'It's getting hip again,' he tells me enthusiastically. 'Students are joining in, getting pissed and falling

over and thinking "This is great!"' He also plays with dance band Tickled Pink, once described as 'the Darkness of the ceilidh scene', but while he's quite happy to dance while playing melodeon, he draws the line at getting a huge tattoo around his navel: 'The day I start wearing spandex is the day I quit!'

But the unquestionable highlight of the night, the moment it all comes alive and forces you to reassess your perception of morris dancing from whatever angle you come at it, is Morris Offspring. Now this is something *really* special: a mixed side of young dancers from all over the country drawn to morris dancing largely as a result of years dumped at kids' workshops at Sidmouth Festival, where the *Shooting Roots* sessions are now starting to produce a determined new generation of young English folk musicians.

After years of association with middle-aged men with beards and beerguts, the sheer grace and energy of these young dancers, with their stylish whites and subtle ribbons on their shoulders, is quite startling. They're thankfully not constrained by stuffy old stereotypes, or hoary old arguments about whether women should be allowed to dance morris or whether the steps are strictly pure. They assemble their own dances and they have a grace and verve that is, well this will sound weird, but the whole thing's actually quite *sexy*. I feel bad about thinking this until I remember the many confusing theories about the genesis of morris dancing include symbols of fertility, sexuality and, er, good crops. So that's all right, then.

One of Shakespeare's mates, comic actor William Kemp, fell out with the bard in 1599 over a production of *Hamlet*, which he insisted couldn't possibly be staged without the presence of a dog on wheels. Kemp registered his protest by morris dancing all the way from London to Norwich. Unfortunately it was winter and there was thick snow around at the time, and it took him nine days of freezing bells, during which time you imagine Will Shakespeare was laughing like a drain, tucked up warm in front of a cosy fire in Stratford knocking out the Scottish play or some such.

Yet the spirit of Sid Rumpo still hangs heavy, and the sight of chunky morris men bounding towards the next pub may be an archetypal image of English summers the great unwashed may still find impossible to stomach without the protection of self-conscious giggles and hoots of derision. But exciting young morris sides are emerging all over the place, and I reckon that if they had given Morris Offspring a slot to dance to one of the day's hits like Pan's People used to do, then the ailing *Top of the Pops* would have been saved instantly. Well, Jools Holland featured Chris Taylor performing a solo morris jig on the St George's Day edition of his *Later … TV* show, and nobody died.

Infused by dreams of morris dancing sweeping the nation, I tell John Kirkpatrick he should be choreographing massed morris dancers in a spectacular stage show. They flocked to see the Irish dance extravaganza *Riverdance*, didn't they, and that didn't even have a proper story, so why not an English equivalent?

'Good idea,' says John. '*You* do it ...'

Suitably fortified, we head for Bampton-in-the-Bush. Come here any other time of the year and you wouldn't blink twice. It's a pleasant enough, but largely unremarkable, Oxfordshire village where the main concerns appear to be the activities of the Environmental Watch Group and the Society for the Preservation of Ancient Junketing. Whatever the hell *that* is.

But hey, this is is Whitsun and the first thing we see in the village is a sign announcing 'NO PARKING – MORRIS MEN DANCE HERE' and a sales pitch outside the Talbot for hot tubs and saunas. For one day only this is the morris dancing capital of the world, and they descend on Bampton from all corners to pay homage to the world's most famous morris tradition. 'To get on the local council here you either have to be in the morris or mummers sides, or be in the amateur dramatic society,' a random would-be politician tells me over a pint in the Talbot. 'Worse than the masons, it is ...'

Inside the Horseshoe, I meet the living morris legend Francis Shergold. A former squire and now president of Bampton Morris, he's like a genial version of Marlon Brando's Godfather, meeting and greeting his flock as they queue to shake his hand and pay their respects. He holds three conversations at the same time, swapping banter with all and sundry, with an eye out for the strangers in town, enquiring about their business. There's one man with a battering ram of cameras round his neck wearing absurd yellow checked trousers at the bar asking for 'a pint of your finest ale, landlord' in a drawling mid-Atlantic accent.

'American, eh?' says Francis, slapping him firmly on the back. 'Yes,' says the guy, looking genuinely surprised, 'how did you *know*?'

Francis is decked out in his whites, but informs me he won't be dancing. He is, after all, now 85 years old. 'I danced for 60 years, I deserve a rest,' he says, peering out as a bunch of dancers launch into action at the front of the pub. 'Is this my side, is this my side?' he says, and starts to turn away when he realises it isn't. 'Come on Francis, there's a space at the front for you here,' says one of the dancers, Tony. 'No ... you don't dance the way I do,' says Francis.

They are loaded words. There are three morris sides in this small village, all with their own character. There used to be one, but way back in the mists of time there was a bitter split over, well, *stepping* differences. 'If you don't know by now, you never will,' Francis says,

when I ask him what it was all about, and he even hesitates when I ask him to pose for a photo with a young lad who dances a tradition favoured by one of the 'other' Bampton sides.

When he finishes his dance, Tony tells me it was Francis Shergold who first taught him morris in 1969. So why did he swap sides? 'There weren't enough opportunities for young boys to dance in Francis's side. I just wanted to dance.' When I ask him what the big split was all about, he says, 'Ask Francis.' 'I just did, he wouldn't say.' Tony smiles enigmatically and dances away.

As the origins of morris itself are long lost in a baffling miasma of theories about moorish peoples and pagan fertility rites, the history of dance in Bampton outlives all existing records. Francis was originally taught to dance by one of the ultimate Bampton legends, fiddler/dancer Jinky Wells, though he was by then almost blind and half-deaf. Francis tells the story that his family were full of reservations about him joining the morris side, because of their reputation for hard drinking. Some things never change.

The Whitsun dancing continued even during the war years, when Jinky Wells rustled up a scratch team to prove the Bampton tradition would go ahead, Hitler or no Hitler. And when he returned from the war effort in Europe – suffering a couple of wounds in the process – Francis Shergold took over from Jinky Wells as squire. According to a wonderful article by Keith Chandler, a senior member of the side, Arnold Woodley, took exception to the quality of the new blood being introduced and set up a rival side of young guns.

It was an echo of an earlier split in Bampton when Jinky Wells set up his own side in the late Twenties after a dispute with the Tanner family – whose members dominated the side – over who should be leader. Alcohol always played a significant role in the Bampton tradition, and stories abound of bad behaviour, drunken dancers colliding mid-morris and tempers becoming lost.

No such tensions are evident today as people tumble out of the pubs into the sunshine to watch the three sides on their various tours of the village, on pub forecourts, in the streets and even in people's gardens. We watch a side of youngsters energetically putting their backs into it and someone observes the young 'uns might learn better if they were mixed into a side with senior dancers. A woman watching her son dancing swings round to disabuse her of this notion. 'Never, *ever* let a father teach his son the morris. It's like teaching someone to drive; you need to keep it out of the family. Believe me, I *know* ...'

Watching Francis Shergold's side dancing as another great Bampton stalwart Reg Hall plays for them in the grounds of what appears to be a minor stately home, an elderly woman scurries along with the latest

exciting news from the village. 'I've just seen two policemen!' She's tickled pink by this historic occurrence. 'Imagine! Two policemen. In Bampton! Never thought I'd see that.' Off she trots, happy as Larry, and the dance goes on.

In the covert surroundings of a clump of trees at the back of the churchyard, I hear some guilty giggles and spot some teenage girls up to no good. 'Go on, do it, don't even think about it, just do it ...' one is saying. I hide behind the trees and take a peek, suspecting a glue-sniffing ring and wondering if this is the real reason for the policemen in Bampton. I see them steadying themselves in a line, pulling something grubby from their pockets, waving them in the air and then ... all leaping forward. A clandestine womens morris side!

Francis Shergold must be informed instantly. I eventually find him in the kitchen of The Horseshoe with a group of chums singing "Lily of Laguna" and "If You Were The Only Girl In The World". It seems a strangely perfect image on which to leave Bampton and I tiptoe away to recall the days when I, too, tripped the light fantastic.

CHAPTER SEVEN

Cheese, Speed and Antlers

'We're poisoned by the greedy
Who plunder off the needy
Leave the factory, leave the forge
And dance to the new St George'

"New St George", Richard Thompson

*W*e spend the night with my Auntie Pat in Swindon, a town once so dominated by the rail industry that all of my relatives there – and there seemed to be 96 of them – worked for Great Western Railways. That's all gone now, of course. All that seemingly remains from those halcyon days of steam is the railway museum that now stands at the converted church where my mum and dad married during wartime.

These days, Swindon is one of those regenerated towns full of new industries like job centres and remainder shops. It has a pedestrianised shopping centre, while motorists grow beards outside the County Ground attempting to make sense of the Magic Roundabout, which welcomes you to the town with the most infamously baffling traffic system known to mankind.

An unfeasibly large number of celebs hail from Swindon. Diana Dors, for one, Swindon's very own answer to Marilyn Monroe. There's a bust of her in the foyer of the Wyvern Theatre. That's a bust *of* her, not her bust, by the way, lest an army of pervy necrophiliacs think about invading the Wyvern. And let's not forget Melinda Messenger. Or XTC. Mark Lamarr. Billie Piper. Justin Hayward from the Moody Blues. Desmond Morris. John Francome. James Dyson, who makes vacuum cleaners. The bloke who invented the wastepaper basket ... and my Auntie Pat's three-legged cat (RIP).

We can't hang around here gossiping, though. There are forests to visit, free cheese to be eaten. We do a quick circuit of Wiltshire first. It's

a less worldly county than most, and that's not just because they all sound like Pam Ayres round here. Half of the world's UFO sightings and a large percentage of corn circles seem to occur in Wiltshire; then there's all the giant white horses cut into chalk hillsides from Westbury to Cherhill. You can spot them from miles away and, dear Lord, they love 'em so much that they put a new one up in Devizes to mark the millennium.

Not far from Swindon is the village of Avebury, with a druid stone temple that's never had the fame of Stonehenge but in its own way is just as impressive, even if they did lose some of the stones when farmers tried to clear them away in the eighteenth century to create space for fields. At Avebury you don't quite get the same class of American tourists, earth seekers and grade A weirdos. I'd half planned to spend Midsummer's Eve here, watching the sun rise with lots of hippies going 'Ooohhhhhhhhhhhh', blowing bubbles and howling at the moon, but the truth of the matter is that I get there on the wrong day and miss it.

'It was great,' says a stray biker, who looks and sounds suspiciously like Reg Presley of the Troggs. 'There were bikers, goths, freaks, hippies, spiritualists, New Agers, travellers, drunks … all just watching the sun rise. So peaceful it was. Mind you, there were tailbacks for miles and you couldn't move for police, but it was cool when the sun came up.' I'm wondering if he *is* Reg Presley. Apart from his long and successful career growling '*Waaaald thing…. I think I lurvve yeww … BUTIWAN-NAKNOWFOSHOOO-WER*' night after night, Reg wrote a book about UFOs, and he's always the token celebrity they dig out for an enigmatic quote whenever a mysterious new corn circle appears.

He's a great English eccentric, is Reg. He was mixing cement as a bricklayer with the radio in the background when his mate said, 'Oi Reg, that sounds like you!' when they played "Wild Thing" back in 1966. Reg dropped his trowel when the DJ said, 'That's this week's new No 2, "Wild Thing" by the Troggs.' He never did pick up that trowel again.

With "Wild Thing" irritatingly enmeshed in my brain, we head off into the forest: the Forest of Dean, to be precise. The only thing I know about the Forest of Dean is that EMF came from here. They were one-hit wonders from 1990 whose name stood for something exceptionally horrid; I can't remember what it was now, but their hit was unbelievable. Well, "Unbelievable". Cracking record, too. They're probably lurking in that rather nice pub over there playing Spandau Ballet covers now. At least the rest of the journey comes with "Unbelievable" stampeding round my head rather than "Wild Thing".

It was Mrs Colin's idea to venture out here into the wilds of Gloucestershire. 'There's this thing they do in this village place, and it

sounds great,' she assures me. 'I don't know exactly what it is, but it's been going on hundreds of years.' 'But what happens?' 'Look, I'm not sure, but you get free cheese.'

So here we are cowering under a tree sheltering from sheeting rain in the gentle village of St Briavels (pronounced Brevvels apparently) in the Wye Valley. It's at times like this I wonder if my zero tolerance policy on umbrellas is in need of urgent review, but then I remember the old woman who nearly poked my eye out bobbing and weaving through Chippenham town centre, grit my teeth, and pretend to enjoy getting soaked.

Despite this, morale is sinking fast, and a swift return to Auntie Pat's house in Swindon looks very inviting. 'That's it, nearly 6pm, it's dark, it's cold, it's wet, there's not a soul around, nothing's going to happen here ...' I announce after skimming through a frankly dull parade of parish notices at the gate of the castle-cum-youth hostel for the fifth time. Then a car pulls up outside the large, old church and a smiling female vicar gets out. 'You here for the preaching, then?' she says. This is a faintly worrying line of introduction. If I don't play my cards carefully here, I could end up at the altar giving a sermon on the evils of umbrellas and caravans. 'The preaching of the Whittington purse ...' she elaborates.

I'm even more baffled. Has it got anything to do with cheese?

She generously shields me with her brolly and explains all. It's something to do with one of Dick Whittington's relatives, who bequeathed approximately 1/8d to provide food for the poor woodsmen of the forest. Every Whitsun the foresters assembled here at St Briavels for the annual dispensation of bread and cheese. There's also something about being allowed to graze your sheep through the village and rights to take wood from the forest, but I'm not concentrating properly on account of the fact that as she waves her arms around, animatedly illustrating her point, the sharp bit of her brolly looks increasingly likely to take my eye out.

She turns out to be quite the social analyst, explaining that foresters have a hard, pig-headed reputation, but when they had such a tough life, how could you blame them? It was a rough, unforgiving lifestyle in an all-male environment in the forest, she says, and the absence of women was so depressing that they bussed in female servants from Cheltenham to meet them.

'It's a bit different now,' she laughs, 'they don't have to do that any more. They used to throw the cheese from the church and then the church tower, but it got a bit wild so now they do it from the Pound. It's great fun. I think it's really important to keep the old traditions alive, don't you?'

Oh I do, *I do*, so when does it all start?

'Right after the church service, at about 7pm. I should be getting in there now ...'

People are arriving from all directions, heading for the church, and I await the pressing invitation to join them. But the vicar's next line takes me completely by surprise: 'We'll be a while and it's a bit wet so my advice to you is to go to the pub up the road for a pie and a pint, and come back when the service is over and join in the fun.'

I didn't get where I am today by not obeying a female vicar when she told me to go for a pie and a pint, so the pub it is. With more vicars like her around the churches would be full. Well, as long as they put a bar in.

The George seems crammed full of people ordered to go drinking by the vicar, and getting right royally tanked up on her instructions, though they've run out of pies by the time I get there. 'What's going on in the village? There's a load of people up there,' one new arrival asks. 'Oh that, it's the cheese and bread thing,' I tell him nonchalantly. He looks totally perplexed so I tell him exactly what the vicar has just told me about foresters and Dick Whittington and maids from Cheltenham, though I don't credit my sources. 'Blimey,' he says, clearly impressed, 'lived here long, have you?' No mate, only just moved in as a matter of fact ...

The natural tranquillity of this Gloucestershire village is soon rudely shattered by some particularly vehement gangsta rap booming out of a nearby cottage window competing harshly with the chiming church bells. As rap battles go the odds don't seem very even; it feels like Eminem going head-to-head with Aled Jones and there's only one winner, even if Aled has got home advantage. By the time we get back to the church the soggy, desolate spot has somehow been transformed into Piccadilly Circus. A couple of hundred people have gathered outside Pound Cottage, just up the road from the church, and squealing gaggles of kids are already expectantly looking up the walls with baskets, hats and hands at the ready.

Then out of the church comes a sallow-faced man in suit and tie with an attractive woman in a white dress carrying baskets brimming with bread and cheese. They enter Pound Cottage and then climb, a tad uncertainly, on top of the wall, totter a bit, as the crowd surges forward, smile ... and start tossing food at us.

Instantly my rather paltry cap is in a losing battle with the old enemy, a front line of upturned umbrellas catching the chunks of cheese and bread raining down. I'm sure there must be something in the rules of engagement banning this sort of behaviour and make a mental note to bring it up at the next parish meeting. But a few discreet

elbow challenges straight out of parks football scatter an excitable but disorganised team of kids in the catching front line, and I return to Mrs Colin having proudly caught our supper.

Which is when our benefactor in the white dress falls off the wall.

Naturally I rush to her aid, but her pride is bruised more than her bottom, she says with a fetching smile. Her name is Margaret Creswick and she tells me she was born to this role. The Creswicks have been doling out bread and cheese here for centuries, although she hasn't a clue how or why it fell to them in the first place. All she and her brother Gerald know is that after the death of their father, duty called and she knew her time had come to throw cheese and fall off walls. As she and her bro' are ushered away to be photographed for the local paper, I ask their mother, also called Margaret, if she knows how the family got involved in all this.

'My father-in-law used to do it, and I think his father did it. So it's been in the family for several generations, but I don't rightly know how that came to be. It goes back to the days when people were real poor.'

So did you used to go up on the wall throwing cheese yourself?

'Oh *no*, not me. Women never threw the cheese. Weren't done, like. But my daughter Margaret took over to give my son Gerald a hand after my husband died eight and a half years ago. I have an elder son but you have to live in the village to throw. Margaret is the first female *ever* to do it.'

Ten minutes with Mrs Creswick and I feel like part of the family, as she tells me all about the tribulations of cheese throwing. Way back in the nineteenth century there were reports of undignified food fights breaking out, after the pastor became the target for blessed cheese pellets (and he'd blessed them a few minutes earlier, so he'd know!)

Outbreaks of fighting and drunkenness in the scramble for the food also caused plenty of local problems through the years – hence the changing venue. Margaret Creswick tells me about court cases resulting from claims over the wood while her son Gerald, who's been doling cheese out for 30 years now, admits they've had to fight a few political battles in St Briavels through the years to keep the tradition going. The various incumbents of Pound Cottage haven't always been amenable to Creswicks climbing on their walls tossing cheese around every Whitsun; they once blamed them for an outbreak of rats in the vicinity.

'As far as I'm concerned, we'll keep on doing it,' Gerald says. 'They used to come for miles and park charabancs in the square. It's still very popular. It wouldn't be right without it.'

I tell him what it lacks is a song we can all join in as the cheese starts to fly. Maybe "For Cheese A Jolly Good Fellow", or something? The

look he gives me suggests I may have outstayed my welcome, so I don my cap and go off to find Alberta. Driving out of the village, I notice a strange sticky sensation and an odd smell on my head. That'll be the lucky Creswell cheese I'd captured in my cap and inexplicably decided to smother my hair with, then.

Just a few miles up the road we innocently bowl into the town of Coleford and find a party going on. There are young people here, *lots* of 'em, wearing young people's clothes and doing young people's things like shouting and pouring cans of lager over each other and involving themselves in rampant text messaging orgies. After the relatively sedate surroundings of the church and the curious ceremony I've just witnessed at St Briavels, this place gives me quite a turn. Mrs Colin hates it and wants to leave immediately, but I'm strangely fascinated. EMF were surely more Coleford than St Briavels.

'It's a disgrace,' says the poor sod trying to mop up the mountain of vomit in the men's loo. 'Waste of time me clearing this up, there'll be another mob pouring their guts out in here in a minute ...'

It seems that way out here in the backwater of Gloucestershire we've chanced upon a real old-school music festival. There are punks wandering around with Mohican haircuts, the likes of which I haven't seen since 1985; helter-skelters; dodgy bands on a makeshift stage belting out throbbing R&B where you can hear only the bass; burger bars that make you retch; and couples snogging on the streets to a chorus of 'Get A Room!' from their mates. The whole place feels like a thrillingly grubby throwback to another time zone awash with noise, tawdry behaviour and the cider-swilling arrogance of youth before political correctness, gyms on every corner and the woes of the world cut it down to size.

I'm fascinated and, momentarily, slightly thrilled by it. There's even a carrot to try and entice us back tomorrow, an appearance by what the posters claim to be the world's longest-running band, the Drifters. I'm all for getting up and nailing my colours to that board-walk right now, but Mrs Colin is surveying the scene in abject horror. 'Where are the morris dancers?' she asks, plaintively. I know that look. It's time to leave.

Inspired by the adventures of Kelly Holmes in Athens, we head off on an Olympics trip. It's not widely known, this, but the modern Olympics originated in the Cotswolds. That's what they tell you at Chipping Campden anyway. At Dover's Hill, overlooking the vale of Evesham, they annually stage the *Cotswold Olympicks* to prove it.

The story is that in 1612, at the behest of King James I, a Norfolk man called Robert Dover organised a Whitsun-week sporting gala on the hill above his adopted home. It was hugely popular, too, involving

coursing, horse racing, fencing, plus some even spicier events like throwing the sledgehammer and shin kicking. Then the Civil War broke out and buggered it all up. However, there were various revivals through the years and it became hugely popular again during the early nineteenth century. So popular, in fact, that all the riffraff of society started descending on it causing all manner of trouble, and the Olympicks bit the dust again.

The current revival has been in existence since 1963 and once more Dover's Hill resounds to buglers, morris dancers, marching bands, fireworks, torchlight processions and the graceful forgotten art of shin kicking. So the modern Olympics started in Chipping Campden, right? But didn't someone say that it was in Much Wenlock? Best find out ...

We bomb through the fine city of Worcester and stop briefly over-looking the Malvern Hills at the home/museum of Edward Elgar, the man who gave us that great football song "Land Of Hope And Glory". Or, as it's more popularly known, "We Hate Nottingham Forest". We take a further break at the old town of Ludlow, where we listen to an opera singer busking outside the castle, admire the Tudor architecture, absorb the town's turbulent history and browse through the huge market.

Want to buy a stuffed fox? It's here. Copper warming pan? Certainly, sir. Ornate jug and bowl for those irritating moments when you desperately need a wash but somebody has been in the bathroom for three hours and you really can't imagine what they can possibly be up to all that time? A mere £55 and it's yours. Summat for the kids? How about a complete selection of "Buffy the Vampire Slayer" videos? And you, sir, you look just the type to want to buy a mint vinyl copy of the Eagles' *Hotel California* ... I tell him I ripped the bloody thing to shreds in 1976 and by God, I'll do it again if I have to, turn on my heel and stomp haughtily away.

I bump into a middle-aged man in white hair and barmy pink shorts buying a picture of the old Pear's soap ad for £20, and have an inter-esting conversation with a woman in a grey shawl who informs me that Ludlow is riddled with ghosts. 'Go to the Globe Inn,' she says. 'Anyone will tell you. It's haunted by a Tudor soldier in a wig and cloak; a man by the name of Edward Dobson. He died there in a pub brawl in 1553.' Seen the ghost yourself, have you? 'No, not exactly. I don't really go in pubs much, but ask anyone ... *anyone*. Go there now, it's not far.'

I'd say I'd love to but I've got to go to the Olympics in Much Wenlock.

In truth, Much Wenlock doesn't appear to be the sort of place they're likely to have held the Olympics. In fact, it seems to be the sort

of place that has trouble getting out of bed every morning. Still, there's a selection of second-hand book emporiums and cute tea shops amid the mix of Tudor, Georgian and Jacobean houses, while the George and Dragon Inn advertises a night of Irish music and, clearly marked outside the Guildhall, you can follow the official 'Olympic Trail'.

The trail relates the story of a local doctor, William Penny Brookes. It seems he was quite a livewire, who built the local corn exchange, formed the Wenlock Gas Company, launched an early lending library and built the Much Wenlock and Severn Railway. He also had a bee in his bonnet about the benefits of physical fitness, campaigning for PE in schools while pursuing a longstanding interest in reviving the ancient Greek Olympics. In 1850, Brookes formed the Wenlock Olympian Class 'to promote the moral, physical and intellectual improvement of the inhabitants of the town and neighbourhood of Wenlock' and staged the first Wenlock Games that year with a selection of athletics, football, cricket and, er, quoits.

Encouraged by the enthusiasm which greeted these events in Shropshire, he then approached the Greeks about reviving the event there. Initially they rebuffed his overtures, but in 1889 Baron Pierre Coubertin – who had the same dream – arrived in Much Wenlock to discuss his ideas. The visit coincided with another Wenlock Games – now including great events like 'putting the stone', 'pole leaping', 'jingling matches' and 'tilting', which involved horsemen wielding lances riding at speed under a crossbar to unhook small rings from the bar.

By this time the good doctor was an old man, and sadly had died by the time Baron Coubertin finally got the dream of a modern Olympic Games off the ground in 1896. Yet despite a few interruptions along the way, the Much Wenlock Games continues as his legacy. The Olympic flame even made a guest appearance here in 1995.

I finally locate the right signs to clamber up a steep hill into its traditional home at Linden Fields. There's not much going on here today, sadly: just a bunch of empty football pitches, surrounded by steep banking and loads of trees. And there's positively no sign of anyone practising their jingling, tilting or pole leaping.

We're about to leave Much Wenlock when I chance upon another gem: *King Arthur: The True Story*. It seems that all that stuff we found about Arthur in Cornwall, Devon and Somerset was total garbage, and he was really a son of Shropshire. Spent all his life here. Won all his battles here. Buried all his treasure here. He got around, this Arthur bloke, didn't he? By my latest calculation Arthur's buried in about 18 different places, all of them claiming he's there ready, willing and able to rise up at any moment to save England from whatever foul deeds

threaten her. Oh he is, is he? Where the hell was he when they launched "Pop Idol", then?

The Shropshire claim on the Arthur legend is all to do with the ruined Roman city of Viroconium at Wroxeter, just outside Shrewsbury. They reckon that in the fifth century, Viroconium was the capital of Arthurian Britain, so Wroxeter is basically Camelot and Arthur's treasures are buried at Much Wenlock. Probably underneath the jingling court.

A couple of miles further on, and we're in Ironbridge. We park up Alberta, wander along damp, empty streets alongside the River Severn, gaze up at the still imposing iron bridge crossing the river in front of us, and try to imagine how it would have felt 200 years ago. It's hard to imagine this little town as the cornerstone of the Industrial Revolution, but there are nine museums within a six-mile radius to assure you that it's true.

The main credit for the erection of this, the world's first iron bridge, goes to engineer Abraham Darby. The Darby family – all of whom seem to have been called Abraham, including the women – are indelibly linked with the area. Abraham's grandfather Abraham built the first factory at Coalbrookdale in 1709, due to its proximity to low-sulphur coal, and invented iron smelting. His son, Abraham, created the forging process to produce huge single beams of iron, thus enabling the building of engines, railway lies, wheels and the like. And Abraham the third knocked up the bridge of iron in 1871.

Yet I'm more fascinated by his mate John Wilkinson, who sounds like a real nutter. From Clifton in West Cumbria, he was so obsessed by iron that he was nicknamed John 'Iron Mad' Wilkinson. He ran a furnace in the Lake District before moving to the Midlands, where he found bliss in his blast furnaces, building everything he could possibly think of with iron. Wilkinson built flat irons, iron barges, iron pulpits, iron cannons and endless iron coffins. You couldn't move in his house without stubbing your toe on one of his iron coffins, apparently. Naturally, when there was talk of Abe Darby building a whole *bridge* out of iron, ol' Iron Mad Wilkinson was right there at his side, going 'Noooooo, you don't wanna do it like *that* ...' But before it was finished he got bored, and went off to build some more iron coffins.

Only one thing rivalled iron in his affections – an alternative hobby that resulted in two marriages and, in his seventies, three illegitimate children. He was 78 when the last of them was born, so we must assume this passion outlived the one he had for iron.

When he eventually died there was, of course, much debate about which of the iron coffins to bury him in. The result was four separate burials. They decided to have a special new coffin built, resulting in a

temporary grave while they erected it. When they finished and laid him to rest again, they found there wasn't enough topsoil to keep him down and raised him again while they drilled a different hole in the earth. Just when it looked as if he was indeed going to be able to rest in peace at his home in Cumbria, the family sold the house. The new owners didn't really fancy 'Iron Mad' Wilkinson at the bottom of their garden, so they dug him up again. Wrapped in iron, he now rests at Lindale Church.

Further exploration of Ironbridge reveals some entertaining shops. I'm strongly tempted to buy an autographed photo of Leslie Phillips saying 'Ding Dong!' in the curio shop for £12; and outside the Victorian Tea Room and Supper Theatre in Waterloo St there's a sign that says 'ALL WANTON WOMEN WILL BE WHIPPED.' I'm in the mood for a bit of wanton women whipping, as it happens, but sadly the Victorian Tea Room and Supper Theatre is shut.

Instead, we head for the Jackfield Tile Museum, passing the Jackfield Sidings and Severn Valley Railway, a line linking Bridgnorth and Shrewsbury. Like numerous other country lines, it became a victim of the Beeching cuts in 1963. I have an uncontrollable urge to boo and hiss loudly whenever the name of Lord Beeching arises, so I stand there booing and hissing for a while. A woman with four small children turns the corner in front of me at the very same moment. There's a moment of panic on her face as she sees this nutter booing and hissing loudly at a dead railway line, and she gathers the children protectively around her and scurries away, mobile phone at the ready for the call to the men in white coats.

'Jackfield is a very poor bit of the fag end of the world, made up of old pit shafts, pit mounds, rubbish heaps, brick ends, broken drains, roofs and paving tiles, dilapidated houses, slurry lanes and mirey roads,' said the Tile Museum's Victorian founder, Henry Dunnill, who clearly went to the same school of marketing as Gerald Ratner. He was chairman of the Jackfield Reading Room and Workmen's Club, and the members must have been thrilled to bits when they heard that. In fairness, he also said this: 'In this neglected, forlorn and desolate place it is yet possible to understand and follow the great movements of the world and to share in the thoughts and emotions of the great leaders in human thought ...' On this spot where previously stood a ramshackle pottery, he went on to build one of the world's biggest tile factories, with a progressive approach that became a model for other businesses to follow.

We repair for a drink to the Boat Inn, whose worrying proximity to the river is confirmed by the series of watermarks on the walls. The highest marker recalls November 1, 2000, when the floods reached 19

feet 6 inches. Inside, a group of people are playing bar billiards. It's a curiously warming sight. Once at the very epicentre of English pub culture, bar billiards has all but been swept away in the ignominious rise of chain bars pumping out brain-numbing dance music at three gerzillion decibels, flogging trendy foreign lagers in saucily shaped bottles and absurd designer food at outrageous prices.

Full of gaggles of morons who look like trainee estate agents drinking Smirnoff Ice, these places will be mown to the ground come the revolution and replaced with pubs with bar billiards and a fruit cake in the corner talking to himself while a couple of others surreptitiously play fiddles and mandolins and the landlord says 'Come on Bert, give us a song', triggering the whole pub into spontaneous choruses, descants and all. It's gonna be quite a revolution, this.

But my quest for Albion has suddenly hit a major snag. The thing about England right now, you see, is that someone is watching you all the time. And roaring round the country with Alberta in such fine fettle it's only a matter of time before the speed cameras that seem to have appeared overnight as a blot on the landscape will do their evil business. So I pick up a speeding ticket. And another. Then another ... all in the space of a few weeks.

I suddenly realise this potentially scuppers the whole journey. A driving ban is looming ominously near, and I really don't fancy making the rest of the trip on a No 28 bus with Alberta abandoned in Shropshire. Especially as the final offence that took my points total over the limit occurs when I'm caught on camera doing 35mph in a 30mph speed limit area. OK, OK, I know the rules; speeding is speeding, it's wrong and dangerous and even a meagre five miles over the limit can kill, but *come on*, it's hardly Michael Schumacher, is it?

But there's an option. I have the chance to pay £90 to go on a one-day Speed Awareness Course, and if I pass and am deemed to have learned my lesson and am no longer a menace on the roads, they won't put any points on my licence and I'll still be free to continue my journey. The course – something of an experiment – is in Stafford, partly because Staffordshire has the most speed cameras and therefore the most victims ... or *offenders*, as the authorities call us. It seems like a deal worth taking, especially as they're offering a free lunch.

So I spend the night in one of those soulless motel places with Stepford Wives at the reception desk a couple of miles from Stafford, because I really don't want to be caught speeding trying to get there on time. Next morning I'm up with the lark cramming in some late revision on the *Highway Code*, and after a few practice three-point turns and emergency stops, I head for the training centre.

What they have failed to mention is that today they're digging up

Stafford. The tailback starts almost immediately I leave the Stepford Wives, and the rush hour hooting and fist-waving is a glorious insight into English attitudes as they wend their merry way to the workplace. Even Chris Moyles's gibbering on the radio seems perfectly coherent in comparison.

So I'm late. Only by 35 minutes – and 15 minutes of that is trying to find somewhere to park. I haven't brought a note so I'm expecting detention or a spell standing in the corner with my hands on my head, but I'm whisked inside by a roly-poly man who whips my driving licence off me and tells me there's a great buffet lunch to look forward to.

Inside there's a motley crew of sheepish-looking speed fiends with name cards in front of them, giving their stories on how and why they got caught. One young guy excels himself with the motoring equivalent of 'the hamster ate my homework'. He was doing 39mph in a 30mph limit and the headmistressy figure coos sympathetically. 'They should have got me five minutes earlier, I doing was 90!' he boasts. 'I don't think I want to know that,' says the headmistress, but *I* do, and so does the rest of the class.

'I was being *chased*,' he adds dramatically. 'Chased? By whom?' asks the headmistress, a Miss Jean Brodie figure drawn into the intrigue against her better judgement. 'Gangsters!' says the guy, pausing to absorb the sharp intakes of breath that sweep around the room. 'See, I was in the car with this girl I'd met earlier that night but it turns out she was the daughter of someone *very high up* in the police force and was involved in a drug racket, and this gang was stalking her and started chasing us. She said they'd kill us both so I had to put my foot down ...'

I'm not sure if he was offering this as a genuine reason for breaking the speed limit or testing the water for a plot idea on his next novel, but it suggested this whole thing would be more fun than I'd imagined.

Other intriguing excuses are then offered. 'My daughter was taken violently ill and I was rushing her to hospital' ... 'No word of a lie, my speedometer was stuck on 29mph' ... 'My brother phoned me from the airport to say he'd left his passport at home and they were on last call for boarding so if I didn't get there quick he'd miss the plane and lose his deposit on the holiday of a lifetime.'

When it's my turn, I tell Miss Jean Brodie I was listening intently to Peter Bellamy's "Conversation With Death", before deciding it was just a tad too heavy for my funeral and might upset the mourners. So I wasn't really concentrating on the road. This doesn't go down at all well, and I wish I'd invented some story about me being an undercover cop in hot pursuit of the daughter of a police chief who was running a drug ring.

Jean tells us we've all been selected for the course precisely because we were doing only a few miles over the speed limit and they figure we can still be saved (if I'd been doing 41mph I'd have been beyond salvation, apparently). There are games ('How many potential traffic hazards can you spot in this picture?') and discussions, not to mention a speed-awareness equivalent of *Who Wants to be a Millionaire*. I feel as if I'm on an Eddie Stobart team-building course. But as the fanfares sound and our sumptuous buffet is brought in, there's a lot of nervousness about the 'practical' test in the afternoon, and the chat resonates around the topic of My Career Collecting Endorsements.

'You know that bit in London, just before you get to the Blackwall Tunnel?' says one bloke who now lives in France and has flown in especially to go on the course. 'There's a hill, yeah, so you can't see what's on the other side, yeah? There's no speed limit so you're bombing up to this hill, yeah? And as you come over the brow of the hill, you go straight into a 40 limit, yeah, so you got no hope of braking in time, and they've only got a load of cops waiting right there with speed guns to catch you ...'

We all coo sympathetically, and ask how much he was fined. 'Nuthin', *nuthin*' ... see, I tol' 'em, dinni? I sez, you try and book me for this and I'll throw the book at you, you see if I don't. I threatened 'em. Said I'd take 'em all the way to the House of Lords if needs be. It just weren't right. So you wanna know what happened?'

Oh yes, we chorus, we wanna know what happened!

'Nuthin'. Zilch. *Fark all.*'

Gosh.

'They knew they was wrong, see. They knew I was serious. I'd have crucified 'em ...'

They're all scrabbling to get their how-I-beat-the-cops stories in now. 'I got done by a speed camera and I thought I was gonna lose my licence, so I asked my father-in-law who used to be an inspector, and he said, "Ask to see the *photograph*!" They don't like that because it doesn't prove who was driving. So I asked to see the photograph, and I never heard another dicky bird!'

There's a hot debate, too, about the motorist's new friend – some sort of gadget you put on your windscreen which detects when you're approaching a speed camera. So you brake just before you hit the camera and then accelerate away at silly mph. Marvellous, innit? Oh we have a right laugh telling each other how naughty we've been, and we all agree the buffet lunch is divine.

In the afternoon the examiners come in, divide us into pairs and take us out for the practical. I've been paired with a young redhead from Cannock in a rather inappropriate tight leather skirt and too

much make-up who turns out to be a gibbering wreck. 'Are they gonna make us drive?' she asks me as we head for the examiner's car. 'I rather think they are, yes.' 'Oh God, I hate driving, *hate* it. Every time I sit behind a wheel I have an accident.' This isn't really what you want to hear as you climb into a car with her, but the leather skirt is nice.

The instructor fellow, who has a peculiar moustache that makes me suspicious that he may be a weekend caravanner, drives for a bit, giving us useful tips like watching for road signs and looking in your mirror. 'The thing is, there's so much to remember to do when you're driving that you shouldn't have *time* to speed,' he advises. He's not too keen on my suggestion that we all get issued with those gadgets that warn you when the next speed camera is likely to strike, and then we'll all have exemplary driving records.

We then have our own chance to strut our stuff behind the wheel, after which he takes us for a coffee to explain what we're doing wrong, and then we go out again to try and put it right. 'Just drive naturally, just as you do all the time,' he says cheerily. Yeah, *right*, of course we will, eyes peeled for cameras, giving way to cyclists, ostentatiously studying our mirrors, and generally transforming ourselves into knights of the road.

Except for red-headed Chardonnay here, who squeals every time she sees another car, appears to be handling a steering wheel randomly injected with 500 volts at regular intervals, has a cavalier disregard for speed limits, seems to be colour-blind when it comes to traffic lights, and threatens grievous bodily harm against the entire pedestrian population of Stafford.

'How'd I do?' she says, pulling up at the coffee shop in a blast of shrieking rubber. The instructor crow-bars his fingers from his face and says rather unsteadily, 'Hmmm ...' She looks at me. 'Great,' I tell her, putting my thumbs up, 'you were bloody great.' 'Aw, thanks,' she says coquettishly, smiling from head to toe.

I leave Stafford with a 'very competent driver' report, that little misunderstanding with the speed restrictions a while back expunged from the records and loads of new chums from what feels like a secret society. Life is good; oh, life is very good.

There's just one more port of call to make before leaving Staffordshire: the village of Abbots Bromley. The Abbots Bromley horn dance is famous. This weird ritual involving blokes dancing around in strange costumes with antlers on their heads is such a bizarre one that its images have spread far and wide as a symbol of exactly how barking the English really are.

What isn't quite so well-known is where Abbots Bromley is (near Uttoxeter, but after that, you're on your own) and when the

ceremony is actually held (first day after the second Sunday after the full moon when Mars crosses Uranus and it isn't a leap year as long as there's a thirsty bunch of people in the market square, some time during the summer). I've had the computer and calculator working for weeks on this and I reckon it's today. But I wouldn't stake my cat's life on it.

After inordinate difficulties and urgent enquiries of everyone I see (two boy scouts and a couple of sheep) I eventually arrive at Abbots Bromley hoping to find crowds thronging the streets and men in antlers. The place is utterly deserted. I mean, *utterly* deserted. It feels eerily empty, like the day after the world ended. It didn't, did it? There aren't any signs up on the parish notice board about the world ending yesterday.

There's only one thing to be done in these circumstances – pubs always have the answers. I step inside the smart, Tudor-beamed Goat's Head where a smiley young blonde is instantly at my service. 'Has the world ended?' I ask politely. 'No but we had the horn dance here yesterday so everyone's lying low, sleeping it off,' she says. 'Ah,' I say, 'so I missed it then?' 'Only by 24 hours!'

Still, she tells me all about it and within a few minutes I feel as if I had been here. 'Rammed it was in here, *rammed*. You couldn't move outside, people here from all over the place. And it's so funny watching them dancing in those funny costumes and the horns and everything and of course half of 'em were out of it by the end, so it were dead funny watching them stagger around.

'I mean, imagine dancing round the village in those antlers all day long ... they weigh over a stone you know. I carried a set of those antlers and boy, they were *heavy*, I can tell you. They're reindeer horns, thousand-year-old reindeer horns. They keep 'em locked away in the church during the rest of the year. Heavy they are, dead heavy. See, they start around 8am or something stupid, they go dancing round the farms and start drinking in the morning. We had a family in from Germany. They couldn't believe it. They were lost on their way to Lichfield and couldn't believe what was going on. They reckon the English are all mad.

'It was a great day,' she concludes. 'It's a shame you missed it. They come from miles around. We get all sorts here. It's the biggest day of the year in Abbots Bromley. Come to think of it, it's the *only* day of the year in Abbots Bromley ...'

The horn dance is certainly one of the oldest and weirdest English traditions and nobody has a clue about its origins, least of all my friendly barmaid, though someone told her friend's friend it started at Barthelmy Fair in 1226. And she's the daughter of a teacher so it must

be true. The claim is that the horn dance has been held here every year
since then, though there was that unmentionable period in the mid-
seventeenth century when dancing and music were forbidden
following the Civil War. If the horn dance *did* go ahead then, the
dancers were taking their lives in their hands to do it. They also had to
cancel one year in the Twenties when one of the dancers died with his
horns on, but apart from *that* the show has gone on.

The reindeer antlers they use have been the subject of much spec-
ulation and intensive research from both folklorists and zoologists.
Brian Shuel's *National Trust Guide to Traditional Customs of Great
Britain* reveals that an unwritten rule that the horns must never leave
the parish was waived when urgent repairs were needed in 1976, and
they went away to a specialist. A splinter was examined by experts who
dated the antlers to 1065 – give or take 80 years. But the plot thick-
ened with the revelation that the horns were from a species of
reindeer that had already been extinct in Britain for centuries before
that date. They appear to have come to Abbots Bromley from
Scandinavia, but why and *how*?

The Fowell family certainly don't have the answers. Like doling out
the cheese at St Braviels, the horn dance is traditionally a familial
thing. Tony Fowell has led the tradition into the twenty-first century,
just as a Fowell has led it into at least three previous centuries. The
current crop of dancers are all Fowells and Bentleys, who dress in a
selection of costumes of green waistcoats, breeches, long socks and
funny brown berets that must have elicited some choice banter even in
medieval times. There are six dancers, plus those decked out variously
as a wooden hobbyhorse, a man as Maid Marian, a bowman and a 'fool'
whacking people with a pig's bladder which he insists will make them
pregnant ... even the blokes.

They don't have a specific Padstow-style song, or even a dance of
any great complexity or intellect – two lines of people bound back-
wards and forwards, form a couple of circles and the odd figure of
eight, and that's about it. But when you're carrying around those dirty
great reindeer antlers on your head all day long, you're probably not
too worried about finesse. Dragging locals to join them at certain
points on their eight-mile trek around the village – once, even the local
constabulary were prevailed on to abandon crowd control and join in
– they dance to a wide selection of old standards and singalongs.

An hour or so has passed, but Abbots Bromley is still a ghost town.
'One of the Fowells might be in later, they could tell you more about
it,' says my barmaid. 'Then again, er, they might not be.' I thank her
and head out into the night. 'Come back next year,' she shouts. 'Just
remember it's on the Monday after the, er, second Sunday of the

month which, er, oh I dunno when it is, but it's worth coming. I tell you, you won't *believe* the size of those guys' antlers ...'

'Size isn't everything,' I cackle as I leave with a triumphant spring in my step. Thirty years of trying, and I've finally cracked that Sid James impersonation ...

CHAPTER EIGHT

Island of Dreams?

'With a crew of 21 Manxmen
Her passengers Liverpool businessmen
Farewell Mona's Isle farewell
This little ship was bound for hell
Oh Ellan Vannin, of the Isle of Man Company
Oh Ellan Vannin, lost in the Irish Sea'

"Ellan Vannin", Hughie Jones

Today, children, we are inducting a new entry into England's chamber of horrors – the Isle of Man ferry.

Tussling with Liverpool's docklands area and its blind determination to get you lost in Bootle with random signposting is grim enough, but even if you overcome this considerable obstacle, there's an army of officious tattooed jobsworths lying in wait on the quayside to add further humiliation with vague instructions and scowling reprimands as you drive on the bloody boat.

I end up broadside across the gangplank having a slanging match with a crop-headed gorilla, after executing an admittedly wayward nine-point turn attempting to reverse into the tiny gap apparently earmarked for me between two lifeboats. The gorilla's face is a mask of incomprehension. 'What the fook? Go back, start again ...' 'I don't know where you want me to go ...' 'I've just told you three fookin' times ...' 'Is this where you want me? Reversing into this little gap?' 'Oh for *fook's sake!*'

The other motorists queueing behind give me a standing ovation as I leave poor Alberta hanging precariously over the edge of the boat and the gorilla turns his attention to some other victim. 'You think it's bad here?' asks a seasoned sufferer, resignedly. 'When conditions are rough, you sometimes get shipped up to Heysham and have to go across from there. Now Heysham ... that really *is* the arse-end of the world ...'

Once on the boat we soon realise the pesky foot passengers and the smart-asses who don't get lost in Bootle have already nicked all the seats. So Mrs Colin and I perch on a back-breaking bench that looks as if it was liberated from the old stand at Accrington Stanley when it went out of business in the Fifties, and get a grandstand view of the annual outing of the Loudest, Most Annoying and Worst Behaved Kids in Britain Association.

Exasperated as, squealing and shouting, they trample my ankles for the nineteenth time, I wreak sweet revenge with a sly hooked foot worthy of Robbie Savage that sends two of them crashing to the deck in a volley of screams, curses and tears. As their bodybuilding father investigates the source of the problem, I make my excuses and retire to the hole in the rigging laughably called the cafe. When in doubt always have a coffee, that's my motto. But as I take a soothing sip, the top of the cup flies off and boiling hot coffee lands in my lap. Raucous kiddy laughter reverberates around the boat.

In silent agony, I grit my teeth, pretend nothing's amiss, and hide behind my guide book to the Isle of Man. Things instantly take a turn for the better. 'Caravans are banned in the Isle of Man,' it says. The coffee pain is forgotten as I read it again. Yep, it's there in black and white. CARAVANS ARE BANNED IN THE ISLE OF MAN.

Now then, things *are* looking up. This, clearly, is an enlightened society. It gets the basics right. It has red phone boxes, no speed cameras (or indeed, speed *limits* outside of towns), minimal taxes, steam railways, free museums and cats with no tails. It also believes in fairies and bans caravans. Me and the Isle of Man are going to get along just fine.

I'd felt instinctively there were answers to be found in the Isle of Man. Its history as the mother of all parliaments, its Celtic spirit and its rich folklore give it a wayward independence that's very alluring. A guy collars me over a pint in Peel later. 'So what are you doing on the island then?' Me? Oh, I'm writing a book. 'A book, is it, then? What's it about?' It's about England. 'England, is it, then? Then what the bugger are you doing on the Isle of Man?'

This becomes a familiar theme. Almost everyone you meet here prefaces a friendly introduction with the firm rebuttal of any notion that the Isle of Man is any way, shape or form, part of England. Or Britain. Or the United Kingdom. Or Europe. Or the universe probably. 'Hello,' they say, 'welcome to the island, which by the way isn't part of England or Britain or the UK or Europe.'

Say it loud and say it proud, the Isle of Man is an independent nation, associated with England purely by geographical accident … and some dodgy agreement knocked out in 1765. The one thing they

all seem to agree on – which in itself appears to be something of a rarity when it comes to island politics – is that England is some distant, foreign land referred to only as 'Across ...' . The Isle of Man – shall we go native and call it Ellan Vannin? – has its own stamps, its own currency and its own parliament, the House of Keys, which makes up its own sensible laws, like death to all caravans. All the signs indicate a boisterously independent nation ... yet it's not quite as simple as that.

I spend a week on the island and various learned brethren and drunken bums in pubs attempt to explain its complicated and highly unique legal status, but I still don't really get it. Strictly independent it may be, but it's a crown dependency, and the Lord of Mann is the Queen, who instals a faceless Lieutenant Governor to keep tabs on what the natives are up to. And although it's not part of Britain, there's an agreement by which the British government look after its interests in cases of grievance against other sovereign states. Which begs the question: what happens if Man's grievance is with Britain? Does it mean the British government schizophrenically argues with itself? Well, no change there, then ...

The one time the respective governments were at daggers drawn and appeared on the verge of declaring war occurred in the Sixties, when the pirate radio ship *Caroline* moored at Ramsey Harbour and filled the ears of Britain's youth with subversive pop music like "Silence Is Golden" by the Tremeloes and "Seven Drunken Nights" by the Dubliners. Harold Wilson wanted the whole *Caroline* crew to walk the plank but, long familiar with the notion of pirates, smugglers and maritime ne'er do wells, the Manx dug their heels in and allowed *Caroline* to stay. Well, for a bit, anyway.

It's a confused and confusing position which, with half the 78,000 population on the island actually English, is a thorny issue for the hardcore Manx worried about the long-term survival of their own culture and independent status. Which is why they're so keen to disassociate themselves from England, or any of the other habitual invaders who've tried to grab a piece of them. It may not do much for my quest for Englishness, but I'm left feeling I'm having a drink with a gloriously eccentric cousin stuck out in the Irish Sea gleefully doing its own thing, basking in its own likeable idiosyncrasies.

Take that mad flag, for example: the one with the three legs twirling around together over a red background. As a symbol of independence it's pretty special, but the killer element is the slogan that goes with it: '*Quocunque jeceris stabit*'. Or, to put it another way, 'Whichever way you throw me I stand'.

Man is only a small island, 33 miles long by 13 miles across, and if I were to take Alberta on a bumpy ride on a complete circuit of the

coastland path, she'd clock up just under 100 miles. It's in a remarkable spot, too, almost equidistant from England, Scotland, Ireland and Wales (note for pub quiz teams: it's marginally closer to Wales than the other three) leading one Welsh historian to describe it, somewhat curiously, as 'the umbilicus of the sea'. The Vikings, English, Scots, Irish and even the French scrapped over it through the years, but George III became Lord of Mann in 1765 and the British monarch has been its titular head ever since.

Not, you imagine, that any of this carries much weight or relevance to its residents, even if half of them these days are originally from England. It's an extraordinarily evocative island, drenched in a mythology and legend that owes little to romantic images to sell to a declining procession of tourists, and everything to a genuine feeling of independence and individuality and a sense of its own history.

I came here 25 years ago, for a folk festival in Douglas. Every day we heard radio reports about the heatwave engulfing England and indeed most parts of the Isle of Man too. But Douglas remained resolutely engulfed by angry mist and swirling rain for the entire week. They told me then the mist was the work of the sea-god Manannan, who did this trick occasionally to hide Man from its enemies. Well, if the enemy was folk music enthusiasts from 'Across', it certainly worked. It was cold, wet and miserable, the outdoor festival was deserted and the organisers lost a fortune. Yet I was impressed by the fact that nobody ever locked their cars or houses ('Crime? On the *island*? I don't think so …') and I had many happy conversations with the fairies under the bridge at Santon, though that might have had something to do with the beer. I found the island irresistibly enchanting, a land still absorbed in its own sense of history and all the better for it.

I even bought a vinyl LP, *Arraneyn Beeal – Arrish Vannin: A Selection of Manx Traditional Songs Sung in Manx Gaelic by Brian Stowell*, which I still have and is probably worth millions now. It doesn't get a bundle of turntable action these days, but George Broderick's sleeve notes remain illuminating. 'The real death blow to the Manx oral tradition,' he wrote, 'was the Methodist revival, which led its converts to abandon much of their traditional culture as unfitting their religious profession. Coupled with this was the increasing use of English instead of Manx among the people, which lent weight to the argument that Manx Gaelic was a restricting factor in the field of commerce. This attitude of the people themselves to their own native language helped considerably to eradicate Manx as a spoken language and the traditional songs were attended upon it.'

One track on *Arraneyn Beeal – Arrish Vannin* still fascinates. It's

called "Berree Dhone" and it tells the story of a witch from the north east of the island considered so hideously evil that even mention of her name would bring severe punishment from the Church. Ann Gelling, for one, found herself in deep water in 1700; she was sent to gaol for accusing her minister of being the 'kindred of thieves and the seed of Berree Dhone'.

On first impressions, the Isle of Man doesn't seem to have changed radically since then. We are staying with Bart the goat, a feral cat and assorted horses on a lovely farm in the old mining stronghold of Foxdale, and quickly make tracks for the small, atmospheric harbour town of Peel on the west coast: narrow streets, tumbledown cottages, small pubs lurking in back lanes, the old castle perched solicitously above the harbour, and waves crashing unceremoniously on a sea front encouragingly free of the usual paraphernalia of burger bars and slot machines.

Peel isn't cute or conventionally pretty – in fact, it could be straight out of the Fifties. Yet its downbeat wildness and gritty austerity wields its own rough-hewn charm, suggesting the modern world has yet to encroach and spoil its fun. Roots radio presenter Andy Kershaw has a house here. They proudly tell me Kershaw has visited 73 countries, but he reckons that Peel beats them all into a cocked hat, and the more you grapple with the erratic lanes and jagged landscape, the more you see his point.

'Peel is the most Manx place on the island,' says Dave McLean over a pint in the White House pub. 'There'll be a session in here later. It's the best place for a Manx music session. Well, to be honest, it's about the *only* place you get Manx music sessions these days.'

We accompany Dave to the Centenary Hall, where tonight a guy called Adrian Byron Burns is playing a natty see-through guitar with commendably nimble fingers, and booming out everything from a radical soul reworking of Bob Marley's "No Woman No Cry" to a moody, blues instrumental version of "God Save The Queen", which is received with wry smiles. The publicity blurb announces he was voted 'England's Top Acoustic Act in 2002 and 2003', which must have come as a bit of a surprise to old Byron, who very evidently hails from the United States.

Afterwards we head back to the White House in anticipation of a rollicking Manx session. The pub is throbbing and the pints are flying, but there's not a note of music. Familiar with Irish session etiquette that decrees that no decent session starts before midnight, we sit tight, but Dave is clearly baffled by the absence of music and goes to make enquiries. He returns with a sad tale of woe. 'They've fallen out,' he says mournfully. 'Who have?' 'The musicians; they've had a disagreement.

It doesn't look like they're going to show tonight.' So we talk of other things, such as the island's glorious past as a prime holiday destination for most of the north of England and parts of Scotland.

'Oh it was lively, all right,' says Dave. 'All the bands would come over and play. We had this place in Douglas called the Lido. I saw Pink Floyd there, and Cream. It would all kick off. Halfway through there'd be this commotion and you'd get a gang of them from Glasgow laying into the Manx or Bolton or somewhere. Great it was. All good, clean, honest fun ...'

Time was when Man was an almost obscenely thriving tourist resort. The faded grandeur of the sea front at Douglas offers but a glimmer today of its throbbing past filled with holidaymakers from the north of England. Even as far back as 1890 there were plans to build the island's own Eiffel Tower and suspension bridge at Douglas Harbour, and soon after the turn of the century Cunningham's Young Men's Holiday Camp – 'luxurious holiday camping in merrie Manxland' – was set up for boys from Liverpool. 'There's no roughing it here!' crowed the ads, showing rows of tents and well-scrubbed boys. 'Only youths and men of good moral character admitted ...'

Tourism boomed through the early twentieth century as half-a-million visitors arrived here every summer, and they still flocked here after the Second World War. Dave McLean recalls that while he was enjoying a front-row seat at the punch-ups that invariably accompanied the high profile gigs at Douglas Lido, 'it was always packed then, you had to walk on the road; the pavements were always so full'.

Cheap package holidays to Torremolinos buggered it all up, as did the Summerland disaster, which killed 50 people in a horrific fire at a high-profile leisure complex in the peak of the tourist season in 1973. So they don't come to Douglas for the beach and nightlife any more. Why would they, when they could enjoy the facilities in Spain or even Florida for almost the same price? Now you pass the initial flurry of bright lights on the sea front at Douglas, and there's a long barren stretch until you reach the Golden Mile Chinese takeaway. *Golden Mile*? Rusty Bronze Fifty Metres, more like ...

So I talk to Christine Collister, who left the island at 21 in 1983 to seek her fortune as a singer 'Across'. Her parents were in the hotel trade during the dying throes of the tourist boom, and Christine cut her teeth singing in the hotels and ballrooms of Douglas. 'We used to get them all over in the late Seventies,' she says. 'I saw them all, AC/DC, Smokie, Showaddywaddy, 10cc, KC and the Sunshine Band, Status Quo: £1.50 at the Palace Lido ... biggest ballroom in Europe, it was. Pete Townshend said it was his favourite venue.' Is it still here? 'No, they knocked it down five or six years ago. Built a car park instead.'

In those days, Christine knew little of Manx history or heritage. It wasn't taught in schools and, far from investigating the Manx traditions, she'd sing Joni Mitchell, Don McLean and James Taylor at the Douglas folk club. However, moving away to Manchester at such a young age made her appreciate her background. 'We used to imagine there was this big bad sinful place across the water where everybody gets clubbed to death. A huge amount of fear was generated about the outside world ...'

So how do you feel about coming back to the island now? 'I love it. I think it's a magical place. Douglas has changed out of all recognition. A lot of the old landmarks are gone with all the buildings that have gone up, and so much of the promenade is apartments where there used to be hotels. Yet outside Douglas it's pretty much the same.'

And, for so long fluent in only one word of Manx ('Hello' – '*Dy bannee diu*') – Christine even learned a song in the Manx language to sing at the Celtic Lorient festival in Brittany. 'I felt it was the least I could do,' she laughs. 'The Isle of Man is a very powerful place; it's a bit strange, but it can really captivate people. I feel incredibly privileged to have been brought up here.'

The tourist industry may have died a death, but the island has found prosperity in other ways. Mostly involving retired millionaires taking advantage of its 'tax haven' status, and alien concepts like offshore banking, low tax and high finance. The island's other primary claim to fame these days is the TT motorcycling festival, involving lots of men in leather racing around the island with something hot and throbbing between their legs. They've been doing it here since 1907, and TT is now a proud part of the psyche of the island, despite Belgian attempts to purloin it, and the safety lobby alarmed by the fatalities it habitually brings.

But go to the Isle of Man without helmet and leathers, big fat wallet or bucket and spade, and they assume you're there to do some walking. 'Here to do some walking, then?' says our man in the farmhouse. 'No, not really, we're here for the music.' Now *there's* a conversation stopper. 'Oh, well, the goat likes apple cores, let us know if you need anything ...'

We head off to the south-west tip of the island at Cregneish. If there's anywhere we're likely to witness the survival of old culture and regional identity, it's down here among the sweeping hills and rugged headlands. This was the last stronghold of the island's Manx-speaking community, which was finally laid to rest with the death of Ned Madrell in 1974. However, up on the rocky hills with a gale raging, the wind knifing through you and a scattering of rare odd-looking four-horned Loughtan Manx sheep grazing on the slopes, a 'folk village' is maintained as a gesture to that recent past.

The star attraction here is the small one-room crofter's cottage of Harry Kelly, with its low stone walls, open hearth, peat fire and thatched roof held down by ropes, paying testament to the old Manx way of life. Like most people in this neck of the woods, Harry Kelly worked both as a fisherman and farmer, and you can only imagine his disquiet as language scholars, folklorists and historians realised that he was one of the last representatives of a dying Manx culture, and beat a path to his door to try and grab a piece of that history.

By all accounts, Harry was a reluctant participant. A Professor Carl Marstrander arrived here in 1933 from Oslo University to make recordings of Manx Gaelic but, perhaps unwilling to play the role of international curiosity just because he could speak the language of his birth, Harry played hard to get. After all, Cregneish in those days was a tight-knit community, where the farmers shared their horses for ploughing and regarded anyone from Port Erin or Port St Mary just a couple of miles up the road as foreigners.

But Marstrander persisted. 'He makes a very good impression,' wrote Marstrander of Kelly. 'He grew up in a home where the parents spoke Manx to each other, he always understood Manx himself and even as a small boy he was able to speak a little. He only achieved complete mastery of the language when he went fishing with the older men when he was about 15.'

Even Ned Madrell, the last native Manx speaker, was astonished when Harry Kelly finally relented and allowed the Prof to record him speaking Manx. 'Harry Kelly would argue with anybody that would argue with him,' said Ned. 'It didn't matter whether he agreed with what he was arguing for, he would argue for arguing's sake ...' I nod approvingly at his old cottage, think of the glass of brandy I'll be pouring later in an attempt to de-freeze the bloodstream after this trek into the Cregneish Arctic circle. I shall be raising it to dear old stroppy, difficult Harry Kelly.

Having got this far, however, we might as well go the whole hog and clamber along to the Meayll Circle Stone Age burial ground, reach the very tip of Man and stare out across at the Calf of Man. A thin, ragged strip of land, the Calf is an innocent, uninhabited bird sanctuary now, but you can almost see the myths and legends crawling all over it. Or maybe it's just the seals and basking sharks that live here.

The great sea god Manannan – he who does the hiding trick with the mist – is meant to have his secret hidey-hole on a phantom island on the other side, and there are any number of stories about mad monks, intrepid farmers and mysterious hermits who've secreted themselves away on the Calf for their own reasons. The most famous of these was one of Sir Francis Bacon's mates, Thomas Bushell, who

paid penance for a life of debauchery, spending three years in exile in a cave there. He must have made it back, as he was buried in Westminster Abbey.

The Calf doesn't look very far and you can get fishing boats to take you over from Port Erin or Port St Mary, but today I content myself with staring at it from a distance across the treacherous Calf Sound which, while now flanked by three lighthouses, has claimed many casualties and is littered with shipwrecks. On the edge of the cliffs, the impressive Thousla Cross commemorates the bravery of locals who successfully rescued all but two of the crew of the French schooner *Jeanne St Charles*, which capsized on the Thousla rocks in a storm in 1858. That was six years after the biggest disaster of all when a Liverpool vessel, the *Lily*, went down here. Six people died, but days later 29 salvage workers were killed when a cargo of gunpowder exploded on the boat.

We drive on to Port Erin, another craggy little harbour town, but in this gale it's not too prepossessing. In fact, it looks *shut*. In the tourist office, I ask if any local pubs have music. Two women behind the counter stare at me in shock. 'Music? What, you mean, music as in people playing and singing?' I'm intrigued as to precisely what other kind of music they can possibly imagine I mean. They mumble among themselves, scratch their heads, shuffle papers and frown a lot. 'What about *beer*?' 'Eh? What's that love?' 'Know any local pubs which have beer?' They're scratching their heads again as I bid them good day.

There's a big sign outside the Falcon's Nest Hotel declaring 'ANYONE WHO CONSUMES LIQUOR HERE AFTER BEING WARNED BY A POLICE OFFICER NOT TO DO SO COMMITS AN OFFENCE, MAXIMUM PENALTY £500.' A fun town, this ain't. In a determined bid for adventure, or indeed life of any kind, I head back to the capital, Douglas. But on a damp, windswept Tuesday night it looks desperately sorry for itself. The Douglas Hotel is rather optimistically advertising a forthcoming all-day rock festival and the Mannerisms, a covers band, appear to be doing a tour of Douglas … next week.

So I attempt to locate some local landmarks. The Heron in Douglas had featured on a Sky TV show about wild pubs, interviewing a middle-aged woman built like a tank who specialised in beating up men who looked at her the wrong way, and an 80-year-old guy who lurched around the place throwing punches at anyone who committed the sin of not being Manx. This sounded like my kind of a place, so I ask someone for directions.

'Why do you want to go there?' I hear it's an interesting place and a jolly venue for an evening of merry ale quaffing. 'Hmmm, what's the *real* reason you want to go there?' I tell him about the Sky TV show

and the 80-year-old bloke who's not fond of outsiders. 'Oh, it's not so bad,' he says, 'there's plenty worse on this island.' He tells me about his mate, who got blind drunk there one night, passed out on a table and woke up to find half a dozen big guys in front of him, looking aggressive and staring, just staring. His mate jerked into conscious-ness, rose to his full five feet five inches, clenched his fists and in an act of astonishing bravado said: 'OK, if that's how you want it, I'll take you all on. Who wants it first, eh?' The six just men in front of him lowered their gazes quizzically, and he realised they were watching football on the telly.

Sadly, it seems the Heron is at Anagh Coar, some way out of town, so instead I go off in search of the Golden Egg restaurant in Strand St. This gained notoriety in 1973 when the manager Nigel Neal was found bludgeoned to death with a frying pan and a fire extinguisher. The case caused a sensation, partly because a crime of such magnitude was almost unheard of on the island. It also triggered a huge manhunt for his suspected killer, James Lunney.

Lunney, a chef at the Golden Egg, had left the island in a hurry the morning after the murder, hiring a private plane to take him to Blackpool and claiming his wife had been seriously injured in a car crash. He was eventually arrested in Scotland, brought back to Douglas and the public galleries were packed for the island's first murder trial in 43 years.

A guilty verdict was passed and Lunney was sentenced to death. This caused an even greater sensation, particularly among the British tabloids, who'd been deprived of such ghoulish fodder since the aboli-tion of hanging in the UK in 1965. It was to be nearly 30 years before the death penalty was abolished on Man – not that the death sentence was ever carried out. The penalty ritually meted out to Lunney and four others found guilty of murder in subsequent years was duly commuted to long-term imprisonment by the British Home Secretary. In fact, the last execution carried out in the Isle of Man was of John Kewish, hanged at Castle Rushen in 1872 after being found guilty of shooting his own father, an offence he blamed on Satan.

Sadly the Golden Egg isn't there any more, and my own one-man ghost-walk around the horror sites of Douglas comes to a premature end. But I do find some music. Sort of.

It's in an unlikely spot. The Trafalgar is a big old white pub bang up against the quayside and rather garishly festooned in Union Jacks and the flags of St George. I hesitate before entering. It looks disturbingly like the headquarters of the Manx wing of the BNP, and I'm genuinely fearful of what may lie in wait as I climb the slightly seedy stairs. But it's amazing what a pint will do, and I join a motley crew of lads and

lasses watching Manchester United on the big screen and peering at endless photographs, paintings and other memorabilia about the battle of Trafalgar on the walls. Oh, that'll be why they call the pub the Trafalgar, then.

And then, over the soundtrack of Gary Neville whingeing and Roy Keane swearing at the referee, I hear the diffident sound of a reel being played in an adjoining room at the far end of the bar. Further investigation reveals a group of half a dozen or so mainly young musicians playing guitars, fiddles, flutes and whistles. As these things go, it's not a hearty session. There are long pauses between the tunes while they drink, tell each other jokes, drink, make themselves comfy and drink. And when they do play, it's not Manx but Irish music.

But, nevertheless, it's a breakthrough. It transpires that some of the musicians in the session are members of a band representing the great white hopes of Manx music, King Chiaulee. From Onchan, just north of Douglas, they formed the band while they were all at St Ninian's High School. University courses and the lack of a proper gig circuit on the island got in the way, but King Chiaulee (Manx Gaelic for 'music heads') have still managed to carve out a promising niche as unofficial representatives of the new young Manx sound.

'It's great,' says 24-year-old David Kilgallon, one of the band's two fiddle players and their nominal leader ('we don't have a leader but they make me do all the talking on stage') over a soothing cup of coffee next morning. 'Because there aren't that many bands here, we end up getting asked to represent the island at a lot of the Celtic festivals. We've been all over the place; just got back from Cornwall after playing the Lowender Peran at Perranporth.'

Yes, he says, they were raised on Manx culture and they do feel proud to fly the flag for the island, but he draws the line at suggestions of a crusade for Manx identity. They were just a bunch of schoolmates having a laugh, and still can't quite believe it's resulted in a couple of albums, exposure on Andy Kershaw's radio show, and invitations to play in far-flung parts of the globe.

He explains that they play a good share of Manx traditional material, but mix it liberally with Irish, Scots, Breton and their own compositions. 'We lure them into a false sense of security and then we slip in something Manx,' he laughs. 'We like to think we're doing something different with it and taking the music on; there's no point in keeping it locked up in a museum.'

There's still not much opportunity for concert work on the island, and David argues that with the steady decline in tourism, money should be diverted to promoting the arts and utilising the island's rich cultural history. There's the Yn Chruinnaght Celtic festival held annually

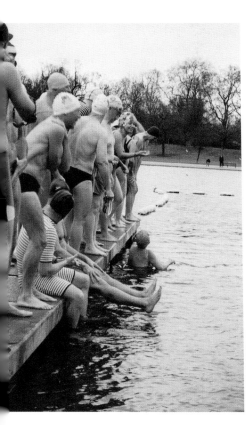

So what did you do on Christmas morning? Let the Serpentine swim commence...

Oss Oss, Wee Oss!' Summer is a-come unto Padstow.

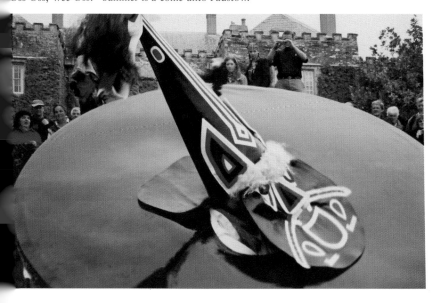

The lonesome grave of Kitty Jay at Hound Tor, Devon.

Francis Shergold, patron saint of Bampton morris, with two young disciples.

If it's Whitsuntide it must be Bampton morris.

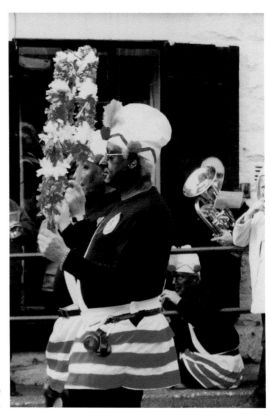

Nutters on the loose
at Bacup, Lancs.

Spot the team who fell for the nettle win trick. The world sedan-chair racing finals in Lancaster.

Pig Dyke Molly model the latest fashions at Whittlesey, Cambridgeshire.

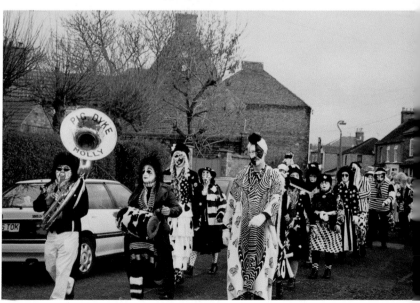

The Whittlesey
Straw Bear goes
up in flames.

Man can fly. No, *honestly*, man
can fly. Tony Hughes launches his
record-breaking flight as the
Bognor Birdman...

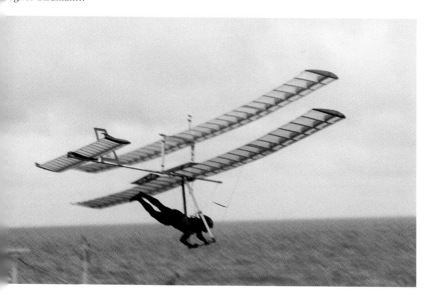

Chasing the dragon in Manchester.

A Norfolk legend –
or at least he *should* be -
Harry Cox.

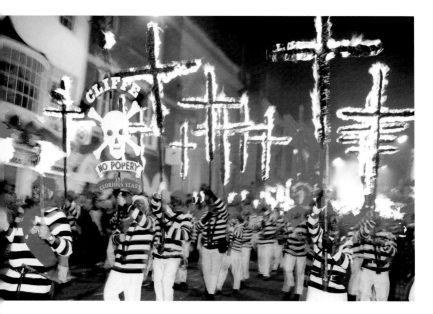

'ope-burning in Lewes, Sussex.

n Allendale, Northumberland, they like to celebrate the New Year
ith something a little heavier than sherry.

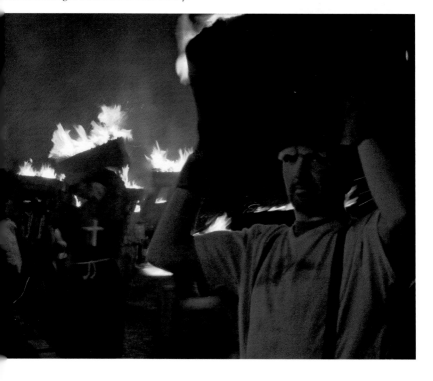

'When I said I wanted teepee I meant the toilet...' Spiritual enlightenment a-go-go at Glastonbury.

The Copper family of Sussex. John Copper on the far left with his dad, the late great Bob Copper, next to him and Jill Copper to his left. Among grandchildren and assorted friends are Norma Waterson and Martin Carthy.

in Ramsey in July, but David reckons the Manx government is seriously underselling the island's status as one of the ancient Celtic nations, with all the colourful cultural heritage it entails. Mostly when King Chiaulee play on the island it's at private parties or, when the tourists *are* around, busking in the streets of Douglas. 'It's great when the TT races are on. You can make decent money busking.

'Mind you, not everyone likes it. Some shopkeeper complained about us playing outside this shop ... said we were taking away business. It got in the papers, and everything.' Was it a record shop? 'No, it sold crystals and stuff like that.' Oh well, they deserved not to sell anything then. 'Quite.'

Mrs Colin and I scoot off to St Johns to view Tynwald, the traditional home of the oldest surviving democratic parliament in the world with its proud thousand-year history, and the Vikings' greatest legacy to the island. All the official business is now done in Douglas, but once a year on Midsummer's Day the great and the good of Mannin dust off their ceremonial gowns and gather outdoors on the symbolic three-tiered mound at Tynwald Hill to observe the ritual reading of new laws.

They are serenaded by a military band and a guard of honour alongside the fluttering flags, while wreaths are laid at the war memorial, speeches are made in Manx and English and democracy, apparently, is the winner. The islanders troop along with their cameras to experience this extraordinary exhibition of living history and are offered the opportunity to air any grievances, but tend to be diverted by the counter-attractions of a fair complete with stalls, music, dance and ale.

Even on a dank, empty, deserted Thursday it's an impressive floodlit setting, and I feel a shiver as I climb the steps carved into the grass to mount the podium. In full Lieutenant Governor fantasy mode, I inform the nation that in addition to a sacrificial burning of a caravan this year, there will be an umbrella amnesty. Form an orderly queue, fling your umbrellas in the flaming pyre, and we'll say no more about it and won't invoke the birch. The golf courses, though, will all be converted into football pitches to facilitate a serious Isle of Man bid for the next World Cup.

'Oh, it's mad, pure *bedlam,*' says the wonderfully convivial waitress at the cosy (and very reasonable) New Tynwald Restaurant, when I ask her what goes on across the road on Midsummer's Day. 'Honestly, you wouldn't believe it. They start coming in here at the crack of dawn wanting cups of tea and cakes and we're rushed off our feet all day long. Crazy, it is ...'

A cradle of democracy it may be, but the Mannin legal system has raised a few eyebrows in its time. The death penalty wasn't officially

abolished here until 1993, and there were all sorts of shenanigans when the rest of the free world cottoned on to the fact that corporal punishment was still an option.

Outlawed in the UK in 1948, birching was still going strong on the island until 1976, when a schoolboy with sore buttocks took the matter to the European Court of Human Rights. It took *them* two years to make a decision, but they eventually ruled the birch was a degrading breach of human rights and told them not to do it any more. The Manx – or, at least, the Manx in high places – weren't too thrilled about all this, and ferociously fought their corner. Not, you hope, because they saw any merit in the practice, but because they didn't like meddlers and thought Europe should just butt out (pun intended).

They didn't test the water until 1981 when a Glaswegian 16-year-old who'd overdone the shandies and got into a fight on a night out in Douglas was sentenced to the birch. He lodged an appeal which, after endless arguments and enormous publicity, was finally upheld. So nobody has officially laid branch on bare buttock on the island since, yet it wasn't actually repealed until 1993 when one member of the House of Keys, George Waft, pointed out that anyone actually birched would make a fortune selling the story to the tabloids.

Still mystified by the island's independent – or otherwise – status, I call up a member of the House of Keys, Philly Gawne (it's easy, all MHKs are independent and all are in the phone book) and arrange to go and see him at his house in Surty, near Port Erin. Philly affably gulps down his dinner and patiently tries to enlighten me. There's lots of mention of the 1765 Act of Revestment, or 'The Great Deceit' as Philly calls it, when the English crown bought the rights to the Isle of Man for £70,000.

'People thought it would be great that the island would be looked after by its great neighbour across the water, but all that happened was we paid for it for the next 200 years. All our money went into British coffers. All the wealth from the Laxey and other mines, a *huge* amount of wealth, went out and we didn't get a penny for it. Up to then most Manx people were either Manx Gaelic speakers or bilingual, but that was the turning point. All the money disappeared, and if you wanted to get on you either had to emigrate or serve the tourist trade.'

Tynwald operates consensus politics (which seems to mean nobody's allowed to disagree with anything) and all the MHKs are voted in as independents. But Philly – a compact, energetic and clearly passionate man – is a fervent nationalist. As a Manx language development officer, he's acutely aware of the divisions the question of Manx Gaelic still arouses. It is being taught in schools again, but taking heed of the backlash compulsory Irish lessons created in Ireland, it is purely optional.

Philly says that when he was campaigning for election to Tynwald in 2003, the one element that lost him votes was his support of the Manx language. Down in Cregneish, he got a furious reaction from an old Manxman after using the Manx language to scold his kids. After years of indoctrination and being made to feel ashamed of having a language that no one else understood, many older people on the island get irate with the younger generation trying to revive it.

For Philly, his hardest job as an MHK was his first job – having to swear allegiance to the Queen. 'I could just about cope with swearing allegiance to the Queen, Lord of Mann, but you have to swear allegiance to the Queen of England. Not that I've got anything against the Queen ... well, apart from not being very comfortable with somebody who has that amount of wealth, but I just don't see what the Queen of England has got to do with me. I had a choice – I could have got elected and not taken up the seat, or ...' Or just get on with it. 'Yeah, and that's what I've done.'

I feel I should apologise for being English, I mumble. 'Oh, I've nothing against the English. My mother's English, some of my best friends are English. There are some nationalists who do have a problem with the English, but ultimately it's not a race issue, it's more to do with numbers. So many people came in so quickly, and this has seriously undermined the ability of Manxness to recover.'

He talks about the downside of a low-taxation policy that's inspired such a large population explosion in recent years: 'Early in the Sixties, there was a fundamental change in our way of thinking. We got real control of the way things are run on the island and raising funds and implement taxation. But that's a double-edged sword. On one hand it's helped us assert our independence, but on the other it's meant building an economy based on low taxes which immediately meant we were importing loads of new people.'

He's on a roll now.

'I've got nothing against any of the people who've come here but they *aren't Manx* and they *don't think like Manx people* or have *Manx traditions* and ways. In the last 40 years there's been an increase in the population of about 35,000; that's a massive change, and with such a change it's very difficult to keep hold of your culture, your way of life and your identity. It makes it very hard to come out the other side still feeling Manx. A lot of people feel the whole point of being Manx and belonging to the island has been pulled from under their feet.'

Later in the week we head north, taking Alberta on the obligatory ride along the TT course clearly marked on the road past the huge Laxey Wheel up the mountain to Snaefell. It's here among the clouds that you realise what an extraordinary island this really is. It has stunning

scenery, impressive mountains, acceptable beaches, windy villages, a proud industrial history, tacky amusement arcades, tiny rural farming communities, hiking opportunities, ancient monuments, wildness and solitude and interesting animals. All human life is here.

Standing at the very northern tip of the island at Point of Ayre, I can't help but contrast and compare with Land's End. At Land's End, there're lots of fences, a horrible hotel, a surfeit of souvenir shops trying to take your money, and someone charging £9.50 to take your picture under a signpost. At Point of Ayre there's, well, a lighthouse, but that's it … apart from a handful of people staring out to sea as if mesmerised.

No, this is how lands' ends *should* be … and it's only later that I discover the place has been bombarded with applications to build holiday homes, fun parks, estates, hotels, coffee shops, sports stadiums, colleges, an oil refinery and the whole darn shooting match on this evocatively desolate spot. Well done Mannin, for telling them all to sod off. So far, anyway.

In Sulby I make the acquaintance of ManX spirit. It's quite a discovery. A colourless liquid in an odd square bottle, it looks like paint stripper. Happily it doesn't taste like it. Not that I've ever tasted paint stripper, you understand. Nope, ManX spirit (see what they've done there with the X thing?) tastes like, well, I was going to say whisky, but apparently any such reference will instantly unleash an army of burly Scotsman to condemn me as a heretic and march me off to the funny farm.

'It *is* whisky though,' says my Deep Throat contact in the off licence, 'it's *white* whisky!'

So why don't they market it as whisky?

'Ah,' says my informant, pulling up a sofa and donning pipe and slippers, 'now *there* lies a story.'

The story goes that distillation was effectively banned on Man in 1767, and it remained banned for the next 209 years … until Lucien Landau came along. Polish by birth, Landau arrived in London after the Great War, joined the London Rubber Company, made a killing flogging Durex and retired to the Isle of Man. After a long but eventually successful struggle to get the distillation ban repealed, he set up the Glen Kella distillery at Sulby and started experimenting with whisky.

Now don't ask me to explain all the ins and outs of it, but he evolved a system of redistilling whisky from Scotland that dispensed with the normal painstaking maturing process in barrels, and was done and dusted in a couple of hours. The only difference was that, denied all those years swimming around in a barrel, Lucien's whisky emerged *white*.

By the late Seventies, Glen Kella whisky was up and running in Sulby and selling very well, thank you very much. But the whisky police were on Landau's case, disputing his right to call his drink whisky because, as everyone knows, whisky isn't white. Eventually (1997) the case came to court and, whatever it tasted like, Glen Kella was barred from calling itself whisky because it failed to observe the three-year distillation rule governing whisky production.

'I don't know why he didn't just change the name to "Whiskee" or "Whiskie", you know, just changed a few letters,' says Deep Throat. 'But he changed it to ManX Spirit and nobody knows what it is ...'

They think it's paint stripper ...

'Personally I think it tastes exactly like normal whisky. The only difference is that when you drink scotch, you can still taste it the next morning. With this stuff, the taste is completely gone in the morning.'

I buy a vat of the stuff off him for £15 and stagger into the night. But I have another significant encounter in Sulby; I meet Vinty Kneale.

At first I can't stop staring at him because he looks just like John Peel. The late, *great* John Peel. The news has just come on the car radio that Peel has died of a heart attack in Peru. It's a horrible, massive shock. After Bob Copper and Brian Clough, he's the third great Englishman and personal hero of mine to pass this year. I'd met him a few times along the way, and he was exactly the same wonderfully laconic character you heard on the radio. Peel was a rare symbol of integrity and musical passion in an increasingly corporate industry. He had no use for focus groups and self-important men in suits dictating daft policies in pursuit of the lowest common denominator.

As evidence of John Peel's greatness, I produce one delicious quote from the great man: 'I regard playing golf as entering the antechamber to death. When my mates say they've started playing golf I mentally cross them off my Christmas card list ...' Godlike.

I had heard Andy Kershaw talking about the times he and Peel had spent together on the Isle of Man watching the TT racing. So when I see Vinty Kneale looking like John Peel it sends a shiver down my spine, and I keep staring at him but don't tell him why. It turns out that Vinty Kneale is a local builder. And a poet. And a performer ('but I rarely get asked back twice'.) And he lives in a house with flying swans on the wall. He's got a few opinions too.

He's quickly into a tirade about the iniquities of the government and Chief Minister Richard Corkill and tells me he's been plotting a blood-less coup. 'I was in the pub with some mates and we were all pontificating about what should be done and we decided we'd stage a coup the following Monday. But when Monday came the only other one up for it was an 80-year-old woman, who said she was game to go

to Douglas to overthrow the government, but she'd have to go there on the bus. And do you know the only reason we didn't do it?'

No I don't, Vinty.

'WE DIDN'T HAVE A BUS TIMETABLE!'

I sniff a sitcom in this, and I want to know how they'd planned to overthrow the government. You know, had they happened to have a bus timetable.

'Easy. We'd just need a couple of bouncers and stick them on the front door. When the members turned up, the bouncers would say, "Sorry, but you can't come in," and when they said "Why?" the bouncers would tell them there had been a coup. And that would be it, they'd say, "Oh, OK" and walk away, and that would be it. We'd be in power. There wouldn't be any opposition. Everybody's so politically correct we'd probably get a grant for it!

'See, they're all spineless! Nobody will stand up against England or Europe. We do everything Europe wants us to do and we're not even in bloody Europe! They've done away with the birch and hanging and ...'

You're a fan of hanging, then? 'No, I'm not, although my great grandfather was the last hangman on the island. We often tell people we still have the rope. We are the nanny state. Health and safety is killing us! It's a nonsense place now! We're not saying anything because we're frightened of offending somebody! We're bland now! We live on an island of *beigeness*.'

He bangs on a bit about the evils of the government, the architecture, the heritage industry, the disappearance of the Manx character and what he sees as a backward step into 'Victoriana' in an attempt to rescue it: 'They're trying to pigeonhole us: "Oh, he must be Manx because he can speak the language or he plays fiddle in a certain way." But it's *not like that*. Manx is about a *feeling*, a feeling of independence, and we've lost it. It comes from living on an island, of being shut off and remote, of being able to cope and be self-sufficient come what may.

'Now we're so diluted by other cultures. What they're cooking up now as Manxness is twaddle. "Let's teach them Manx at school ..." No! Let's teach them Japanese, or something! I can almost see us in our little enclosure down the wildlife park eating spuds and herring with a sign reading "DON'T FEED THE MANX".'

Vinty even manages to dismiss the Viking invasion on which Manx history is essentially built as a conspiracy theory. His alternative version is that, far from marauding their way through the island, the Vikings were actually *lured* here by knowing islanders: 'I can imagine the Manx beckoning the Vikings: "Come ashore, lads, we need your

gene pool." And when they weren't looking we nicked their boats so they had to stay. See, there's never been anything straight about us. We were always crooks and smugglers, but at least we were entrepreneurs. I'll tell you what being Manx is all about, it's being crafty, awkward and crooked, doing whatever it takes to survive. Those are the Manx traits.

'So yeah, I reckon the Vikings were lured here. I see very little evidence of Viking attacks, and it's amazing how diluted the Viking influence is compared with the Celts'. The only battles we had were with the Scottish, who didn't like us for some reason. I don't know why: maybe it's because we used to kill them ...'

He's ranting so much, I have to ask ... if he's so pissed off with it, *why stay?* And that's when Vinty tells me about his other plan: to leave the Isle of Man and become the lord of Barra.

Barra? *Barra?* That tiny island in Scotland?

'Yes, I looked it up on the internet. It's just a rock in the middle of nowhere. The man who owns it is Lord McNeil of Barra but he's getting rid of it, he wants to live on the mainland and get someone else to run it. I rather fancy being Lord Kneale of Barra ...'

I leave Vinty in a bit of a daze, all assessments of the Isle of Man up in the air in a mélange of images of Vikings and flying swans and bus timetables and lords of Barra. Is Manannan's spirit really all washed up?

I decide to seek out Greg Joughin from the band Mollag, widely considered the font of all knowledge in Celtic Manx matters. I head out to his home on the sea front at Peel and knock on his door. Ten minutes later I'm knocking so hard that the power of my blows nudges the door open to reveal ... another door inside.

A further 15 minutes of ferocious knocking reveals no answer, just two black cats clawing at me from inside. I try the handle and it opens. The cats spring at me and I dive to shut the outer door lest they're not allowed out. I shout and bang things and talk to the cats loudly, but there's no sign of Greg ... or, indeed, of anyone else.

It's nice to know that even in these dangerous times, some Manx don't feel the need to lock their doors. I worry briefly there may be a pile of dead bodies upstairs, ravaged by mad cats. Then I hear a noise in the house and run for my life. Maybe a drink's in order.

I wander up the steep hill to the White House and meet a man with huge curly hair who is only too keen to tell me more about the ills of the island. Mark Kermode at your service, chairman of Mec Vannin, the island's nationalist party (not that they tend to run for office, what with having to swear allegiance to the Queen of England and declaring you are British and all that).

The idea of Manx nationalism engenders all manner of images, and

initially I fear that once he discovers I'm from England, he may fly into a rage and start ripping my ears off or something. But lovingly caressing a pint of Guinness he turns out to be a hugely personable chap, even if the odd blood vessel does come under threat as he reflects on the illogical memory of large slithers of the Manx-born population waving flags of St George and supporting England in football matches.

'Even Manx radio presenters let it slip in their commentaries. They're talking about England v. France and they say "WE" scored, meaning England. We've pulled them up on that, said "Oi, what's this *we* business?" Even if England play Scotland most people over here will mentally align themselves with England rather than Scotland, which is peculiar. When the chips are down, when England are playing I'm always with the other side!'

Mark's proud of being Manx ('Even from an early age, I knew how lucky I was to come from here'), and it dismays him how much of the indigenous culture has been eroded: 'Most of the teachers here now are English, teaching under the English curriculum without any knowledge or appreciation of Manx history. I'm afraid my glass is half empty rather than half full.'

You're not optimistic about the future, then?

'Not if the government continues to paint us in a corner with an economic policy which, to be successful, requires ever increased immigration. This social engineering that's going on, if it's unsuccessful it will result in a total economic collapse and if that happens we'll have total *emigration*. A lot of people will say, "Great, it means all these tax dodgers will disappear", but it doesn't work like that.

'In 1996 we door-stepped a meeting of Swiss bankers and lawyers at the museum and gave them leaflets, saying the European Court of Auditors had identified tax havens as a problem and were going to start shutting them down effectively. Our government's immediate response was, "They can't do anything to us, we're not part of Europe", but six years later they're doing whatever Europe tells them to do!'

Mec Vannin's avowed aim is creating a completely independent republic ... which seems a bit of a pipe dream to me, frankly. 'No, it's *not* a pipe dream. It might not happen in my lifetime but look at Ireland. The Irish home rule movement started in the mid-nineteenth century and there was the uprising in 1916 ...'

Ah, so you're going to have an uprising! 'No, we wouldn't want to see violence. There shouldn't ever be any need for violence. The problem is, we live in a very isolated environment and people are frightened of expressing opinions. The papers here are very hostile to dissenters, very supportive of the government line, and very easily bought.'

But I'm sure I read something about Manx nationalists burning

down holiday homes ... 'That wasn't us! There was a campaign in the Seventies and again in the Nineties with an underground newspaper and a bit of arson and daubing, and they knocked over an electrical sub-station somewhere, but it wasn't us ...'

I tell him it's my last day on the island, and I'm determined to hear some Manx music before I leave. He frowns. 'Oh you missed it. There would've been a session in St John's last night. No, I tell a lie ... what day is it?' Friday. 'Then it's tonight. The Tynwald Inn. There's always a session there on a Friday ...'

So. I bound up to the Tynwald Inn anticipating a rip-roaring night of Manx music and Okell's ale and find my way barred by a sign on the door declaring 'SORRY – CLOSED FOR PRIVATE PARTY'. I contemplate trying to gatecrash it but can hear a guy inside singing Jim Reeves songs, so I flee to the pub up the road. It's called the Farmer's Arms, and the first person I see is Elvis. Well, when I say Elvis, I mean a small little guy with preposterous black sideboards decked out in a loose (literally) approximation of the famous Vegas caped white suit, flares, studs, mad collar and all.

He's over in an instant, showing me his rings, including *the very one* that Elvis used to wear. It has his initials, so it must be his. 'I got it off the thingy,' he informs me proudly. 'What thingy?' 'You know ... whatever they call that thingy?' 'Er ... e-Bay?' 'Yes, that's it! The internet! Cost me $300 ...'

He tells me his name is John ('but you can call me Tony'), says he makes his living doing something with trees (Planting them? Chopping them down? Swinging on them?) and shows me another ring with his own initials (JTR) on it. Born and bred on the island, he's appalled to hear I've travelled from London to see him. '*London?*' he says. 'I went there once, but I wouldn't go again. Everyone gets knifed in London don't they?' Well, not *everyone*, Tony. I've miraculously managed to avoid being knifed so far ...

'You won't catch me going to London. I'm going to Memphis next year though. That's where Elvis is from, did you know that?' Yes, I'd heard a rumour about that. Do you always dress like this, Tony? He chortles merrily at the very idea. 'Oh nooooo, only when I'm *performing*.'

Ah, so will you be giving us a little less conversation tonight? 'No. Well, not here. I'm on up at the Tynwald Inn up the road later. There's a fiftieth-birthday party they've asked me to sing at. You should come and see me. I've got all the moves and I do the voice and everything.' He offers a deeply disturbing 'Howdy, I'm Elvis Presley' in a voice from the coffin that's more Scouse than Tennessee as proof. I swivel round in mock amazement. Hey, did Elvis just come in the pub ...?

*

Early next morning – just as the sun is rising – I sit rather disconsolately on the Seacat out of Douglas (which is much better than the glorified floating bath that brought us over) contemplating an island of dreams.

Christine Collister is right. There *is* something indefinably magical about this place that gets into your bones, and I'm sad to be going. But I came here looking for answers, somewhere with enough discernible roots of its own in the past to offer hope there may still be something tangible to hang on to across the water.

Instead I'd found more questions than answers. I'd found a place stumbling around in its own confusion, trying to make sense of a changing world and fretting about its own role in it. There are no answers to be found here.

I open up Vinty Kneale's book of poetry, and contemplate what life would be like as lord of Barra …

CHAPTER NINE

They'll Never Walk Alone

'I've been dreaming of a time when to be English is not to be baneful
To be standing by the flag not feeling shameful, racist or partial'

"Irish Blood English Heart", Morrissey

A piece of advice: when you walk through a storm, hold your head up high. And don't be afraid of the dark. For at the end of the storm there's a golden sky …

It's easy to stereotype Scousers … so let's get on with it. Parking as near as we can get to Anfield on a match day, Alberta is instantly submerged in a gaggle of kids in hoodies and 'Trust me, I'm from Liverpool' faces, promising – for a small fee – to guard her and not let her out of their sight until the match is over. I glance at a group of tracksuit-clad men with daft mullets gathered in a huddle around one cigarette on a street corner. They look such a cliché that I can only imagine they are perfecting their expressions of 'calm down, calm down'. I look back at the gang of boys pleading 'Your motor'll be safe with us, mister, honest', and I wonder which particular mob will have the wheels off first.

I thank them kindly for their generous offer, but on this occasion I'll pass and walk up towards the ground wondering if I'll ever see Alberta again, while my disappointed would-be guardian angels swarm around a rather flash Rover that has foolishly elected to park behind me.

It's the media's fault, creating all these images of people and places, and when you get there you can't shake them off and ultimately they do seem to blend into their own caricature. I mean, the ones getting up at the crack of dawn laying towels to claim their patch of the beach really *are* Germans. And the Irish I know do tend to like a drink and outrageously play up to their cartoon selves as convivial hosts and storytellers. And here today everyone I see in Liverpool seems to have a mad splash of Seventies hair and be wearing the exact same tracksuit Harry Enfield has immortalised them in.

They've had the preposterous Tory MP Boris Johnson up here to feed on after his leader ordered him north wearing sackcloth and ashes to apologise for accusing them of wallowing in their own sentimentality. Always a delight to see a Tory squirm, of course, but it's impossible to deny Liverpudlians are a more sentimental breed than most.

Sitting in the Kop behind the goal as the Liverpool fans raise their scarves in ritualistic salute and sing "You'll Never Walk Alone" as the players prepare to kick off is an almost religious experience. The emotions aroused before a ball is even kicked go way beyond football. It's not merely voicing support for a bunch of absurdly overpaid players, many of them now from foreign shores and who can't possibly share the fans' passion for the club. Raising my arms and singing '*Walk on with hope in your heart*' with them – and believe me, when you're right in the thick of it, it's impossible not to – it seems you're partaking in a genuinely spiritual expression of community and *pride* in the city that's surely unique among English clubs.

It is one of the few remaining major clubs with its ground right in the heart of grubby urban city life and, despite massive ticket prices to pay for all the imported fancy foreign labour, a shoulder-to-shoulder working-class solidarity prevails. The *Sun's* sales figures in Liverpool are still relatively minimal since the boycott resulting from the rag's unforgivable stories of fans stealing from the dead during those horrific scenes at the Hillsborough disaster when 94 fans were crushed to death in 1989.

There has been much discussion about dumping Anfield and moving into a modern, purpose-built stadium in a more amenable area of the town. It would be a huge mistake. You can almost taste the history as you walk through the Shankly Gates and sense the respect for its own traditions, whether honouring past greats, giving rousing receptions to opposing goalkeepers or indeed, the Kop singing "You'll Never Walk Alone" with a fervour and respect that gives me goose bumps.

Various theories exist as to how and why an old Rodgers and Hammerstein show tune (from *Carousel*), which initially served as a defiant message of hope when it played on Broadway during wartime, became the ultimate football anthem. On a grand tour of the stadium with a Japanese family the following day, the personable guide tells me it dates back to the Gerry and the Pacemakers version of the song, which hit No 1 in the charts in 1963. At the time they had a match announcer who always played the week's Top 10 prior to the players running on to the pitch. He duly played "You'll Never Walk Alone" when it made the top spot and the crowd heartily sang along with

Gerry Marsden, him being a Liverpool lad and all. When the record finished they just kept on singing it ... and they haven't stopped singing it since.

Being at Anfield reinvigorates a favourite long-held theory of mine that football songs are the one true living organic expression of the folk tradition. You can be there watching a dull period of play and suddenly, seemingly without pre-planning or prior signal, the crowd will burst into a chorus of *'Score in a minute, we're gonna score in a minute ...'* and it takes a while to remember the original song was "Guantanamera".

The songs adapted into football anthems seem gloriously random, with some unlikely highbrow reference points like "Land Of Hope And Glory" aka "We Hate Nottingham Forest" and the Welsh hymn "Bread Of Heaven" / "We'll Support You Ever More" to Lennon's "Give Peace A Chance" / "Give Us A Goal" and inexplicable outbursts of humming to the instrumental likes of "The Liquidator" and Tom Hark. Most curious of all is the rallying call *"We love the Albion, we do, we love the Albion we do"* which is based on "We Love the Beatles", a flop single from 1964 by the Vernons Girls, a group formed by workers at the Vernon's Pools company.

Who knows why Bristol Rovers fans first spontaneously broke into Leadbelly's "Goodnight Irene", Sunderland fans chorused "I Can't Help Falling In Love With You", West Ham fans lit up the terraces with "I'm Forever Blowing Bubbles" and Manchester City started singing "Blue Moon"? The one time I think fondly of Manchester United fans is when they occasionally interrupt the morgue-like mood at Old Trafford to give a sensitive rendition of Joy Division's "Love Will Tear Us Apart".

I have visions of every supporters' club electing a secret chorus committee whose job is to come up with a repertoire for each game, with a specific brief to come up with something new each time. At some hidden signal they all burst into the song at appropriate moments, gradually dragging the rest of the crowd into it with them. As with old folk songs, they evolve and change along the way and the originators are long forgotten, unsung heroes.

A lot of it is cruel and bawdy, of course – you can only wonder at Victoria Beckham's feelings when, proudly watching her husband David, there's a loud volley of "Does she take it up the arse?" However, it was hard not to laugh when Ozzy and Sharon Osbourne were intro-duced on the pitch at half time during a Watford match the week after a robbery at their house, to be met with a chorus of 'Where's yer jewellery gone?'

And like football, folk music is deeply ingrained in Liverpool history. Jacqueline McDonald, who ran one of the country's first folk

clubs, the Liverpool Coach House, for 40 years, confirms this. 'We had them all there,' she says. 'Tom Paxton, Ralph Rinzler, Jeannie Robertson, Margaret Barry, Young Tradition, the McPeakes, the Watersons. Willie Russell used to come; Peter Bellamy met his wife Anthea at our club. The week Don Partridge was booked to appear he went to No 1 in the charts with "Rosie", but to his credit he still came and did our club for £8.

'We had no booking policy; people could sing what they liked at our club. We had lots of American guests. Doc Watson came, as did Jean Ritchie; she's still a great friend of mine. Utah Phillips came. He hated England. He didn't like the snobbish culture we had then and probably still have now. He said England had a "shabby gentility ..."'

Originally a teacher, Jacqui was also a member of the Spinners, who ran their own Liverpool folk club. However, she quit them to link up with her friend Bridie as Jacqui and Bridie, a duo that went on to become one of the most popular acts of the early British folk scene. 'It was amazing,' she recalls. 'We didn't have a manager, and the idea of two girls going on the road together on their own was unheard of. At the time in Liverpool women couldn't even get served at the bar. If you tried to get a drink, it was like you'd become invisible. People couldn't believe we were on the road together. This was before motorways; I think they based the route of the M6 on our gigs. People would ask what we did apart from sing, and we'd say, "Oh, we're lorry drivers, we just sing at the end of the journey." '

The early Sixties were, of course, a good time to be associated with Liverpool. The way Jacqui tells it, in its heyday there were 27 folk clubs every week in Liverpool and people would go folk-clubbing around the city, taking in three or four clubs a night. For obvious reasons it was the music capital of the world, and when Jacqui and Bridie arrived for a tour of the States in 1964, just after the Beatles had made their debut there, they were mobbed just because they were from the same city. Not that they ever met the Beatles, though a friend of Jacqui's met Paul McCartney recently, and she reckoned Paul told her 'the lads' used to sneak into their gigs to pick up a few pointers about presentation.

They didn't meet John, Paul, George or Ringo, but they *did* meet the Queen when they appeared at a special Royal Command Performance when Lizzy came to the city in 1971 to open the second Mersey tunnel. Jacqui takes pride in the fact that the Queen complimented them on their choice of material after they'd performed "Back Buchanan Street", an earthy song by Harry and Gordon Dison protesting about changes going on in Liverpool forcing people to move out of the city: *'Don't want to go to Kirkby, don't want to go to*

Speke/ Don't want to go from all I know in Back Buchanan St ...' Bridie died in 1992, but Jacqui still performs, is still involved in folk clubs and still adores Liverpool, though she now lives in Kendal. 'It's boom time again in Liverpool now and it's still a fantastic city with great, great people.'

Mrs Colin and I contemplate a Magical Mystery Tour trip around Liverpool, taking in all the Beatles-related sites, but the thought of being whacked in the face by the cameras of all those Japanese tourists is too painful to contemplate. I take solace in the story told to me by the singer with rock band Sizer Barker of the time he moved into a new flat on the outskirts of Liverpool. On his first morning there after a night on the town, he put on a pair of grubby underpants and opened the front door to collect the milk. He looked up and parked right outside was a coach full of Japanese tourists taking photos of him. Nobody had told him John Lennon once lived there, and he was now officially part of the tourist trail.

From Liverpool, we head for Manchester with a quick stop-off at Salford, famously the home of Laurence Stephen Lowry, the 'matchstick men' depicter of grimy industrial scenes who really didn't deserve to have that appalling "Matchstalk Men And Matchstalk Cats and Dogs" (a No 1 for Brian and Michael in 1978) in his honour. On the other hand he did spend most of his working life as a debt collector, so maybe he did. Lowry was an eccentric who turned down a knighthood from Harold Wilson and left half his estate to a girl (coincidentally also called Lowry) who'd randomly written to him as a 13-year-old asking for advice on how to become an artist.

Less famously, Salford was also the birthplace of Ewan MacColl. Not many people know that. I was nearly excommunicated from the family after a quiz in which I challenged a mass of impeccable documentation insisting that Ewan MacColl was a true Scotsman.

It certainly suited his purposes to let people assume that and, the son of a Stirlingshire iron moulder and militant trade unionist, Ewan was fiercely proud of his Scottish heritage. But the fact is that MacColl was born in a two-up-two-down in Salford in 1914, and originally answered to the name Jimmy Miller. It was here he left school at 14, became involved in the Workers' Theatre Movement and the Young Communist League, sang on the streets, became a builder's labourer and, as the Depression bit deep, became a prominent figure in the mass demonstrations and marches by the unemployed which originated in Salford in the early Thirties.

His satirical sketches and agit-prop productions with Red Megaphones – a group of unemployed teenagers – documented, among other things, the decline of the Lancashire cotton industry.

After he married Joan Littlewood in 1934, they set up the experimental Theatre of Action and had many provocative theatrical adventures together – in 1939 their 'Living Newspaper' production of *Last Edition* caused such a rumpus that Jimmy and Joan were arrested and bound over to keep the peace.

Reconvening his theatrical work after the war, Jimmy Miller's reputation was big enough for George Bernard Shaw to describe him as 'the best playwright in Britain – apart from myself, of course'. Inspired by the political Lallans poets like Hugh McDiarmid who wrote in the dialect of the Scottish lowlands, he changed his name from Jimmy Miller to Ewan MacColl in 1953. But the relationship with Joan Littlewood foundered and he went on to marry a dancer, Jean Newlove, with whom he had two children, Hamish and the magical, sadly missed Kirsty. Now based in London, he turned his attention to traditional song ... with seismic results.

Ewan MacColl contended that British folk song had been misrepresented by collectors prettifying the music and polishing its rough edges, thus eradicating proper social context and presenting a mythical idea of prissy respectability. He described the images of folk music resulting from this disservice as 'a nebulous grouping of merry Arcadians, coy rustics prancing perpetually round village maypoles and flirting archly with each other'. It suited British society, he said, to foster such false images, as damning as they were to the true heart and soul of the music: 'To have confused "folk" with the great army of rural cottagers driven into the Bastilles and factories by successive Poor Law acts, with the half-starved Irish navvies building the first railroads, or with the evicted Highland crofters, would have been unthinkable.'

Small wonder, he said, that people had rejected such a sanitised version of folk music and turned instead to music hall and other genres. So he duly set about reclaiming folk music. Drawing parallels between British folk songs of struggle, human emotions and the working life with American blues, he set up the Ballads and Blues club which settled successfully at the Princess Louise in London's High Holborn.

Things then moved fast. MacColl split with Jean Newlove and formed a musical and personal relationship with the North American singer and banjo player Peggy Seeger that was to last for the rest of his life. The skiffle boom came and went, leaving behind a nation of burgeoning young musicians who'd had a taste of American folk music without knowing quite what to do with it. Ewan MacColl was only too happy to tell them.

Ballads and Blues – later to become the Singers Club – had many highly respected residents, including famous American collector Alan Lomax, the great Irish uillean piper Seamus Ennis, Bert Lloyd, Ralph

Rinzler and Isla Cameron. It also pursued a musical policy so contro-
versial that it still inspires debate 45 years later. The club allowed
artists to sing or play music only of their own heritage, a stance Peggy
Seeger says was taken after discussions with residents and an audience
committee, following a particularly gruesome Cockney version of
Leadbelly's "Rock Island Line". It was so bad, she said, that the audi-
ence was laughing at the hapless young singer, and they felt something
had to be done to discourage it.

Whatever else, it concentrated the British folk revivalists' minds
away from slavishly copying the American songs gaining currency
from the likes of the Weavers and the Kingston Trio, and triggered a
flurry of research into the roots of the English tradition. Another
Ballads and Blues dictum apparently stemming from the audience
committee was that resident singers shouldn't perform the same tradi-
tional song more than once every three months, ensuring a frenzied
turnover of new material. Such rigid rules have helped cement Ewan
MacColl's dictatorial reputation, but there's no doubt the strong stance
empowered British folk song enormously, while unemployed ex-skiffle
group members rapidly involved themselves in a network of folk clubs
all over the country.

MacColl was a man you didn't mess with. I only met him a couple
of times and he scared me witless. He didn't suffer fools gladly, was
uncompromising in his stringent views about politics and the purity of
folk song, and was one of those who felt betrayed by Dylan's decision
to go electric.

But his influence was profound and his output was phenomenal. He
remained as angry in his dotage as he was in his youth, and even as his
health failed he continued to write vitriolic songs on topical matters,
more often than not involving Margaret Thatcher. His "Radio
Ballads", compiled with Peggy Seeger and Charles Parker, were revo-
lutionary, mixing his own wonderful songs with traditional material
and recordings of real people to tell the true stories of working life.
The first, "The Ballad Of John Axon", is a chilling depiction of the
February 1957 death of a railwayman who was driving a train from
Buxton to Edgeley when the automatic steam brake pipe fractured,
filling his cab with steam.

John Axon told his firemen to jump clear but clung on to the side of
his cab to warn signalmen along the line of the runaway train, saving
the lives of a trainload of children aboard and earning him a post-
humous George Cross for bravery. The 'narrative documentary'
produced by MacColl, Seeger and Parker daringly broke with the
usual BBC tradition of using clipped Home Counties accents and
trained actors on its programmes; this was a story told through the

music of MacColl and the mouths of Axon's friends, work colleagues and his widow.

It didn't simply explain what happened; it conveyed the attitude of railwaymen to their jobs, the state of the industry and the working conditions, as well as colourful details about their lifestyles and the character and personality of John Axon, with whom MacColl shared a love of rambling. 'A technique and subject got married,' said the *Observer* the following week, 'and nothing in radio kaleidoscopy or whatever you like to call it will ever be the same again.'

There was disquiet at the Beeb over such a radical initiative that flew in the face of normal BBC policy, but the trio managed to put together seven more "Radio Ballads" over the next few years, which took a similarly insightful look at different aspects of British life: the fishing industry in "Singing The Fishing", the building of the M1 ("Song Of A Road"), coal mining ("The Big Hewer"), boxing ("The Fight Game"), gipsies ("The Travelling People"), polio ("The Body Blow") and teenagers ("On The Edge").

Still deeply emotional and hard-hitting, the "Radio Ballads" stand now as incomparable social documents of the period, fulfilling MacColl's avowed aim of restoring folk music to the people as a living tradition fully interacting with everyday lives. It also inspired him to write a magnificent series of songs blending that tradition into working life so convincingly many of them formed a staple part of the burgeoning folk club movement … and have remained so ever since. A quick burst of "Shoals Of Herring" from "Singing The Fishing" or "Manchester Rambler" ("The Ballad Of John Axon") or "30 Foot Trailer" ("The Travelling People") and any self-respecting audience will burst into a chorus to raise the roof. And there were plenty more where those came from …

Written by Ewan in a couple of hours and taught to Peggy Seeger over the phone when she needed a big song at short notice to close the first act of a play in which she was appearing in California, "The First Time Ever I Saw Your Face" became a multi-million seller for Roberta Flack and topped the US charts for six weeks after being featured in the Clint Eastwood movie, *Play Misty for Me*. Kirsty MacColl, who had an uneasy relationship with her father and often fell foul of his dogmatic views, told me once that the happiest time she could remember with him was when Elvis Presley's version of "The First Time Ever I Saw Your Face" came on the radio, and they both fell about laughing because they thought it was so bad.

But here we are wandering through Salford, and there's only one MacColl song to be be sung. It's the one that the Pogues took into the charts in 1985; the one that raises the roof when you get to that chorus

made in heaven. The one Ewan wrote about his upbringing in Salford ... '*I met my love by the gasworks wall/Dreamed a dream by the old canal/Kissed a girl by the factory wall/Dirty old town ... dirty old town.*'

As we leave Salford, we play "The Joy Of Living", one of the last songs that Ewan ever wrote, which effectively served as his own epitaph:

> *Scatter my dust and ashes, feed me to the wind*
> *So that I may be part of all you, the air you are breathing ...*
> *I'll be riding the gentle breeze as it blows through your hair*
> *Reminding you how we shared the joy of living.*'

See, that's the way to come up with the perfect funeral song – write your own.

I haven't had much to do with Manchester before – and I am proud to say I'm one of a rare breed in England who's never *ever* seen an episode of *Coronation Street* – and the vibrancy of the city comes as a bit of a shock. There's a confident swagger about it that belies its history as cotton capital and fulcrum of the Industrial Revolution. Elements of Victorian grime suggest it may have been the template for all those 'It's grim oop north' jibes, and there is a hint of rain in the air to confirm its legend as a city permanently waterlogged; but Manchester seems like a place on the move which knows exactly where it's heading.

It's also a haven of multi-culturalism, underlined by a visit during the Chinese New Year celebrations. Manchester has the biggest Chinese population in the country outside of London, and the first true Imperial Chinese Archway in Europe was built here. So the Chinese New Year celebrations are a big deal and the streets around Albert Square are packed. The kids have already been out in force around the city giving little displays and there's an air of real anticipation as traders try to flog balloons, streamers, and even miniature Welsh flags to the crowds (the latter on the thin pretext that the flag has a dragon on it, and the Welsh are therefore honorary Chinese).

But the Chinese seem to have more in common with the Irish, at least in their attitude to timekeeping, as we wait and wait and wait for the action to start. It's a pleasingly varied crowd that suggests, superficially at least, that the Mancunians have fully embraced the colourful culture that the Chinese have brought since they started coming here in serious numbers in the Fifties ... or maybe they just want to buy a Welsh flag.

Eventually we hear the booming clash of drums and cymbals along

Princess St and the long, swirling, glittering red and yellow dragon held aloft on sticks comes dancing along the road to an incessant soundtrack of drums and firecrackers. It's spectacular ... but brief. The dragon comes, the dragon goes and that's about it. But fearful of being short-changed or missing something, we join the throng following the dragon into Chinatown and suddenly it all gets a lot hairier as the crush behind sends us lurching into various crush barriers that have been seemingly randomly placed as the road narrows on the lead-in to the Ching Dynasty Arch.

It's getting serious now as people start to panic and try to fight their way back through the oncoming crowd. Some are fainting, others find themselves wedged against the barriers, and it all gets scary. There are stewards around but, in the normal way of stewards, they seem oblivious to anything untoward and assume the shouts of alarm are healthy excitement.

Happily there's no disaster: nobody is trampled underfoot, nobody is crushed, nobody implodes. The crowds start to thin and we escape into the square to watch a series of brightly clad performers giving enthusiastically received displays of Chinese singing and dancing. There are the usual barrage of stalls selling tat, candyfloss and Welsh flags, and further exploration reveals some interesting back-street shops. In one I find a Chinese newspaper that opens from back to front. This seems eminently sensible, given that most people are right-handed and gravitate to the back first, and the natural inclination is to turn the pages from left to right rather than the other way around.

Working at the BBC once in the dreaded black void known as Special Projects, with the brief to come up with a startlingly original new magazine idea, I had proudly presented this very notion of a publication that you opened 'backwards'. 'It'll cause a sensation!' I said, a tad naively. 'It'll cause us to go bankrupt,' said the man in the grey suit and the token flashy tie. Oddly enough, I didn't have a long career at the BBC.

Meanwhile, a mini-dragon continues its tour of Chinatown, weaving in and out of the small restaurants to vigorous applause and bidding goodbye to the year of the sheep ... and a sponsorship deal with West Union Money Transfer.

But we can't stay here all day chasing the dragon. Full of the joys of multi-culturalism, I meet with another Manchester resident, singer Glen Latouche. Glen is a reggae singer: his parents came to England from Jamaica in the Sixties during the post-*Windrush* influx and moved to Huddersfield, not so far away from here in west Yorkshire.

The way Glen tells it, this turned out to be a surprisingly idyllic

upbringing, relatively free of racial tension, though there weren't many black faces around. 'It was nice,' Glen tells me. 'Everyone got on well, and there was a lovely country vibe about the place. The white people we lived with were great; I had no problems going through school. We were treated with respect and I learned to appreciate white people; my mother and father raised me to appreciate people of any culture, any colour. They taught me not to judge people by the colour of their skin, but by their heart and character.'

His musical upbringing revolved around his dad's collection of classic reggae: Dennis Brown, Gregory Isaacs, Winston Groovy and many others. With various musical brothers, sisters and cousins, Glen was inspired to sing amid dreams of fronting Huddersfield's answer to the Jackson 5. When he moved to Manchester and started gigging seriously, his repertoire was entirely reggae-driven and he knew nothing of English music.

Then his mate, drummer Alton Zebby, saw an advertisement for a folk group looking for a reggae drummer and was intrigued. He applied, and the next time Glen saw him, Alton was drumming with Edward II and the Red Hot Polkas. It wasn't long before they needed a singer, too, and in 1990 Glen Latouche found himself fronting the first band fusing the two apparently alien traditions of Jamaican reggae and English traditional dance music.

'It was a culture shock, man,' laughs Glen, 'I didn't know nothin' about folk music. And then suddenly I was in this band and we were playing somewhere like South Petherton and it was like, everything was *different*. It was like going back in time. The scenery wouldn't have changed much over the years, and the whole spirit in these places was completely different to what you get in cities. I grew up in Huddersfield, which is a country area, but it's not *rural*. Going to South Petherton I felt like an alien.'

King Edward II had grown out of informal pub sessions in Cheltenham playing English dance music. Offered a one-off gig, they drew inspiration from nearby Berkeley Castle, where Edward II, 'the gay blade' and the first Prince of Wales, was killed in 1327 after being deposed and held captive by his own fiendish wife, Isabella.

In a moment of genius they named themselves King Edward II and the Red Hot Polkas. Naturally it stuck and while in due course it was shortened to Edward II and, ultimately, E2, the band always had a good line in album titles which reflected their penchant for English dance music. There was *Let's Polkasteady* in 1987 and *Two Step to Heaven* in 1989. As titles go, they're not quite up to the first Oyster Band album *Rock'n'Roll: The Early Years (1800–1850)*, but they're not bad.

English dance music had been enjoying a formidable renaissance, in no small part due to the pioneering work of another Cotswold outfit, the Old Swan Band, who nailed their specifically English colours to the mast by titling their debut album *No Reels* in defiance of the Celtic music boom sweeping England in the Seventies. There were others, and Flowers and Frolics, New Victory Band and Cock and Bull were also influential, but Edward II took it all into new territory when it decided to embrace the West Indian culture that had been arriving in force since the Fifties. The prime mover appears to have been the band's late bass player, John Gill. 'He'd listened to a lot of reggae and he basically just wanted to see what could be done by fusing these Studio One bass lines with folk tunes,' says Glen Latouche. 'The whole thing evolved out of a jam.'

It was a successful fusion. Glen stayed with E2 for nine years, and eventually saw nothing but logic in mixing the different cultures. The band toured the world and represented the British Council at concerts in India, Sri Lanka, Pakistan and Brazil, and Glen feels they may have destroyed a few cultural barriers en route. 'We got a few complaints. Some of the folkies moaned there was too much bass or drums and some of the hardcore reggae people asked what the hell we were doing playing with those twiddling melodeons and those violin things, but on the whole people liked it. In the end I didn't see anything strange in it at all. See, reggae is a very simple music; it's all about feel. It's not what you do, it's the way that you do it.'

Glen was even prevailed on to sing the old-school chestnut "Dashing Away With The Smoothing Iron" reggae-style with the band, which briefly threatened to take them into the charts. However, he drew the line at the suggestion that they all dress up in morris dance costumes for an album sleeve: 'You'd have to get me *very* drunk to do that ...' Now Glen has a new reggae band with another ex-E2 band member, bassist T Carthy, but doesn't rule out the idea of exploring English traditional music again. But when we talk some more about Englishness and multi-culturalism, he's rather less convinced about our supposedly enlightened nation of racially harmonious living.

He says racism is alive and well out-of-order in Manchester – and, indeed, most English cities. 'There's a lot of stuff going on with Muslims, of course, and racism is still there, I still feel it. It's not like you get people calling you the N-word in your face, but it's there in an underground way. He who feels it, knows it. It's something we have to deal with.

'Actions speak louder than words. It makes me angry, yes, but I'm not gonna go around hating the rest of the white population because of it, that would be wrong.'

Then he starts singing Bob Marley at me. The song is "War":

*'Until the philosophy which hold one race superior and another inferior
Is finally and permanently discredited and abandoned
Everything is war – me say war
Until there no longer first class and second class citizens of any nation
Until the colour of a man's skin is of no more significance than the
 colour of his eyes
Me say war …'*

I'm consequently feeling slightly depressed as we plunge deeper into Lancashire. A few weeks after the Chinese New Year celebrations in Manchester, at least 21 Chinese people are drowned picking cockles in the infamous tides up the coast at Morecambe Bay. Awful stories emerge of asylum seekers and illegal immigrants living in hideous conditions, and you wonder what kind of civilisation this really is.

But I watch 17-year-old Amir Khan fight for Olympic gold in a back-street pub, and cheer up a bit. Swathed in a Union Jack, Amir's exuberant Pakistani dad is jabbering away about pride and heart like a benevolent Don King (if you can imagine such a thing). And Bolton, Amir's home town, is thrilled by his exploits in Athens. It seems there is no whiff of racism or prejudice when the local lad makes good and is knocking seven bells out of Johnny Foreigner.

A small group of us, all white, gather round the tiny telly in the corner as the teenager lays into Mario Kindelan, the Cuban champion. 'C'mon Amir, my son,' we urge as one, but it's soon obvious the wily old Cuban has too much for him. We groan as the Cuban notches up the points, cheer the Bolton boy's successes and between rounds chat intimately about Our Lad's plucky English heart and never-say-die spirit. At the end, when Amir has to settle for the silver medal, we raise our glasses to him and talk some more about how he's done the country proud and what a great future he's got. Not once does anyone mention his colour, race, upbringing or Asian heritage.

This feels exactly as it should be. Maybe next century Amir Khan will be remembered as one of England's greatest ever boxers, bhangra music will be as much a part of English traditional music as Harry Cox and Bob Cann, and the Prime Minister will be a Mr Patel. Bring it on.

Yet a cloud descends again as we head into Burnley. I'd long entertained romantic notions about Burnley, mainly due to a distant admiration for their football team of the Jimmy McIlroy/Ray Pointer/Adam Blacklaw/Jimmy Adamson era and their epic clashes with Tottenham. I'd pictured Burnley as a quaint northern mill town, and it may have been back then, but today it looks like any other

town, with its anonymous pedestrian shopping centre and anodyne chain stores.

Over a tasteless coffee in a charmless cafe, I scan the miserable expressions on the faces of the other customers and wonder: who's to blame? Is it that woman in the corner whose bags of shopping keep falling over and tripping up the waitress in the micro skirt? Is it the group of lads in the corner leering at the waitress in the micro skirt and making lewd comments in loud stage whispers that everyone can hear? Is it the two middle-aged blokes in overalls perusing the racing pages? Is it even, heaven forbid, the waitress?

There's no way of knowing who, but *somebody* in this town voted for the British National Party. In 2003 the BNP had eight seats on the local council, making it the official opposition to Labour. They'd come in brandishing a touchy-feely new image, fighting on law and order and local issues, fervently denying racism and feeding on fears about immigration and widespread disillusionment with the other parties.

But one BNP councillor, Maureen Stowe, subsequently quit to join an anti-fascist group, claiming that she, too, had been duped by the BNP's clean new image. 'I could never understand why all those people were calling the BNP fascists,' she said. 'Well, I do now.' In 2004, the BNP's council representation in Burnley had slipped to six seats. Clearly that's still six seats too many, and it's hard to feel at ease sipping your coffee in a crap cafe in a town that still represents such a stronghold for racists.

I consult Boff, who's an anarchist so he must know. Boff plays guitar with musical terrorists Chumbawamba (the ones who drenched John Prescott at the 1998 Brit Awards) and has lived the ultimate dream: he's seen his beloved Burnley FC play at Turf Moor while the crowd sang his song. Well, it's not *just* his song, but of all the things Chumbawamba achieved with the rabble-rousing 1997 hit "Tubthumping" (changing the words to make a political point on the *David Letterman Show*, going to No 1 across the world, smuggling striking Liverpool dockers into the Brit Awards), Boff's proudest moment was hearing the Burnley fans sing the song: "*I get knocked down, but I get up again ...*" They made a lot of money out of it too, of course ... which always makes people assume they sold out and now live in mansions. 'Some cynics say the easiest way of curing an anarchist is to offer him lots of money,' says Boff. 'Well, it didn't work with us. We were offered a lot of silly money and decided to take it ... and give it to someone who needed it more.'

Yet Boff is from Burnley, and frankly admits he used to run with the racists. 'I was sexist, racist and homophobic!' he says with disarming

honesty. So what changed him? Music. He heard Tom Robinson singing "Glad To Be Gay" and it was such a good song it made him think twice. And he thought the Specials were the bee's knees. He loved their song "Racist Friend" that said if you had a mate who was a racist, then he shouldn't be a mate any more. It altered his thinking about a lot of things. And they say music doesn't have the power to change anything.

'I realised I liked seeing black bands like Steel Pulse and all-women bands like the Raincoats and the Slits,' he explains. 'It was an alien world that suddenly became a normal world. I went to anti-Nazi carnivals and it was so cool I decided this was the side I wanted to be on. I mean, what was on the other side? Nasty, inward-looking stuff that doesn't do anyone any good, and you end up hating everybody.'

Boff says Burnley became a flashpoint after race riots in 2001, when gangs of whites and Asians clashed in the streets, creating confusion and fear in the community. The telling point about the BNP councillors elected was that they were voted in by the smarter, predominantly white areas of the town. 'Half of them are retired and they've never seen a black or Asian person in their lives, but they saw the riots and it scared them. They read the BNP leaflets explicitly talking about immigration and saying that Burnley is a flashpoint, and that scared them even more.'

But sod this for a game of soldiers, let's go and see some coconut dancers. The photos I'd seen of the Britannia Coconut Dancers leaping around the town of Bacup had appeared positively surreal. A bunch of blokes with blacked-up faces wearing turbans, knee breeches, white stockings, clogs, coconuts strapped to their knees and what appear to be red and white ra-ra skirts waving garlands around does look more like a dare than a tradition. Small wonder they are affectionately known locally as the Nutters.

First, though, we have to find Bacup. It's not easy. Lancashire signposting is maverick at the best of times, but there seems to be a deliberate conspiracy to hide Bacup from prying eyes. Mrs Colin finds it on the map, we scrupulously chart the route, estimate it should take about 20 minutes, follow the right roads, see the signs and ... it's *just not there*. We come in from different angles, use alternative starting points, buy a new map to see if they've moved it since it was printed in 1978, but there's no sign of it.

And everyone we ask is suspiciously evasive. ''E wants to know where Bacup is,' they whisper conspiratorially to one another, before returning with vacant expressions. 'Not rightly sure, but tek the low road, t'ward Rawtenstall, tek a right up the hill, go left when you see

the sign to Ramsbottom, down by Rossendale, drive into the field, swim across the pond, go down to the big old house in the valley, knock three times and ask for Alice. Can't miss it.'

There are times, oh there are times, when the search for Bacup hangs by a thread, but if they are so keen we don't find it, then they must be trying to hide something special, right? So in the true spirit of Vasco da Gama we persist ... and persist ... and persist. Rations are almost exhausted, we're running on empty and we're just about to light the emergency flares when we try a road we've been up five times already in the last two hours and, like Camelot, Bacup appears through the mist.

Initially, there doesn't appear to be much to hide. It's an unremarkable market town quietly going about its business on a drizzly Saturday lunchtime. The usual stuff: women falling out of the pubs drunk as skunks while the men gossip on street corners and the sound of Chumbawamba singing the 'pissing the night away' line from "Tubthumping" drifts amiably through the doors of a bakery that only has one Cornish pasty and one custard pie left.

Then we hear the distant strains of a brass band ... and see a guy with his face blacked up, running and waving some sort of whip. In *that* costume: the one with the black top, turban, frilly red and white skirt, breeches, stockings and clogs. There's waving and peering and gesticulating and beckoning, and a crowd comes tumbling down the hill. As the advance Nutter takes his life in his hands and dives into the middle of the road to hold up the traffic, the rest of his chums wave their garlanded hula-hoops above their heads and rattle their coconuts between their legs. Oo-er, missus.

No matter how many pictures you've seen, the sight of them still stops you in your tracks and makes you laugh. There is no danger of them getting mown down in the traffic as the drivers stop to let them pass, mouths hanging open, wondering if the Martians have landed.

The Bacup Nutters perform a display in the town square, and it's wonderful. The dance is essentially morris, but the Stacksteads Silver Band and those bizarre costumes give it an entirely different slant. Kids dance around them in imitation, mums swing babes in arms in time to the music and a couple of Hell's Angels even stop by with eyes on stalks to give them a warm round of applause. Everyone loves a Nutter.

Led by the Whiffler (the man with the whip), they've been up since the crack of dawn, dancing from 9am at their spiritual home, the Traveller's Rest in the village of Britannia out of town on the Rochdale road. They perambulate their way into Bacup, arriving around lunchtime, dance around for a bit, have a couple of pints in a selection of pubs, and then wend their way out of town again to wind up in Stacksteads. Some of the dancers are fixtures. 'See old Dick there?'

asks the man in the turban and frilly skirt, pointing to a chap with a beard leaping higher and more enthusiastically than anyone else. 'This is his 48th year. Legend, he is. *Legend.*'

Old Dick 'Legend' Shufflebottom shakes my hand warmly when I attempt to buy him a drink at the George and Dragon, but politely declines. He didn't lead this mob for nearly half a century without learning how to pace himself, and he looks happy enough with the way things are going. 'Good turn-out,' he reflects, as well-wishers gather round to shake his hand and offer him drinks.

We open the inevitable debate about the dance's origins. Various theories are proffered. 'Right here in this exact same pub in this exact same spot exactly one year ago, I met a woman who told me her great-great-grandad worked in the tin mines in Cornwall and it was him who brought the dance here,' says a dancer in a blacked-up face and turban. 'At least, I *think* that's what she said; I were too pissed to remember.'

'I thought it came here from Morocco,' says another dancer. Other blacked-up faces in turbans tell the story that this morris side was started in 1903 by a quarryman called James Mawdsley, who'd previously danced with the defunct Tunstead Nutters and founded this lot when he moved to Britannia and roped in members of the working men's club. So how do you get to be a Nutter? 'Oh, *now* you're asking,' says a bloke in, guess what, a blacked-up face and a turban. 'Traditionally, there's very strict rules about that. You have to live in Bacup and you have to be married with grown-up children. The average age of the dancers is about 50.'

I'm thinking of summoning Peter Tatchell to picket next year's event over what sounds like a homophobic recruitment policy, but the Nutter emphasised the word 'traditionally', and Mrs Colin points out that there's at least ten blokes here in blacked-up faces, turbans, frilly skirts, knickerbockers, stockings and clogs, and by the law of averages at least *one* of them must be gay.

I talk to the Quiet One in the side, the George Harrison of coconut-banging Nutters, and ask him how long he's been doing it. 'Only a couple of years,' he confesses. 'I didn't think I'd be able to make it; I was supposed to be working. Had to take a sickie.' How did you get involved? 'I answered an ad in the paper.' This comes as a bit of a shock. There are none of your exclusive family rite of passage membership deals here, then. 'No, I think a few of the dancers had dropped out and they were a bit short, so they put an ad in and I thought it'd be a laugh.'

Is it a laugh? 'Oh yeah, great fun. People love it. I think the locals are really proud of it. Bloody tiring, mind.' What did your mates say when you said you'd become a Nutter? 'Nothing. I never told them.'

Ah. And it's not as if anybody will recognise you. 'No, but I don't live in Bacup.' You don't live in Bacup? Are you married? 'Nope.' Got any grown-up children? 'Nope.'

You may take it the gay lobby can sleep a little more easily in their beds tonight.

'If you want to talk some more,' says another bloke in a blacked-up face and turban, 'we'll be back in town at the Crown around nine 'o' clock to drink ourselves blotto. You're welcome to join us. Not that we'll be making much sense …'

It's a tempting offer, but that's enough Nutters for one day. Besides, it's Saturday afternoon and I fancy a bit of footie. In one of the several dozen circuits of the Calder Valley I'd seen a sign to Darwen. This was surprisingly exciting news. My second son Christy isn't too hot on coconut dancers or the Chinese New Year or the rise and fall of Lancashire cotton mills or the life and works of Ewan MacColl … but he *is* the self-appointed world's leading expert on football trivia. Darwen, he'd informed me, was the oldest football team in England. 'Oh,' I'd said at the time without too much enthusiasm, but now I was overwhelmed by a sudden compulsion to view this living history. So off we go: Division Two of the North West Counties Football League – Darwen v. Great Harwood Town.

Aye, aye, I think, as we close in on Darwen and see 'PARK AND RIDE' signs to the football, this club is bigger than I thought. Then we hit the queues with the fans hanging out of the car windows waving flags and chanting obscenities. Wow, Darwen really *is* big news in this part of the world.

And then I see the huge floodlights, the enormous stand and the sign reading EWOOD PARK, and I realise that for the past 45 minutes I have been queueing to see the Premiership team Blackburn Rovers. A swift consultation with the map, an ugly three-point turn enduring a fusillade of hooting and we're on our way to Darwen with me again contemplating demanding a refund on Mrs Colin's map-reading course.

The town seems nice enough, but nobody has a clue where the foot-ball ground is. 'I didn't even know bloody Darwen had a bloody football team.' Oh yes, it's the oldest football team in the country, mate, surprised you didn't know that, you living here and all. '*Gerrawaywiya!* Oldest bloody football team in the bloody country, gerraway!'

After copious vain enquiries, I find a small sweet shop with a poster giving a list of forthcoming Darwen FC matches. They happen to be last season's matches, but no matter, it has the address of the stadium – the Anchor Ground in Anchor Road, should you ever desire to visit. Eventually we locate it; a tumbledown shack of a ground, guarded by

a man on the gate who's shocked to discover a couple of people offering him real English pounds in exchange for admission to view 22 blokes hoofing a ball around inside.

'It's already started,' he says. 'Any score?' 'Don't think so. Didn't hear any cheers. Not that there's been much to cheer about with this shower lately.'

Instantly I like the place. It's a shabby ground and a raggedy pitch, with a bunch of guys of limited technical ability kicking great lumps out of one another. Football played the wrong way for the right reasons. Honest, passionate and rubbish; I'm hooked. I'm also pathologically incapable of being a neutral at any game. We haven't been inside the ground for ten minutes before I'm roaring on the red-and-white army of Darwen, standing shoulder-to-shoulder with a huge, foul-mouthed bald guy who is berating the roly-poly ref.

The game is a thriller: comedy misses at both ends, a flurry of yellow cards, a couple of strops. And then the ref gives Great Harwood a penalty. We have no idea why. The guy is going nowhere. Our boy doesn't touch him. He's nowhere near him, and the guy goes down like a sack of spuds. When the ref whistles, we think he's gonna book the cheating little oik for diving; we can't believe he's pointing to the spot.

Me and my new best mate the giant are beside ourselves with rage and practically on the pitch. Great Harwood score from the penalty and we yell more abuse at the ref. We carry on at half time, when we join our manager (whoever he may be) berating the ref for such a travesty of a decision. 'Enough!' he shouts back at us, and scarpers into the dressing room. Coward.

We continue the barrage throughout the second half, and at one point the veins start sticking out of my new best mate's head and I'm worried he's going to have a seizure. The match fizzles out, but it's been a cracking afternoon, fully vindicating my controversial decision (well, Mrs Colin thought it controversial) to spend it in the company of the oldest football team in England.

Except that it transpires Darwen *isn't* the oldest. That honour apparently belongs to Sheffield FC, formed in 1857. Then there was Notts County in 1862, Nottingham Forest in 1865 and Chesterfield in 1866. Darwen didn't come into the equation until 1875, but they did make quite an impact when they arrived. They were the first English club to sign any foreign players (Scotsmen Fergus Suter and James Love from Partick Thistle), as well as the first professional players – or, at least, the first to find money mysteriously appear in their boots at the end of a match.

Darwen also caused a sensation in the fourth round of the 1878–9 FA Cup, showing terrific bouncebackability to draw 5-5 against the

Old Etonians after trailing 5-1 with 15 minutes left. Old Etonians, the southern softies, refused to play extra time but had a whip round to raise the £175 for Darwen's fare to London for the replay. That also ended in a draw at 2-2 and the tie went to a second replay, which the Old Etonians finally won 6-2.

The football league was already two years old when Darwen were elected to the newly formed Second Division in 1892, winning promotion in their first season in a play-off match with Notts County. At one point they even tonked the big girls' blouses of Walsall 12-0. The scoreline remains a record defeat for Walsall, although the way they are heading at time of writing under the management of the hapless Paul Merson, it has every chance of being beaten very soon.

Darwen's glory years didn't last long, sadly, and they lost their place in the league after finishing bottom of the Second Division in 1899. The following season they moved to their current palatial shed at the Anchor and joined the Lancashire League. And that's effectively all anyone can possibly need to know in one lifetime about Darwen FC.

I'm asking my new best mate the Giant when the next match is and wondering if we can adjust the schedule to accommodate a Darwen away encounter, but Mrs Colin is already dragging me away. She's saying something about witches ...

CHAPTER TEN

Witches, Sedan Chairs, Chavs and Lakeland

'All the world over each nation's the same
They've simply no notion of playing the game
They argue with umpires, they cheer when they've won
They practise beforehand, which spoils all the fun ...
The English, the English, the English are best
I wouldn't give tuppence for all of the rest'

"The English", Flanders and Swann

Pity Alice Nutter. Pity Mother Demdike. Pity Old Chattox, and all.

It all started round here somewhere, in north Lancashire. That's it, there's Colne Cemetery, so it's right round about *here*. Young Alizon Demdike was on her way to Trawden Forest to go begging, as per usual, when she bumped into a pedlar, John Law of Halifax. Alizon asked if she could buy some pins from him, but suspecting the girl would steal his bag and run off with it, Law refused. Alizon cursed him and marched off. She looked back just in time to see John Law struck down by a stroke. He was carried to a nearby pub, paralysed, his speech impaired, but said he'd been 'pricked by knives, elsons and sickles' ... and he blamed the curse of the beggar Alizon Demdike.

It triggered perhaps the most notorious witchcraft case in British history. This was March 1612 when families living around Pendle Hill were ravaged by poverty. They were deeply superstitious times. Fairies, elves and goblins were believed to inhabit wells and ponds, unruly children were routinely subjected to exorcisms, and people hung horseshoes and circles of rowan twigs on their doors to defend themselves against the evil spirits they believed roamed freely.

Still firmly Catholic at a time the rest of the country was turning

Protestant, Lancashire was itself considered a renegade, lawless county, and was under close scrutiny from the seat of power. The Earl of Derby described it as 'an unbridled and bad handful of England', and since two of those implicated in the gunpowder plot to blow up the Houses of Parliament seven years earlier had admitted the plan had been hatched in Lancashire, there was widespread paranoia that here lay the road to revolution.

In 1612, King James I ordered justices of the peace in Lancashire to prosecute anyone who didn't take Protestant communion in church, and was so obsessed by witchcraft that he wrote a book, *Daemonology*, encouraging magistrates to thwart the black magic menace with the death penalty as a deterrent. One of those who eagerly bought into the King's fear-mongering was Roger Nowell, prosecutor at Lancaster Assizes, who sought favour with the King in his dogged determination to rid the north west of witches.

John Law just about lived long enough to give damning evidence against Alizon Demdike about their encounter on the road to Trawden, and under intense questioning she came to believe that, yes, it *was* her curse that had killed him. Confused, terrified and not the brightest fir tree in the forest, she confessed to witchcraft.

For Nowell, Alizon Demdike was merely a ripple in the ocean, and her confession triggered an investigation into her whole dysfunctional family. There was Old Mother Demdike, 80 years old, blind, crippled, half-starved and frankly doolally. Alizon's mother Bessie wasn't much better. Deformed at birth with one eye permanently looking up to the sky and the other looking down to the ground, she'd always been considered mentally deficient. Most damning of all, a strip search revealed she had an extra nipple ... which she used for suckling the Devil. Obviously.

Bessie had no husband, but there were three children; the unfortunate Alizon, the halfwit James and nine-year-old Jenet, all living in horrendous squalor in a converted farmhouse in Newchurch with the deceptively grand name of Malkin Tower. By the time Roger Nowell finished with them they'd all confessed to witchcraft. Nine-year-old Jenet sang like a bird, telling elaborate stories about curses, murders, strange rituals and, the clincher, marks of the Devil on her family's bodies. They also wasted no time at all implicating their feuding neighbours, the Chattox family, who were equally helpless to help themselves. Old Chattox was as crazed, as blind and as old as Mother Demdike after a poverty-stricken life, mumbling constantly to herself without making any sense. Her daughter Elizabeth was a thief and a liar, accusing the Demdike family of every crime known to mankind, while her foul-mouthed sister Anne was considered a psychopath and too terrifying for any of them to talk to.

Roger Nowell must have thought all his birthdays had come at the same time as they eagerly pointed the finger at one another and the magistrate pieced together piles of imaginative evidence suggesting every innocent death that had occurred in the Forest of Pendle over the last fifty years had been due to the witchcraft of either a Demdike or a Chattox. The bizarre series of charges laid against them when the case came to court in Lancaster included desecration of graves, communing with imps, plotting to blow up Lancaster Castle by magic and at least 16 murders.

Quite how Alice Nutter got dragged into it, nobody really knows. The Nutters were well-to-do local landowners living in grandeur at nearby Roughlee Hall. But somewhere among the spew of confessions, accusations and tittle-tattle collected by Roger Nowell, Alice Nutter's name appeared and she, too, found herself charged with witchcraft ... and specifically the murder of one Henry Mitton.

Unlike the others, who wouldn't shut up in the witness box, Alice Nutter pleaded not guilty, but otherwise refused to say a word at her trial. She was duly sentenced to death, along with Bessie, James and Alizon Demdike and Old Chattox. Mother Demdike would surely have joined them had she not cheated her fate by dying already. On August 20, 1612, the motley assortment of 'witches' were marched through the jeering crowds lining the streets of Lancaster, led to the gallows a mile out of town and, in front of a large crowd, hanged by their necks until they were dead.

It's no wonder this place looks so solemn ... but the Pendle Witches Museum is sadly shut. 'Political reasons,' says the bloke at the heritage centre, tapping his nose meaningfully when I ask why that is, before helpfully adding: 'But the potting shed is open.' Apprehensive about what dastardly evils may await in the potting shed, I pass, and instead we grab a leaflet offering the route of a scenic drive for us ghouls to suck in the dank scenes where the grimy drama unfolded: Newchurch, Barley, Pendle Hill, Worston, Chatburn, Newbee, Blacko, Roughlee, Barrowford, Fence, Higham and Padiham. We look around in respectful silence, inspecting the tomb at St Mary's Church, Newchurch where Alice Nutter is supposed to be buried ... but weren't witches' bodies refused burial in consecrated graves? I vaguely wonder what Alice Nutter might have chosen as her funeral song.

We stop off at England's newest city, Preston, where town planners appear to be trying to reinvent it Burnley style, with modern precincts and the exact same shopping centre that's strangling the life out of most of the other town centres in the country. They haven't quite succeeded here, though. Parts of Preston still look straight out of a Hovis ad, with cobbled back streets where you expect to find Tom

Finney trotting around in long shorts doing keepy-ups against the wall with an old leather ball the weight of a bag of cement.

The fast-expanding student population should be Preston's salvation. They may be responsible for sustaining comedy drinks like cider and bacardi breezers, but where there's a student there's usually a pub where you can get Sunday lunch for £3.50, a half-decent band playing somewhere in town and the reckless pursuit of a party. So rock on, Preston, don't you dare be afraid of the dark.

We hit the M6 for Lancaster and a one-way debate about the biggest town in England that's never had a league football team. I think it may be Lancaster, though subsequent heated debate with my son the self-appointed football expert (the one who got it so wrong about Darwen) elicits alternative suggestions of Worcester, Gloucester, Canterbury, Harrogate and, most animatedly, Bath.

We arrive at Lancaster in the middle of its Maritime Festival, which probably isn't the best place to find the answer to the football question, but is a lot of fun anyway. In fact, Lancashire's county town is a splendid city, one of the oldest in the country. Its impressive castle is shrouded by leafy lanes, attractive Georgian buildings, and a plethora of inviting pubs. The quayside, too, looks weirdly dramatic, if a little seedy.

There's plenty of music going on around town, with the sound of shanties being sung at full tilt in the John o'Gaunt, the Three Mariners, Wagon and Horses and the Royal King's Arms. But I slide into the Maritime Museum just in time to catch John Conolly singing "Fiddler's Green":

> '*Dress me up in my oilskins and jumper*
> *No more on the docks I'll be seen*
> *Just tell me old shipmates, I'm taking a trip, mates*
> *And I'll see you someday in Fiddler's Green.*'

The story of the death of an old fisherman, "Fiddler's Green" has an irresistible chorus that *demands* you join in, and has come to be regarded as such a folk classic, many assume it's a traditional song. In fact, Conolly wrote it in 1964, inspired by the fishing families he knew at home in Grimsby. He, Bill Meek and a few others had launched the Grimsby Folk Song Club and were trying to come up with big chorus songs to give the audiences something to sing. This was one of those songs.

'I actually got the story from the *Daily Mirror* in the days when it was a respectable Labour newspaper,' John tells me. 'They had this column, *Old Codgers*, answering readers' queries about everything

under the sun, and there was a letter asking if anybody knew anything about Fiddler's Green, which was supposed to be the sailors' heaven. There was a deluge of replies from sailors and I just thought it was a great subject. So I turned it round from sailors' heaven to include things that sailors love: booze and women!'

Tim Hart and Maddy Prior, later to come to national attention as founders of Steeleye Span, heard John singing it when they were guests at the Grimsby club and they took it around the country, recording it on their vinyl LP *Folk Songs of Olde England*. The song spread like wildfire, and in no time at all became part of the fabric of the folk music movement. When the Dubliners later recorded it, people assumed it must be an Irish traditional song. Mostly they still believe that.

'I always feel I'm being paid a great compliment when people think it's a traditional song because that's what I try to do, I try to write *traditional songs*,' says John Conolly. Ah, I say, but it must be annoying too. All these people singing your song thinking it was conceived in a pub in Cork a couple of centuries ago. Surely a bit of credit wouldn't go amiss ...

'Whenever I'm in Ireland and see a book or a record shop, I'm straight in there looking through the records and songbooks to see if "Fiddler's Green" is in it and if they've given me a credit.' And if they haven't? 'I take a note of the publishers' names and addresses. Not that I ever do anything about it; I just come home and grouch about it.'

John also sings his nostalgic seaside classic, "Punch And Judy Man", and tells me the story of this one, too: 'I wrote that in 1970. I know that, because it was the year I got married. I remember saying to my wife: "I've got a wonderful idea where we could go for our honeymoon. Let's go to Sidmouth Folk Festival. That way we'll have something to do in the evenings!"' They're still together, so it can't have been that bad an idea, and the Sidmouth seaside inspired him to write "Punch And Judy Man" as a honeymoon present ... or maybe an apology.

Lancaster turns out to be a vintage event for the guardians of the English tradition of sea songs. The great Geordie singer Louis Killen is there in decent voice, along with the well-regarded likes of Jim Eldon, Roy Harris, Johnny Collins, Keith Kendrick and, joy of joys, Cyril Tawney.

Now, not many people know this, but Tawney is one of the finest English songwriters of modern times. Now based in Exeter, he's an ex-Navy man, and his songs tell his story. He's now 74 and looks worryingly shaky on his feet, but on stage gently strumming his guitar and embarking on his storytelling in that soft West Country accent, he wields a special kind of magic. Every song sounds like a lovingly crafted classic, giving a very human insight into his former adventures in the

Navy, even if his job as an 'artificer' was more naval entertainments than Jolly Jack Tar. 'I did go to sea for a living, but I'm no sail freak,' he says. 'Don't ask me about knots and splices, or a sailing ship's rigging ...'

He became the only active serviceman with his own BBC TV show, before buying himself out of the Navy in 1959 to base himself in Plymouth and become a leading light in the front line of the folk song revival. He studied traditional songs and wrote a whole host of material that people now assume *is* traditional.

In front of an appreciative audience here in Lancaster, he glides through a series of stories and songs about life at sea. Many of them are hugely familiar from a glut of cover versions ... like "Sally Free And Easy". A highly unusual English blues, Cyril wrote it in 15 minutes, after walking back to his ship through a deserted Portsmouth dockyard one Sunday morning in 1958. He also describes it as a 'phantom song'. He clearly remembers serving on HMS *Murray* at the time, but when he checked into naval records to establish the exact date in order to celebrate the song's 35th birthday, there was no record of the ship ever docking at Portsmouth. Spooky, huh?

And there's "Grey Funnel Line", a masterpiece of melancholia depicting the loneliness of the long-distance sailor, homesick and lovelorn in foreign seas. *'The finest ship that sails the sea/Is still a prison for the likes of me'* he sings, and this frail senior citizen with the small acoustic guitar and the haunted voice just cuts you dead.

My favourite Cyril Tawney song, though, is "Sammy's Bar". It recalls a hole in the wall doubling as a tiny bar at Pieta Creek in Malta, close to where the submarine HMS *Forth* was anchored and where Cyril regularly sang. 'It sold very cheap, very strong white wine and it was very cramped, but the acoustics were marvellous,' he says. The bar has long been demolished and the story, about the last boats leaving Malta, was fictional, but whether in the hands of the mighty Martin Simpson, the outstanding Anglo-Irish band Last Night's Fun or the fine Canadian singer Garnet Rogers, the song paints a uniquely evocative mood of human passions, cleverly blending nostalgia with anticipation. It's one of the great, *great* songs of the last 50 years and I unequivocally state, right here, right now, that I want it played at my funeral.

But that's all fine and dandy; what's really brought us here to Lancaster is the sedan chair racing.

Part of the 'Trafalgar Victory Fair' staged in blazing sunshine behind the Maritime Museum, the sedan championships are the climax of a lively day of events that include a whirlwind re-enactment of the life and death of Admiral Nelson, the 'magnificent temple of the Nile', a *very* strange puppet show, a surfeit of evil-looking nettle wine, and loads and loads of mad costumes.

But the twelfth National Sedan Chair Carrying Championships are for real. On a carefully designed course of straw bales, various duos of strapping and not-so-strapping young men take their place at the starting grid, eyeball their opponents, introduce their chosen fair damsel to her rocky ride, raise the chairs with a confident flourish, and wait for the starter's call.

Their progress after that is variable, depending on their age, fitness and how many beers they had last night ... or, possibly, this lunchtime. By the time they reach my vantage point 30 metres along the course, just before they reach the canal turn and have to run back again, there is already carnage. One dark-haired young maiden is tossed unceremoniously from her carriage as her front runners crumple in an unsightly heap in front of me, and another one cannons into the bales of hay as her outriders spectacularly fail to spot the bend in the course. They sit there dazed and helpless with laughter, while their white-faced passenger shakily steps over them, makes her excuses and leaves. 'It's all right for you to laugh,' one gasping, defeated wreck tells me, 'have *you* ever carried a sedan chair? It's fookin' HEAVY!'

The chancers and fun-runners are rapidly whittled away in the knock-out stages, while the serious guys – clearly identifiable because they nonchalantly stand around at the start pretending they don't give a damn – stick rigidly to their high-carb training diet and suss out the opposition. There is early support for Her Majesty's Press Gang team, but by the time the semi-final comes around, the glamour boy in the pony tail and rippling biceps looks a bit the worse for wear. 'I didn't know we'd have to race again, I only entered so the girls could see my hair!' he moans in spectacularly camp fashion, and though they may have won the best-turned-out team award, HMPG take a resounding beating from a couple of burly lads in army fatigues representing a local taxi firm.

They then go through to take on the reigning champions from Lancaster Castle, but this proves one sedan chair too far for the taxi lads, who make a major tactical error by succumbing to the temptations of a refreshing nettle wine offered by a temptress who many suspect may have been in the employ of Lancaster Castle. While they down their pre-race wine in one, the glowering castle team are fully in the zone, eyes fixed firmly on the haystacks standing between them and glory. Once their charge, Maxine, is aboard, they silently psyche themselves up, while the taxi boys laugh and joke with the fans and wonder if there's any more nettle wine.

So in the end, it's a procession. The taxi lads are plucky losers but they're no match for the big guys from the castle, who bring home the bacon – or, at least, the serene Maxine – and bask in glory afterwards.

Call me a conspiracy theorist, but it doesn't seem like a universally popular win. There's muted applause as the fragrant Maxine takes her place on the victory rostrum, but there are low mutterings too from the rank and file.

'They've been training for this all year,' says a disgruntled loser who had to be pulled out of the Wagon and Horses to take his place on the starting grid, and barely made it to halfway. 'It's not on, is it? They're like … *professionals!*'

I try to grab a word with the victorious castle men, but they're not desperate to talk. I hear you've been training for this all year, I suggest. 'Me? Noooo …' counters the muscular guy a bit too quickly. 'I've had a broken ankle; did it playing rugby. I haven't done any training at all. Didn't even think I'd be able to go in for this today.' He glances at his running partner, already bounding up the hill at a rate of knots. 'Mind you, *he* has …'

So if you're going to visit the lovely Lancaster Castle, lose the official tour guide and check out the garden that says 'PRIVATE' on the gate. Under the cover of moonlight, you'll surely find two hefty rugby types and a woman called Maxine conducting clandestine sedan chair-carrying training sessions in readiness for next year's big event.

And hey, let's be fair to the castle boys, why the hell not? Sedan chair racing has got everything: history, tradition, thrills, spills, athleticism, brute strength, skill in negotiating the canal turn and a bit of eye candy too with the graceful Maxine or, if you prefer, the Press Gang man with the pony tail. It meets one of the two crucial criteria defining sport (shorts and/or a finishing line) and it's more of a spectacle than Graeco-Roman wrestling or bloody equestrianism, so come on, *let's get it in the Olympics.* With the Lancaster Castle team in our corner we might actually win a gold medal.

We're back on the road again into Cumbria, entering the Lake District, and I belatedly try to register my Radio 5 vote for this part of the M6 as the most beautiful stretch of motorway in England. We stop for lunch at a very charming, but desperately overpriced pub overlooking Lake Windermere and populated by tweed jackets and fur stoles, then we wend our way across the lakes.

We finally tumble into Ambleside, the 'anorak capital of the world', according to my guide book. I assume this means the place is full of shops selling vinyl albums and populated by specky collectors zealously hunting for that elusive 1972 Quintessence B-side, but I soon realise the only thing they sell in Ambleside is climbing gear: boots, woolly jumpers, knickerbockers, knee socks and warm coats.

It's scarily full of odd people in huge jumpers and red cheeks walking very fast and talking very loudly with annoying, squeaky

voices. You can't walk down the street without some bumbling hiker whacking you in the mouth with a bagful of bargain anoraks. I am overcome by an uncontrollable urge to invent a killer anorak that escapes from one of the shops to systematically gobble up Ambleside. Coffee shop, coffee shop, I need an *emergency coffee shop* …

We dive into one in the nick of time, just as Madame Cafe Keeper is about to stick a CLOSED sign in the window and I'm on the verge of doing real damage and giving the killer anorak a psychopathic walking stick as its sidekick. Mrs Coffee Shop isn't best pleased to see us. She huffs and puffs before reluctantly agreeing to bring us coffee 'as long as you're quick'. She then stands over us while we drink it, offering us the benefit of her forthright views on the sorry state of Ambleside.

'Business rents have gone through the roof … it's impossible to make a living … such hard work for what? … no rest these days … season is all year round now, not just summer … no time off … nobody can afford to live here any more … except students … bloody students … can't get to sleep at night because of students … drunk in the street … all night … it's not right … in my day, we couldn't afford to go out drinking all night … I know a student who spent three years getting drunk and then got a top job in the council … it's not right … that's what's wrong with Ambleside … students … *students*.'

Yeah, lock 'em up, I say. Shoot the lot of 'em. Feed 'em to the killer anorak and his mate the psychopathic walking stick. She cheers up instantly, and thinks it's a damn good idea.

I want to escape fast from this deranged woman and all the other mad people in Ambleside, so we decide on a death-defying drive across the Wrynose Pass. It's the sort of place I thought you only ever saw Lance Armstrong grappling with up the Alps in the Tour de France. The road is narrow, the climb is steep, the mist is descending fast and the drop on either side is the stuff of nightmares. Naturally, just when you get to the very top of the pass, the one with the hairpin bend and the thought of sliding over the edge making you dizzy, a huge 4x4 hurtles round from the other way, roaring past without even touching the brakes, leaving you clinging to the edge of the road for dear life.

Somewhere along the top, I open my eyes long enough to spot the Three Shire Stone marking the old county boundary between Cumberland, Westmorland and Lancashire, but they're soon shut again as another 4x4 hoves into view. Then, just when you think it's safe to open your eyes again, you're into the Hardknott Pass. It's even narrower, even higher, even steeper drops either side, and has even more hurtling 4x4s rampaging past and leaving our lives hanging by the grace of Alberta's handbrake. Quivering with relief and nervous

exhaustion when we finally make it to the other side, I see a sign for Wast Water.

'Whatever else you do, you've got to go to Wast Water,' said my brother the chef before we'd left. I felt I owed him something after nearly burning his restaurant down once while working there as a waiter. Carefully pouring a rare 1953 Château St Emilion during a fine wine dining evening, I'd suddenly felt an oddly warm sensation at the pit of my stomach and glanced down to see my crisp white shirt smouldering as I leaned across the candle on the table.

By the time I finished pouring the St Emilion, my shirt was fully ablaze. I swiftly returned through the restaurant with as much dignity as you can muster while trying to beat off flames as your charred shirt disintegrates from your body, and the carefully prepared ambience of sumptuous romanticism is shattered by panicky diners shouting 'The waiter's on fire!' My career as a waiter was short-lived, but in certain parts of Wandsworth I'm still known as 'the human torch'.

So yeah, I said I'd go and pay my respects to Wast Water, the place where my brother dreams up his sauces.

England's highest mountain, Scafell Pike, looms behind us like a scolding uncle saying 'Why didn't you fill up at that nice petrol station in Ambleside?' when, halfway down into Wast Water, I realise we're running on empty. So, what is it? Execute a tricky three-point turn on this narrow descent, head back on the high road and fill her up ... or say a little prayer, bang on down into the dark void below, and hope for the best? They don't call me the Gambler for nothing, so we plough on.

. The road down just seems to get darker and darker, and pretty soon it feels as if we're in the very bowels of the earth. It's a shock to find the lake itself is completely *black*. In fact, everything down here is black; even the bloody sheep are black. It's all desperately still and horribly cold. We seem to be driving for hours along the windy lane running round the lake without seeing a soul, the petrol gauge anchored resolutely in the red bit. There's no signal on the mobile phone down here, so if Alberta throws the towel in now we've got one packet of chocolate hobnobs, and then we're on our own. I start revising the list of songs for my funeral.

Then, out of the gloom, it miraculously appears. Cradled at the foot of a succession of imposing mountains is a white building, and in big letters on the top is the magical word INN. I stare at it ahead, and am sure I see a Bampton morris side dancing around on the top. 'I wasn't worried,' I lie to Mrs Colin, who's already gnawing the chocolate hobnobs. As we close in on INN, unbelievable sights greet us. People. Loads of them. Getting out of the car I reel back in pain from the

unyielding wind, and stare in amazement at the swarms of hikers yomping up and down the mountains. Heavens to Betsy, there's a couple of women who must both be over 80, wearing *shorts*. Glory be, here're some *cyclists*. Sweet Jesus, there're even people *camping* up there.

We fish out our hiking boots, make a grand exhibition of putting them on, look at the mountain, slap our cheeks a bit to pink them up, take a few deep breaths and trot straight to the pub, where fellow hikers are warming their bottoms reclaiming their circulations. The landlord nods with respect as we enter: 'Been far?' Phew, we'd say, yes we have, exhausted we are: walked all the way from Ambleside. We could do with a soup if you could manage it, landlord.

There are all sorts of wonders to be found in this remote alleyway of Cumbria. Wast Water is the country's deepest lake, Scafell is the highest mountain, and the nearby church claims to be the smallest in the country. 'Obviously, size means nothing,' says one witty entry in the visitors' book. The graveyard also provides a sobering catalogue of the names of climbers who've fallen to their deaths on the various surrounding peaks. There's an interesting advert at the church, too, for 'singing walkers' to participate in climbs through the lakes. They walk twelve miles per day, performing selected concerts en route in churches, pubs, caverns, waterfalls and mountain passes. So if you're ever in the Lakes and you think the hills are alive with the sound of music, then they probably are.

The proper name of the pub is the Wasdale Head Inn, whose first landlord, in the nineteenth century, was a bloke called Will Ritson. A bit of a character, Will was a wrestler, huntsman, fells guide and raconteur, but his biggest claim to fame was as 'the world's biggest liar'. No wonder they didn't believe us here when we said we'd walked from Ambleside. At one point, Will Ritson managed to convince everyone in his pub that all the sheep sheds in the area were made out of giant Cumbrian turnips. Such was his capacity for telling porkies that a 'World's Biggest Liar' competition is held in his honour every year at the Bridge Inn at nearby Santon. Strange, I always thought that contest took place every day at Westminster.

With renewed vigour we nurse Alberta back up the lonely trail out of Wast Water, head into the small but perfectly formed seaside town of Seascale, and eventually find a garage near the menacing monstrosity that's been a scar on the landscape since we got out of Wasdale. 'Welcome to Sellafield' says the sign, and on a whim I drive in.

Sellafield has achieved such notoriety as a giant nuclear energy plant that will one day kill us all that I'm expecting to see people wandering around with three heads and luminous green bodies. But directed into the smiley, fun-for-all-the-family Visitors' Centre, you're encouraged

to wonder what all the fuss is about. Clean, bright, ultra-modern and high-tech, it gives you lots of leaflets and buttons to push, ultra-violet exhibitions, facts to absorb and working models to explain how this exciting nuclear thing produces all that lovely electricity.

In a fashion, Sellafield confronts its critics. Its literature talks about Hiroshima and Chernobyl, and concedes that the 8,000 workers at the plant run a slightly increased risk of contracting cancer from radiation, but concludes that it 'considers the benefits to outweigh the risks'. And what about the people living in the area who *don't* get the choice but, if the wind blows the wrong way, may still get the cancer? 'The risk increases by one in 2.8 million,' says the genial Sellafield man with all the answers.

The blurb talks about the pros and cons of nuclear energy, and the benefits and disadvantages of the alternatives; just *imagine* the blot on the landscape of those horrid turbines on wind farms if we try the natural option. No, Sellafield Man assures us warmly, nuclear power here is as safe as it can possibly be. After all, there's been a plant of some description since they first set up an atomic energy base in the Forties and they haven't had any accidents yet, have they? *Have* they? And there is nothing to prove the high instance of cancer and leukaemia they discovered among local residents a while back is *anything at all* to do with the nuclear power plant.

Strangely enough, I don't feel totally reassured: one terrorist attack on the place could send us all into orbit. It makes you want to get as far away from it as possible. Cornwall? *Uh-uh*. But guess where the highest naturally occurring radiation levels in the UK are? Yep, Cornwall ...

Hours later, we're out on the north-west coast, now, on t'other side of the Lakes, in the bit you don't see on the brochures. This is the bit that Americans never visit, and caravans wouldn't *dream* of messing with; the bit where you can get a pie-and-a-pint for under a tenner. And then we come inland ... to the charmingly named Cockermouth.

William Wordsworth was born here and his house is still here to prove it. So was one of his distant relatives, Fletcher Christian, who mutinied on the *Bounty* during a trip to collect breadfruit from Tahiti in 1789, and went on to an idyllic exile fathering most of the population of the Pitcairn Islands. John Peel of 'D'ye ken John Peel?' fame was also born, lived and died up the road among the fells at Caldbeck. To be honest, he sounds a right fruitcake; he was so obsessed by hunting that he was up every day at five in the morning with his dogs, horn at the ready, seeking foxes. When they heard his horn, the good people of Caldbeck dropped everything to saddle up and join the hunt. When darkness fell, Peel would retire to the local pub where he'd

drink all evening, get completely ratted and roll home at midnight to his long-suffering wife.

So why is he so fondly remembered? Well, he was in the pub one day in 1832 with a mate, a woollen weaver called John Woodcock Graves, whose mother was sitting in a corner rocking his baby son to sleep singing "Bonnie Annie". The legend is that Graves grabbed a pen and paper and wrote a song about Peel there and then to the "Bonnie Annie" tune.

Graves emigrated to Tasmania soon afterwards following a fight with his mill manager and was quickly forgotten, but his impromptu song about the mad hunter John Peel took on a life of its own after William Metcalfe, a choirmaster at Carlisle Cathedral, heard it, adapted it to his own tune, and sang it in London at a special Cumbrian evening. He sang it again for the Prince of Wales and it became part of the fabric of English music. Search hard enough in the library in Carlisle and, remarkably, you'll even find a version of it in Swahili.

We discover there's a folk club nearby at the Wheatsheaf at Embleton, so we stroll down to check it out. It's a nice pub with a good little room upstairs, a friendly crowd and a reasonable programme of floor singers. Now, floor singers can be the bane of folk clubs. The theory is sound – it's an unconditional opportunity for the untried to develop in front of a small audience making no judgements on them, and many fine singers have emerged from the training ground of a folk club residency. On the other hand, they can be awful. I've seen some floor singers clear a room in seconds, and a series of bad warm-up acts will destroy the night for the main guest and put the audience off folk clubs for life.

Tonight the floor singers are fine. It's just the main guests I'm worried about – Gary and Vera Aspey. It's been years since I've seen them, and the last time Gary's personality totally overwhelmed Vera's gorgeous singing. The Aspeys are from Lancashire, and boy did we get to hear about it in Gary's bombastic introductions: 'This is Vera, she plays guitar, piano accordion and concertina, clog dances and sings … and if you want to know what I do, I put the smile on her face!'

Well, a joke's a joke, but northern stereotypes were nudged over the edge when they released a Seventies LP called *A Taste of Hotpot*, with a cover photograph showing a grinning Gary sitting down to an enormous Sunday roast lovingly served up to him by Vera. In the days before expressions like 'post-ironic', 'post-modernist' and 'piss-take', it was met with exasperated sighs – and some people have never forgiven them.

As soon as he gets in front of the audience, I realise that Gary, wearing a garish red shirt, has lost none of his bull-in-a-china-shop

subtlety. Roaring and ranting, he grabs the audience instantly by their throats, and while Vera remains a fine singer, she also has rather more to say for herself than in the old days.

Outside of stand-up comedy clubs you never see people as in-yer-face as Gary Aspey any more … but it turns out to be an entertaining eye-opener. Amid the verbal charges, he even makes some pertinent points about Englishness. Introducing a song about canals, he says, 'We collected this from a lady called Emma Vickers. Who's heard of Emma Vickers?' People shuffle nervously, and sit on their hands. 'OK, then, who's heard of Leadbelly?' *Everybody's* hand shoots up instantly, like an infants class eager to please the teacher. Except that the teacher's not happy: 'Huh! Isn't it a sad indictment that we are proud to know about the custodians of the American tradition, but not the English tradition?'

I want to punch the air and yell 'Right on, Gary!', but I'm scared he might recognise me and berate me publicly for slagging him off in *Melody Maker* in 1978, so I stay quiet. But Gary wouldn't have noticed anyway. He's away again, asking how many of the audience are English. Nobody moves. A few people pretend to do up their shoe-laces, others feign coughing fits, one or two pretend to be Albanians without a clue what he's on about, and *everybody* dives for their pint. OK, he says, any Welsh here? Any Irish? Any Scots? And of course there are, and they're up waving both hands in the air, eating leeks, singing "Fields Of Athenry" and dancing the Highland fling to prove it.

That's when Gary delivers the *coup de grâce*: 'See? See? *They're* not ashamed! They're proud to put their hands up. Why, oh *why*, are we ashamed to be English? We should be proud of our culture. In Scotland, in Ireland, in Wales, they look after their culture and they love their culture. What's wrong with us English? The English don't look after their culture. Why the hell *not*? Let's get *our* culture back. The BBC won't play English songs, so *we will* …'

I quite expect to see the flag of St George unfurling behind him while a brass band marches on playing "Land Of Hope And Glory" and the audience goes marching off to Flodden Field, but there's simply another outburst of embarrassed coughing, beer-swilling and Albanian impersonations, and Gary and Vera sing Emma Vickers's song about canals. I'm warming hugely to Gary by this time, and am thinking he should definitely be on the next series of *Celebrity Big Brother* when he gives us a quiz. 'What's the only instrument that the English invented?' It's a good one, that, and we're all scratching our heads, but the Scots guy has the answer: 'Concertina'. Full marks, Scots guy. Gary then asks which instrument the Welsh invented, and the Scots, and the Irish. And the answer is *none*: a big, fat, lonely zero.

The Aspeys close with a rousing performance of Pete Betts's feel-good paean to nostalgia, "They Don't Write 'Em Like That Any More" and Gary tells us, in his own inimitable way, what a great audience we've been: 'We've played places like the Royal Albert Hall in London but we still love playing little folk clubs like this, and do you know why? Because it's what it's all about, *this is what it's all about …*'

I think Vera's a saint.

Next day we awake full of the joys of country life, visiting Bassenthwaite, and – here's a good one, triv fans – this is the only true lake in the Lake District. 'Tis true; the rest are either 'waters', like Derwent Water, or 'meres', like Windermere. But Bassenthwaite is a real lake. Stick that one in the locker for the next pub quiz.

Last night someone at the folk club asked me a baffling question: 'Have you seen the osprey yet?' I'd assumed she was talking about some hot new band, but she tells us the story of the bird that hadn't been seen in Cumbria for years, but took time out en route to Scotland a couple of years ago and has been nesting here ever since.

His recent arrival is an animated topic of conversation, and both locals and bird enthusiasts are united in excited anticipation about the expected arrival from west Africa any day of Mrs Osprey to join him. Four chicks have hatched here in the last three years, and as osprey chicks usually return to the place of their birth when they're three years old, there are hopes that the eldest son will also be returning and maybe bringing his own mate.

To be honest, I'd always thought of birds as odd creatures who wake you up in the morning and the cats like to play with – and I really don't like to talk about the painful incident when we accidentally killed the neighbour's budgie. But clambering up the hillside to the osprey-viewing centre at Dodd Wood, it's impossible not to get caught up in the patent joy being exhibited by these bird-watchers.

The osprey's mate has, indeed, arrived and with various guides, telescopes and even a webcam available to view them, it's possible to view every movement as she sits on the nest and he goes fishing across Bassenthwaite. I'm genuinely enthralled and want to know everything it's possible to know about osprey. Like, have the osprey got names?

'Names?' says the ranger guy, a tad bewildered. 'Yeah, you know, like Oswald or Olaf or something.' No, apparently not. He quickly moves on to talk to someone sensible about flying patterns, and the intricacies of the nest platform erected by the Forestry Commission in the hope of attracting another pair of osprey to establish a proper colonisation in the area: 'Look, can ye see? Look at him fly! He's got summat in his mouth, he's bringing home the supper, can you see, can you see?'

Yeah, but he hasn't got a name then? We used to have an alarm clock

called Egbert. The glass had been smashed, its springs were hanging out, it had only one hand, and it hadn't worked for years, but it still took pride of place on the mantelpiece. Why? Because it was Egbert and it was part of the family. I really wish they would give the osprey names. But then, I'm not David Attenborough.

Yet more thrills await us in Workington. I've been looking forward to this ever since the trip began and I first heard about the 'Uppies and Downies', an annual challenge involving a leather ball stuffed with horse hair and a longstanding rivalry between those from the opposite ends of the town.

'See, the team from the top end of town have to get the ball down the bottom, and those from the bottom end have to get it to the top!' the young bloke in the Man Utd shirt in the pub tells me enthusiastically. It sounds simple enough; how do you know when they score? 'Well, they don't actually *score* ... the Downies have to get the ball to the big hall, and the Uppies have to get it to the harbour.'

And what happens then, they kick off again? 'No, mate, it's game over.' *What?* So if someone gets the ball in the harbour in the first minute that's it, we all go home? He laughs like a drain. 'Have you *seen* where the harbour is? It's over a mile from the other end. This thing goes on for hours. *Days* even! The last one finished at about four o'clock in the morning.' It sounds great; what are the rules? 'There aren't any.' Ah. 'That's what makes it so good. You just pick a team, pitch in and off you go. It can go anywhere. It's just a load of people fighting over a ball. It's good fun – you'll have a great time.'

Have you ever played? 'Oh yeah, I been in it a few times. A great laugh, it is. It gets a bit wild sometimes: you know, you get some gorilla on your back trying to get the ball off you, or you find yourself on the floor with a pile of blokes on top of you. But I've had a great time in the Uppies and Downies.' So are you playing this year? 'Nah ... United are on the box tonight. I think I'll stay here and watch them.'

He's probably from Kent.

So, we join the fray assembling down at the Cloffocks around 7pm as the Uppies face the Downies across a small bridge on some wasteland linking a huge car park with the old dog track. There are no team colours, no pre-match huddles, no tactical discussions, no speeches or fanfares; just a bunch of guys having a stand-off in what could be the prelude to the gang fight scene from *West Side Story*. There's a bit of banter, but not very much, and a couple of the mainly young crowd look as if they've already been in the pub all day. Two hard men strip their shirts off to reveal rampaging beer bellies in the cold early-evening drizzle and I watch and wait, from a safe distance across the stream, for hostilities to begin.

A smart-looking man arrives, smiling broadly, and heads for the bridge with a brand-new brown ball under his arm. He's a local businessman, apparently, who always starts the match for the simple reason that his family have *always* started the match. He doesn't say anything, but the mob goes quiet, parts respectfully to allow him on to the bridge and focuses, sedan chair-racing style. He takes a quick glance to each side, then casually tosses the ball into the air, turns on his heel and marches away without even a backward look to see where it lands.

In fact, it doesn't *land* at all. The ball pings around in the air as the front lines jump, frantically trying to claim it, and then a nine-foot-tall guy takes it and, in one movement, hurls it back across the bridge. The next thing I see is the ball whizzing past my nose and an avalanche of pumped-up lunatics thundering towards me.

I brace myself and close my eyes as they come charging past, and when I open them the pack is already up the road and grappling along the wall of Allerdale House, headquarters of the borough council. There seem to be hundreds of them in there, sweating and panting and wrestling each other to the ground, but there's little evidence of a ball secreted somewhere beneath the pile of bodies.

There are a few plaintive Henmanesque cries of 'Come on Downies' from the spectators, but I have no idea – and I don't think they do, either – which ones the Downies are, where they're going, or how they'll get there. But as the rain intensifies and the scrum heaves and slithers this way and that, falling into gardens, tumbling into ditches, trampling on hedges, barging into shops and, at one point, threatening to disrupt the traffic on the dual carriageway, the will to win of the grunting players is startling. Every so often the ball will squirt from a heap of brawny combatants to be whipped up in the air and flung towards the castle, triggering a mad sprint followed by yet another scrum as the pack picks off whichever heroic athlete reaches it first.

One guy who'll never see 50 again emerges, gasping for air. 'Call it a day now, luv, eh?' asks his worried wife, dabbing at the blood trickling from a wound in his forehead. 'Aye, you're right,' he says, comfortingly. 'We'll go to the pub, have a couple of pints, and then I'll come back and finish the game.'

This is the third in the three-match Uppies and Downies series, which begins annually on Good Friday, but nobody seems to know who won the first two. Nobody seems to know, either, how or why these matches started. 'It's pagan,' the Man Utd fan had told me in the pub – the stock explanation for traditional events whose origins are long lost. More reliable theories claim it was originally held as a challenge between coal miners and dock workers, while others say it was a

battle between landowners and peasants. Now, they insist, the split is simply between those from above the Cloffocks and those below.

This kind of street rugby is not unique to Workington, and there remain similar events in Ashbourne, Derbyshire and Kirkwall in the Orkneys, but this lot will vociferously tell you that the Ashbourne crowd are snivelling pansies in comparison, and Workington is the only true raw street football/rugby match where *anything* goes.

Inevitably, there have been casualties along the way. In 1983, one of the Downies, 20-year-old Robert Storey, drowned in the River Derwent as darkness fell, and there's always been a lobby in the town worried by the dangers of the apparent lawlessness of the event. Some businesses have also been concerned about damage to property. The running battles rarely encroach on the town centre these days, although on one famous occasion in the Sixties, the audience enjoying *Alfie, Here We Go Round the Mulberry Bush* or some other such romp at the Ritz cinema were shocked to find their movie disrupted by Uppies and Downies charging into the foyer. On another occasion, the mob brawled their way into a Chinese takeaway.

The main threat to the continuity of the event, though, now comes from town developers. They are keen to build a new shopping centre on the Cloffocks, the traditional Uppies and Downies heartlands, where games are won and lost and heroes made. The axe permanently seems to hover over this extraordinary event, but I certainly wouldn't want to be the one to tell 'em that they can't play any more.

Meanwhile, back on the green towards the castle, the maul goes on. The ball suddenly whizzes past my ear again into a crowd of squealing spectators. Trying to escape, I slither and fall just as the pack arrives, and I'm left huddled in a ball on the floor, feeling like a jockey thrown at Aintree while leading the Grand National. When I get up my dictaphone is in pieces and the camera is dead, but there are more squeals as the huge ruck starts sliding down the hill like a hundred Eddie the Eagles on a particularly bad day on the piste.

As the scrum ebbs and flows, up and down the hill, a man temporarily appears flat on top of their mob, crowd-surfing with the best view in the house. In another moment of confusion, with everyone wondering where the ball has gone, a pregnant man shiftily ambles away from the scene of the crime. He might have got away with it too but for the guilty glance back at the pack, and a nonchalant stroll turned incriminatingly into a panicky gallop, after which the ball is swiftly liberated from under his shirt.

Suddenly the ball is loose again, and a bloke in a striped football shirt has got it. Unlike most of the others, who fling it like a hot potato as soon as they get it, he puts his head down and runs. He's quick, too,

and for a moment I think he may make it all the way down to the harbour, but a guy with a multi-coloured Mohican who's been quietly supping beer puts his can on the floor and, as the sprinter comes past, dives full length to take him down. The mob is on him in an instant. Mohican man gets up, brushes himself down, picks up his beer and carries on drinking.

I'm keen to see this through to its conclusion. I want to see who 'hails' the ball, winning the match by throwing it three times above his head either at the gates of Workington Hall or the end of the harbour, depending which side he's on. In the old days, when crowds of 30,000 or more would flood into Workington for the matches, the man who 'hailed' the ball became a major local hero. They still talk in awe of Maurice Lawman, who hailed six times in successive years in the Sixties, though the ultimate Uppies and Downies legend has to be Tony Grima – he hailed an unbeatable 11 times, the last one in 1990.

So, yeah, I'm desperate to hail this year's hailer and buy him a drink. The problem is that the pubs are already shut, and there's no way of knowing when the logical conclusion is likely to be. They've been at it over four hours now, it's bitterly cold, rain is lashing down and they're right back where they started from.

I reluctantly leave them to it to, in order to address the hypothermia and give the camera and dictaphone a decent burial. But I'm up at the crack of dawn scouring Cumbria for internet cafes to check out the result … and eventually I find it. A random message board tells me everything I need to know. It seems an intricate strategy worked out in the training ground, involving all manner of dummy runners and pincer movements, was set into operation with a secret Downies signal around 2am. The tired Uppies were caught cold, and the Downies hailed the ball to claim a 3-0 whitewash in the series. But, my anonymous correspondent adds, it was a great game. And at the end of the day, Brian, Uppies and Downies was the winner.

Nearby the sad little harbour town of Maryport underlines the extent to which this western end of Cumbria plays Cinderella to the Lake District's romantic ramblers' paradise. Once a busy shipping centre on the Solway estuary, Maryport has fallen on hard times and looks wounded, lame and defeated. Houses are dilapidated, shops are boarded up, and the only sign of life is a group of kids running around and putting in some shin-kicking practice for the next Cotswold Olympicks. It's been this way for a while; during the depression of the Thirties, Maryport had an 86 per cent unemployment rate – the highest in the country.

But at least you can buy a two-bedroom house here for £55,000, and have a cup of coffee in the exact same seat at the Port of Call cafe

where Captain Sensible once had a vegetarian dinner and signed the photo that now hangs on the wall with a ringing endorsement. On it, the good Captain declares his time spent here to have been 'quite enjoyable'. Damned by faint praise from the bloke from the Damned: it seems to sum up Maryport.

North of Maryport, the sheer bleakness and sense of remoteness is refreshing. The tide is out, the landscape is spartan, and the 20-minute drive beyond Allonby without spotting another car – or even another person – is heartening. So not *every* blade of this land is a traffic jam just yet. There are certainly no caravans. We do find a funfair, further up the coast at Silloth, but there's no sign that it's seen much action in recent times. Amid the gloom, a Mr Softee ice cream van is rather optimistically parked nearby touting for business, but the only potential customers are two little kids who fish vainly in their pockets for coppers then shuffle disconsolately on their way.

We plough on all the way up to Skinburness, but the road disappears into an impassable track with just a single hotel to entice us on, so we duck across to the medieval town of Wigton. There are things like butchers' shops and fishmongers in Wigton, and the place is a heart-warming reminder of the way that towns used to be before being gobbled up by supermarkets, burger bars and fashion emporiums. This is where Melvyn Bragg is from (Wigton is loosely disguised as 'Thurston' in some of his work), and so I imagine everybody here has a nasal impediment. Also, Anna Ford's dad redecorated the local church when he was the vicar here. But Wigton has been in the news lately for other reasons.

After a spate of crime during school holidays, the local police introduced an experimental curfew, banning anyone under 16 from being on the streets between 9pm and 6am. The local press is full of it, reporting on police round-ups of ten-year-olds at the dead of night, and some groups of kids openly defying the exclusion zone in order to smash greenhouse windows and damage allotments. Wigton doesn't *seem* the sort of place that you'd find gangs of youths roaming round pillaging, but you can never tell what they get up to after dark, so I'm with the police on this one. Yes, let's ban kids from the streets at night. And why just in the school holidays? Why just at night? Confine them to barracks the whole day. Send the wagons round scooping them up, lock the door and throw away the key. And then send them out sweeping chimneys. And, while we're at it, bring back national service. And public flogging. And scurvy. That'll teach the little blighters a bit of respect.

I'm also reliably informed that Wigton is 'chav city'. This is highly exciting news. Reading the tabloid press recently, England's youth

appears to have been completely overrun by some curious new master race called chavs. I want to meet a chav, but nobody has ever success-fully explained how they can be recognised, apart from the fact that they wear Burberry. I might be able to identify them if only I knew what Burberry was.

There's no sign of any Burberry shops in Wigton, and my polite enquiries of a couple of youths as to whether they are chavs aren't terribly well received. 'Bog off,' they say. 'Bog off yourself,' I reply, looking at my watch. 'It's getting near tea time, shouldn't you be off the streets by now?'

Then we attempt to reach Carlisle but there's the mother of all traffic jams so we pass on by and decide to call on a bloke called Hadrian …

CHAPTER ELEVEN

The Flowers of Northumberland

'Good people come and gather round me,
Listen to me sing my song,
I'm a wind-blown seed in a land of greed,
Living with a dream gone wrong,
But some day, some say,
They'll all be growing greener in the North Country'

"A Call For The North Country", Jez Lowe

I don't wish to be rude but ... Hadrian's Wall? It's *rubbish*. If they had as much trouble finding Hadrian's Wall as we do, it's no wonder the Scots failed to mount a successful invasion of England. ''Scuse pal, any idea where England is?' 'Och aye, up the hill, turn left, follow the path round to the right and there it is; ruddy great wall, can't miss it. I'd give it a miss if I were you tho', pal, place is full of Sassenachs trying to kill you ...'

Our drive across country along the A69 is directly parallel to the wall, yet it's still elusive. When we eventually pull off the main drag to the Roman Army Museum near Greenhead there doesn't seem to be much to see: a load of fields and three deeply underwhelming tiny stone walls heading off in different directions. We have absolutely no idea which is the one that Hadrian knocked up. What did the Romans ever do for us, eh?

There's a clump of people in big boys' boots and Ambleside anoraks clearly doing the wall the proper way – yomping the entire length from Bowness-on-Solway right across to Wallsend – who give Alberta a dirty look in the car park. Their disapproval seems to be mirrored by a ferociously cold, angry wind, so we stand around for a while – about two minutes – staring at the crumbling wall vainly hoping to experience some divine connection with our Roman roots, then dash inside the museum in search of coffee and buns.

Inside, a well-laid-out museum and a short film show attempt to fill the gaps in my knowledge about Hadrian and the hazy crazy days of AD122, when his barmy army put up the 76-mile wall to keep the Scots out ... or, as they put it, 'to separate the Romans from the Barbarians'. In truth, we could be here for the next three months trying to fill in my gaps and they would still be cavernous, so after 45 minutes I'm reeling with new information – the most astonishing of which is that Emperor Hadrian was gay ... or, at least, bisexual.

Born in Spain in AD76, Hadrian had a long-term childless marriage and a six-year affair with a Greek lad called Antinous, who accompanied him everywhere until the boy died suddenly in the Nile. It was a sign of the times that everyone knew what was going on, including Mrs Hadrian, but nobody gave a stuffed toffee. After all, it wasn't as if Roman emperors had a reputation for frugality and pure living, and that Caligula character made Hadrian look like an innocent choirboy. The shit really hit the fan only when the heartbroken Hadrian declared the late Antinous a 'deity', thus commanding his subjects to regard him with 'divine reverence and honours'. This didn't go down at all well in Rome. St Anthanasius denounced Antinous as a 'sordid and loathsome instrument of his father's lust' and *The Decline and Fall of the Roman Empire* says Hadrian's memory was dishonoured by his reaction to his lover's death.

We check into a hotel in Hexham where the staff all seem to be about 13, and the whole place is a baffling melange of secret passages and corridors going nowhere. Completely lost in the hotel, I follow one door leading into a room where a wedding party is in full swing. Everyone's far too pissed to care that I seem to have mislaid my invitation, and I'm quickly offered the opportunity to spend an enjoyable evening drinking these fine people's champagne and discussing the life and work of Alan Price with the bridegroom's father. Give me some more bubbly, mate, and I'll even tell you my Jimmy Nail story.

But I'm not really dressed for the occasion, and when the house band – in matching red satin shirts and black trousers – start playing Phil Collins songs, it's time to move on. I mean, what's the *point* of Phil Collins? Another corridor, another door, and look, here's the bride in floods of tears while her bridesmaid appears to be about to throw up all over her. They both look at me hopefully, as if they're expecting the angel of the north, but when you can't even find your own hotel room, let alone Hadrian's Wall, advice about marriage problems and alcohol abuse isn't on the agenda.

We end up in the Bowes Hotel, an intriguing pub in the village of Bardon Mill, where the walls are full of pictures of people holding leeks. Leeks are big news in these parts, says the landlady, after an

uncomfortably graphic description of how her finger had been torn off in a mangle when she was a kid. 'They have these shows to see who can grow the biggest leeks,' she continues. We laugh, but she's serious. And there's more. 'The day after the leek show they all come in here for the auction ...' OK, I'll buy it ... the *auction*? 'The stick. We auction the stick.' What stick? '*This* stick.' She retrieves a small stick from behind the bar. You auction that stick? 'Aye, we got £300 for it this year. Last year we got £250.'

I don't know what to say to this. It's a perfectly respectable-looking stick, nicely varnished and all, and one day it might grow up to be a walking stick, but you couldn't seriously threaten intruders with it, and it doesn't look the stuff of family heirlooms. If you saw it behind the bar, you'd say, 'What's that stick doing behind the bar?' But here in the Bowes they auction it every year and the winning bidder isn't even allowed to take it home – the stick never leaves the pub.

There's only one question to be asked really. *Why?* 'Would you believe I've got absolutely no idea,' she shrugs. What's the history of it? 'I haven't got a clue, love. All I know is it gets auctioned once a year and then stays behind the bar until next year. Strange isn't it?' Just a bit.

Thankfully, we fall into conversation with a woman from Sunderland who is covered in tattoos. What's Sunderland like then? 'Well, you have to tie your dog down, else it'll be stolen. Don't drive through Sunderland in a posh car. They'll have your wheels off before you get to the end of the road ...' We strike Sunderland off the itinerary.

Still, anywhere that has a competition to grow the biggest leeks and auctions sticks deserves further investigation, so come New Year's Eve we're back here for a bit of tar barrel (or barl, as they call it locally) blazing. This all takes off in the nearby town of Allendale, which claims to be the geographical centre of Britain. After a hearty meal in the Bowes Hotel, we drive into the town, or as near as we can get, meeting badly punctuated 'TAR BARL'S PARK AND RIDE' signs a mile and a half out of town. The cars randomly abandoned on grass verges suggest that things are getting busy down there.

It's 10pm when we hit the town, to find the pubs heaving and people in strange costumes wandering around in a state of high excitement. There are monks, cowboys, Vikings, Robin Hood, Little Richard, Elvis, knights, clowns, Father Christmas, burly blokes in drag and even an Ozzy Osbourne. Barriers protect an unlit bonfire in the square in front of the Golden Lion and the King's Head, while the tea rooms are doing a roaring trade in soup, pies and mushy peas.

A lone police car is parked discreetly in the square, amid mutterings

that an over-zealous presence had overshadowed recent tar barl occasions. There's certainly no sign of over-exuberance or bad behaviour in the crowded local pubs ... just a load of people getting quietly pissed. One of the hotels has a big sign announcing 'PRIVATE PARTY', which momentarily looks worth gatecrashing, but a quick glance inside reveals one bearded guy, who must be 90 if he's a day, sitting alone in a corner nursing a gin and tonic, while a bored couple peer through the window at the people peering back at them and wondering if a wild party is going on inside. A few sad curled sandwiches and gnawed chicken legs on the table suggest it's not. A firework explodes in the sky and the 90-year-old in the corner leaps out of his chair and makes a dash for safety, presumably imagining Hitler is up to his old tricks.

At about 11.15pm a brass band strikes up outside the church with a vigorous rendition of "Blaydon Races", and people pour out of the pubs to watch as more 'guysers' in costumes and blacked faces arrive carrying their tar barls. As they make last-minute adjustments, nailing bits of wood together and lovingly arranging the woodshavings soaked in paraffin (tar is no longer harmed in the making of this tradition), I talk to an elderly man with shiny eyes and a breathless countenance.

'I did this for 50 years,' he tells me, proudly. 'I were 14 when I started. I never missed it. It's busier now, mind. I lived in Allendale all me life; I live in Hexham now, but I still come. There's nothin' like it anywhere else. Only in Allendale; only in Allendale. I couldn't lift a barl now, mind, they're heavy ...'

As if to prove it, one guy tries to lift the barl on his head but ends up tipping the contents all over himself, much to the amusement of the crowd gathered round him. 'I preferred it the other year, when it snowed and Allendale was cut off and there weren't anyone else here,' he grumbles, taking a slug from his hip flask.

With the clock nudging 11.45pm and the 50 or so costumed characters assembled in some sort of ragged order, barls are raised on heads and, in one dramatic movement, they go up in flames. The brass band leads them off at a brisk pace and as they pass, the heat of the flames sends you reeling back. It's an astonishing sight to watch a surreal collection of characters march behind a brass band around this small Northumberland town with their heads are on fire.

It's a short but spectacular ritual, conducted to the backdrop of a cheering, whooping crowd. They walk fast, wincing under the weight of the barrels and the heat of the flames around them. It looks so absurdly dangerous you wonder that, in these days of the nanny state, the health and safety people haven't intervened. 'Some things you don't mess with,' a chap dressed as Robin Hood tells me gravely. 'This is one of 'em.'

By now, the parade is back in the square, circling the bonfire at the stroke of midnight when the barls are put out and the bonfire goes up. Bottles of champagne are magically produced out of thin air as corks pop, cheers echo, everyone starts kissing and a few plucky circles of people launch into "Auld Lang Syne".

There's even a bit of first-footing and several sweaty, charred barl carriers disappear into a nearby house, though it's not like the old days apparently. 'Oh aye, we used to go around wandering into people's houses,' says one of the elder guysers. 'Everyone just opened their doors. We'd no idea who they were, half of 'em, but we'd go in and have a drink with them. These days everyone's too knackered after carrying the barls around, they just want to go home to bed.'

The inevitable, all-purpose reply of 'it's pagan' greets our queries about the origins of Allendale's colourful ceremony, but the folklorists tend to disagree. Bob Pegg's book *Rites and Riots* notes that a local paper in the Thirties claimed tar barls were introduced in the mid-1800s, when a band always played the New Year in. However, one year, it was so windy the candles they used so they could read music kept blowing out and someone hit on the idea of lighting a tar barl instead, and the band gathered round it. In the ensuing years the tar barl became central to the celebrations, and the procession followed. Formal costumes were the order of the day then, and fancy dress was introduced only after the Second World War, when clothes were in short supply and had to be made out of spare material.

We are in deep England's borderlands now – an area rich in folklore and tradition. Constantly caught in the interminable crossfire between the Scots and the English, life was a recurring nightmare for different generations of border families living in the 'debatable lands'. Their crops were regularly destroyed, their homes burned down and their loved ones were permanently under threat from one side or the other.

With the border constantly shifting, people decided the only side they wanted to be on in the constant conflicts between England and Scotland was their own. In the fourteenth century it became bandit country, ruled by 'reivers': infamous raiders of the night who terrorised the official forces with guerrilla raids on farms, people and property in their own renegade battle for survival. They turned the debatable lands into a no-go area, but a gruesome romance grew around the reivers, who were feared for their menace and ruthlessness yet also admired for their cunning and courage.

This went on for 300 years until their reign of terror was finally ended at the start of the seventeenth century, when James I unified Scotland and England and systematically sought out and destroyed the reivers (although strongholds like Tynedale and Redesdale were

approached with trepidation for many years afterwards). They also gave the English language the words 'bereave' (as in the reivers have robbed you) and blackmail (an expression used by reivers for protection money) as well as some stonking border ballads. Northumbrian historian George Trevelyan (1876–1962) described the reivers as 'cruel, coarse savages, slaying each other like the beasts of the forest, yet they were also poets who could express in the grand style the inexorable fate of the individual man and woman'.

The ballads, which were brought to wider attention by Sir Walter Scott, revealed many stories and insights into the adventures of the reivers, and still define the true character of this wonderfully atmospheric, magical region. As in the west of Ireland, Northumbrian music has the capacity vividly to reflect the history of the place, the character of its people and the geographical landscape that created it. In spirit, character and deed, this is the nearest thing you get to an oral landscape of an area. It's small wonder Northumbrians often regard themselves as a separate entity to the rest of the nation.

'We don't have to ask who we are, we *know*,' says Mike Tickell, who recently returned to live in the village of Wark, just north of Hadrian's Wall, to find it pretty much as he'd left it nearly 50 years earlier. 'We were Northumbrians here before we were English.'

Considering Wark and its surrounding areas were once in Scotland, it's hardly surprising that there is such a spirit of independence and self-sufficiency. The popularity of ballads like "Twa Corbies" ("Two Ravens") straddled the border, and Robbie Burns was as popular here as he was in Scotland. In villages like Wark, they'd sing ballads and play tunes you were unlikely to hear anywhere else in the county, or indeed the next village, though sometimes the songs had the words or titles amended to suit their own locality.

The gorgeous "Fair Flower Of Northumberland", for example, which tells the story of a Scottish knight imprisoned by the Earl of Northumberland, has alternative endings. The Earl's daughter falls in love with him and helps him escape, but when they reach safety in Edinburgh, the deceitful knight reveals that he's married with children, and abandons the girl. That sorry conclusion, however, does vary according to who's singing it and which particular piece of racist propaganda they are trying to propagate.

"The Battle Of Otterburn" relates the story of a battle in 1388 when the Scots won a famous victory when they caught a much larger English force off guard when they were resting. It was a conflict that brought the two most powerful leaders from opposing sides of the border head to head: the Earl of Northumberland's son Henry Hotspur and Scotland's Earl of Douglas. Douglas was killed in the

clash but, before he died, insisted his army hid his mortally wounded body under a bracken bush, so as not to deflate his troops and encourage the enemy.

Many of the key participants are name-checked in the song, and most of those family names are still prominent in the area, an aspect of the border ballads that Mike Tickell believes is an important reason for their enduring relevance and popularity in the region. It's one of the characteristics of the songs that the common family names of the area – Milburn, Dodd, Charlton, Armstrong, Robson – recur very frequently, maintaining a palpable link between succeeding generations.

With such localised reference points, these songs are still sung in the villages on the borders. Mike Tickell, who himself organises regular informal sessions of music, song, monologues, storytelling and jokes in Wark, says: 'I think people are more aware of their heritage here than they've been for a long time; certainly more than when I was a child. It actually varies from village to village. The thing about Northumbrians is they can pick on each other, but insults are like a form of affection here, and when things go wrong it draws them together and they support one another.'

Rural and thinly populated with a relatively low turnover of people, you wonder how socially enclosed the region is. I mean, you don't see many black faces round these parts ... 'Actually,' says Mike, 'we used to have a black doctor up here in the Fifties: Dr Coker. He was a chemist as well as a doctor, and he was a much-loved member of the community. He used to play for the pub darts and dominos teams and was very much liked and respected; I don't think the perspective on colour has changed.'

Mike's daughter, the magnificent Northumbrian piper Kathryn Tickell, has done a lot of work encouraging young musicians in the area, teaching both in schools and at the first folk degree course in the country at Newcastle. The north east, she says, is the only area in the country that could sustain such a course; the only region where folk music is regarded as the equal of classical, jazz or any other genre of music.

'If there's an aspect of the Northumbrian tradition that is dying out,' she says, 'it's learning tunes by osmosis from the older musicians. I was lucky enough to learn tunes by playing with people like Willie Taylor night after night, that whole context of playing by knowing their character, their lifestyle, their friends and their homes.

'I do a bit of teaching in the middle school at Rothbury, and I might teach them a tune like "Biddlestone Hornpipe". They say, "Is that the same Biddlestone where my aunt lives?" and I say yes, and it gives it a

context. One girl learned to play "Rothbury Hills" and she told me she played it at home one day, and her grandad said, "I used to play that on the accordion", and he got his accordion out and started playing it with her. It's not about creating the latest hotshot; it's about giving children music that means something to them.'

Of course, Kathryn's first love remains the spectral, beautifully evocative Northumbrian pipes – but more of that anon. First, we have more swimming nutters to watch.

On New Year's Day we hit Whitley Bay, just in time to see 40 or so people emerge blinking in the chill air in their swimsuits, arms wrapped round themselves in a futile attempt to fend off the cold of the morning. This is apparently another tradition in the north east – mad people going for an 11am New Year's swim in the sea.

I'd have joined them, of course, but Mrs Colin gets her ring roads mixed up (when we pass through a village called New York I get *very* worried) and the swimmers are taking deep breaths and christening the New Year with anguished splashes by the time we make it to the beach. While I'm still searching for my Speedos, half of them are already on their way back to the beach, shrieking and howling as a wave reaches their waists.

'It's bloody freezing,' yells the first out, a woman in a Santa hat and a *Sun* t-shirt who's barely got her knees wet. New Year's morning on the north-east coast, and the sea's cold? Surely not, love … it looks like a sauna in there. A few hardier souls give it more of a go, offering token Duncan Goodhew impersonations, but Christmas Day at the Serpentine it's not. There's a spate of applause as they sprint back to the safety of towels and hip flasks, but I'm not sure they deserve it. Where's the singing, where's the race, where's the cup?

There's no time to find out; we've got a wheelbarrow race to find. 'Oh aye, Ponteland – the posh end of Newcastle,' my friend the Geordie had said when I mentioned the wheelbarrow race, and it certainly seems quite smart. Bagpipes greet us as we arrive in Ponteland, joining a modest crowd outside the impressive Blackbird pub on a site where a peace treaty is reckoned to have been signed between England and Scotland in 1244. There is no outbreak of peace today, though, just a lorry unloading a host of what looks like a set of brand-new wheelbarrows.

In truth, you would suspect that the pub had a brainstorming session about what they could do to drag the punters in on New Year's Day, and came up with the idea of a wheelbarrow race … except that the event is actually over 700 years old. It started in the early four-teenth century when, during a severe winter, the lord of the manor encouraged the locals to forage in the countryside for anything to help

them survive. 'Oh aye, it's a tradition; you've got to keep it going haven't you?' says Lorna, the landlady of the Blackbird.

The sun is barely over the yardarm but there are plenty downing their first pints of the day – and, perhaps, the year – while discussing last night's shenanigans and watching intently as the competitors assemble. There are skinny blokes in shorts three sizes too big for them, several tracksuits specially imported from Liverpool, a couple of girls wondering what the hell they've let themselves in for, and several young guys who look as if they've stumbled here for a sharpener on their way home from last night's party. Some of the pairs are limbering up, others crawl to the starting line on the road outside the Blackbird and I put a tenner on a couple of Prince William lookalikes in rugger shirts who look as if they mean business.

A guy who'd look a bit scruffy were he not wearing a top hat and some tacky bling gear calls them to order. This is the Lord Mayor of Ponteland and he's clearly making the most of it, because his period of office lasts only for today. As he ambles to the starting line people jump into the barrows while their partners limber up behind them, throwing in little trial lifts before the Lord Mayor sets them on their way. Without ceremony, the 18 teams are off at a sprint; the first leg of their course is uphill. The first casualty occurs after 10 seconds; one poor guy is tipped out of the barrow as his mate's legs give way at the first sign of the hill kicking in and the only female duo in the race, already bringing up the rear, immediately swap roles and have a giggle.

The course around Ponteland is about a mile but the terrain is tricky, and it seems an inordinately long time before they return, gasping and spluttering. The eight-minute record for the event is safe for another year. My tenner is safe, too, as my rugger boys David and Marcus freewheel comfortably home to break the tape in triumph. I bound over to congratulate them, but doubled up in pain, they are starting to turn green and don't seem inclined to answer my questions about tactics, technique and the finer subtleties of good wheelbarrow racing. 'Jesus, man,' says one of the heroes, David, an agricultural student, 'that's the hardest thing in the world like ... especially today of all days. What the hell were we thinking doing *that*?'

Oh, you had a few beers last night, did you? 'More like a *vat* ... Jeez, I feel rough. We were third last year but I don't remember it being as hard as that. Nightmare. I only did it 'cos *he* said it'd be a laugh.' He looks accusingly at his partner, Marcus, who is now in the foetal position, rocking gently backwards and forwards.

He's about to use the famous Steve Redgrave line, 'If you ever see me in a wheelbarrow again, shoot me', when there's a huge roar from behind us. The female duo has finally made it safely home about 20

minutes after everyone else. Oddly enough, they don't seem tired at all. 'We got lost!' they say, still giggling as they sensibly head for the bar to demand that the landlady Lorna introduces a women's race next year. Wheelbarrow racing? It's got shorts and a finishing line, so yep, it's more of a sport than darts or skating. I add it to sedan chair racing as a must for inclusion in the next Cotswold Olympicks.

We head on into the city of Newcastle. I'm anticipating top-notch mischief here. Everyone loves a Geordie, and according to everything you see in the papers you can't move in Newcastle these days without being ravaged by hordes of drunken hen parties staggering around in their undies, while the bars are full of madmen in Toon Army shirts necking Newcastle Brown by the gallon and throwing up all over one another. Life in Newcastle, we are led to believe, is one long, loud, colourful, hair-raising karaoke.

Well, not today it isn't. OK, it's obviously a bad time, a so-cold-I-think-my-nose-is-dropping-off New Year's Day, but we were expecting a little more action than this. The city isn't just dead, it's been cremated, and the mourners haven't even bothered to turn up for the wake. Nothing is open and no one's around, not even the remnants of last night's parties; just a few stray souls like us wandering around looking lost and looking for something to do.

Yet presently groups of people start arriving, and drifting into bars and greasy spoons in their black-and-white-striped shirts to pore over the Sunday papers. Newcastle United will be performing for their pleasure at St James' Park later today, but despite their reputation as the most passionate fans in the country, even *their* mood seems muted by the grey of the day. A few hardy attempts to raise a chorus of 'Unite-*edd* Unite-*edd*, die on their lips before they've even begun. Where's Jimmy Nail when you need him, eh? Newcastle today is so dead that I decide to tell my Jimmy Nail story ...

I've met Jimmy Nail twice. The first time was an interview for now-defunct music magazine *Melody Maker* around the time he released his first hit, a cover of Rose Royce's "Love Don't Live Here Any More", in the mid-Eighties. He'd become a huge TV star in *Auf Wiedersehen, Pet*, where his dour, hard-man Geordie image helped foster a mean reputation and, the first in a long line of interviews arranged for him that day, I was a tad nervous.

The PR ushered me into his presence in the Virgin Records board room, and Jimmy peered at me with that trademark scowl, casually shook hands and looked irked as I set up my recorder and pushed it under his nose. I asked him a vacuous opening question and he pushed the tape recorder back at me. Then he leaned forward, put his hand on my arm and asked the magic question ... 'You don't fancy a pint, d'ya?'

On balance, I felt it would have been rude to say no, so we snuck out of Virgin Records without a word to anyone and wandered round west London looking for a nice boozer. We found one, too, up a quiet little side street, and slipped into a corner. Jimmy got the pints in while I set up my tape recorder, and we were away. He turned out to be a reluctant interviewee but a good one, telling me the story of his wild nights out in Newcastle, his accidental involvement in *Auf Wiedersehen, Pet* and his secret life as a rock'n'roller.

I got another round in and he loosened up a bit more ... then he got another round in and started getting a bit indiscreet ... then I got another round in and he became my best mate in the world ever ... then I spilt beer over the recorder, so we thought we'd better have another pint to assess the damage ... then I ran out of tapes so we had another pint wondering what to do about it, but I can't remember who bought that one.

Then the barman closed the bar. This was in the days of the old licensing hours, when pubs shut at 3pm, and we were well past that. Jimmy said we should maybe leave as he had another 18 interviews to do that afternoon, so we tried to assemble our coats and bags from their disorganised heap on the floor and negotiate as dignified an exit as possible for two ratted blokes talking bollocks. We rattled on the door for a few minutes before realising it was locked. So we sat down again to recover our breath ... just in time to see the landlord bringing a couple of fresh foaming pints to our table. 'Here you are, Jimmy,' he said. 'The doors are locked, but you and your friend are welcome to stay as long as you like. Drinks on the house ...'

Phew; a real live celebrity lock-in! So we had another pint. Then another. Then another. The landlord just kept on bringing them. He got his camera out to snap us, brought his family to meet us, and sat down with us as we lapsed into Swahili and started howling at the moon. The pub reopened for the evening session and we were still there. The locals came in, pointing and saying, 'Look, there's the big geezer from that show on the telly', and bounded across to shake hands and clap us on the back, buy us drinks, and ignore the fact that we were almost comatose.

Then one of them made a vaguely racist remark about a black lad he reckoned caused a bit of bother in the bar last night. Jimmy was on his feet like lightning, ready to take on all-comers. He stood there for a moment, swaying and waving his arms around and gabbling about racist bastards, lurched to the door and stomped off into the street. I stumbled after him but fell flat on my face, and was helped to my feet by his distressed PR, who had been tramping the streets for the last three hours trying to find us.

I never saw Jimmy Nail again. Well, not for seven years anyway. Then, out of the blue, I got a call from the same PR at the same Virgin Records. They'd got a new Jimmy Nail record coming out, she told me. They needed a biog to send out to the press ... and Jimmy wanted me to write it.

By now Jimmy Nail had his own office, and as I waited there to interview him about his new record I wondered why I was the chosen one, and if he would remember our last meeting or would mention *that day*. In fearful, darker moments I wondered if there would be a son of *that day*. Suddenly he was there, framed in shadow in the doorway. I'd forgotten how big he was and, bearing down on me from a great height, he looked quite intimidating. 'I'd just like to say,' he announced gravely as I rose to greet him, 'I haven't touched a drop of alcohol since *that day*.'

Sadly Jimmy, I said, I can't say the same thing.

But the boat hasn't come in, there's no Jimmy Nail here and the city centre's a dead duck, so let's go for a meander around some of the famous outskirts. We start at Blaydon, of course, the subject of the Geordie anthem, "Blaydon Races". A race meeting was held at Blaydon until 1916, when a riot broke out after a winning horse was disqualified and the event was discontinued amid allegations of fixing. The only races at Blaydon these days are on foot. Victorian music hall artist Geordie Ridley from Gateshead wrote the song describing his coach journey from Newcastle to Blaydon in 1861 to attend the races, only to discover they were cancelled due to a heavy storm. He first sang the song at a testimonial for a Tyneside sporting hero, rower Harry Clasper, at Newcastle's Balmbra Music Hall the following year.

Our tour of the outskirts also takes in Gateshead, which now boasts the new Sage Theatre complex, which is promoting local culture in vigorous fashion. And Jarrow, starting point of the 1936 crusade, where 200 unemployed men began the march to London in protest at the crushing unemployment and poverty endemic in the north east. And Byker Hill, which gives you a memorable view across Newcastle city centre without offering much information about the fun colliery song it inspired.

I do, however, meet a clever person who tells me the origin of the term 'Geordie' to describe someone from Newcastle. It all dates back to the early eighteenth century, apparently, when Northumberland stood squarely behind the Scottish Jacobite rebellion. Well, all of it except Newcastle. Newcastle declared itself loyal to King George, and ever since then Newcastle folk have been called Georgies or, in the local vernacular, Geordies.

We plough on north and check in at the White Swan in Alnwick; a

hotel full of memorabilia and furniture rescued from the *Olympic*, the forgotten sister ship to the *Titanic*. Conceived to be bigger and better than the *Titanic*, she turned into Cinderella, being commandeered for work in the Great War and then swiftly forgotten as faster and more luxurious liners were constructed.

Alnwick – pronounced *Annick* if you know what's good for you – is also home to Barter Books. You can't go to Alnwick without visiting Barter Books, and that's an order. Situated in the old Victorian railway station building at the top of the hill, it is surely the biggest – and probably the finest, too – second-hand bookshop in the land. Founded by Durham businessman Stuart Manley and his American wife Mary in 1991, it encourages you to lose yourself in the endless shelves and passages, where the old gents' first-class waiting room houses rare books on history and topography, and the ladies, waiting room has the oversize books. The waiting room used by the plebs now offers its customers papers to read, a nice coal fire, coffee, biscuits and a Nick Drake soundtrack.

So the deification of Nick Drake has even made it to Northumberland, eh? Don't get me wrong, it's preferable to the normal muzak pumped out in shops, but there was a reason Drake was totally ignored in his own lifetime, and his Messiah-like rediscovery is surely based on the image of a troubled, sensitive, misunderstood, good-looking young guy who died tragically young in mysterious circumstances rather than anything to do with his obtuse songs. You want to get rhapsodic over a tragic singer songwriter? Go check out Phil Ochs, or Tim Hardin, or Tom Farina, or Stevie Goodman ...

Anyway, this gorgeous railway station got the chop in the cuts made by the evil Dr Beeching (boo!) in 1968, and one Stuart Manley has launched the Aln Railway Project to restore the old Alnmouth–Alnwick branch line and the station with it. I end up spending £25 on an old book about Grace Darling ... which leads nicely into our next point of call.

Seahouses is fast asleep when we arrive, as it is when we leave. It's a small fishing port that clearly minds its own business and hopes we do the same, but it does have one notable attraction: we can get a boat out to the Farne Islands from here. Well, not *today* we can't, apparently, but we've done it before and returned with a tale that's fascinated me ever since: the story of Grace Darling.

The seventh of lighthouse keeper William Darling's nine children, Grace was raised in, and lived her whole life in, lighthouses off the Northumberland coast. She was 22 when the steamboat *Forfarshire* was wrecked in the middle of the night, during a fierce storm on the treacherous Farne Island rocks half a mile from the Longstone

Lighthouse in 1838. Accounts from that point vary enormously and it's hard to decipher fact from romantic legend, but Grace Darling raised the alarm, rousing her father and insisting on accompanying him as he launched a lifeboat on a dangerous rescue mission. In cruel, hostile conditions they managed to row out to the *Forfarshire*, rescued five survivors of the wreck, and got them back to Longstone to safety.

To those guys whose lives were saved, the slight Grace Darling, struggling through the pounding rain and roaring waves to rescue them, must have seemed like an angel of the night. That's the way they told it, anyway, when they got back to dry land, and by the time the press got hold of it, Grace was a national heroine.

At a time when the first rumblings of votes for women and female rights were under way, here was a direct gender role-reversal of the old fairytale of the knight in shining armour saving the helpless damsel in distress. And Grace was virtually elevated to sainthood overnight. *The Times* even asked this question: 'Is there in the whole field of history, or fiction even, one instance of female heroism to compare for one moment with this?'

Everybody wanted a piece of Grace Darling. She had marriage proposals, requests for personal appearances and locks of her hair, books and poems written about her, fan club members arriving from nowhere wanting to meet her, portraits painted of her, and constant media interest. It's hard to know what effect that would have on a young girl who'd spent her entire life living at the top of a lighthouse on a remote island off the north-east coast, but for whatever reason, Grace was a reluctant, wary superstar. The nineteenth-century version of the paparazzi and the tabloid press got little joy out of Grace, who seemed utterly bewildered and not a little scared by all the attention, but whether she liked it or not (and 'not' seems to be the answer) she was a national icon.

There have been claims that all the pressures of fame caused her death in Princess Diana fashion, for despite her hardy upbringing and her heroics that night rescuing those men on the *Forfarshire*, Grace was actually quite delicate. In 1842, just four years after the famous rescue and still aged only 26, she died of tuberculosis.

Naturally we hare off up the road, past the spectacular Bamburgh Castle ('Sorry – closed today') to visit her tomb facing the sea at St Aidan's Church in Bamburgh. It's hideous. Railings protect a large stone sculpture of a woman lying on her back with an oar in her hand above an inscription telling her story. The coastal backdrop is dramatic, but as a monument to a national heroine who lived such a frugal, remote life, you wonder how they came up with something as grotesque as this.

In need of spiritual sustenance we plough on to Lindisfarne – Holy Island. It's an unyielding, freezing, exposed spot today. Any remnants of the pints sunk in the bar watching some awful blues band knocking the living daylights out of Cream, Hendrix and Canned Heat in Alnwick last night are decimated in the torrential wind. Even that dodgy mead wine they dish out to sample in the tourist shop is downed in one as a desperate defence against this particularly vehement cold.

Climbing the hill up to the castle, I'm immediately sent into a blind panic that I hadn't really read the signs about tide times properly on the worryingly low causeway crossing on to the island, and will end up stranded here until the morning. It's nice but by God it's bleak and loveless, and I couldn't imagine a lonelier place to be holed up in without a woolly hat. No wonder all ye who entered here embraced religion when the King of Northumbria dispatched St Aidan in 634 to evangelise the north east.

Naturally we find the castle is shut when we make it to the top – something about being closed for sedan chair racing training? So we hide among the lime kilns for warmth and watch the fishing boats, then make a dash down into the village to buy a beanie hat and sink another free glass of mead. Sally's, the confectionery shop, is shut, but the handwritten sign on the window is reassuringly informal: 'We're open weekends for sure and the occasional random day, but not sure which ones yet.' There's also a picture of Sally meeting the Queen in 1958, but as she was the island's oldest resident even then, I don't hold out much hope that she'll come bounding out to invite me in for a warm by the fire and maybe a nice glass of brandy.

So we move on and we keep right on to the end of the road until we reach the most northerly town in England – Berwick. One bridge too far and we'd be across the Tweed into Scotland. Indeed, there are plenty of times through British history when we *would* have been in Scotland. Berwick changed hands 14 times between 1174 and 1482, and Berwick Rangers, whose small ground we pass as we drive into town, still play in the Scottish league.

It still has the slightly sinister edge that characterises most garrison towns and the wild, weather-beaten look of somewhere on the verge of tumbling off the edge of the country at any moment … yet I instantly like Berwick. After all those centuries being tossed from one side to the other like a tug-of-love child, in which time it clearly acquired many scars, there's a real hardy spirit about the place and it's making a determined comeback. That's what the guy in the Brown Bear reckons, anyway.

'It's a great place to live, it's just that not many people know it yet,' he tells me. 'It feels special, being right on the border like we are.

That's the thing; this town has always had to fend for itself, and it has learned to look after itself. We're not part of Scotland but we get forgotten by England; it feels like being stateless. You get all this stuff about arts in the borders but it all comes from the Scottish Tourist Board, so it's all about stuff on the Scottish side. You'd think nothing went on at all on the English side. The Scots know how to promote their culture a lot better than the English.'

We climb up on to the ramparts overlooking a particularly vicious-looking sea and head off on the Lowry trail around the Elizabethan walls protecting the town. It seems Lowry, bless him, took quite a shine to Berwick and spent a lot of time here sketching. He usually stayed in the Castle Hotel, and talked of buying a house up here by the wall. In the end he decided against it – rising damp, or something – so he did a picture of the house instead. It's since been restored and is still here, with two lions over its gateway, watching out across the sea beyond the allotments. The football pitch is just below us on the exact place where a moat used to run outside the walls. This football pitch inspired Lowry more than once; one of his Berwick works, 'Going to the Match', painted in oils in 1953, sold for £1.9m in 1999.

We carry on down along the border and pause briefly at Norham, described by Sir Walter Scott in his poem 'Marmion' as the most dangerous place in Britain because of the vehemence of the Anglo-Scots tensions there. The castle ruins don't look too enticing (and are closed, anyway), and right now Norham looks about as dangerous as a gerbil, so we point Alberta at Flodden.

Now Flodden Field really *is* scary. There's barely a sign to guide us through the maze of country lanes that bring us in direct combat with a platoon of kamikaze pheasants and a series of potholes that wouldn't be out of place in the Grand Canyon. As tourist attractions go, this one is decidedly low-key, as perhaps befits one of the darkest events in British history. There are lots of fields – there's nothing *but* fields – but not too many clues about *which* of those fields was drenched in English and Scottish blood in September 1513.

We try another tack and climb Flodden Hill from the other side of the village of Branxton. Eventually, we find the battle path leading up to a forbidding memorial at the top of the hill, paying tribute to those who died from both sides of the last great battle between the English and the Scots. James IV of Scotland had felt duty bound to attack the English to honour an old alliance with the French, which was invoked when Henry VIII prepared to invade France. The 30,000-plus Scottish soldiers who marched on Flodden represented the biggest Scottish army in history, even if they did lose a large number of deserters en route.

After crossing the Tweed at Coldstream, they spent 14 days

reaching Flodden, which suggests Mrs Colin was navigating and by which time even the English had got wind of the fact that they were on their way. Now, I don't know much about war, but the next bit seems very strange. Led by the Earl of Surrey, the English sent their people to meet Scotland's people to have a nice chat about the arrangements. You might have thought they'd be negotiating a way out of this crazy notion of killing each other and maybe decide to settle their differences with a wheelbarrow race, but all they wanted to do was set a time and place for the battle.

The English wanted to hold it up the road at Milfield Plain – presumably because the grandstand was bigger and it would look better on Sky TV – but the Scots had already encamped at Flodden, liked the view, and insisted they do the show right here, right now.

So in foul weather at 4.15pm on September 9, 1513 the medieval equivalent of David Elleray blew his whistle and the first cannonballs were fired.

The battle lasted only a couple of hours. The Scots fought like men possessed and initially scored some big hits but the accepted wisdom is that, carried away by his early successes, James let his heart rule his head and charged, crazily, downhill into the English forces. Slithering down in the wet and trapped in the bogs at the bottom, the Scots were slaughtered by Surrey's surrounding troops and James was among the casualties. He was later found with deep wounds across his face, a hand almost severed and a body stripped naked by looters.

I'm looking across this vast, desolate area and trying to get my head around the fact that over 9,000 Scots and several thousand Englishmen died in two hours of carnage here, when there's a voice behind me: '*TheScotsheeranddeathdidhappenwhicharmykilledfirst?*' Eh? '*Whenkingandmurderbloodbowandarrow. Yes?*' He seems to be a pissed Scandinavian who was taught English by Ozzy Osbourne. I nod and agree: 'Yes, oh yes.' He jabbers away some more, and I look at his mad, staring eyes, his thick Viking beard and his macho black leather jacket and wonder if he's challenging me to re-enact the battle.

Scando-Ozzy babbles some more, and I nod and smile in a conciliatory fashion, the way we're all told to do when Martians are landing. Where did he come from? How did he get here? '*EnglishmanyesyouluckyupthehillwetdaybeenchurchHenrykingeightbigpigyes?*' He guffaws loudly, thumps me across the back, beams, adjusts his jacket, turns on his heel with a quick bow and disappears into the mist. It's all very odd. My moment of epiphany and marrying Englishness with my Scots ancestry lies shattered at Flodden Field.

Ah, yes, my Scots ancestry. My great-grandfather was born and bred in Glasgow, played football for Queens Park and was quite a lad appar-

ently – a drinker and philanderer, and something of a black sheep. My grandmother also had Scots blood. She was a MacDonald, so even today I feel duty bound to hate anyone called Campbell.

Further south, we decide to look for Billy Pigg. He died in 1968, but I've absorbed enough of Northumberland by now to feel the spirit of his piping through the farmlands we pass, the hillsides we admire and the people we meet. Everyone loves Geordies, and the gentle passion of the people soon seeps into your consciousness; it suddenly feels OK to be unashamedly sentimental. So serene, so graceful, so nimble, so spirited; I can hear pipes in the air. For if there's an instrument completely at one with its own environment or better equipped to express its character, it's the Northumbrian small pipes. The pipes *are* the sound of Northumberland.

So driving through this gorgeous countryside now, images of Billy Pigg, the king of Northumbrian pipes, loom large. I'd talked to Richard Thompson about him. You wouldn't imagine that Richard, a singer-songwriter from a rock background noted for his searing electric guitar runs, would have much to say about Billy Pigg, but he told me that Pigg's *Border Minstrel* album had basically changed his life.

'I had no idea English music could sound like *that*,' he said. 'It was the first time I'd heard an English musician playing with real soul. I'd grown up listening to American music and I thought soul belonged to people like Howlin' Wolf, but suddenly I heard someone who played with the same passion that Maria Callas sang. I learned a lot about connecting to traditional music through Billy Pigg.'

So we skirt the magnificent Cheviot Hills and enter Pigg country. We make a brief pause at Otterburn, the scene of another famous England v. Scotland clash, and where they're now advertising belly dancing lessons on Wednesday afternoons. Driving into the hills through Elsdon we spot a sign for a gibbet, and naturally follow it along a drove road where cattle were once driven from Scotland to the English markets. Pheasants scatter and three impossibly fat bearded cyclists struggle up the hill, steam coming out of their noses. We are impressed that they still find enough breath to gasp good day to us. And at Whiskershields Common, over a stile, ploughing through the mud opposite Harwood Forest ... we find the gibbet.

Excluding being exposed to John McCririk in his undercrackers on *Celebrity Big Brother*, this is the most revolting thing I've ever seen in my life. It's a huge scaffold stretching to the sky ... and from it dangles a severed head. From a distance it looks so real I almost throw up, and I can barely bring myself to take a second look until Mrs Colin assures me it's merely a carved face. And so it is, but still ... it's a disturbing sight after a night on the beer. The gibbet creaks, the wind howls, and

there's something unspeakably unseemly and incredibly eerie about the whole place. I'm thinking *The Wicker Man* again.

The more I discover about it all, the weirder it gets. The face on the barrel is an effigy of William Winter, who was hanged in 1791 and left here to rot in sight of the place where he'd murdered 'old Margaret Crozier'. It seems Winter wasn't a terribly nice character at all. He'd spent much of his life in gaol, and his father and brother had both been hanged already for various offences.

Winter and his accomplices, Jane and Eleanor Clark, gruesomely murdered poor Margaret Crozier in an attempted robbery at her home at Raw Pele. She was found with her head caved in, but she was also strangled *and* had her throat cut, so they weren't leaving anything to chance. They were convicted by a schoolboy who'd witnessed the whole thing; a boy who later achieved a grimy sort of celebrity when publicly applauded for his observation skills regarding the murder by Lord Baden-Powell in his book *Scouting for Boys*.

The guilty were hanged at Westgate, Newcastle, by William Gardner, who was himself facing the death penalty for sheep stealing, but agreed to hang Winter and his accomplices in exchange for his life. When it was done, the bodies of the Clarks were sent to a surgeon for dissection, but the body of Winter was returned to the scene of the crime and left here as a very public deterrent for everyone to see. They say it was left hanging here for ages until Winter's clothes rotted and his body started disintegrating. The gibbet itself also rotted because people kept scraping splinters off it to rub on their gums in the belief that it would cure toothache. They were indeed very odd times.

You'd imagine they'd have quit while they were ahead, but they just wouldn't let it lie, and in 1867 a replica gibbet was built, along with a sculpted wooden body to hang on it. It became a local sport for people to take pot shots at it; the body eventually disappeared, and the only thing left was the head. This in turn has been liberated at regular intervals but a replacement has never been far away. The one that's currently making my stomach turn somersaults has been there only since 1999.

Feeling distinctly queasy we continue the journey into the Pigg country of the Cheviot Hills. Billy Pigg was originally from south of the Tyne – his father worked on Lord Allendale's estate – but the family moved to Blagdon on the Great North Road out of Newcastle. His first instrument was the fiddle and he didn't take up the pipes until he was 18, regularly cycling a 12-mile round trip to Newsham to take lessons in the kitchen of the 'Prince of Pipers', Tom Clough. Pigg became a motor mechanic and a bus driver, but his piping quickly turned him into a local legend. He was eventually banned from compe-

tition playing – he became a judge instead – because nobody else stood a chance.

We meander round the tiny village of Hepple, where Billy lived for 22 years at Wood Hall Farm, looking for signs, but nothing stirs here today. There are no plaques saying 'BILLY PIGG LIVED HERE', no outward signs of life at all, but I still hear his wild, intoxicating, rhythmic playing echoing through the Cheviots around us.

It has been on its knees a few times down the years, but in this remote, unchanging, highly distinctive outpost of the country, Northumbrian piping represents one of England's few unbroken traditions. It's a tradition now in ebullient health thanks to the work of the Northumbian Pipers Society and others, with many fine young players emerging, partly as a result of the recently instituted folk degree courses at Newcastle.

One of the part-time tutors there, and an inspirational figure for the new young generation of pipers, is our friend from earlier in the journey, Kathryn Tickell. She was actually born in Lincolnshire, but the family background was Northumbrian and many of them were musicians. Despite this, Kathryn grew up with only two records in the house – one was of organ music from Durham Cathedral and the other was Billy Pigg's *Border Minstrel* LP. It affected her as much as it did Richard Thompson, and made her want to play the pipes.

'His playing was just so … wild and *exciting*,' she tells me. 'The general nature of Northumbrian pipes is a very staccato sound with no dynamics, and it's very hard to get a feeling of swing into it. It's easy to play Northumbrian pipes technically correctly, but to get real feeling into it is much harder than on something like the fiddle. Billy Pigg just had incredible *feeling*; the way he played was wild, inventive and original. Was that genius or did he just speed up and lose the rhythm and invent this style? He also seems to have been very open-minded; he had no qualms about incorporating other bits of music into his playing, and he moved the music on.'

Kathryn started playing at the age of nine, winning every small-pipes and fiddle competition going (and there are lots) by the time she was 13. She released her first LP, *On Kielderside*, when she was 16, became a professional musician soon afterwards, and has gone on to many glories. At one time appointed official piper to the mayor of Newcastle, she has also worked with everyone from Sting to jazz saxophonist Andy Sheppard.

Kathryn spent a lot of time playing informally with the older musicians of the area, striking up a firm, enduring friendship with piper Joe Hutton, mouth organist Will Atkinson and fiddle/box player Willie Taylor. These three Cheviot shepherds gained national fame in the

Seventies, performing together at many concerts and festivals after being promoted by concertina icon Alistair Anderson.

Willie guested on Tickell's *Northumberland Collection* and *Back to the Hills* albums and was a character-and-a-half, overcoming many afflictions to achieve his reputation as one of the area's greatest musicians. The first finger of his left hand was severed during an argument with a turnip chopper, and he suffered arthritis and paralysis in the tips of his other fingers after dropping a rock on them ... but this didn't stop him at the weekly village dances in the Wooler area. He professed to hate the fiddle and refused to play it for many years, but picked it up again in later life and continued playing right up to his death in 2000.

'He was a fantastic character and a close friend; I still miss him,' says Kathryn, recalling the duets they played together in the front room of his home at North Middleton. 'I believe the music is fundamentally important to the way people see themselves here. If I drove out with my uncles and family or Willie and Joe (Hutton), there would be a constant commentary on every field or farm, the people who worked on it, and their families. It's part of who we are; it's a constant and it makes a connection. I feel very privileged to have such a background.

'For many years I was very definite that I wasn't playing English music or English pipes; I was playing *Northumbrian* music. It wasn't a militant thing but I was serious about that – English music at the time seemed to bear no relation to what I was playing, especially as there's always been a big crossover between Scottish and Northumbrian music. People thought I was being very radical, but it was just how I felt.

'I still don't think I play English pipes, but perceptions of English music are changing now, with the way people like Eliza Carthy are playing the old English tunes, and my attitude is mellowing. Yes, of course we're English, but we feel so removed from the centre of power, and close enough to Scotland to be forgotten about. We feel marginalised, but that draws you closer together ...'

Amen to that. So we take one long, searching look back at those breathtaking Cheviot Hills, listen to Billy Pigg playing "The Wild Hills Of Wannies", and turn Alberta around to take the low road south.

CHAPTER TWELVE

Mined – The Gap

'It stands so proud, the wheel so still
A ghostlike figure on the hill
It seems so strange, there is no sound
Now there are no men underground ...'

"Coal Not Dole", Kay Sutcliffe

A minor miracle occurs in Durham. We find it.

This is a first. For once, the map hasn't sent us off on a wild goose chase to Consett or Peterlee, and we arrive in the compact, attractive city shaking hands with each other and pinning Vasco da Gama badges on our lapels. We are talking about entering the national orienteering championships when we realise we've been sitting in the exact same spot on the road into Durham for 20 minutes without moving. The city is jammed, and the glimpses of bandsmen in their smart maroon jackets and black trousers and colourful banners disappearing up side roads give us a clue why.

It's Durham Miners' Gala Day. 'Miners? *Miners?*' asks my friend Dave, when I tell him later. 'There aren't any left, are there? *Are* there?'

Well, there are one or two, as it happens, and a lot of others who *used* to be miners, converging on Durham just as they always did when they had jobs, to march through the city behind their banners and their brass bands, have a few songs and speeches and a bit of a craic, and generally gesture to the world and to each other that, while the mines may mostly be gone, their spirit survives. They have never lost their dignity, even though the last mine in the north east, at Ellington, has been earmarked for closure this year.

We queue for an hour to get in the car park and then can't find our way out and spend another 20 minutes wandering around the concrete void attempting to find an escape route. A kindly man takes pity on the thick southerners and escorts us out through a series of fire escapes,

underground passages and secret doors. 'Here for the gala, are you?' he asks politely, pronouncing it 'gay-la'. 'Oh aye, it's a proud day. It's not how it used to be, like; in the old days, you couldn't move in the city, there were that many people. There used to be coaches from all over: people dancing in front of the banners, like. Everyone would arrive first thing in the morning and stay all day. It were a great occasion. Labour leader always used to come. I don't s'pose we'll be seeing Tony here this year, mind. Not if he knows what's good for 'im, eh?'

As he starts guffawing at his own wit, a passing woman, laden with shopping bags, earwigs the conversation and joins in. 'Ah, the gala,' she says wistfully, also pronouncing it 'gay-la'. 'I remember when I used to live out in Wingate; we'd get up early in the morning to come in on the bus. I'd be carrying all the kids trying to get on this bus and it was packed out, we were all squashed in like. One time I slipped a disc in me back. I couldn't move. Stuck on the bus with all these people and I was just ... *stuck*. Great days ... great days.'

I don't know what it was like in the old days but it's still pretty packed outside the County Hotel now, as the Fishburn Band belt out some lively old jazz stomper while a group of cowgirls in pink tassels kick their legs, Tiller Girl-style, in time to the music and somebody else sticks a yellow I HEART CO. DURHAM on my chest. 'It's not like the old days, but it can still get lively,' says the woman in the paper shop as she watches brass bands clamber out of the coaches parked outside. She points to the bridge over the river: 'Every year we get idiots jumping off the bridge pissed, and they end up having to be rescued. Some come here on the coaches and never get out of the pub.'

I'd remembered Durham as an unusually attractive city with its glorious cathedral, fine castle and rich sense of history, and it has lost none of its dignity and splendour. The weather is dull but the small city is ablaze with colour and music. The narrow streets throb to the squeals of the children, the pounding of the bass drums and the cheers of the crowd, and the lines of lodges march proudly behind their banners: Greenside ... Eppleton Lodge ... Trimdon Grange ... Shotton ... Silksworth ... Easington ... Whitworth Park ...

The *Morning Star* salesman is grinning as if his face is hosting its own stand-up show, while *Socialist Worker* roars 'LABOUR'S POLITICS OF THE GUTTER' on its front page. You can almost see the years roll back as the marchers return – if for one day only – to a more familiar world where dreams were in black-and-white and idealism wasn't a vote loser. It feels like the Eighties again, and there's a real sense of joy about the place as the old battle cries are dusted down, the brass bands play "The Red Flag", and the mineworkers and their supporters walk on with hope in their hearts.

We join the flags as they march up to the old racecourse ... straight into the booming voice of Billy Bragg. He's talking about his days playing the coalfields during the miners' strike of 1984, and the Red Wedge collective of pop stars who'd assembled to see if music really could change the world – or at least a small corner of northern Europe – and get the Tories kicked out of office. He remembers one time in particular when he followed an ex-miner, writer and singer, Jock Purdon, on stage.

'I was a Clash fan, and I thought I knew the way of the world and I was supercharged and political,' says Billy, 'but that day I realised the folk world had got there before us and were more political than we were, and I had to change my perception of folk music and the tradition. So coming here today reminds us there is more to this job than just getting on "Pop Idol", and that there are other things to connect with people.'

It's the twentieth anniversary of the miners' strike, and its emotional fall-out is everywhere today. A string of speakers recall its impact and the roles of the main players in the drama. A venomous barrage of boos greets every mention of Margaret Thatcher and Ian MacGregor, the American 'union buster' installed as chairman of the Coal Board by Thatcher. There is a standing ovation when one of the speakers wistfully speculates about the death of Thatcher and dancing on her grave; there's measured applause for Arthur Scargill, the mineworkers' leader during the struggle; and there are wild cheers for every reference to unions standing shoulder-to-shoulder on the picket lines. Mention of New Labour, Tony Blair and the current government elicits a low rumble of mixed responses amid an endless debate about whether or not the unions should cut off all ties with the Labour Party. 'I'm not New Labour *or* Old Labour, I'm *organised* labour,' says Billy Bragg.

Unequivocal star of the show, though, is Bob Crow, general secretary of the railway workers' union, RMT. He could be a Harry Enfield parody of the old union hardliners, his speech rapidly accelerating into such a frenzied rant you'd lay odds his head will explode any moment. He's like a Cockney stand-up ...

'I've had the *Daily Mail* camped outside my door, following me around, taking pictures, trying to catch me out ... and you know what? I'm *glad*. And you know why it makes me glad? If the *Daily Mail* is trying to get me, it means I'm doing something right!' There is no appeasement policy with New Labour here. Bob wants Tony Blair out and he wants the rest of the cabinet out too. 'Tony Blair is a war criminal and everyone else in that cabinet is a war criminal for what they did in Iraq ...'

He's among friends here – you might call it the last bastion of Old

Labour – but, even here, his fever-pitch hyperbole is turning him into the cartoon loony left of popular Tory propaganda. I mean, I applaud and agree with an awful lot of what he says and his speech is hugely entertaining, but I still turn away thinking that he's got a screw loose.

The most emotional moment comes when the whole congregation stands in silence to remember those who lost their lives underground as the Fishburn Brass Band play the the miners' hymn, "Gresford". It was written in response to one of the worst pit disasters ever, when 262 miners were killed following an explosion at Gresford Colliery, Wrexham in1934. The pit was closed down in 1973.

As I listen, head bowed, to the mournful hymn, it brings home with a sudden jolt what this industry, indeed what this whole day, is all about. It's about small communities shaped and driven by an industry built on hard toil, grief, danger and tragedy; communities that had unity, common bonds and shared struggles; communities brutally ripped apart by Thatcher and MacGregor in the events of 1984 and beyond.

Yet beyond the hyperbole and the nostalgia and the emotion and the anger, this is a cracking day out. The people here are extraordinarily friendly; happy to tell their stories and flog you some memorabilia. The gala – or 'The Big Meeting' as some call it – has survived over 120 years, and those involved aren't going to stop coming just because of a little thing like most of the coal mines being closed down. As far as they're concerned, survival, solidarity, defiance, pride, dignity and sense of history are still well worth celebrating. And watching them cheerfully share their stories, crack their jokes, sink their pints and catch up with old comrades, I think they're right.

There are various stalls and sideshows to add to the communal family spirit. They are selling, among other things, old copies of the NUM's *The Miner* magazine, which catalogues a long list of grievances against the police. 'ONE-ARMED MINER FINED FOR "ATTACKING" POLICE AGENT' reads one memorable headline: '*A one-armed bespectacled miner has been fined £300 for allegedly attacking a policeman who is well over six feet tall. Mr Paul Brewster, a 24-year-old lamp-man at Yorkshire's Treeton Colliery, was accused of head-butting PC Smallman at Orgreave coking plant. Mr Brewster is five foot nine inches tall and the inappropriately named PC Smallman is six feet four inches …*'

And I meet motormouth Ken Ambler, a walking history of the pits, and get the full, animated blood-and-thunder story from the front lines of Selby and Wistow. Running battles with the police, camaraderie on the picket lines, rows with scabs, hardships of the family … Ken talks me through his experiences of the 1984/85 dispute. He details the background to the strike, including the sudden announce-

ment, without warning, that Cortonwood Colliery was to close. He talks contemptuously of the Nottingham miners who caved in and failed to back the strike. He speaks warmly of meeting Arthur Scargill. He spits venom at the 'scabs' who crossed picket lines on a daily basis to keep the mines open. And he recalls, rather fondly I fancy, the various times he took a pop at the police and got arrested.

'Weren't local police that caused the bother, it were the outside forces that come in knowing they could run riot in our area and then they'd go home to Manchester or London,' he says. 'One of our top police, 'e knew this were happening and 'e told the London men that if this carried on 'e'd make sure they'd go back and din't come here again. They got paid a lot of money, see. I seen some of 'em; they had t-shirts made up, and printed on them was ASPOM. It stood for "Arthur Scargill Pays Our Mortgage".

'I got me own back though ... I belted one of 'em and if 'e didn't have his visor on, his jaw would've been flattened!' He cackles with laughter at the memory. 'It were his fault, 'e come at me with 'is idiot stick. I had no choice. Then another one come running after me, and if I din't jump over this bloody barbed-wire fence and go down the railway embankment, he'd have caved me 'ead in!'

Ken was arrested four times, and his favourite was for an assault on a Manchester police inspector. 'I got fined £150 for that one,' he says proudly. Then, with a twinkle in his eye ... 'T'were worth every penny! I gave him a right whack! In fact, t'were worth £500, that one!' There's that explosion of laughter again.

Ken has written his own breathless, 'What did you do in the miners' strike, Daddy?' account of it in a highly readable yet still inflammable book called *A Coalfield in Chaos*. In it he explains his philosophy with a rather touching parable. 'I have two hands. In one hand is a thousand pounds and in the other is a friend, and I have to choose which to pick. If I pick the money I could spend it in a day, but if I look after my friend I have got him for ever ...'

Next day we explore County Durham some more. I pull up at Trimdon to inspect a strange, incomprehensible sculpture stuck – seemingly at random – on a patch of green in front of someone's house. I'm thinking it may be some sort of miners' memorial, but the resident, Joan, is quickly out of her house to put me right ... sort of. 'No, I've no idea what it is, either. Something to do with the millennium; it just appeared there one day. There were supposed to be a Maltese cross on it, but I think they ran out of money ...' Her mate studies it, but isn't so scathing. 'You're lucky; you should see the one at Fishburn. A monstrosity it is; a *monstrosity*.'

Trimdon Grange is writ large in my psyche, and it's mainly due to

Tommy Armstrong. Described by A. L. Lloyd as 'a small, lively, bow-legged man with a huge family and an indomitable thirst', Armstrong was a Durham miner, who had a sideline as a song-maker; he sold cheap prints of them round the pubs at weekends for a penny a time. Born in Shotley Bridge, Armstrong was nine when he first started work in the pits in 1857. His brother William carried him to work on his back because Tommy's crooked legs were so painful. He worked first as a 'trapper boy', sitting in the dark all day opening and closing the ventilation doors to allow the colliers and the coal through. Then he graduated as a 'pony boy', leading the ponies that pulled the mine wagons that carried the coal. He reckons the first songs he sang were to the ponies, 'just to show them I wasn't as bad as I seemed'.

He quickly graduated to people, and his topical ballads depicting the daily lives of miners and the local community in witty, barbed lyrics earned him the title of the 'Bard of the Durham coalfields'. Using the dialect of that community, his subject matter ranged from practical jokes ("The Hedgehog Pie") to the Tyne flooding ("The Sheel Raw Flood") and memorable nights in the pub ("The Ghost That Haunted Bunty"). He also wrote eloquent accounts of the hardships and struggles of the miners, with vivid portraits of the various disputes and strikes.

But the song I'm playing right now is Martin Carthy's relentlessly cold, rhythmic, intensely chilling telling of "Trimdon Grange Explosion". It happened early in the afternoon of February 16, 1882, when a massive gas explosion ripped through Trimdon Grange colliery, killing 74 people. No family in the area was left untouched by the tragedy. One victim was due to marry the next day, and was buried at the exact same moment he was due to be making his wedding vows; another was working his last shift before emigrating to America; and several of the dead were would-be rescuers from the adjoining Kelloe pit who were poisoned by the noxious gases. But over 70 people were rescued and one pit-worker survived as a result of being arrested in the pit yard for non-payment of a fine just as he was about to go underground to start his shift. Most of the victims were buried in a mass grave at Old Trimdon ...

> 'Let's not think about tomorrow, lest we disappointed be
> Our joys may turn to sorrow, as we all may daily see.
> Today we're strong and healthy, but how soon there comes a change
> As we may see from the explosion, that has been at Trimdon Grange.'

Within a few days of the tragedy, Tommy Armstong was singing his song in the streets and in local halls to raise money for the fund launched to help the widows and children ...

'Let us think of Mrs Burnett, once had sons and now has none
With the Trimdon Grange explosion, Joseph, George and James are
 gone ...'

We take a trip out to Tanfield and admire the majestic Causey Arch, the oldest single-arch railway bridge in the world, built in 1725 by Ralph Wood. But there's tragedy here, too. Worried that the arch would collapse before its completion, Wood climbed to the top of it and jumped to his death.

Tommy Armstrong spent most of his life in Tanfield Lea and we look for the Red Roe pub, where legend has it he held a 'sing-off' with a rival balladeer, William McGuire. The idea was that they met at the pub, where they were given a theme and told to make up a song on that theme. In a confrontation reminiscent of today's rap battles, they each had to perform their hastily written songs to decide who was better. On arrival at the Red Roe, the subject presented to them was the nearby Oakey Colliery. Oakey was in the throes of a bitter dispute at the time, which got *really* nasty when the striking pitmen were summarily evicted from their homes by the mine owners and their belongings were unceremoniously dumped on the streets by candymen – bailiffs recruited from the docks and slums.

The two balladeers drew lots to see who went first and McGuire started. If he came up with anything decent, it's long forgotten now; but Armstrong's winning effort, "The Oakey Strike Evictions", still stands as a classic of the genre, with a particularly telling chorus:

 'And what would I do if I had the power mesel?
 I would hang the 20 candymen, and Johnny who carries the bell'

Candymen were ruthless bailiffs hired by mine owners to evict strikers and their families from their homes; the bellmen identified the homes in question. The song has had some mighty cover versions through the years, too, from some of the north east's finest – Louis Killen, High Level Ranters, Jack the Lad, Tarras, the Hush and Whisky Priests among them. But they're missing a trick in Tanfield Lea. There are no Tommy Armstrong souvenir shops, no little cafes playing his greatest hits, no statue on the green, no references whatsoever. We can't even find a trace of the Red Roe. It looks like time to move on.

We head back across Birtley, home of Jack Elliott and one of the north east's best-loved singing families. Then we head east again, hit the coast at Ryhope, drive down through Seaham and arrive at Easington. At first, all seems well. The village district looks OK, as bright and busy as you feel it should be. But the visage takes a serious

turn for the worse as we turn Alberta out to Easington Colliery, on the other side of town. Easington was the last big colliery to close, in 1993, taking out 1,400 jobs. There are no outward signs of any of the much-vaunted regeneration programmes that are supposed to put these mining villages back on their feet and the whole ambience is of an area in freefall.

Just 15 years ago, Easington was a buzzing pit community, with all the social accessories that come with it. Now it's reduced to a husk, hushed and bowed before the might of the North Sea lashing against the rocks. The silence of the place is deafening. We walk around, desperately seeking excuses for optimism or lights at the end of tunnels, but there is none ... just lines of rundown blocks of flats, mortally wounded cars, and one or two kids skulking around the back roads with guilty looks on their faces.

You look across at the vast reclaimed void overlooking the sea and there are few clues to its former, frenetic existence; little indication that less than a generation ago, it provided the heartbeat of a tight-knit community. That community now appears to have been left to rot. There's such a thing as an index of deprivation apparently, and Easington – with unemployment set at around 40 per cent – features high on it.

We do manage to find a tree planted in 2003 by the chairman of the parish council to commemorate the tenth anniversary of the mine closing, but even that looks as if it's wilting a bit. The 'reclamation' scheme covering the pit with natural grassland has been so 'successful' that it's as if generations of working lives have been completely wiped from the records. We walk around trying to find the pit, imagining there would be some sort of memorial to mark the spot.

There is none ... so I ask a guy walking his dog. It turns out that, like so many locals, he used to work there. 'They closed it overnight, you know,' he says. 'One day we were working there as normal; the next we got our letters and they shut the whole thing down. Just like that. There was no warning, no discussion. They started dismantling the next day and that was it. A lifetime. Over.' What do you say to him? I mumble sympathetically, and ask if he's managed to find any work since they closed the pit. He looks at me pityingly.

'There's no work here. *Nothing*. I worked for over 20 years, but I'll never work again, that's for sure. The only thing going is casual labour at the crisp factory. You put your name down and you might get a few shifts but you're getting £4 an hour and working alongside staff earning £8 an hour ...' He points to the gloomy block of flats we'd passed earlier. 'There's lads living over there, lads of 30 who've *never* worked, and the way it's looking here, they never will.' His gaze

returns to the sea. 'What they *don't* tell you is that there's millions of pounds' worth of coal under there; good-quality coal. *We* knew that, *they* knew that, but they still closed us down and flooded it. They couldn't re-open it now even if they wanted to. And you know what they're doing now? They're importing cheap coal from Colombia.'

He shakes his head, and the dog cocks its leg in sympathy. 'It wasn't just us, like. Shutting us down ripped the whole place apart. Coal affects everyone. The steel industry, Marks & Spencer, Pretty Polly ... everything. Thatcher cut all our throats ...' He points out the sole, token remnant of Easington Colliery, a lonely pit cage jutting out at the top of the hill. We climb up to it slowly, reading a succession of signposts that tell the bare details of its life and death.

1930 *The Depression: partial closure.*
1945 *Nationalisation and unionism.*
1951 *Disaster: 83 killed.*
1964 *Record output.*
1970 *Strikes.*
1984 *Miners' strike.*
1993 *Closure.*
1994 *Pit shaft head-gear demolished.*

At the summit, we look back across at the bleak scene. There are rows and rows of colliery houses to one side; an unforgiving coastline on the other. Then I stare at the ugly black pit cage sticking out of the hill in a faintly grotesque fashion, and try to visualise its 60-second journey into the blackness below. There's a quote beside it from Ted Holloway, one of the 'Bevin Boys' who answered the call from Ernest Bevin for boys to help the war effort by going underground to cover the shortage of miners caused by the call-up for national service:

'*I found myself with ten others in the cage sliding down the deep shaft. At the bottom I stood knee deep in a pool of fear and glancing up the shaft I saw only a tiny saucer of light. The noise was deafening. The other men moved off. I was now a man, for a man's not really a man in Durham until he goes down the pit.*'

That's the dichotomy: the bitter irony of Easington and the other Durham mining villages. There can be few grimmer ways to earn a crust than getting up at the crack of dawn to spend your day in darkness under the ground, digging out the innards of the Earth. At best, you'll make it back to the top and have enough money and energy for a couple of pints and a decent life with your family. At worst, you'll end

up with lung disease, or the ground will cave in over you, or the whole thing will erupt around you, or poisonous gas will seep into the tunnel and gag you.

No wonder the National Union of Mineworkers has had such a long history of conflict fighting for a living wage, safety and acceptable working conditions. Yet that final evil, and ultimately unsuccessful, war with Thatcher and MacGregor in 1984/85 was all about the right to work. As hard, life-sapping and destructive as this life was, it was all they knew; it was all they had.

I talk to Jez Lowe, a forty-something singer songwriter of sharply crafted, socially conscious songs. Jez is from Easington. His dad worked down the pit earning £5 per week and they lived in one of the colliery houses here. 'It was very basic. We didn't have running hot water or an inside toilet. It was hard, but not as hard as some had it. We never wanted for anything.' His dad was buried in one accident but survived to tell the tale, and was working back at the pit again six months later. 'Well, they all did. You'd see them all, old and hobbling. That was just the way of life.'

Many of Jez's songs are inspired by the area and the mining life. One of them, "Those Coal Town Days", is specifically about Easington Colliery. He still lives in the area, and is shocked by the disappearance of the sense of community in his old home village: 'All the other mining communities seem to have come out of it and turned it around, but not here. The place seems bereft ...'

Jez himself had the chance to work down the pit ... and ran a mile. 'That scared the hell out of me,' he admits. 'My dad was adamant he didn't want me to go down the pit and as soon as I went to college I decided I had to make a go of music. Mind you, a lot of the guys I was at college with went down the pit and ended up getting college schemes and qualifications and doing very well out of it. My brother-in-law ended up as an electrical engineer. It wasn't a dead-end for him.'

When Jez was growing up, folk music was still a key part of daily life. He grew up knowing Tommy Armstrong's songs, and vividly recalls people singing in the streets – especially during the weekly drops of free coal for the colliery workers. In time, he gravitated to the local folk clubs and absorbed the historical context of the music and the contributions of local icons like the Elliotts of Birtley.

'There was always an awareness of the tradition, without knowing what it was. I think these things are very entrenched in the north east, probably more so than anywhere else. I started off doing Irish songs and all sorts of other stuff, and then it hit me like a ton of bricks: the fabric of the songs was right on my doorstep.' He started writing about the locality and the lifestyle that is fast disappearing ... much to the

consternation of some of the people who were still living it. 'One of my mates said, "If you were working down there, you wouldn't be singing about it in pubs every night." '

So what was it like in 1984 in Easington? 'It was an awful time. You couldn't drive though for all the police being bussed in and pickets everywhere; it was like Northern Ireland during the troubles. That was the beginning of the end of the place. The community spirit was torn apart; people were starving and demoralised. We knew what was going to happen; they were stockpiling coal even before the strike. It was all part of the Thatcher masterplan. There was such a lot of anger about it ... there still is.'

We continue down the coast to Blackhall Rocks, where legend has it that King Canute attempted to order the waves to turn around. Canute was actually attempting to show that he could do no such thing, but history has unkindly – and erroneously – recorded him as a deluded egotist trying to battle the forces of nature. Mind you, even if Canute couldn't manage it, I'm sure David Blaine would have had no problem.

Hartlepool seems to have a history of weirdness. Arthur Scargill once stood here in a general election against Peter Mandelson, and was comprehensively beaten. And as Hartlepool's MP, Mandelson took a lot of credit for helping to make Hartlepool one of those shiny brochure examples of a regeneration process that has spectacularly succeeded. Not so long ago it had the highest unemployment in the country, but a £150m private and public sector investment programme has worked its magic, and the town now boasts a swanky new marina, loads of new housing, gleaming retail and leisure developments, and lots of groovy new industry. It's still no oil painting, but Hartlepool now does have a big fat smile on its face.

It needs to have, to cope with all the merciless jokes about monkey-hangers. It's a famous legend and probably wasn't even true in the first place, but it won't kill us to hear it again ...

The story goes that one day during the Napoleonic Wars, part of a shipwreck was washed up on the beach with a monkey sitting on top. A group of wide-eyed fishermen were on the beach to greet it. Now, they didn't know much about the French and they knew even less about monkeys, so when it responded to their questions with an outburst of gibberish, they took the view that it must be French.

They gave it a fair trial, mind, but the monkey refused to co-operate and, when they asked if it was a French spy, it responded with yet another outburst of grunts, high-pitched squeals, lots of chest-beating and that anti-social thing that monkeys always do with their bottoms. The Hartlepool judge and jury understandably took this as a guilty

plea, and promptly convicted the monkey of being a French spy and hanged it.

It's an easy mistake to make, as I tell the bloke in the hot-chocolate shop. He doesn't seem wildly amused by the idea of some idiot coming in the cafe doing monkey impressions, flopping his head to one side as an imaginary noose jerks his head back, and shouting 'What am I? What am I?' 'OK,' he says, through clenched teeth, 'apart from the obvious, what are you?' A French spy …

A word of advice; if you're ever in Hartlepool, don't mention the monkey. I did once, but I think I got away with it …

CHAPTER THIRTEEN

A Dalesman's Litany

'I'd like to tell you people, I met her at a fair
But I met her in a pub down by the far side of the square
She was dark and she was handsome and her name was Mary Lee
And I'll tell you of the good times, of Mary Lee and me ...'

"The Gipsy", Bob Pegg

*Y*orkshire, then.

It's the absolute king of counties. The undisputed 'I'm the daddy, kiss my ass the rest of you suckers' Muhammad Ali of the country. The unrivalled lord of all it beholds; swaggering across the north with an irresistibly dangerous beauty and gritty tell-it-like-it-is mentality. The Pennines: all darkly satanic, brooding and mysterious. The Dales: all earthy splendour and curvy, romping charm. The villages: all compact, homely and cute. The people: all scurrying, rosy-cheeked and forthright.

I heart Yorkshire.

The north-east bit with its fishing heritage and its rugged scenery is always a pleasure. Whitby is a continuous, buzzing cavalcade of festivals: gospel, line dancing, country, northern soul, world music, folk music and any number of maritime events commemorating Captain Cook's voyages to Australia. At certain times of the year the town is also overrun by Goths, irresistibly drawn to the setting of much of Bram Stoker's *Dracula*.

And let's not forget the Planting of Penny Hedge, a tradition dating back to 1159, when three hunters chasing a wild boar ended up killing a monk at Eskdaleside instead. The Abbot of Whitby agreed to spare their lives, but gave them a very odd penance. With the aid of a knife worth one penny, they were told to make a load of stakes, carry them to Whitby, and stick them into the seashore as a stake hedge capable of withstanding three tides. When they'd finished, a bailiff would blow his horn and they could all go home.

OK, fair enough, they said, it's better than being executed. Oh, but hang on, said the Abbot, there's one other thing I almost forgot. You have to come back and do it again next year. And the year after that. In fact you have to do it *for ever and ever amen*. Oh, they said, maybe we'll take the execution after all. We can't plant stake hedges in the sea if we're dead now, can we? No, said the Abbot, but your *descendants* can, and he stuck on the fiendish condition that Whitby will have a new penny hedge erected every year by the descendants of those hapless hunters until the end of time.

And that's what happens even to this day. Every Ascension Day, you imagine a bemused member of this particular family, the Huttons, carrying stakes and building walls in the sea at Whitby and waiting for the bailiff to blow his horn. Unfortunately, I've got no idea when Ascension Day is, so I miss it.

We pass through Robin Hood's Bay, another lovely little spot which was once a hotbed of smugglers, and which has a special place in the hearts of folk music lovers as the home of the Waterson-Carthy family. Originally from Hull, the Watersons have virtually spanned four decades of the folk revival. Orphaned as kids, Norma, Mike and Lal Waterson were effectively raised by their grandmother and a family friend who was later immortalised in Lal's "Song For Thirza".

Hull had a lively old music scene in the early Sixties, again recalled in another Godlike Lal Waterson song, "Some Old Salty" (sampled by Chumbawamba on "Salt Fare, North Sea", fact fans) and like everyone else, the Watersons were drawn in by jazz and skiffle and started off singing American songs. But they soon turned to their own tradition and set up one of the early folk clubs, which shifted venues before settling down at the Blue Bell.

They soon dumped the American material – and the instruments – to concentrate on collecting their own vast repertoire of English traditional songs, which they sang full of joyous harmonies and unbridled passion. There were four of them (Mike, Norma and Lal Waterson, and their cousin John Harrison) and they had a natural empathy, harmonising instinctively and with unusual power. Their first LP, *Frost and Fire*, in 1965 – which pursued a cycle of English ceremonial songs – was groundbreaking. Rich, powerful and uncompromising, it swam completely against the tide of sweetness and light favoured by folk records of the time, and caused a mild sensation.

Their progress around that point was documented in "Travelling for a Living", a terrific 1966 BBC2 special filmed by Lal's husband Derrick Knight, which ably demonstrated the thrilling earthiness of their singing and the persuasive ebullience of their personalities. Watching Mike Waterson in the film now, in his Beatles haircut and

sharp boots, he looks the height of nonchalant cool – eat your heart out, Liam Gallagher.

Above all, they made a connection not only with the explosive passion inherent in traditional songs, but with the people who made those songs in the first place. They were pioneers and possibly visionaries too, but they had no game plan beyond singing songs they felt deserved to be heard. Norma Waterson told me recently they never sought a career out of music. In many ways, she said, the folk revival had failed. Its legacy was a professional circuit where folk artists could make their livings, but the real ideal had been to restore local music to an informal social level in pubs, dances, special events and private get-togethers – and that hadn't happened. 'The folk revival now has nothing to do with traditional music,' she said.

The Watersons appeared at the very first Cambridge Folk Festival (with the likes of Shirley Collins, the Clancy Brothers, Peggy Seeger, the Strawberry Hill Boys and Paul Simon) and embraced a real pioneering spirit. But they opted out in 1967, Norma disappeared to the Caribbean to become a DJ in Montserrat, and that was that. Except that Mike and Lal constantly wrote songs and poetry, and more and more people – a certain Martin Carthy among them – urged them to record this material. So, in 1972, they made *Bright Phoebus*. It was a revelation, and like nothing they – or anyone else – had ever done before. Lal's songs were strange and intoxicating, full of rich imagery and unpredictable sound patterns; Mike's songs were quirky, fun and upbeat; and half the folk scene came along to the recording sessions to welcome them back.

The purists were dismayed to hear the family using instruments and singing modern songs, but *Bright Phoebus* still stands as one of *the* folk records, the pedigree of the songs proved by the regularity with which the likes of "Rubber Band", "The Scarecrow", "Magical Man" and "Bright Phoebus" itself still get played.

It also got them performing live again, albeit not with the *Bright Phoebus* repertoire or musical form; they reverted to their iconic role as unaccompanied harmony singers of traditional song, and re-established their revered status. Martin Carthy joined the Watersons, following his marriage to Norma in 1972, and juggled family gigs with his other life as the pride and joy of the folk club scene, and a member of Steeleye Span and the Albion Country Band.

By the Nineties, Lal and Mike had grown tired of live performance, and specifically the travelling, and backed off from the group, but a new generation was blossoming to take the family into a new era. With Martin and Norma's daughter Eliza Carthy developing in her own right as a singer/fiddle player and doing her own gigs, initially with Nancy

Kerr (daughter of another notable folk revival singer, Sandra Kerr), the Watersons evolved into the wider-ranging Waterson:Carthy.

This stimulated a fresh outburst of creativity, gaining a degree of acclaim and respect that once again fuelled the broader folk movement. Norma's very first solo album, 1996's *Norma Waterson*, broke barriers for her with its emphasis on accompanied contemporary song, and achieved unlikely national attention when it was shortlisted for the Mercury Music Prize.

I was on that Mercury judging panel, and well remember the appalled reaction of a couple of the other judges when I argued its merits. 'That voice,' they said, 'how can you listen to that voice? She sounds so ... *odd*.' 'That voice,' I said, tetchily, 'is one of the *great* voices. Do you think Edith Piaf had an odd voice? Mahalia Jackson? Aretha? Lena Horne? Maria Callas? *That's* the sort of calibre we're talking about, but because she's an English folk singer, she sounds *odd*, apparently, and we don't take her seriously.'

When we reconvened on the day of the awards to decide which of the nominated records would win the £25,000 prize, the judge who'd been most vociferous in condemning Norma's album made a beeline for me: 'I've been listening a lot to that Norma Waterson album and I just wanted to say *what a voice!*' Supported by unexpected new allies on the panel, it really looked at one point that the impossible might happen and this 'token' folk album by a Yorkshire grandmother would win the Mercury Music Prize, but she ended up losing by a single vote to Pulp's *Different Class*. She beat Oasis, Manic Street Preachers, Black Grape, Underworld, Courtney Pine and Peter Maxwell Davies, though ...

Two years later, we were all back at the swanky hotel in London for the same awards toasting Eliza's brave double album *Red Rice*, which made the shortlist; and again in 2003 for her immaculate *Anglicana*. Above all others, *Anglicana* stands as the flagship of Eliza's very conscious and up-front campaign for musical Englishness. She's a formidable personality is Eliza; a voluble, passionate character with an ongoing personal mission to raise awareness of notions of Englishness. 'We're ignorant of our roots, it's a big hole in our national psyche,' she says, and describes *Anglicana* as 'an expression of Englishness as I feel it; with people who were there at the time, no border checkpoints, nobody pushed out; just what it is'.

Yet for all her energising music and crusading interviews, and despite a similarly gung-ho approach by other fine young English musicians like Jim Moray, Spiers and Boden, Mark Bazeley and Jason Rice, the campaign has barely dented the mainstream cultural establishment. Nominated for the Mercury Music Prize for her *Sleepless*

album in 1999, the young Barnsley singer Kate Rusby charmed the socks off everybody there with her homespun humour, topped off by a lovely performance of Iris DeMent's "Our Town".

The next day on Radio 1, the tediously fluffy Jo Whiley sang her praises and declared her a 'star'. Yet it never occurred to Whiley to play a Kate Rusby track. Nor, indeed, anything by the British Asian Talvin Singh, who actually won that year with *OK*, an album conceived in east London but drawn from and recorded in three continents. It wasn't on the playlist, see. Didn't come up in all those focus group surveys. Didn't have record companies deluging management with details of their marketing campaigns and advertising sell. Robbie Williams – give 'em Robbie. That's what the public wants. And, as Paul Weller, so shrewdly pointed out, the public wants what the public gets.

As we head towards the Yorkshire moors, I'm playing "I Bid You Goodnight" by Blue Murder – the stunning amalgamation of the Watersons and Coope, Boyes and Simpsons – and wondering how it would sound at my funeral. This leads on to a further internal debate: who is my favourite Waterson? John was my favourite Beatle, Baby my favourite Spice Girl and Nadine my favourite Girl Aloud, but the Watersons, well, that's tougher ...

See, I'm a huge admirer of Eliza, who's laying the seeds for the music to blossom for years to come. And I love Norma, the rock on which the Waterson sound is built, and who still doesn't know how good a singer she is. Martin has been a constant hero since I first got into this music a million years ago; perhaps the one hero who's never let me down. And Lal ... well, I'd say what Lal did approached genius. Her songs seemed to emerge from the Yorkshire earth at some secret place that nobody else ever discovered: dark, mysterious, unpredictable, beautiful, melancholy and haunting. The enduring magic of her *Bright Phoebus* songs is a given, and her 1996 *Once in a Blue Moon* album with her son Oliver Knight is a difficult, challenging, deep, but ultimately glittering treasure. Lal's death from cancer in 1998 left a massive void.

But if you are dangling me over that cliff at the top of Robin Hood's Bay by my toenails and demanding I choose my favourite Waterson, I'd have to go for Mike – Mike, with his hunched shoulders and flat cap, pint in hand, going 'yip' a lot. Sometimes he ambles on stage and looks like the bloke who's come to mend the plumbing, before launching into one of his throwaway gems like "Three Day Millionaire" or "Mole In A Hole", with an eccentric delivery and an unorthodox sense of timing that sometimes sounds as if he's pursuing a private conversation with himself.

Having a cup of tea with him one day in his kitchen in Robin Hood's

Bay, the anecdotes came thick and fast, as he provided his own very individual commentary on the triumphs and failings of the folk revival. It was full of deliciously indiscreet asides about all who sailed in her, and the odd volley of song to illustrate a point; the "Magical Man" indeed ...

But enough of this; let's go Burn a Bartle.

In the heart of Wensleydale, south west of Richmond, West Witton is an entirely unremarkable place. The A684 passes through and, ordinarily, so would we – without a second glance. But tonight's different; tonight's Bartle time.

The story we get is a garbled one. It appears to be something to do with a sheep thief, a bonfire, a song and a piss-up, so we call in at the splendidly named and jam-packed Wensleydale Heifer Inn to find out more. 'You want a meal? Tonight? Come back in about four hours, love ...' Still, we have a nice chat with a middle-aged lady who provides ample evidence that the fourth part of the sheep stealer/bonfire/song/piss-up rectangle is certainly an ongoing part of this tradition, and she's very happy to explain all.

'What it is, love, it's this. They carry this thing through the, you know, and stop and do this thing and have a drink and carry on and do this thing again, then they have a drink, then they do this thing and walk some more with thing and then they ... what do they do then, Mary love? Oh that's right they have a drink, then they carry on and do the thing. Then they set fire to it.'

It's perhaps as well that we are despatched to the end of the village to find out for ourselves. A small crowd has gathered, and we gradually glean a bit more information. The story does indeed concern a sheep stealer or some other lowlife, whose specific crime is long lost in the mists of time. The 'Bartle' is understood to be a reference to St Bartholomew's Day, the date when the trial was convened and the hapless defendant was humiliatingly marched through the village to face his accusers.

I voice the theory that there was a *Straw Dogs* vibe going on here, and the villagers ended up sticking the sheep-stealer on a bonfire and burning him. This theory causes quite a stir among my new friends on the street corner. 'Interesting,' says a scholarly gent thoughtfully scratching his beard. 'Never 'eard that 'afore, but it's possible. See, they take the effigy down to Grassgill, and this would explain why they set fire to it.'

Ah, they're a piece of cake, these obscure customs.

Eventually, amid warm applause, three old chaps arrive on the corner. Two of them look a bit wobbly, but the one in the middle is completely out of it. His head is lolling around, he can't stand by himself, and his clothes look disgusting. Then there's a collective gasp

as the comatose one in the middle jerks his head back. His face is a grotesque mask – literally, it's a grotesque mask – and his eyes are bright red and *flashing*. Horrible, it is. The crowd steps back, children start screaming and the throng thickens as more people gather to see what the fuss is about. Suddenly, another guy with them gives a blood-curdling yelp and starts shouting rhythmically in a strange tongue. *Wicker Man*, here we come ...

The party moves forward at a sedate pace, and stops at the first house they reach. A couple are already out in the pathway with a tray proffering glasses of whisky, which our strange entertainers down in one ... except the guy in the middle with the flashing red eyes whom I now realise is the Bartle; a Guy Fawkes figure with an unhealthy penchant for sheep.

Then we get that peculiar rap again. The party slowly moves on another half-dozen yards and look, there's someone else at the gate dishing out glasses of whisky. Down in one they go. And here comes that song/rap/war cry again. By the fifth whisky pit stop, the procedure has become very familiar. And so has that rap, which is now almost decipherable:

> *'On Penhill Craggs he tore his rags*
> *At Hunter's Thorn he blew his horn*
> *At Capplebank Stee he 'appened his fortune and brek his knee*
> *At Grisgill Bek he brek his neck*
> *At Wadham's End he couldn't fend*
> *At Grisgill End we'll mak his end*
> *Shout lads shout ... hip hip ...'*

And we all go 'hooray'. Very loudly.

The length of West Witton's Main Street can't be more than half a mile, but the procession takes over an hour. A queue of motorists stare at the extraordinary sight ... two guys surrounded by a large crowd, staggering along the road with a glorified Guy Fawkes under their arms and stopping every couple of minutes to get right royally pissed, while another guy yells an incomprehensible rhyme. One of them winds his window down and tries to discover what the hell's going on, but the chief Bartle-bearer leans inside the car, gives him a sloppy kiss on the cheek and tries to wrestle the steering wheel off him.

The drink-breaks and accompanying verse just keep on coming, and by the time we reach the end of Main Street, the Bartle is looking a lot healthier than its escorts. We stop at Grassgill End, and I look around expecting to see more trays, more drinks, more increasingly fraught tales of Penhill Craggs and Hunter's Thorn. But this time the Bartle is

dumped rather unceremoniously on the floor and propped up on a wall by the side of the road. We all gather round in a semi-circle with a hush of anticipation. There's one last volley about Craggs and rags, one last hoorah for the Bartle, and then he's doused in paraffin and set ablaze, flashing eyes and all.

We stare at the pyre and a small cluster break into an enthusiastic but ragged verse or two of "Ilkley Moor Bah'tat". The chorus is hearty but it fizzles out without reaching the third verse and, with Bartle already collapsing in a charred heap, there are several other attempts to get the choir going. But the age range is diverse and the musical taste divided. A group of teenagers clutching their alcopops make a valiant attempt to make it through to the end of The Streets' "Dry Your Eyes", but the oldies are in another corner hammering away at well-known Yorkshire songs like "Keep Right On To The End Of The Road" and "Knees Up Mother Brown", while both factions are noisily distracted by one member of Team Bartle bellowing out an inventive mix of "Wild Rover" and "Seven Drunken Nights".

As the last shreds of Bartle disappear in a heap of ash, we shuffle back towards the pub. The guys who've been carrying the Bartle are the last to leave, looking back at the pile of ashes as they weave their way back to the pub. I weave along with them and get a bear hug from the Bartle-bearer in chief, Robert Harker.

Robert is tired and he's *very* emotional. This, he tells me, is the first year they've burned the Bartle since the death of his brother, Alan: 'He did it for over 50 years; aye, he loved it. I used to help him, like. We 'ad to keep it going for 'is sake ... you've got to keep them ol' traditions goin', else what is there? But it was 'ard this year, without my brother here.' Yet by the time we're in sight of the pub and the prospect of more drinking, he's cheered up immensely. 'You like the flashing lights in t'Bartle's eyes? First time we done that. Always try and do summat different, we do, y'know to keep it *fresh*.'

I know he's bladdered, but he talks with such passion and pride about his inherited role as keeper of the Bartle that it's impossible not to be infused with the same sense of propriety about this strange little tradition: 'I hope it won't die out. It's 'arder as we lose the older ones, and new people come into the village who don't understand the history. We're getting less people coming out giving us drinks these days ...' You could have fooled me, Robert. 'There's more traffic now too, but we still walk in t'middle of road. It's important. It's who we are. Without tradition what have we got?'

Most of the others are in the pub by now, but Robert is over 70 and decidedly wobbly, so our progress is slow. A lad of 11 or 12 comes trotting along the road to make sure I haven't abducted the star of the

show. Robert introduces me to his grandson, scrabbles around in his carrier bag and retrieves a can of lager. He snaps it open, takes a generous slug and then passes it to the boy. 'Don't tell yer mam,' he says with a wink. 'When you're a Harker, you've got to be able to drink. One day the lad'll be carrying the Bartle, so he's got to learn to sup. There's a lot of drinking that has to be done on Bartle night so 'e might as well start now. Can't 'ave 'im falling over first time he does it. Don't tell 'is mum, mind ...' We're right outside the pub now. 'I feel like a drink,' he says unsteadily; 'fancy one?' With Alberta waiting anxiously in the car park, I give him another bear hug, make my excuses, and leave.

Driving happily through those glorious Dales next morning, I search the glove box for something Yorkshire to play as a soundtrack. And there it is, staring me in the face: Mr Fox's "The Gipsy". As soon as Bob Pegg starts singing those immortal opening lines '*I'd like to tell you people, I met her at a fair ...*', I know exactly where we're going next: the Yorkshire Dales. 'Tell you what,' I say to Mrs Colin, 'let's go to the Buttertubs Pass.' 'The Buttertubs Pass?' she asks, with a trace of panic in her voice, grabbing the map. 'Yes,' I say coolly, 'the Butterubs Pass, it's steep and it's high and the horses would find it a hard way to go ...'

'Pardon?'

'If I kept on the road and my boots didn't fail me, I might catch them up before daylight was through.'

'Eh?'

'The song, the song; it's the song.'

'What song?'

'What song? *What* song? Only the greatest song in the history of the world ever; "The Gipsy", that's what song ...'

If Fairport Convention, Steeleye Span and the Albion Band were the kings of folk rock, Mr Fox were the scraggy, unkempt cousin with the runny nose, the permanent scowl and the irrational temper that everyone else avoided. And I worshipped them. I chased them around the country at gigs and festivals when they looked permanently on the brink of total collapse. Bob and Carole Pegg were constantly having spats on stage, and Bob would regularly depart from the script to deliver a sardonic sermon, sometimes mid-song, about the ills of the world.

The songs – mostly Bob's – were wayward, maverick interpretations of the dark side of the tradition, honing in on weird, often bloody stories like "The Hanged Man", about a rambler who fell from some rocks and was found hanged by his own rucksack. Or there was "Mr Fox", a gruesome tale of a severed hand. Carole cultivated a

deliberately earthy, raucous fiddle style based on traditional village music and, concentrating on the more dramatic and colourful elements of folklore specifically rooted in Yorkshire, they had a uniquely English mentality and sound.

In 1971, they released their second album, *The Gipsy*, and the 13-minute title track blew me clean away. I'd never even been to Yorkshire then, but the story of the guy who falls in love with a gipsy girl in Bradford and then decides to follow her when the gipsies decamp for Scotland enthralled me. In vivid detail the song tells the story of his journey through the Dales. 'One day,' I promised myself, 'I will follow in his footsteps and do that journey myself.' It may have taken 30 years, but that time is now …

> '*Early next morning I started for Ilkley*
> *The city was silent and still as a stone*
> *With hope in my heart and fire in my head*
> *I set off to find where the gipsies had gone …*'

We get an immediate result on arrival in the posh town of Ilkely – just for today, a one-off special: free parking! Bless you, Ilkely. Happy days are here again! We feel we should buy something expensive from one of the 300 antique shops in the town, but then we remember we've got gipsies to chase. The star of our song hitched a ride to Bolton at this point, so that's where we go now, admiring the grand abbey and the low hills of Wharfedale before weaving along the river up to the pretty town of Burnsall.

We pass the Devonshire Fell hotel, and as the climb steepens I'm already marvelling at this guy's determination. Alberta is groaning at every turn as we reach Grassington, but after this guy's girlfriend had dumped him to take a ride to Scotland, he went after her *on foot*. We raise a sympathetic glass to him at the Tennant Arms, but decide to give the Dickensian Fair a miss.

> '*By evening I came to the village of Buckden*
> *And decided that here I would make my night's stop*
> *Have you seen the gipsies? I asked my friend Jacky*
> *They've moved on, he said, they've gone over the top …*'

Jacky is Jacky Beresford, a character who looms large in Pegg's Dales adventures. As a student in Leeds, Pegg would get a bus to Wharfedale on song-collecting missions. His path invariably started – and ended – in the pub with Jacky. They'd meet at the Buck Inn at Buckden, where Jacky worked, maybe drive up to Hubberholme in Jacky's old taxi, sink

a few up there, then return to Buckden, where Jacky might sing a few songs and play some tunes on his piano accordion.

At one point the place was humming as a centre of the lead industry, a popular haunt of deer, and, like other villages in the Dales, was a regular venue for dances, with plentiful tunes exclusive to the village that would attract people from miles around. Today, though, it just dozes quietly away and doesn't even bother to get up and say hello. There's no one around except us and a small group of serious-looking walkers on their way up to Langstrothdale, who pause before they start their journey to read about a Polish pilot who parachuted out here in the Second World War and found his way to survival only by following the footprints of foxes.

> '*I stopped an old man I'd met once before*
> *Kit Calvert the maker of Wensleydale Cheese*
> *And when I asked him if he'd seen the gipsies*
> *The words that he spoke helped to put me at ease*
> *He said 'The gipsies left early, I watched as they went*
> *They had one among them a fine dark-haired lass*
> *She shouted to me from the back of the wagon*
> *They were making for Keld, by the Buttertubs Pass …'*

Kit Calvert was indeed a maker of Wensleydale cheese, which was originally a product of Cistercian monks at Jervaulx Abbey in the twelfth century, and more recently became associated with a Wallace and Gromit advertising campaign. However, the dairy at Hawes would have been long gone had it not been for the work of Calvert, who, as a sideline to his cheese-making, opened a bookshop and translated parts of the Bible into Wensleydale dialect.

The Buttertubs Pass; it's steep and it's high, and the horses would indeed find it a hard way to go. In fact, if they're towing caravans filled with families and all their worldly goods, I reckon they'd find it an *impossible* way to go. Poor old Alberta's struggling a bit, creaking and groaning as we inch our way forwards through a mist that is suddenly swarming all over us. The views are probably magnificent, but I can barely see the end of my nose and it feels as if we're being swallowed by the sky.

We haven't seen another soul for at least 20 minutes, but I'm still suspicious that a 4x4 will come roaring round that sharp bend right ahead that I can't see but feel sure is there. Progress is painfully slow. The Buttertubs Pass seems to go on for ever, but eventually we crawl into the village of Thwaite. We're almost there …

'As the sun dropped down low I came into Thwaite
Leaving behind me the dusk on the fells
I started straight way down the road into Keld
Where Neddy once played his harmonium and bells
From a field by the road I saw the smoke rising
I hitched up my pack as I rounded the bend
I first saw the horses and then saw the wagons
And I knew that my journey was nearing its end ...'

As we pull down a the narrow lane into the tiny, grey village of Keld, the highest in Swaledale, a mad dog appears from nowhere, yapping with venom and leaping at the windows trying to take chunks out of Alberta. Surprisingly, there's no reception committee waiting to greet us after our epic journey, just the killer dog. He's clearly been on the mobile to his mates since we passed him, and a whole pack of them have assembled in the small car park ready to tear us limb from limb.

We sit in the car for a bit parked outside the toilets, doors locked, pretending to study the map while the hounds stare at us with evil eyes. We wait there until a group of ramblers come striding into the car park in their shorts and red socks and backpacks and climbing boots and posh accents and start patting the dogs who wag their tails and start licking them ... at which point, we creep out of the car to have a look round.

There's not much to see, as it happens, although there is a notice board giving chapter and verse on the village, its Norse ancestry, its lead industry and its modern role as a target for serious walkers. Further along, however, there's the old post office, once the home of Keld's most celebrated – and unusual – son: Neddy Dick.

Mentioned in "The Gipsy", he was the subject of another fine Bob Pegg song, "The Ballad Of Neddy Dick". It told the story of Richard Alderson, an extraordinary character who lived in the late nineteenth and early twentieth centuries, and who reputedly collected musical stones from the River Swale (though his detractors said he just nicked them off walls), which he would then beat with mallets to make tunes out of them. He was, you might say, a one-man rock band.

He also had an old harmonium and an assortment of bells which he'd play at the same time as the stones, and while few eye-witness accounts suggested too much musical merit in his work, they'd come from miles around to hear him play. In his book *Folk*, Bob Pegg relates the story of a local man who once gave Neddy Dick a rabbit for his tea in exchange for a tune and was rewarded with a stirring performance of the "Hallelujah Chorus". Pegg describes Neddy as a fierce recluse who lived alone, never married, and didn't look after himself properly. He ended up in Reeth workhouse, where he died in 1927.

Cock-a-hoop at having completed his "Gipsy" journey and being alive to tell the tale, I talk to Bob Pegg, who's still performing but now lives in the Scottish highlands. He tells me that Neddy Dick might not have been quite the eccentric one-off we'd all fondly imagined. There was a Cumbrian outfit, the Till Family Rock Band from Keswick, doing similar musical turns with Lakeland slate; they toured around the country at the same time playing classical and ocarina music and once even appeared before Queen Victoria. Bob is convinced that Neddy Dick would have got the idea of his own one-man band after seeing the Tills.

He also disillusions me of my impressions of remote wilderness about the Dales. 'The truth is that when I started going there in the Sixties, it was a lot quieter than it was in the Thirties,' he says. 'In the nineteenth century, it was a hive of industry when everybody worked in the lead industry. There were railways across Wensleydale and Wharfedale, and you'd get two families living in those tiny cottages. In that context, Neddy Dick doesn't seem such an isolated character as he first appeared to me.'

I'm also dismayed to learn that I'm not the first to re-create Neddy's epic journey in pursuit of the gipsy (incidentally, the song has a poignant end when he does finally catch up with her). Apparently the Buttertubs Pass is frequently crammed with folkies re-creating the journey in "The Gipsy".

'So did you walk it?' he asks. '

Walk it? Good grief, no, Alberta took me.

'Then it doesn't count if you didn't walk it.'

Who walks it?

'I think the first were a load of bikers from Welwyn Garden City in 1984. They said they'd got into "The Gipsy" after a mate of theirs was in a coma. Apparently they'd play him *Ancient Maps* (a Pegg solo album which charts another journey entirely, in *Lord of the Rings* territory, but we won't go there) and it gave him great solace before he died. There was a girl called Shrub, who was the ex of the guy who died, and they came up in their leathers and stayed with me in Yorkshire, then set off the next morning. They left their bikes in the Dales and walked it.'

And they did the whole journey on foot?

'Yep.'

Are you sure?

'Yep.'

Bastards.

So then we go to York. You can't visit Yorkshire without calling on York, can you? Everyone likes Geordie accents and everyone likes York; that's just the way it is. Anywhere that has a cobbled street called the Shambles is OK by me. And there're those big walls, and the endless

ghost walks, the Minster that keeps getting struck by lightning, the medieval atmosphere that hits you from all sides, the house where Guy Fawkes lived and has his own pub, the Museum of Psychic Experience ... and let's not forget the Grand Old Duke of, eh?

Folk icon Nic Jones and his wife Julia live in York. They came up here from Essex in the Eighties after the ... well, after the accident. They like it. Nic goes swimming every day, plays chess, reads books, goes for cycle rides, cooks curry, takes 'Arry the dog for walks, listens to his Radiohead albums and, strictly within the privacy of his own four walls, practises his guitar.

There was a time, mostly in the Seventies, when Nic Jones was considered one of the best acoustic guitarists in the country. His deft rhythmic accompaniments were a revelation, lighting up the mainly traditional songs he was singing and making him one of the most admired folk musicians in the country. He was right up there with Martin Carthy as one of the most popular and influential folk musicians of the day, a veritable icon, whose reputation reached a peak in 1980 with the release of his fourth solo album, *Penguin Eggs*. The fluency of his playing and singing, the percussive swing of the arrangements and the strength of material like "Courting Is A Pleasure", "The Humpback Whale", "Flandyke Shore" and Paul Metser's "Farewell To The Gold" combined to create a classic album that seemed to take British folk music to a whole new level of excellence. Bob Dylan certainly thought so, going on to record his own version of "Canadee-I-O", and *Penguin Eggs* went on to inspire many of the younger generation of musicians.

At the peak of his creativity, Nic had never been more popular. He'd rid himself totally of the rigid old stylisation that had strangled much of the second wave of the folk revival and, always free-spirited and independent, seemed on the cusp of taking the music another great leap forwards.

And that's when the accident came.

It happened in February 1982. Nic wasn't far from home, after playing a gig at Glossop Folk Club, when his car collided with a lorry. The common assumption is that he fell asleep at the wheel, but Nic has no recollection of that – or anything else that happened in the horrific aftermath of the crash – but Julia remembers *everything*.

She instinctively knew something had happened that night. She was already worried because he was driving a new car, and when she heard someone coming to the house she knew it wasn't Nic. The dog was barking, and the dog wouldn't have barked if it had been Nic.

Nic smashed virtually every bone in his body in the crash. He was in a coma for a long time, with his whole body in plaster and a cage

around his head. People sent Julia tapes of Nic's gigs to play to him and he finally came round ... and that's when the trouble *really* started. He was in hospital for eight months, his memory shot, and prone to terrible rages and irrational behaviour as he fought to comprehend what had happened to him. Nic and Julia certainly found out who their friends were. With two young kids, life wasn't easy, but the folk scene responded with various fund-raising events and others showed support in different ways.

Tonight, Nic and Julia are both in excellent form. Nic's a tad lopsided, which makes the guitar playing difficult, and there are still a few gaps in his memory, but otherwise for a bloke in his late fifties, he's in decent shape. And as for anecdotes ... well, he's got 'em. Like the time he was so disgusted by the audience chattering among themselves when they should have been listening to him he turned his back and played to the wall: 'They seemed to think I was the jukebox, so I played to the wall because I figured it was a more receptive audience.'

Another time he sang the ballad "Bonnie Bunch Of Roses" twice in succession and nobody noticed. And, during another bad gig, he asked how long the organiser wanted him to play for. 'As long as you like,' said the promoter. 'In that case ...' said Nic, packing his guitar, 'I'm off' and left the stage.

He had no time, either, for the ultra-purist element who wanted only traditional material (they didn't cotton on to the fact that he was for ever changing the words to trad songs if he didn't agree with them, and if he didn't like the tune, he'd change that too). Once he was booked to appear at Nottingham Traditional Music Club, which famously had a purist policy – and sang "Chattanooga Choo-Choo". He even had a politically incorrect attitude to morris men: 'I just thought the idea of all those men dancing together was a bit ... *odd*. I always took the piss out of morris dancers, but it was probably jeal-ousy because I could never dance myself. That's why I never joined the Shadows.'

He was chuffed when *Penguin Eggs* was named 79th Best Album of All Time in the *Observer*, with the Rolling Stones' *Let It Bleed* at 78 and David Bowie's *Station to Station* at 80. The citation read: 'English folk genius who inspired Dylan.' Do you feel like an English folk genius, Nic? He winces at the question. 'Oh no, I was *OK*; I could do a few songs, that's all. I was just an average singer and an OK guitarist.'

Hmmm ... if that is true, why are you so revered by so many people, Nic? 'Because I'm *not there* any more; I'm at home. If I came back they'd hate me.' It's not going to happen, although he is writing new material. He describes the plot of one of his new efforts, "The Supermarket Song": 'It's about this guy who goes shopping to the

supermarket. He gets his basket and goes to the till and he sees this lovely lady taking all the cash and falls in love with her without realising it. So when he gets to the till he's very nervous about being with her, drops the basket and the lady gets pissed off and the security comes, sees the mess on the floor and chucks him out. When he tries to get back in again he gets a punch on the nose ...'

Who said the art of the tragic ballad was dead? I ask Nic if it's true that he used to write songs and pass them off as traditional. 'Oh no,' he says, 'I never did that.' Julia looks at him hard. 'Yes, you bloody *did*! You never acknowledged they were your own ... which is why we never get any bloody money out of them ...'

Then Nic starts going on about how much he loves Radiohead. They're a bit miserable, I say. Not many jokes in their songs. Nic disappears upstairs and returns wearing a very strange mask with dials and an aerial on it. 'This is my Radiohead ...' he chortles. 'I love that band.'

John Wesley Harding made a tribute album of Nic's songs and he's for ever being name-checked as an influence by the new breed of folk star, like Kate Rusby and Jim Moray, so his music lives on, even if half his albums are still largely unavailable. Julia has released a selection of previously unreleased stuff on two collections, *In Search of Nic Jones* and *Unearthed*, and they occasionally visit the local folk club in York.

Nic's highest-profile recent sighting, though, was at Sidmouth Festival, when he walked on stage with his old compadre, the ailing Tony Rose, with the entire audience in tears. All week people came bounding up, hugging him, engaging him in merry banter, and he had a wonderful time though he patently had no clue *who* they were. His hugely likeable son Joe was with him at Sidmouth. He's a lad with the same irrepressible sense of mischief as Nic, and has inherited some of his talent, too.

Nic plays me a song Joe made for him because he was skint and couldn't afford a birthday present. It's a joke song which he sings in a cod Dylan accent, and he was apparently pissed at the time anyway, but it still sounds good. Joe had talked at Sidmouth of following in his father's footsteps and trying to make it as a singer, but the weight of Nic's reputation hangs heavy and holds him back.

'I don't know why,' mutters Nic, 'I wasn't that good.' I ask him what he thinks of England and if he's proud to be English, but he says he doesn't believe in the question, because nationality is bullshit. So what would you do if you ran the country? 'I'd get rid of the Queen and put 'Arry in charge of it ...' Prince Harry? 'No, this 'Arry ...' The dog leaps up and starts nuzzling him. 'See ... that would work. 'Arry would make people happy.'

As we leave, I turn round to see Nic waving goodbye. He is wearing his Radiohead mask.

We head south to Sheffield. I like Sheffield, an industrial city that doesn't hang around on street corners feeling sorry for itself and remembering how things used to be. The constant hill-climbing you have to do to reach anywhere in the centre is a pain, of course, but five minutes outside and you're in the midst of the Pennines and some of the loveliest countryside in England.

Sheffield has a proud history as England's steel capital – its cutlery bagged a mention in *Canterbury Tales* – but serious damage during the Second World War meant it required a lot of regeneration and rebuilding. Now it's full of students at two universities, and has the vibe of a young city intent on dancing its way through the next century. It's long had a rich musical tradition – Pulp, Human League, Heaven 17, ABC, Def Leppard, Comsat Angels and Joe Cocker are among those who have hailed from Sheffield to cement its reputation as a rock'n'roll city, as well as a snooker one. The high-tech National Centre for Popular Music with its interactive games giving you the chance to remix various hits and make your own beats was a glorious failure, but the fine building is still there at the top of the city as a bold landmark.

It also has a lively session scene, a legacy largely of the student population playing informally in pubs and the emergence of dance groups like Hekety. We land here in time for the revived Sheffield Folk Festival, though the artistic energy doesn't seem to stretch to marketing and promotion. My efforts to get organised for once in my life and sort out the wheres, whys and hows with advance information were largely stonewalled by the promoters, and there's not much more help at hand on arrival in Sheffield.

'A folk festival, you say? This weekend? Hmmmm ...' says the tourist office chap. Eventually, someone in the library finds a leaflet about it and sends us off to Kelham Island. Which is impossible to find, obviously. We've missed the English session by the time we get there, but salvation is at hand in the form of an ebullient Northumbrian concert, headed by the excellent Doonan Family Band, with clog dancers and all.

We also pay a visit to the reigning BBC Folk Club of the Year, the Rockingham Arms, up the road at Wentworth, on the edge of Rotherham. I'd been here years earlier and they've made a few changes to the place since then, but in classic folk club style, it's still in the room at the back of the pub and still run by Rob Shaw, who operates with the same philosophy he's had here for the last 30 years.

'In the Seventies and early Eighties it was packed every week,' he recalls. 'We could have put a donkey on the stage and it would have

sold out. The bottom went out of it in the Maggie years ... but we kept it going. We're doing OK now.'

Who have been the highlights of the 30 years? 'I'm very proud to have put on Richard Thompson three times and Flaco Jimenez twice. We booked De Dannan and I didn't realise it was the same night England were playing Brazil, and I didn't think anyone would come. But we put posters around the Irish clubs and they came out in force, and we had a great night.'

The guest tonight is Irish singer songwriter Kieran Halpin who, with his gritty voice, edgy songs and gentle humour, delivers a fine night. At the end he says, 'Thank you all for coming ... and staying' and tells the story of playing an Australian gig at Canberra Irish Centre on a Friday night. The large hall was packed and Kieran rubbed his hands, anticipating a cracking night. Just as he was about to go on, however, they held an elongated raffle to win numerous pieces of beef and steak. The place was in a frenzy of excitement as the draw was made ... but as soon as it was over and Kieran came onstage, the hall emptied. He started playing to 27 people; 50 minutes into his set, there were three people left.

'I had two demons on my shoulder,' he explains. 'One was saying, "You might as well give up, no one will notice if you don't play any more." And the other one was going, "Carry on playing, you can clear this place!"' He carried on, was paid, spent the money on a couple of bottles of fine Australian wine, and drank himself halfway to Van Diemen's Land.

The most cherished tradition in this part of Yorkshire, though, occurs in the weeks leading up to Christmas, when local villagers gather to sing in the festive season with a repertoire you won't hear anywhere else in England. Or in Yorkshire, come to that. There are some songs you won't hear anywhere else but in the one pub in the one village. These are the people's carols.

We decide to spend a weekend on a pub-crawl around these south Yorkshire villages. With our navigational skills it's a tough call, fraught with danger from the outset. First on the list is the Traveller's Rest at Oughtibridge, and it takes only two hours trying to find it, so that's a result. The outward signs aren't promising. There's only a scattering of cars outside, the pub looks quiet and there is no sign of any singing going on.

Inside, though, it's a different story. A largely middle-aged crowd already three sheets to the wind are all rammed into a 'singing bar', singing their hearts out for the lads to a jaunty keyboard accompaniment while a woman carefully unveils the words on a flip chart at the front. There isn't room to put a ferret down your pants in there so we squeeze into the other bar, only slightly less crowded, where people

strain their necks to glimpse the sauna in the other room and sing along twice as heartily to ensure they are heard. I hang in there with them. There's a certain protocol about these events, and while visitors are welcomed, the etiquette is not to get among the singers unless you intend to sing, and don't get in the way of those who do.

Some of the carols are vaguely familiar – alternative versions of "Oh Come All Ye Faithful", "Silent Night" and "The Holly And The Ivy" are popular, but top of the pops in the Traveller's Rest is "Christmas Tree", with even the fierce-looking barmaid joining in with the 'ho ho ho' chorus, and the rafters rattling. So, Saturday night in Oughtibridge singing "Christmas Tree" with a female accountant from Rotherham and a bloke wearing brown corduroys and a flat cap. It doesn't get much better than this.

Except that it does. It's Sunday morning, and the Blue Ball in Worrall is rocking to a completely different repertoire. 'Where do the songs come from?' repeats my new best mate in the pub, taking his cap off to scratch his head. 'Well, now you've got me there.' His wife has a theory: 'They're *local* carols. The villagers got fed up with the ones everybody else sings so they made up their own. You won't hear these carols anywhere else, you know.'

The Blue Ball is very organised. It has song sheets and everything. My mate offers to share his song sheet with me when a big booming hallelujah starts up, but I say I'll get my own and wade into the throng belting it out in the singing room. I make it halfway through before colliding with the guy balancing four pints above his head. One of them goes over him and the other is over me, so I'm not sure what the protocol is about who should get the compensatory round in. So, obviously, I do the decent thing. I find Mrs Colin and sneak out.

Nothing seems to be occurring at the Fountain in Ingbirchworth except a strong run on Sunday lunches, so I elbow my way to the bar and order a pint. I'm halfway back with it when suddenly, without prior warning or signal, yet perfect synchronicity, the fellow drinkers all around me burst into song. There's a bloke singing bass harmony at my left shoulder, another one to my right is offering a treble counterpoint and the chap behind me is giving me quite a turn with his lusty insistence that the Messiah hath come.

It's a fantastic choir and a truly religious experience, but a slightly disconcerting one to find myself slap-bang in the middle of them, self-consciously sipping my pint. I have visions of people nudging one another and saying: 'Who's the bozo in the middle? He's not singing; he's an impostor; a southern pansy boy come here to take the piss out of us on the pretext of writing a book about northern traditions. Let's get him and feed him to the gerbils ...'

Happily, none of that happens and we escape to the Royal Hotel in Dungworth. It's almost impossible to find along a string of wet, bumpy lanes that all seem to want to take you to Chapeltown. It's eventually located at the dip of the valley, and we can hear the singing before we've even got out of the car. It's a big pub but it's so full that people have spilled outside with their pints, still singing with harmonies intact. We gather at the door with them trying to listen, and a woman there asks, 'Do you want to get to the bar?' I nod pathetically. 'OK love, no problem,' she says. Then her voice is upped to foghorn levels and she yells, 'One coming through!' before picking me up and launching me along a human chain. The heat of human flesh and the odd whiff of sweat hits me immediately, but my body surf into the pub and straight to the bar is swift and frankly astonishing. 'Are you gonna shoot the bar?' says the barman, seemingly suggesting that I should buy everyone in the house a drink. Er ... no, I'm a bit strapped today, as it happens ...

We both pause as the singing breaks out again. There is no specified singing room here. No flip charts with the words. No newfangled keyboard contraptions to keep you from straying from the melody. It's just a crowd of people in a pub, pints in hand, beautifully singing stirring traditional songs to the manner born.

It's a wonderful, wonderful feeling. I'm starting to think that England's not so bad after all.

CHAPTER FOURTEEN

East Side Story

'Conquers the crown too, grave and the gown too
Set you up a province, but it'll pull it down too
No gospel can guide it, no law decide it
In church or state, 'til the sword sanctified it'

"The Dominion Of The Sword", Martin Carthy

'SKEGNESS IS SO BRACING' roared the famous slogan that first sold the town as a holiday resort in 1908, and there was no way back from that.

In 1936 Billy Butlin opened his first holiday camp here, cementing its special place in our hearts as the epitome of the old-fashioned northern coastal town. And when we get here, that's *exactly* what it's like – the living cliché, full of fish and chip shops and saucy seaside postcards showing rosy-cheeked bald men with eyes on stalks ogling the buxom blonde taking two dogs for a walk and asking, 'That's a nice pair miss, can I stroke them?'

Tonight, it lives up to its Edwardian billing. It's so bracing that it brings tears to my eyes, and by the looks of the guys mincing along the sea front in cutaway t-shirts and tight leather pants, it's pretty camp too. We gaze at the collection of middle-aged women looking daggers at each other as they prepare to fight to the death over a bingo card, resist the temptation to join them, and instead inspect the 300 chip shops along the promenade. It's a toughie, but we eventually go for the one that doesn't have a menagerie of 15-year-old boot boys standing guard on the door, endure a plate of chips made of rubber and a cod that died of old age, and go for a pint in the pub next door to wash away the taste. It's thoughtful, too, of the barman to celebrate our arrival by whacking up the sound system so we can enjoy Britney Spears singing "Toxic" at ear-bleeding decibel levels. I ask the Australian barman if he's got any

Nic Jones records he can play instead, but he doesn't seem to under-
stand.

We're seriously contemplating the bingo when we pass a pub with a
sign in the window saying 'LIVE MUSIC TONIGHT' and a hook
appears from some hidden panel in the roof and yanks us in. Somehow
we've mysteriously been deposited in the middle of a pub-cum-cabaret
theatre with a bunch of octogenarians watching a guy in a horrible wig
singing John Denver songs.

But the weirdest thing isn't this guy attacking "Take Me Home
Country Roads" and "Annie's Song" as if his life depends on it, but the
audience. Someone must have been on a crawl of Lincolnshire retire-
ment homes to scoop this lot up and dump them here in their glad rags
to singalongaDenver and drink themselves gaga. The malt whisky is
being passed to them with prodigious regularity and closer inspection
reveals they're all pissed. But it's worse than that even. Not only are
they pissed and getting very loud, they're all *on the pull*.

'I don't like it; can we leave, please?' whispers Mrs Colin, downing
her lager shandy in one as a rotund pensioner starts winking at her, but
I can't take my eyes off this lot. There's a silvery-haired woman who
can't be a day under 75 wiggling her considerable hips in a sparkly
purple mini-skirt and sticking her tongue out suggestively. The bald
old guy in the cool hipsters and red open-necked shirt with the flap-
ping collars can't contain himself any longer. 'Don't put your tongue
out at me unless you intend to use it,' he smirks, grabs her by the bum
and sticks his tongue down her throat. And all this while the smiley
gonzo on stage is wittering on about "Leaving On A Jet Plane".

This opens the floodgates and in no time at all, the whole place –
aggregate age: nine trillion and one – is a seething, sensual mass of
gyrating pensioners with lurve on their minds. They bump and grind,
they show their bums, they wolf-whistle, they swear and they, this is
making me feel ill but ... they *snog*. I'd say they're drinking themselves
into an early grave but that patently isn't true.

Eventually, I have to concede that Mrs Colin has a point. I mean,
I'm all for growing old disgracefully but have you ever *smelt* testos-
terone on a senior citizen? We wave to John Denver, slide past the old
dear straddling the chap whose glasses are rapidly steaming up, and
head for the hills. 'Going so soon?' asks the young doorman/bouncer
(he's about 70) as we leave. 'Yes,' I say, 'can't keep up the pace of that
lot. Is it always like that here?' 'Oh aye,' he says, 'this is well behaved
for them. It's pretty quiet at the moment; come back later and it'll get
really wild. We know how to enjoy ourselves in Skeggy ...'

Next day, we head for Brigg. I'd always wanted to see Brigg, but I
can't remember why now. It was something to do with Joseph Taylor,

Percy Grainger and Brigg Fair. The Australian concert pianist, composer and collector Percy Grainger visited Brigg in 1905, and offered a 10/6d prize for a folk singing competition at the annual Brigg Fair. Only four people entered, and the winner was the bewhiskered Joseph Taylor.

Taylor was a super-fit 72-year-old, still working as a local bailiff, and he sang his way to triumph with "Creeping Jane", a song about a race-horse that he had learned as a small child. Unlike Cecil Sharp, Grainger favoured the newfangled phonograph as a means of preserving his folk songs, and he and Lucy Broadwood returned to north Lincolnshire to record Taylor singing "Creeping Jane", "Brigg Fair" and other songs, as well as other north Lincolnshire singers.

This is a landmark event in English music. Grainger's arrangement of "Brigg Fair" was orchestrated by Delius and re-emerged as "Brigg Fair – English Rhapsody", and Joseph Taylor was an invited guest at its première. Crucially, Taylor's own unaccompanied 1908 rendition was preserved on cylinder to become the oldest existing example of a traditional folk singer. It's available on different compilations, and his sweet voice sounds remarkable for a man of 75, as well as providing food for the modern folk revival – Martin Carthy, for one, has recorded "Creeping Jane".

Brigg Fair is still held annually, but alas not while we're here and there's little evidence of Joseph Taylor-mania. Nor, in truth, of anything else. Today, Brigg is shut. There's nothing cooking at Taylor's home village, Saxby-All-Saints, either, apart from a memorial to Queen Victoria commemorating the 60th year of her reign. It doesn't look as if things have changed much since then. There couldn't have been much bailiffing for Joseph to do here; there are only a handful of cottages in Saxby.

There's not much more up the road at Horkstow either, though it was a song from this village, "Horkstow Grange", that prompted – at Martin Carthy's suggestion – Steeleye Span to take up their name. The song, collected by Percy Grainger from the singing of George Gouldthorpe, tells the story of a market-day fight between one John Bowlin, who was apparently the baddie, and the good guy, Steeleye Span. A lovely rendition by Shirley Collins brought it into modern currency.

We take a brief look at the faded fishing frenzy of Grimsby, move on to the even more faded sand, sea and sadness of Cleethorpes ... and aim for Louth.

Henry VIII hated Louth. It was here that the peasants started revolting against his religious reforms in 1536, goading the king into the mother of all hissy fits; he dismissed the whole of Lincolnshire as

'the most brutal and beastly in the whole realm'. The blame was placed squarely on the local vicar, who was hung, drawn and quartered as a result.

Robert Wyatt lives in Louth. If anyone is going to provide a sharp, intelligent insight on Englishness then it's surely Robert, one of our most enlightening left-field musicians and original thinkers. Robert was the drummer with psychedelic/jazz-rock fusion pioneers Soft Machine until they sacked him in 1971, though he still doesn't know why. Things took an even more traumatic turn a couple of years later when, drunk at a party, he fell from an upstairs window and broke his spine.

He spent three months flat on his back staring at the ceiling and was at Stoke Mandeville Hospital for eight months before he re-entered the world as a paraplegic. After all that time with nothing to do but think, he reinvented himself as a solo artist. He concentrated on keyboards, started singing in earnest and became something of a cult hero with the Seventies albums *Rock Bottom* and *Ruth is Stranger than Richard*. He even emerged as an unlikely pop star with a quirky 1974 cover of the Monkees' "I'm A Believer".

His music gradually became more obtuse and political, but included a series of challenging cover versions, including the Billie Holiday classic "Strange Fruit", "The Red Flag" and "Stalin Wasn't Stallin'". And then he was back in the charts during the Falklands War with his disquieting version of Elvis Costello's sharply barbed response to the war effort, "Shipbuilding". Since then, Wyatt has continued to plough a determinedly individual and highly unpredictable path, carefully avoiding the mainstream. But maybe that's not so difficult when you never play gigs, do little promotion, and make abstract albums loaded with political intent and reference points ranging from the Far East to modern jazz.

It's a bright-eyed Robert Wyatt who ushers us into his house in the centre of Louth. He dispenses tea, warm welcomes and an unexpected dissertation on the joys of oyster-burgers, which he orders once a month as a special treat. He and his wife Alfie recently returned from a rare trip to London for the Mercury Music Prize awards after his *Cuckooland* album became a surprise nominee.

It didn't win – that honour went to Scottish art rockers Franz Ferdinand – but he's still tickled pink by the experience. 'Yes, very nice,' he says, 'we had a lovely dinner and I met Dizzee Rascal.' He thought the Streets should have won, that Amy Winehouse was 'amazing', and says he likes Joss Stone, the 17-year-old white soul singer from Devon, because she gives work to British black musicians.

I start waffling about the meaning of Englishness, but he's looking blank. He doesn't recognise notions of borders or nationality, so he

doesn't understand the question. Yet his own English genealogy is as pure and undiluted as it comes – every one of his ancestors as far back as he can go is of unadulterated English stock. 'I'd survive the Nazi test, but not the Norman Tebbit test,' he says. 'And I feel I can say *exactly* what I like. I asked my auntie if there was any history of immigration at all in our family and she thought about it and said, "Oh yes there was ... one part of the family came to Southport from Bolton."'

Robert was actually born in Bristol and raised in west London, but has 'lived in lots of places in my head'. Like where? 'Forties Harlem; I actually went there in the Sixties and it had been ruined by rock'n'roll.' His influences and reference points span many places, geographically and culturally: 'Picasso and Coltrane give me a reason for getting up in the morning,' he says at one point.

But surely, I say, there must be some English artists who inspired him? 'Yes: Benjamin Britten and Vaughan Williams. I'll always be grateful to Britten because he used a lot of old scales that hadn't been used for a very long time to get a better range of sound.' OK, I say, where's your *spiritual* home? 'Anywhere Alfie is ... that's home to me. If she wanted to live in Spain, then that would be my home. But my ethnic heart is in Soho. The only person I cried over when they died was Ronnie Scott – an East End Jew in the West End.'

We talk about his adopted county, Lincolnshire – he's outraged by the fierce protests that greeted plans to bring Kosovan refugees to the Grimsby area. 'What are they complaining about? There aren't *enough* people in Lincolnshire. Anybody ambitious always leaves so they should be glad of some strong hard-working Kosovan genes to mix with theirs ...'

People think their concept of Englishness will be diluted by immigration ... 'People worry about the pepper effect of immigrants coming over and diluting Englishness but I see *the reverse* happening. Immigrants actually become English. They take on the characteristics of Englishness and lose their own culture. It's like Trevor McDonald, who's from Trinidad and is now cited as the perfect English speaker. It happened with the black Africans in France. Some of them went there from small villages, but they ended up becoming completely French; they had the gestures and everything.'

As I thank him for his time and head for the door, Robert Wyatt has one last message. He hates Hugh Grant ... or, at least, the images of Englishness that the actor invariably propagates. He can't stand images of the English being polite, tolerant, modest and uncomplaining, and tells me not to further this myth: 'If I read *that* in your book, I'm not going to read another chapter. I'm going to vomit over it and throw it in the bin, OK?'

OK, Robert …

We trawl Louth for somewhere to stay, and check in to a local pub because the landlady's lovely. 'It's not the Ritz,' she warns apologetically. Oh, it'll be fine, we say. But she's right, it's not the Ritz: it's a hole. The rooms are cold, the wallpaper is peeling off, the crackling telly is stuck on BBC2 and looks about to electrocute us, and the bathroom up the hall is a mess. 'Everything all right?' she asks anxiously when we reappear. 'Oh yes, lovely thanks, couldn't be better,' we smile. We're English, see; we're polite, tolerant, modest and uncomplaining.

The sound you just heard was Robert Wyatt vomiting and throwing this book in the bin …

The next day we're up with the lark (ascending) to seek the sanity of East Anglian graveyards. I'd never bothered with East Anglia much. The odd visit to Norwich Folk Festival, the occasional dirty weekend in Ipswich, a memorable week trying to stay afloat with a barge on the Norfolk Broads … and that's about it. Can you really trust a region that has no hills?

'East Anglia? It's all incest there, isn't it?' said my friend Dave helpfully. 'They're all at it, shagging each other morning, noon and night. Not worth going there, they're all inbreds.' I didn't know you'd been to East Anglia, Dave … 'Well no, I haven't actually *been*, but everyone knows it goes on.' Do they? 'Oh God, yes. Shagging they are: all the time. I'm surprised you didn't know that …'

In our first port of call, a pub in Swaffham, I begin to suspect he might be right. We'd been expecting a quaint country pub, but we walk in to find a semi-circle of men with bulging eyes and their backs to the bar staring intently at a large screen in the corner. They turn round to glare at me in distinctly unwelcoming fashion for a minute, and then point their faces back to the screen in the corner. Oh good, I think, footie's on.

But it's the Boomtown Rats playing "I Don't Like Mondays" and suddenly the bulging-eyed Neanderthals are on their feet, singing along, clapping each other on the back and dancing like dads. As soon as the track finishes they're back in their seats staring at the blank screen in sullen silence. Until there's another whirr from the screen and on comes "Come On Eileen" by Dexy's Midnight Runners and they're all up, smiling, dancing and singing.

The other pubs in the market square don't appear any more inviting, with a plethora of skinheads lurking outside and all, so we put it to the committee and decide on an early night. That's if we're allowed to. The large sign in our room certainly doesn't make us feel welcome: 'NO SCOTTISH NOTES ACCEPTED ON THESE PREMISES, NO UNAUTHORISED FOOD, NO ANIMALS, NO

VEHICLES IN FRONT OF THE ESTABLISHMENT, NO SINGING BOOMTOWN RATS SONGS, NO HOW'S YER FATHER, NO BREATHING ...'

We spend most of our time in Norfolk on the trail of Harry Cox. When I first got into English music and traipsed around watching the likes of Martin Carthy, Tony Rose, Nic Jones, Shirley Collins, Peter Bellamy, the Coppers, and Robin and Barry Dransfield, the name of Harry Cox was always mentioned in hushed, reverential tones. He'd died in 1971 and his memory was still fresh, although few I encountered seemed to have seen him, or even heard him. Accessing traditional music wasn't easy then and the occasional account of somebody who had heard Harry sing in the flesh – or even met him – was hungrily devoured.

But if they didn't know the man, they certainly knew the songs he'd put into circulation. There was "The Female Drummer", which, while hardly exclusive to Norfolk, tells a cracking story of a girl so determined to join the army that she passes herself off as a boy. Which worked very well until another girl started getting fruity with her. And there was "Black Velvet Band", which went on to become a hit for the Dubliners. Not to mention the frankly filthy "Maid Of Australia", which survived the cull of collectors who tended to censor anything as risqué as this. Peter Bellamy later recorded a delicious version of it.

Oh, and let's not forget "The Pretty Ploughboy", whose girl-friend's parents thought she could do a lot better than him, and called the press gang to ensure he was out of their hair and doing something useful, like being shot at by Johnny Foreigner. But their daughter was made of sterner stuff. She blagged her way to the front lines and, with 500 bright guineas, bribed the Captain to let her take her ploughboy home. A haunting line of Cox singing *'And they sent him to the wars to be slain, to be slain, they sent him to the wars to be slain'* was sampled to startling effect by Chumbawamba on "Jacob's Well", a track on their *Readymades* album that cleverly linked the story of a sea battle from the Second World War with the tragedy of the Russian submarine *Kursk* in 2000.

So we drive along the north coast of Norfolk in pursuit of Harry Cox's legend. We laugh cruelly at the would-be picnickers dashing for cover as the skies suddenly open at Sandringham; explore the maritime history of King's Lynn; and stand shivering on the beach at Heacham on the very spot where the splendidly named Mercedes Gleitze became the first person to swim the Wash in an epic 13-hour endeavour in 1927.

We stop off at the quiet rural idyll of Burnham Thorpe, birthplace of Horatio Nelson, which is a good excuse for a peek at the graveyard,

though Nelson isn't one of the bodies buried here – he's at St Paul's Cathedral in London. In fact, there's surprisingly little hoopla here to attract sightseers to what a gun-slinging marketing wizard might consider a prime landmark. There're no coffee shops, or anything.

Nelson's white ensign flag – the only one of its kind in the country – does, however, proudly fly above All Saints' Church. And there is some blurb in the village singing the praises of his one-eyed, one-armed lordship, informing us he was of typical vintage Norfolk stock and changed the Navy's attitude for ever with the 'traditional independence of mind of Norfolk people'.

Eyes a-popping, we also stop at the extraordinary village of Little Walsingham. The place is humming. There are coach parties, souvenir shops, people being led on conducted tours ... and nuns. Everywhere, there are nuns. It's all because, in 1061, the lady of the manor, one Richeldis de Faverches, had a vision. The Virgin Mary came to her in a dream to show her Santa Casa, the house she'd lived in at Nazareth, and told her to build a replica right here in Walsingham. This she faithfully did, and pilgrims have been coming here to pay homage ever since. Even though Henry VIII destroyed the shrine in the 1530s after that nasty business with the Pope.

They stopped coming here for a bit after that – well, about 300 years as it goes – but they started flocking back here in the Twenties. Walsingham's reputation as 'England's Nazareth' was fully restored and now the place is Pilgrims-A-Go-Go. Later that night, I have a dream that I've got cement on my feet and can't get out of Walsingham's Shrine Shop and am destined to spend the rest of my life there among the zillion Bibles, colouring books, Daniel O'Donnell albums, religious trinkets, poems, prayers, crucifixion scenes, statues of Our Lady (very reasonable at £250) and books about Walsingham and its history living with the Franciscans and Augustinians.

I wake up in a cold sweat, still in panic after the trauma of the dream, yet euphoric, too, because I've just realised it's only a dream and I won't be spending the rest of my life in Walsingham. We saddle up Alberta and hit the road quick, just in case ...

Harry Cox was born in 1885 at Pennygate, on the north-east side of Norfolk, right on the edge of the Broads. It was a tough upbringing then. His dad earned ten bob a week on the land or on fishing boats, the cottage they lived in was cold and damp, and with eight brothers and sisters, the money didn't go very far. There were certainly times they went without food or, as Harry Cox would say, 'I seen more dinner times than dinners ...'

But like his father and his father's father before him, Harry could sing and he could play the fiddle, and even as a small boy he'd be

playing in the pub with his dad passing the cap round. Harry was 11 when he sang in public for the first time – at the Union Tavern in Smallburgh – and began to play regularly for step-dancers. He left school at 12 to become a farm labourer, hiring himself out to the various farms in the area. He joined the Navy to help the war effort in 1917 and was part of the fleet that accepted the surrender of the German ships. It's said he had a piece of a German flag, which he kept for the rest of his life.

But there aren't any Harry Cox museums or pubs telling his stories or playing his songs in Pennygate, or anywhere else in the vicinity. We tour the places Harry was associated with – Pennygate, Barton Turf, Potter Heigham, North Walsham, Catfield, Sutton – but nobody professes to know anything about him. At Potter Heigham, where Harry was buried, enquiries about the graveyard are met with blank stares.

'What's 'is name again? Harry Fox?' No, Cox – Harry Cox, he was a famous singer from round here. 'Don't know any famous singers from round here. What did he sing? Things like "My Way?"' No, not "My Way". He sang English traditional songs. 'Did he now? And he was famous? Can't have bin famous, else I'd 'ave heard of 'im. Don't know any famous singers from round here. Are you thinking of the Darkness? They're from Suffolk. I like the Darkness, they play *real* music.'

We give up and watch the raft-racing under the bridge, won by a team wearing Union Jack hats with the St George's cross painted on their faces and a sign saying 'Kiss my rudder' on the back of their raft. They are pelted with water bomb balloons as they cross the finishing line. I want to shout 'If you're so bloody proud of England, how come you've never heard of your own local hero Harry Cox?' but of course, being English, I just applaud politely and walk away, silently seething. We eventually find St Nicholas Churchyard and search in vain for the grave of Harry Cox. It's only later I discover the grave is unmarked.

Harry was effectively discovered in 1921 by a Norfolk composer, Ernest John Moeran, who initially tried to collect songs from Harry's father, Bob Cox. Bob was having none of it, but told him that Harry was singing them anyway on Saturday nights in the pubs of Sutton. It was the beginning of a long relationship that Harry had with collectors, enthusiasts and admirers trekking out here to hear him sing and note his songs down or record them. Harry's singing, fiddle and melodeon playing was thus preserved for posterity more than any other source singer before him, and as his lifespan spilled into the early days of the folk revival, he became a celebrated and revered figure.

Jack Moeran took him to London to record at Decca Studios in

1934, the first of many such trips to record and make personal appear-
ances, and in later years he appeared on radio and television. And
despite what the Darkness fan tells me in Potter Heigham, he became
a local celebrity, albeit a reluctant one. In his book *Folk*, Bob Pegg
rather poignantly describes a trip down here to Sutton to worship at
the altar and see Harry Cox sing in public for the first time for several
years at a gathering organised by the Norwich Folk Workshop at the
Windmill Inn in 1968. But he was already 83 by then, and it seems to
have been a profoundly uncomfortable occasion for him.

'The first thing I noticed,' said Pegg, 'was his nervousness. His
hands shook and there was a constant rattle in his voice. Nevertheless
it was still the same Harry Cox we heard on record. The songs were
steadily and tunefully sung and each one delivered as if it was a matter
of personal experience.'

Harry also delivered a party piece by operating a set of dancing
dolls, but the night deteriorated fast as the audience got drunk and
talked among themselves, while locals in the next bar started
barracking. 'The sense of uneasy awe with which the evening had
started had become a feeling of strange indifference,' wrote Pegg. 'For
some there, Harry Cox was little more than a curiosity; a musical
dinosaur miraculously preserved long after ceasing to operate as a
function of his environment.'

He died of cancer a few weeks after his 86th birthday in 1971, but
Harry remains a giant among those who kept traditional songs alive
during the early twentieth century, even if they've never heard of him
in Potter Heigham. The next time you go boating on the Norfolk
Broads, buy a copy of the Topic Records compilation *The Bonny
Labouring Boy*, read the superb sleeve notes by Paul Marsh and Steve
Roud and get a feel of what Norfolk used *really* to be like.

In fact, both Norfolk and Suffolk are well served by traditional
singers. We pay our respects to the village of Knapton, where another
great singer, Walter Pardon, lived his entire 82 years in the same
house until his death in 1996. And, with some difficulty, we eventually
find the village of Winterton, home of Sam Larner. Born there in
1878, he spent most of his early life on sailing luggers fishing for
herring, until being signed off due to having 'worn himself out with
hard work'. Confined to dry land, taking any job he could get to keep
the wolf from the door, his singing caught the attention of the nascent
folk movement.

He'd first sung for pennies to coach outings passing through
Winterton and, a bit of a showman as well as a keeper of the tradition,
he became an adored figure at the various concerts and club events
where he was invented to appear. He'd occasionally dance a jig mid-song

and would cup a hand to his ear in a manner that in time became adopted as a stereotypical parody of all ballad singers.

He was a sprightly 80-year-old when invited to appear at Ewan MacColl's folk club in London in 1962. Crucially, one of those in the audience that night was a young Martin Carthy. The way Martin tells it, it was a night that changed his life. 'It turned my whole conception of music upside-down,' Martin tells me. 'He broke every rule in the book – or at least every rule I thought was a rule. He was just ... *astonishing*. The audience went crazy for him and he knew *exactly* what he was doing. The last song he did was "Henry Martin" [about a private sea battle between merchant seamen and the press gang]. It was the weirdest song in his repertoire with the weirdest tune ... and it brought the house down.'

We stay overnight in Cromer. After the abomination in Swaffham, we hit gold with a lovely guest house in Cromer. Guest houses have become a bit of an issue on our travels. If you just want to stay somewhere one night on a Saturday, good luck. The trend is for guest houses, pubs and B&Bs to reject one-night stays at weekends and accept only two- or even three-night bookings. So we feel like lonely orphans trying to find a bed for the night, and are contemplating spending it with Alberta when we find Gillian's gaff, the Captain's House in Cromer.

We get tea and cakes and jolly chat on arrival; some fine insights about life in Cromer, the habits of the tides and the recent activities of the lifeboat that's housed directly beneath our bedroom window; and all the creature comforts you could possibly hope to find on the coast of Norfolk. Gillian even sends us away with an anecdote.

It seems that a guy who had tried to book a room several times at the guest house eventually arrived and seemed to be behaving rather oddly, in his Val Doonican cardigan and all. He seemed to be taking a keen interest in the minutiae of the guest house, and was particularly obsessed with the sheets on his bed and where she'd got them. When it was time for him to depart, he said he just needed to change and then he'd pay. When he reappeared, the Val Doonican cardigan was gone and he was wearing a smart suit. He planted a brief case on the table and asked, 'You know who I am, don't you?'

Actually Gillian didn't. She was thinking he must be a famous actor; maybe he's in a soap? 'Sorry,' she said, 'I don't watch much television.' This tickled him pink. 'Oh come on,' he says, 'you *do* know who I am, don't you?' At which point she thought he must be a royal. 'You're going to have to give me a clue,' she said, and he handed over his business card: 'English Tourist Board Inspector'. Basil Fawlty would never have missed that one. Then, as he picked her up off the

floor, he told her he was upgrading the guest house to the maximum five diamonds.

We plough on south through Suffolk, stopping to sit on the beach at Lowestoft for a while looking for the Darkness, then bang on down through Southwold, Aldeburgh, Ipswich and Hadleigh ... and then we're in a) Constable country and b) the lap of the gods. We seek the village of Polstead, but get little help from the signposts or a map that seems intent on dumping us in Sudbury.

But finally we find Polstead, a village so cute that you daren't sneeze for fear of breaking its fragility. In bright sunshine in the garden of the Cock Inn, with its thatched roof and pink walls, it actually feels as if you're sitting in the middle of an oil painting. And over a cool, refreshing pint we discuss the case that brought us here: the murder at the Red Barn.

Maria Marten was the daughter of a mole-catcher born in 1801 and at some point in my life I want to find out more about mole-catchers. Like, how did they catch the moles? And why? Are moles that evil? What do they do that's so bad that it requires a specialist to catch them? I always thought moles were terrified of daylight and cowered in holes all day long. And even if they were evil, is being a mole-catcher really a serious job for a grown man?

One day all this will be revealed. Meanwhile, the mole-catcher's daughter seemed to have got it made growing up in Polstead. She received a good education and was smart and intelligent and, apparently, was drop-dead gorgeous too. All the nice boys in Polstead were after her but, like many before her and since, Maria was drawn not to the nice boys, but the wrong 'uns. Maria embarked on relationships with three of them. The first ruined her reputation, the second left her with an illegitimate baby and the third ... well, the third was William Corder. He fathered another illegitimate baby, which died suspiciously in its infancy, and then he killed her at the Red Barn.

The case has fascinated journalists, dramatists and songwriters ever since, partly because of the sheer callousness of William Corder's deception as he lured Maria to her doom on the pretext that he was going to marry her. She probably wasn't anticipating a white wedding with all the trimmings, what with the bastard children and the village calling her a slut and a whore and everything, but she'd still have wanted to look her best when she went off to meet her future husband to take their vows.

But she didn't even get to do that. William Corder gave her one of his suits, and asked her to dress in it for the wedding. She was probably a bit worried she might be marrying some sort of transvestite and wondered what he might be making her wear *after* the wedding, but

she certainly wasn't expecting him to shoot her dead and bury her under the floor. He'd asked her to wear the suit so she wouldn't be recognised en route.

> *'If you'll meet me at the Red Barn*
> *As sure as I have life*
> *I will take you to Ipswich town*
> *And there make you my wife ...'*

That's what he said he'd do. This is what he really did ...

> *'After the horrid deed was done*
> *She lay there in her gore*
> *Her bleeding mangled body lay*
> *Beneath the Red Barn floor.'*

I was first alerted to this epic tale of treachery, deceipt and violence when it was staged by Horsell Amateur Dramatic Society as a Victorian melodrama. But Shirley Collins and Ashley Hutchings came out with the trailblazing Albion Country Band album *No Roses* in 1971 and "Murder Of Maria Marten", presented in almost cinematic musical fashion with different sections and sound effects, was one of the key tracks.

There were various sub-plots in the story. With Maria's body securely secreted under the Red Barn floor, Corder continued his deception, writing to her family to tell them he and the new Mrs Corder were perfectly well and blissfully happy living on the Isle of Wight. But Maria's mother thrice dreamed that her murdered daughter's body was under the Red Barn floor. She eventually persuaded her husband to start digging ... and he found Maria. William Corder was then tracked down to Brentford, where he was living with his real wife and running a school for young ladies.

Corder denied everything. He'd never heard of Maria Marten; never been to Polstead; didn't father her child, and wouldn't have, even if he had known her. At the trial he remembered that he *had* been to Polstead and he *had* met Maria, but pleaded not guilty, saying that she'd shot herself in an almighty tantrum after he told her he'd changed his mind about marrying her. Shortly before his execution, he made a full and frank confession about the murder, and after he was hanged, Polstead was besieged with souvenir hunters. A bidding war even broke out over who was going home with the hangman's rope that choked William Corder and the pistol that killed Maria Marten:

'Adieu adieu my loving friends
My glass is almost run
On Monday next will be my last
When I am to be hung.'

Driving across the much-maligned county of Essex later, we see the strange sight of a woman strangling a swan. I decide this is a practice that's probably illegal, even in Essex, and stop the car. It turns out she's *saving* the swan. The swan had some wire caught round its throat and, as a registered swan rescuer, she'd answered the SOS call and freed the poor thing while all its mates stood around watching curiously.

Is it good fun, rescuing swans, I ask. 'Oh you'd be *amazed* the pickles they get into,' she says. 'Mostly it's people leaving their cans and other rubbish around. We're getting more and more of these incidents. They call me out, and I do what I can.' Isn't it dangerous? I heard a swan could kill a man with one swish of its wing. 'It suits us to let people believe that,' she says with a wink. As her helpers hold the swan down, she liberates it from the wire, calmly walks to the pond and dumps it in. The swan swims away as if nothing has happened.

'Amazing,' I say, 'well done, you're doing a good job.' 'Well,' she says, 'we're always looking for new recruits to help out so if you fancy joining the team ...'

I would, but I've just spotted a couple in leather jackets and hair everywhere, taking two ferrets for a walk on a lead. 'Oh, ferrets make great pets,' they say animatedly, picking them up so I can stroke them. I thought ferrets just got in your pants. 'Only if you put them there,' they say. 'Think about it; if you were a ferret would you fancy being put down someone's pants in a confined space in the dark, where it's probably smelly?'

I think they have a point.

Still, strangulated swans and ferret walking are perfectly ordinary compared to what we encounter at the Whittlesey Straw Bear festival. As soon as we arrive we're almost mown down by rampaging morris sides hurtling from all directions. There are some spectacular displays among them, including the Goth-looking Pig Dyke Molly from Yaxley, near Peterborough, with their bizarre array of costumes dancing to the unlikely accompaniment of a tuba.

There are also the equally strangely clad Gog Magog Molly from Cambridge, dressed like a cross between Rob Roy and Wurzel Gummidge; the mysterious Witchmen from Kettering draped in black and purporting to perform pagan dances from 'the dark side'; Old Glory Molly Gang, dressed like Victorian undertakers in long coats and solemn expressions; plus assorted clog, sword and Appalachian dancers.

Up a side street, I corner a lone member of Kent's Seven Champions Molly, who's somehow become detached from the rest of the side. Like the other molly dancers – molly is widely considered the East Anglian version of morris – his face is blacked up, and I go for the throat. 'Tell me, why *do* you black your face up?'

Ah, he says, scratching his nose as if he's never been asked this before. 'Now, do you want the full and frank explanation or just the soundbite? There are various theories. I'm inclined to think it's because people would dance for money but they were looked down on for doing it and it was illegal to beg, so they blacked their faces so nobody would recognise them. Another theory is that a lot of the dancers were miners, and they'd dance after coming up from the coalface with their faces still black. But they've been arguing about this stuff for years, they've made studies of it and still nobody really knows, so we don't really worry about any of it; we just dance.'

What we're all here for, though, is the Straw Bear, which looks like a bloke plastered from head to toe in great sheafs of straw. Which, I guess, is exactly what he is. The dancers assemble at the Ivy Leaf club and set off on their tour of Whittlesey, ending up in the marketplace. The Straw Bear, directed by a keeper, makes his way over there while the band plays on. In truth the Whittlesey Straw Bear tune isn't up to much – it's certainly no Padstow May Song – and the amiable Straw Bear is easily distracted, dancing up side roads and getting himself embroiled with well-wishers and small pockets of children.

But the whole place seems to come out for it, and it's certainly put this small Cambridgeshire town on the map since the old tradition was revived 25 years ago. The Fenland custom of draping a single ploughboy in lengths of twisted straw and parading him through the town had been banned in 1909 by the town's Police Inspector, on the grounds that it constituted, er, 'cadging'. They threatened anybody who indulged in this heinous crime with prison sentences.

There are no such worries today, as the town comes out in force to celebrate a wholehearted and likeably random dancing spectacular, which climaxes on Sunday afternoon with massed displays at Sir Harry Smith's Community College, after which we all troop outside for the ceremonial burning of the bear. I'd imagined there would be wizened old barnacles out there telling me about the pagan origins of this fiery conclusion to the festivities. But nope, it was simply that when they revived the festival in 1980 they didn't know what to do with the bear at the end of it, so they set fire to it.

So now the crowds gather as musicians play the Whittlesey tune and morris dancers escort the bear to its final resting place. Suddenly the bonfire is lit and the Straw Bear is aflame. I still don't like that

Whittlesey tune, but as it plays and the Straw Bear seems to stand tall in one last gesture of defiance amid the flames, the whole scene is genuinely emotional. An old morris man leans forward and throws his hat into the fire. So does another one. 'They're retiring,' whispers the woman next to me. 'This was their last dance ...'

We shuffle away, and pretend we've got something in our eyes.

Next morning we're back in Essex at Manningtree, which proudly announces itself as 'England's smallest town', which must be one in the eye for North Petherton. If North Petherton was England's largest village and was then upgraded to town status, wouldn't it automatically be installed at the bottom of the league table of towns? Or doesn't it work like that? Does Manningtree bask so much in its smallness that nobody dare tell it there's a smaller one in Somerset that's undertaken it?

Well, probably not. Not with Manningtree's history of burning witches; the town was the home of the infamous seventeenth-century Witchfinder General, Matthew Hopkins. Merely owning a cat was damning evidence that you were a witch, according to ol' Matthew. Which explains a lot in our house.

It looks as if there's more witchcraft afoot when I'm prowling through Northamptonshire villages late on a cold Sunday night in December.

I'd been sceptical about this one from the start, to be honest. A friend had mentioned it in passing: 'So you're doing a book on English customs, eh? You've got to do the tin kettle band thing ...' His rambling explanation had left me convinced it was some elaborate practical joke, and driving through Northants in the pitch black, I was wondering which particular heinous disservice to my contact had earned this payback.

Yet still I was intrigued. A band that came out only at midnight once a year playing household tins, and marched through a village near Kettering called Broughton? We arrive shortly before 11pm and dive into the Sun public house where, I feel sure, I'll sit down with the locals and we'll all have a laugh about the wild goose chase I've been sent on, but we'll have a good time anyway quaffing into the early hours around a log fire.

It doesn't happen that way. The Sun is full, but the natives are hostile. 'We're closed,' says the barman before I say a word. 'Sunday night, we shut at 10.30pm.' Right. Plan B it is, then. I turn to the bloke standing at the bar licking his lips as he prepares to engage with a full pint of foaming ale, and ask if he knows anything about a tin can band coming out at midnight.

If the barriers had already been drawn up the fusiliers are now training their guns at my head. 'You're a journalist, aint'cha?' he yells,

loudly enough for the whole pub to stop their conversations about caravanning and stare at me, appalled. 'Journalist? *Moi?* Nooo,' I protest limply. 'Yes you are!' he accuses menacingly, before addressing the rest of the pub: 'Nobody talk to this guy, he's a JOURNALIST!' I feel like the bloke who's brought the Black Death to the village.

I try to explain. I'm not a *journalist* journalist or anything like that; I'm just interested in English customs. 'We don't kill 'em any more, y'know?' my tormenter says cryptically, as his wife ushers him away. 'We don't want no trouble, do you understand? It's not as dangerous as it used to be.' I'm still trying to decode that when another guy sidles up, whispers 'be at the church at midnight' in my ear, and strides away before I can see his face. The plot has indeed thickened.

I hide with Alberta for almost an hour and then gingerly creep up the path between the gravestones to the church door. The instant I reach it the lights on the church snap off and I'm left in the pitch black shivering as the clock strikes midnight. I shut my eyes listening intently to every rustle of the wind, creak of a door and chime of the clock. When I open them I'm expecting to see something hideous ... a zombie emerging from one of the graves, a headless monk, a herd of antelope pounding towards me, Margaret Thatcher taking tea with General Pinochet ...

There *is* a noise and I look up to see a group of hooded figures silhouetted in the moonlight, marching purposefully up the lane. I crouch in the shadows as they approach the church and watch as they sit on the wall opposite. They are talking to each other, but not in any tongue I recognise. Alberta is parked directly opposite them and I fear for her safety, wondering if one of them will take her out with the strange metal container he's holding, and trying to work out if I can make a quick dash, get Alberta going and make our escape before any of them can react.

But it's too late. They've seen me. I emerge from the undergrowth, hands up. 'Wotcher!' says a kid of about 15, holding a frying pan and a stick to beat it with: 'You here for the tin band, then?' His mates have an assortment of kettles, saucepans, whistles and trays. 'It's great, this is,' he says. 'We go round the village making as much noise as we can.' Yeah? Why? 'Oh I dunno, summat to do with scaring away evil spirits. It's been going on hundreds of years. They're letting me off school tomorrow and everything.'

He wants to know chapter and verse on what I'm doing there, and gets very excited when I mention London. 'Are you on crack?' What? 'Everyone's on crack in London, ain't they?' Well, not quite everyone. 'Yeah, but *most* of 'em, innit? You know how to bong? You got any crack on yer?' Damn; I *knew* there was something I'd forgotten to bring.

As we talk, others silently emerge around us, clutching their kitchen instruments. There are couples, old men, young men, a few kids: about 50 of us in all. And without any ado, no ceremony, no big speech, no song, no group hug, somebody starts crashing a frying pan against a kettle and that's it, we're on our way. It's a strange assortment of people yelling and screeching at the tops of their voices, crudely banging kitchen utensils and playing everything *including* the kitchen sink ... and nobody really seems to know why.

'It's to frighten off the evil spirits,' repeats my young mate who thinks I'm a crack dealer. But there are more sinister theories voiced. One guy is suggesting the evil spirits they were trying to ward off were gipsies, and someone else who may just have been in the pub all night is positive that way back in the mists of time some kind of black magic was involved.

For now, though, we're just having a good time stomping around Broughton in total disarray in a wholly pointless but hugely entertaining exercise in din-making. There is something strangely cathartic about walking around a small village in the early hours being outrageously noisy. It feels like anarchy in the UK. A few net curtains twitch as we pass and a couple of people open their front doors for a closer listen to the cacophony of sound, but the Broughton Tin Can Band largely barges its way through the village without an audience.

The 'band' is a rabble, strewn along the street in little clutches. There are no tunes, no route; just incessant *noise*. We seem to be accumulating some new band members along the route and losing others as the long, slow, weird parade fractures even more. A bunch of lads bound off to wake up their neighbours up a little side road, but they're soon replaced as a well-to-do couple and their little boy join us.

I fall into conversation with a big guy weighed down with elaborate cameras. At first I think he's using his cameras to beat out that rhythm on a drum, but he is taking pictures. It turns out he's an Anglophile from Poland, who's come here specifically to see the Tin Can Band in action: 'I heard about it before but never got the chance to visit before. We have nothing like this in Poland. This is what makes the English special. It's just so ... *mad*! You mustn't lose these things.' I'll try not to, I tell him, me being the guardian of English culture, and all.

After an hour or so, the rabble shuffles back up the hill and arrives back at the church, still banging and shouting and whooping and hollering. When the stragglers catch up we stand around together for a moment or two and link hands for a desultory "Auld Lang Syne", wish each other good evening, say same time, same place, next year, and disappear into the night.

As I drive away it feels as if I've dreamed up the whole thing. Except there's a teenage lad running alongside the car, knocking on the window and asking me for crack …

CHAPTER FIFTEEN

The Travelling People

> '*All you freeborn men of the travelling people*
> *Every tinker, rolling stone, or gipsy rover*
> *Winds of change are blowing, old ways are going*
> *Your travelling days will soon be over*'

> "Freeborn Man", Ewan MacColl

*B*utlin's looms out of the mist and drizzle like some grotesquely bloated, beached white hump-backed whale. It's just parked there in the distance, grimacing at me in crazed bewilderment as squealing small children doubtlessly dance on its underbelly while self-consciously wacky young wannabes in red coats fuel their frenzy.

I put my foot on the accelerator and hope the poor demented creature doesn't suddenly erupt into life and eat me for dinner. 'Bugger Bognor ...', as someone eminent once said. Well, it was the bloke who put the Regis into Bognor actually: King George V. He smoked like a chimney did KGV, and when his lungs started to cave in they carted him off to Bognor to test the benefits of the sea air. Feeling a bit perkier one day, he bestowed regality on the town, which has proudly answered to the name of Bognor Regis ever since.

A rejuvenated George swept back to London to resume his kingly duties trooping the colour and such, but his smoker's cough swiftly returned and he fell ill again. Legend has it that when, in 1936, his physician suggested a return visit to Bognor might do the trick, KGV said 'Bugger Bognor' ... and died. Well, better that than face Butlin's....

I spent a midwinter weekend at Bognor in Butlin's once. They'd had the idea of livening up the off-season with special events and Mrs Colin and I were lured through those forbidding gates by the promise of a folk music weekend. This is very enterprising, we thought, as we marched into the hall in search of flaming fiddles and magical

melodeons. Instead, we found a roomful of nubile pre-teens in tiny, saucy costumes bumping and grinding provocatively while a lumpen disco track throbbed around us. It felt as if we'd stumbled into a Paedophiles Anonymous party, but the banner on the wall said 'JUNIOR DISCO DANCING CHAMPIONSHIP.'

The young girls had scary, garish smiles painted on their faces, which were already caked in make-up, and the lewd gyrations were truly stomach-churning ... I indignantly wanted to inform their parents of the degradation their children were being subjected to in this place. I would have done, too, except that their parents were too busy screaming the kids on to even more lurid moves, adjusting their costumes and touching up the make-up. We fled to another hall, and walked straight into a room full of silver-haired couples from Brum in full cowboy regalia (hats, holsters, spurs, guns, the lot) while Rattlesnake Annie sang of whisky nights and cheating men and railroads in the sky. With added yodelling.

We spent the next couple of days colliding with junior disco dancers or amiable cowboys who assumed we were there for the country music weekend but had somehow mislaid our hats and pistols. As surreal weekends go, this clash of the country festival, the junior disco dancing championship and the folk weekend ranks right up there with my trip to Venice when I went to Austria by mistake, and then got arrested with Keith Emerson of ELP in Milan after the Incident on the Train. But I won't go into that now.

As we accelerate past Bognor's beached whale, I briefly consider adding Butlin's to my list for "Room 101". However, in fairness, it does perform society a service in keeping all those strange people away from the rest of us. Surely they're better there than causing carnage in Majorca with their rampaging libidos, drinking games and rotten music? And I couldn't put Butlin's in "Room 101" out of loyalty to my brother who, as a young reprobate, always spent his summer holidays at the Butlin's Holiday Camp in Pwllelhi in Wales, and without fail returned beaming with a bevy of brunettes from Blackpool on his arm.

Today Bognor's promenade is blocked off to traffic. A man in a yellow coat is attempting to explain to an eastern European visitor why. 'It's the Bognor Birdman,' he's saying patiently. 'Eeezzzaaaa WOT?' 'Bognor Birdman ...' The poor visitor stares at him in uncomprehending wonder. Yellow Jacket takes a deep breath and attempts to explain: 'Bog-nor B-i-r-d-m-a-n.' The visitor still looks quizzical. 'People dress up and jump off the pier ...' He looks up optimistically, hoping this explanation will suffice or at least his new chum will have turned on his heel, muttering 'Crazeee Ingleessh.' No

such luck. The guy is still there, open-mouthed, agog to hear more. 'Whytheyjumpoffthepeeeeer?'

In truth, it's a fair question, and Yellow Jacket struggles to answer it. 'Er ... they jump off the pier 'cos they're trying to ... *fly*.'

This is all too much for our eastern European chum. Shaking with laughter, he lurches back to relay the news to his waiting fellow travellers. 'The roooodeezshutt,' he tells them, snorting with mirth, 'the roooodeeezshutt and peoples jump off peeeer as they *try to fly*!' He flaps his arms, Dixie-chicken style, to illustrate the point. Their howls are still plainly audible amid the hubbub of seagulls, feuding families, fish and chip shops and Karen Noble ('Queen of Soundalike') pretending to be Tina Turner and shaking her booty on the Spirit FM road show stage.

In truth, Bognor wouldn't have much to sing about without King George V and the Birdman competition. It's one of those quintessential seaside towns on the south coast that is locked in a slightly quaint, if dozy, timewarp of candyfloss and saucy postcards. It's even got the grotty weather to confirm your worst suspicions despite the tourist office woman insisting to me that Bognor is the sunniest place in Britain: 'Fact!'

This is controversial stuff. Half of the towns on the south coast make this claim. Eastbourne would certainly dispute it, while both Jersey and the Isle of Wight are full of weather-geeks singing up the claims of St Helier and Sandown respectively to this much-disputed title. After hours of intensive research I uncover an unreliable league table of sunshine hours with the Isle of Wight at the top, but it also brings the east coast into the equation, with Clacton, Folkestone and dear old Cromer romping home ahead of Bognor, which limps behind in fifth place. Michael Fish is unavailable for comment.

I negotiate a blue wristband that allows me on to Bognor's rather tatty pier to witness the bizarre spectacle of the Bognor Birdman. Watching the curious mix of fancy dressers, fun flyers, foolhardy dare merchants and serious aeronauts fretfully fussing over their equally odd range of self-created flying machines is an edifying sight. Anything that promotes England's old image of brave derring-do and rank eccentricity over the more familiar modern image of rampant drunkenness is to be encouraged, and I instantly warm to the mad array of characters getting hyped up on the pier.

I love the idea of the Birdman contest. Anything that reignites the old English image of daft eccentrics at play is welcome, and the very notion of man attempting to fly is surely born from the finest – if totally bonkers – ideals. Man, bless his dirty toenails, could never quite get his head round the fact that tiny little creatures with minuscule

brains just had to flap their wings and they were up, up and away, while he stayed rooted to the ground, no matter how much flapping he did. It just wasn't fair or logical, and even when they built that big flying machine thing, there surely had to be a more natural route to aerial travel.

The Birdman competition had its beginnings in nearby Selsey in 1971 as a wacky fund-raising idea for Selsey RAFA Club dreamed up by one George Abel. They offered a first prize of £3,000 to anyone who could dive off the walkway leading up to Selsey Lifeboat Station and stay airborne for 50 yards. Nobody did it, of course, but the event achieved some notoriety with the interesting range of would-be Supermen it swiftly attracted ... Mary Poppins, Peter Pan and, inevitably, various naked people.

Each year thereafter bigger crowds gathered, contestants started arriving from all over the world, and sleepy Selsey didn't know what had hit it. In 1978 the whole daft shooting match shifted along the coast to Bognor and, realising that he had unleashed a monster, its inventor George Abel wisely fled to Australia. But since then they've come here to Bognor from all over the world to defy gravity ... flying Popes, Ninja turtles, giant condoms, Donald Ducks, Batmans, dragons, human doughnuts, ice creams, vampires and, doubtless, teams of pre-teen disco dancers and country and western enthusiasts escaping Butlin's.

Today, as the jabbering team from Spirit FM endlessly informs us, there is £25,000 at stake for anyone who can fly 100 metres. Last year that well-known flier HRH Richard Branson effectively hi-jacked the show, filling Bognor with Team Virgin and making a small leap for man and an even smaller one for mankind himself. But this time around, the best we can muster is a giggly woman from the sales department at Spirit FM and a bloke who's on the telly on some nature show I've never heard of.

Back on the pier, our heroes are making last-minute adjustments to their crafts. The serious competitors have their people studiously wiping the rain off their carefully engineered wings, while the others adjust their wacky costumes, pose for pictures and tell us how much money they're raising for charidee. A man with a bald head and goatee beard emerges from a chicken costume and introduces himself as the landlord of the Southdowns pub in Felpham. 'Ask me what it'll be like when I get up in the air,' he says. 'What will it be like when you get up in the air, Paul?' '*Poultry in motion!*' Boom boom!

I ask a guy dressed in a Thunderbirds uniform where he's from and he says 'Saturn', while a posh-looking businessman called David plays me the *Dr Who* theme from his impressive-looking Tardis, and

accountant Keith Lane attempts to stick a wind- and rain-damaged Statue of Liberty craft back together again.

The smart money is on Ron Freeman, a flying instructor from Sunderland, who's won the competition for the last five years and holds the course record of 81 metres, though the magic 100 metres still eludes him. A bobbing distant buoy denotes that landmark but the rescue boats ominously hover at about ten metres as the first competitor gingerly climbs the ramp to the launch pad dragging a flimsy-looking 'Terror-dactil' creation with him. The shivering hordes watching from the beach offer a plucky cheer as Stephen Wisdom leaps towards the sky, flaps furiously ... and drops instantly into the murky water.

There are a few moments of anxiety as man and prehistoric monster thrash around, but the rescue boat is there in an instant and Wisdom, thumbs up and beaming, is hauled aboard. The adjudicators announce a princely 7.5 metres distance has been achieved, which inspires a few hoots of derision from the beach. But following a succession of belly flops, stone-like plummets and – in the case of a skateboarding cow – backwards flying, it looks as if it could end up being the winner.

A blind piano-tuner edges into the lead as our publican friend in his chicken costume clocks up a poultry score and Jan, an outsize fairy, nearly capsizes the rescue boat. Icicles are gathering on our faces when the serious guys make their way towards the ramp. Ron Freeman, Bognor Birdman legend, is suddenly in front of the mic at the top of the ramp bigging up one of his competitors, a flying instructor from Wiltshire called Tony Hughes.

He has good reason. In an unnamed craft, Hughes spends for ever looking at the angles, judging the wind and taking advice from Freeman about the run-up, but finally he's ready, sprints forward and launches himself into the air. At first it looks as if he's going to dive-bomb straight into the sea just like all the others, but at the last minute the wind gets beneath his wings (cue for a song there) and he hovers for a second or two, suspended in space. You can almost hear people gulping in their breath waiting for the inevitable 'plop' as Tony hits the water, but suddenly he's gliding serenely above the surface of the sea. There's spontaneous applause and whoops of excitement from the beach as he starts to skim the waves like a bird waiting to swoop on a fish. It's a graceful sight and, following an afternoon spent watching people drop like stones, it's a thrilling one too as he continues to fly through the air with the greatest of ease before finally sinking gently into the waves. Bognor, well, erupts.

We wait with bated breath for the distance to be called – it really looks as if he could be the first one ever to fly the 100 metres and take

the big bucks. But when the call comes in, it's 82.5 metres. Nevertheless, it's a new Birdman record, vanquishing Ron Freeman, and it easily wins the competition, but not his place in history as the first Birdman to beat 100 metres.

It's so cold by now we decide to escape before our toes fall off, but the lady next to me, Jackie Beaney, tells me she has to stick it out to the end because she's presenting a cup – the Lyn Award Cup for 'skill, determination and courage – and the biggest foul-up of the day'. It's a prize for the *worst* one then Jackie? 'No, not the worst, but the unluckiest ... OK the *funniest*.'

Jackie is torn between the fancy fairy whose wings disintegrated on the way down, the baked chicken-and-mushroom pie which somehow finished further back than it started from, and 'A Great Day at the Office' in which a boss and secretary ended up being pitched out of their craft as their desk got wedged on the launching pad, swinging grotesquely around off the end of the pier like the effigy of that hanging head we saw in Northumberland. 'One desk, that's all it is, and they still couldn't even get it over the starting line,' she laughs.

The award is in memory of her daughter Lyn, the youngest ever competitor in 1988. She paid her £5 entrance and arrived dressed as Miss Bognor Regis 1888 to raise money for guide dogs for the blind. 'When she got there they said, "She looks young for 18", and I said, "What you on about? She's not 18, she's 12." They said in that case she wasn't allowed to take part, because they had an age limit of 18. I said, "You what? She's paid her £5!" but they said sorry, but she couldn't jump.'

It was at this point that Eddie 'the Eagle' Edwards, the heroic English ski-jumping failure, wandered by in his Speedos. He was preparing for his own leap when Jackie collared him. 'I didn't know him or anything, but I explained the situation and said Lyn had paid her £5 and was all dressed up, but the organisers said she wasn't allowed to jump because she was only 12, and could he help? "No problem," said Eddie, "she can jump with me."'

And jump with him she did. They didn't jump *very far*, but they both won a lot of friends that day, repeating their dual flight the following year when Lyn was dressed as a St Trinian's schoolgirl. In 1991 she jumped as Peter Pan, and in 1992 as a patient with a St John Ambulance man. Sadly, Lyn – a diabetic – was to die suddenly at the age of 21, apparently after a reaction to an insulin injection, though the details are hazy and the coroner delivered an open verdict.

'We still don't know what really happened,' says Jackie sadly. 'But I'm so pleased we've got an award in her name. She was a real character, always up for a laugh, and she loved life. And she loved

jumping here and she raised a lot of money for charity. I'm so very proud of her ...'

On the surface Sussex seems so ... *civilised*. Or, rather, it *pretends* to be. That's the façade perpetuated by all those rich bankers who've got country piles down here and still commute into town on the stupid o'clock express and annoy the pants off proper people by getting their laptops out and breathing their deadly rays all over them. Yet when you get into it, Sussex isn't quite the sedate old buffer it likes to portray itself as ... and the proof of the madness of Sussex lies in the old county town of Lewes.

With its cobbles and its Georgian architecture and its steep, narrow roads and its maze of cute shops, Lewes looks like the soul of old-fashioned sweetness and innocence. You expect to be surrounded by little old ladies who sit in rocking chairs day-dreaming about that day they went out of control in 1930-something and entered the Charleston competition.

But William the Conqueror rolled over King Harold not too far from here, and the arrival of the Normans seems to have planted the seeds of insurrection. In 1264 Simon de Montfort, the Earl of Leicester, led a revolt against Henry III, and they fought the Battle of Lewes. It was an extraordinarily daring challenge because Simon had a broken leg at the time after a fall and had to be carried on to the field of battle. The bookies took one look at him and made Henry the red-hot favourite.

But Henry's tactics were all wrong, and when his team started squabbling among themselves, Earl Simon pulled off the shock win of the century. Not that it did him much good; Henry's boys rallied and exacted sweet revenge just over a year later at the Battle of Evesham. There was no way back for Simon de Montfort after that ... especially after his body had been dismembered and his head sent to the wife of Roger Mortimer, one of his bitterest opponents.

So Lewes has been a hotbed of non-conformity ever since. Tom Paine, the radical writer and humanist, was stung into direct action while working as an excise officer in Lewes in the 1750s. He was on the town council and started a debating society in his local pub that campaigned for higher wages where he worked. When he was sacked, he published a pamphlet, 'The Case of the Officers of Excise', which caused such a hoo-ha he ended up emigrating to America, where he backed the American fight for independence. He caused even more ripples when he went to France and in 1871 published *The Rights of Man*, which, despite being banned and landing him in prison, had far-reaching consequences for British Parliament.

But one thing really marks Lewes's card as a rebellious cauldron

disguised in sweetness and light ... and that is fire. When Mary Tudor
was reviving Catholicism, all guns blazing, in 1556, she had 17 local
Protestants – the Lewes Martyrs – burned. And they've been burning
people in Lewes, in effigy at least, ever since.

The foiling of the Gunpowder Plot in 1605 gave Lewes an ample
excuse to get out the matches again to burn effigies of Guy Fawkes and
his fellow Catholic plotters, and the town's November 5 bonfire
display has been a focal point of the town's year ever since. At times in
the past it was an unsavoury conduit for out-of-control exhibitions of
anti-Catholicism, with so-called 'Bonfire Boys' rampaging through the
town, throwing fireworks and rolling flaming tar barrels. In the nine-
teenth century, the anti-Catholic frenzy hit such a dangerous peak that
there were running battles with the police.

They warn you not to come anywhere near Lewes in a car on this
day, so I come in on a train, jam-packed with revellers. Most of them
appear to be on the verge of creating their own bonfires by sponta-
neous combustion, and plenty of them seem to be saying 'Let's have
the party *right here.*'

They've been telling people not to come to Lewes: it's too crowded,
you won't enjoy it, you'll probably have your comb nicked. 'Oh, they
always say that,' says my new best mate, Tim the student. 'The locals
complain about the visitors coming in and say it should just be for
themselves, but they should be proud that people want to come to their
town. Don't you agree?'

Recalling some of the propriety with which the guardians of local
traditions in Padstow, Allendale, Bampton and Bacup protect their
special traditions, and the tension in the air when the visitors encroach,
I understand where Lewes is coming from ... especially if there's still
any lingering suggestion of a sanctioned excuse for bigotry and
Catholic bashing. But at the same time, local businesses are having a
field day with all the visitors, and when all's said and done, it's not a
trillion-year-old tradition, it's a *just a firework display*. Isn't it?

It is, but it's the biggest in the country, and there's some pretty
strange stuff going on down here. The first firecracker explodes with
a jolt as I get off the train, and I'm a gibbering wreck before I've even
left the station. Collective madness has gripped the town. Packs of
lads race up and down the back lanes, tossing bangers as they go,
while the stall-holders selling drinks and snacks are cleaning up and
my progress to the masses gathered in the High Street for the parade
is scarily propelled by the throng behind me. You don't want to be
stopping to tie up your shoelace with this mob careering along
behind you.

The Lewes Bonfire Night procession is expansive, dangerous,

thrilling ... and dead weird. It is huge, the costumed marchers walk resolutely past in a breathtaking blaze of fire and explosions and it seems never-ending. The New Year's Eve tar barl parade suddenly looks very tame indeed compared to the all-singing, all-flaming affair going on here. In Lewes, the guys not only carry flaming tar barrels; they have bangers and firecrackers in them. With massive eardrum-bursting explosions going on all around, the procession just keeps on coming, charred but unfazed.

For all the efforts to discourage visitors, they reckon there are 150,000 here this year. Five different Bonfire Societies in the region spend all year planning their elaborate costumes, their huge array of firepower, the banners they carry and the effigies they wield above the parade to be ceremonially burned at the end of the night. At times in its history it's said to have been hi-jacked by political parties and by the monarchy for their own propaganda purposes, but my student friend Tim, who's made a bit of a study of the whole thing, reckons at the heart of its tradition is the opportunity it gives for the common man to register a protest. Yes, I say, a protest against Catholics trying to blow up Parliament ...

'No,' he says, mildly affronted. And then changes his mind. 'Well, yes, it *is* about that, but it's not a Catholic witch-hunt. The plotters were Catholics, but that's almost irrelevant. It doesn't matter who they were; they were trying to destroy our way of life and we are celebrating the fact that they didn't do that. It's never been an anti-Catholic thing. The king was married to a Catholic, did you know that?' No, I say, ashamed to admit I don't even know who the king was in 1605. 'Well, it was James I, the first Scottish king of England. And his wife was Anne of Denmark, a Catholic, so the last thing he wanted was a nation going round culling Catholics. This event is nothing to do with bigotry.'

So it's just an excuse to set fire to Lewes, then? 'It's an excuse for the people to have their say and let their feelings be known. In the old days there would be a lot of arrests and people were frightened of being arrested, so they'd disguise themselves in different costumes and make their point by burning effigies of people and things they disagreed with. They are making a political point out there; take a close look at the banners and the pictures they are burning, and you'll understand what it's about. Catholics isn't it at all.'

Considering the first flaming effigy that I see is of the Pope, alongside a banner screaming 'DOWN WITH POPERY', I'm not entirely sure I believe him. The appearance of Guy Fawkes and his co-plotters is greeted with an almost hysterical cascade of jeers and catcalls. When he sees them, the guy behind me starts leaping on my back amid a

torrent of screaming and swearing; 'Burn ye ferking FERKERS, burn ye bastid BASTIDS, ye ...'

I remove his hand from my neck, and say, 'Excuse me, my man, there are minors present who may be offended by your coarse tone, perhaps you would consider moderating your language?' Or something like that. He looks at me long and hard, with eyes so wide I begin to suspect something a little more serious than a couple of glasses of shandy may have prompted this outburst, and then he says, 'Oh, OK, sorry mate, no offence' and starts yelling again: 'DON'T ferking burn them ferkers, let them ferking bastids LIVE, yer ferkers!'

But I take Tim's advice and study some of the other banners and effigies. There's a whole host of traffic wardens and a giant parking meter on fire – a comment about new parking restrictions recently introduced in the town. And there's a blubbery John Prescott somewhere amid the smoke – a comment on Brighton and Hove Albion's bid for a new football ground, which is apparently being sat on by the sizeable Deputy Prime Minister. More obvious targets can be spotted – Bush, Blair, bin Laden and, this may be wishful thinking, but ... Simon Cowell?

As the noisy, colourful, scary spectacular passes, a bloke has a heart attack right in front of me. Medics are there fast with oxygen but it takes an age for the ambulance to get through the cheering, drunken crowds while a mate tries to comfort him on the floor. By the time they get him away to hospital, the long procession is finally fading and we are left with streets full of smoke and the acrid smell of used fireworks and spilt bottles of cider.

The crowds disperse, flocking over the bridges to one of the five huge bonfires being lit in different corners of the town by the different bonfire societies. I get caught up in one of the throngs piling over the bridge, along the riverbank, into a supermarket car park, we go like a marauding herd of antelope ... only to come slap, bang up against a tall wire fence. Some of the hardier souls try to scale it and are up and over in an instant, others opt for the conventional route, I wonder if I'll be able to find the station again and catch the last train home.

So I watch the displays filling the skies from the safety of the station. Is it bigotry, people's protest, or just the English at play? I'm really not sure, but the irony is that parading around Lewes spraying fire and explosions all over the place in a torrent of noise and visual drama is likely to do far more damage than the Gunpowder Plot ever could have done. The barrels of gunpowder that Guido Fawkes was discovered guarding in the bowels of the Houses of Parliament in 1605 were apparently so old they wouldn't have blown up an anthill, let alone the Houses of Parliament.

I'm back in Lewes several weeks later and barely recognise the place without Vikings, sailors, monks, colonial armies, clowns and cavemen rolling flaming tar barrels around, and bangers exploding everywhere. It's quiet, sedate and dignified, pretending it's just like all the other respectable towns down here. And quite right, too ... for tonight it is honouring a very great Englishman.

A secret haven of insurgents it may be, but this part of Sussex is also Copper country. The Copper family from Rottingdean, a few miles out of Brighton, have graced the area for centuries, working the land, drinking in the pubs and singing their hearts out for love of tradition. The Copper Family *are* tradition; their extensive repertoire of folk songs have been sung in the family for at least seven generations. They are songs essentially celebrating the old ways of rural life that, delivered with gentle, unaccompanied harmonies and slow delivery, have inspired and sustained the folk revival for over 40 years.

Bob Copper, the genial patriarch of the family, passed away in April 2004 at the age of 89, days after receiving the MBE from Prince Charles. Apart from singing, he was also a broadcaster, a writer (his *Song for Every Season* is a lovely, graphic recollection of old rural Sussex life) and, not many people know this, an avid blues fan. On his 85th birthday, which he celebrated, as usual, at Lewes Folk Club, he was prevailed on to sing "Divin' Duck Blues" and "Goin' Down To Brownsville". At the end, he commented, 'I've always said it takes a black man to really sing the blues ... and tonight, I've proved it.'

With other great traditional singers like Walter Pardon and Fred Jordan passing away in recent years, there's a case for arguing that Bob Copper really was the last of the traditional source singers, who had orally learned songs that had been in the family for hundreds of years. He *may* have been the last ... except that, in the grand tradition of the Coppers, Bob has passed the baton on.

His son John and daughter Jill have long accepted with relish their role in the Copper dynasty, but the greatest joy of Bob Copper's last years was seeing his grandchildren adopt the songs and add another link to the chain. For years they showed no interest, but at one recent Christmas the grandchildren Mark, Andy, Sean, Ben, Lucy and Tom got up to say they had a special present for him, and started singing the family's songs. And they were singing for him again at Rottingdean Church at his memorial service, when a huge turnout assembled to pay their respects and follow his ashes around the village.

Bob had celebrated his 89th birthday at the Lewes Folk Club at the Royal Oak and the organisers Vic and Christine Smith thought that, even though the great man was absent, they should have another celebration in his honour for his 90th. So I'm back in Lewes joining the

queue outside the door of the Royal Oak and wondering if this might turn into an orgy of sentimentality, full of weeping and wailing.

Happily, it doesn't. Slides of Bob from various stages in his life – policeman, publican, folk singer – appear on a screen, while a succession of artists get up to sing Copper-related songs, read poetry, or simply tell stories about Bob. The family is out in force, too, even if they have to be prised from the bar to come upstairs to sing. 'Oh, hello,' says John Copper, eventually. 'We thought we'd come here and have a drink for Bob … we didn't realise you lot were doing the same up here.'

And then all the great old songs flow, just as they ever did … "Claudy Banks", "Come Write Me Down", "Thousands Or More", "Spencer The Rover", "A Week Before Easter" and all. They are warming, loving songs reflecting simpler, more innocent times, full of exquisite harmonies and uplifting choruses that fill the top room at the Royal Oak. It's an emotional night thick with nostalgia, yet there's something inspirational and natural about it, too, as we see the sands shift and the generation game moves on a notch. With the new generation of Coppers out in force, singing well and clearly feeling something that goes far deeper than mere performance, it's like being in the front row watching the tradition being passed on.

For the Copper family, it's a powerful testament to the incredible legacy of Bob, his dad Jim and grandad Brasser, and the various Coppers that had preceded them, and to the strength of genealogy and family values. But somehow it seems significant, too, as a genuine recognition of Englishness; of values steeped in the dim and distant past but moving forward and finding relevance in a fast-changing modern world.

The young Coppers are just like anyone else: they work, they go clubbing, and they reflect all the trappings of the era in which they've landed. However, they have a natural connection with something a lot older, far deeper and profoundly precious. They're not *fantastic* singers; neither are their parents, and nor was Bob. But that's not what it's about. It never was. It's about soul and instinct and feeling and heart and emotion and history, and all those other gooey things that move them as it moves us listening to them. Maybe it's called folk music.

I'm lost in a confusing mix of emotions driving out of Lewes, and instantly get completely lost and wind up on a dark little lane that seems to be taking me to somewhere called Polegate. I'm wondering what wonders may lurk in Polegate when a deer leaps out into the road in front of me. I swerve and end up in a ditch, while the deer stands in the middle of the road glaring before sprinting away with a supercilious toss of the head that clearly states, 'And don't come on my patch again, buster.'

Shaken, I stick on a tape randomly and drive on. I'm contemplating tradition and keeping it alive; not for tourism, not for gain, not for vanity, not for political purposes, but just for its own sake. In his last decade Bob Copper had travelled to America quite a bit singing with the family, and on one of the trips he met up with the grand old man of American folk song, Pete Seeger, in a discussion broadcast by the BBC. 'You have put your talents and your repertoire to a good social purpose,' Bob told Seeger, the great political campaigner and social song-writer. 'We, I'm afraid, have been a bit dilatory. We just sing for the sheer joy of singing …'

Are there many left who just sing for the sheer joy of singing? The tape clicks on to Ewan MacColl singing "I'm A Freeborn Man", his majestic song from very possibly the best of the radio ballads, "The Travelling People", reflecting the ignorance, abuse and changing lifestyle of the gipsy community.

> *'Now and then you'd meet up with other travellers*
> *Hear the news or else swap family information*
> *At the country fairs, we'd be meeting there*
> *All the people of the travelling nation …'*

I'd seen the great singer June Tabor performing a couple of months earlier and, introducing one song sourced from the gipsy community, she said something that had stuck in my head: 'Gipsies have been the keepers of the tradition and have kept the songs alive. Remember that next time you see them on the road …'

Of *course*. If ever there's an example of the oral living tradition in song and in lifestyle, it's the gipsy community. So right here, right now, still recovering from the trauma of being chased into a ditch by a mad deer in Polegate, I resolve to talk to some singing gipsies. It's not that easy.

A few years ago I'd tried to track down the gipsy singer Jasper Smith for a BBC radio programme, and had spent a couple of days being given the bum's rush and going from one Surrey trailer park to another. Eventually I found him on a park in Epsom – the same one I'd been to three times already and categorically been told he wasn't there. He'd eventually got fed up with seeing me knocking on trailer doors: 'Jasper Smith?' 'Who's asking?'

Eventually we got it together and a few days later, armed with a bottle of whisky, a producer and I were invited into Jasper's immaculately kept trailer to interview him and his son Derby. Derby had transformed one of Jimmie Rodgers's songs about hobos into a protest song about the way gipsies were being treated: "Will There Be Any

Travellers In Heaven?" He had sung it at Loughborough Folk Festival and caused quite a stir. With the whisky going down well, we persuaded him to sing it. By the end of the night Jasper and Derby were relating uproarious stories about life on the road and various encounters with the police and hassles with the local authorities ... and they sang us a succession of glorious songs.

Jasper remembered his dad playing jigs on a flute cut from a hedgerow weed, said his uncle Billy the Pro had danced on the London stage, and that he had played mouth organ and sung as long as he could remember. He also talked about the annual pilgrimage to the Epsom Derby, where they'd busk and play in local pubs, but if they were performing for pennies they wouldn't sing the traditional songs they'd sing in the camps, but country or music hall or George Formby songs.

Sadly Jasper has since died, and the travelling community is relatively immobile these days. However, they are still fighting some hoary old stigmas and a bout of vicious press from the right-wing papers, outraged by their attempts to buy up land for their trailers, provoking locals into silly prices to outbid them.

So I rouse Mrs Colin and Alberta for one last hurrah to complete the cycle, and we wind up back where we started – in Cornwall, but this time in pursuit of gipsies. In Bodmin we find Sophie Legg. Sophie is now 86, white-haired and blind, but is still as sharp as a button, with clear recall of her early life, and angry about the media clichés that still haunt the travelling community. She slept in a tent until she was 12 and moved around from school to school, but says she never encountered any prejudice at all about her background or culture when she was growing up. Life under canvas stopped when she was 34 and the family built a bungalow.

'The whole family could step-dance, except me,' she laughs. 'When everyone got together at a fair or a wedding or Christmas time or something, we'd have a sing-song. Nearly all of us had our own song, and they were looked on as traditional Romany songs.'

Sophie did well at school and was perfectly happy with the nomadic lifestyle. Although times did get hard, she enjoyed growing up. She got a dose of some of the prevailing attitudes, though, when she married a 'gorgio' (a non-Romany) and immediately her two eldest sisters-in-law refused to come to the wedding and wanted nothing to do with her, saying a gipsy wasn't good enough for their brother. That must have been upsetting, I say. 'Oh no,' she says. 'It wasn't. They came around, in the end.'

Sophie frowns on the very term 'gipsy', although many other Romanys have no problem with it. '"Gipsy" is really a derogatory term

for Egyptian,' she says. 'It's like calling the French "Froggies". As far as I'm concerned we're Romany. They say this and that about us, that we don't pay taxes and all this, but what they *don't* say is that we don't take a penny off the state. The only thing my father ever had free was a little bit of medical treatment because he had anaemia, and he had to have injections every month. But he didn't get a penny from pensions, or anything like that.'

Sophie made money from hawking; knocking on people's doors selling things, *any* things. Wood for the fire, trinkets, underwear, pots and pans, brooms … 'You'd get one or two slamming the door in your face, but that was just ignorance. Most people were pleased to see us, because they knew we'd have some good stuff. A lot of them would wait for us to come. Not much hawking gets done now. People have got transport and they can go to towns.'

Like her father, Sophie sang. 'Well, I made a *noise* …' she laughs. 'I knew the songs and I had a go at them, but I made a crow sound like a nightingale.' She's made a record and she's clearly talking nonsense, but Sophie has passed on the songs. Her son, Vic Legg, is a fine singer who has also had a longstanding involvement with Bodmin Folk Club. After a lot of cajoling, her daughter Viv is now also singing the songs in public.

Viv says she was too scared to sing in public before, and she was also married to someone who discouraged her, but the fear that the songs would die eventually overcame her fear: 'The songs have come down through the family so they will be lost unless we sing them.' She's immensely proud of her Romany heritage, but admits she kept it quiet at school for fear of all the spite and teasing: 'I had a lot of friends at school, but I knew if I let on I was a gipsy I wouldn't have any friends. There was one girl who wasn't a gipsy but because she was poor and her hair was matted, they'd call her a gipsy; "You're a dirty gipsy", and "You're flea-ridden", and this, that and the other. I didn't say anything but I'd sit with her and support her. But as time went on I didn't care what they thought. I was who I was, and they could like it or lump it.'

Sophie and Viv both worry, too, about the Romany language going the way of Cornish and Manx. It was in common use in the family when Sophie was growing up, but there are fewer and fewer travelling Romanys now, and the old ways are changing. 'I've got four children and they don't want to know about the Romany language,' says Viv regretfully.

'Most of the old ways are gone,' agrees Sophie. 'I don't know what it's like up country, but down here most of them have settled and are integrated. But there's still a lot of harassment around here. I don't know why. We can't stop anywhere, and we can't go anywhere.'

That night we go back into Devon – to Okehampton – and meet up with Paul Wilson from the Wren Trust, a charity helping to promote Devon culture. He introduced me to another gipsy musician, Brian. Brian is appalled that old prejudices and stereotypes about the gipsy lifestyle persist; that people still aren't accepted for who they are. He's angry that they're still being harassed and treated like dirt, just for having an alternative lifestyle. He also knows that as the days of travelling gradually pass, the gatherings at fairs and private parties are becoming few and far between, and folk clubs now offer the best opportunity to keep the Romany songs and music alive.

Paul Wilson also turns out to be one of the musicians with the elusive Minehead Hobby Horse. 'I went to Minehead and I couldn't find you,' I say, and he seems genuinely chuffed. 'That's how we like it,' he says. 'We like to keep people guessing.'

And then Paul comes out with a sentence that makes everything else in this odyssey slot into place. I'd been fretting about trying to equate a love of traditional culture and its ongoing status in England with getting enthused by, and fully embracing, the brave new British world of multi-culturalism.

'The thing is,' says Paul, 'the more we know about our own culture, the more secure we feel about it. And the more secure we feel about who we and the country are, the more we will understand and tolerate the culture of others coming in, and we can get rid of racism and the rest of it …' We're in high spirits on the slow, leisurely journey home. Now this is something I can understand, my quest for England is making sense.

We wind up back at the place where the notion to spend the year trotting around England to check its pulse originally began – the Serpentine, in London, for the Christmas-morning swim. Somebody's stuck up a Princess Diana memorial fountain there in the meantime, but otherwise all is well. The gang's all here and, despite my grave fears about a commercial makeover this year, all seems well in the state of Albion. There's no sign of Sky TV showing up in force waving a freshly signed contract, and demanding we shift the starting time to early evening to suit the home audience. Or of a franchise of burger bars and Chinese takeaways. Or of anyone who takes it remotely seriously.

I spot last year's winner Alan Lacy, now 81, and race up to wish him well, but he's clueless as to who I am and swiftly excuses himself and leaves, while the same assortment of old-fashioned bathing suits and thrusting Speedos line up on the pier ready for the big splash. 'It's 41 degrees,' yells someone in the know who's been testing the water, and the 50 or 20 competitors emerge to play their part.

Two impostors dive in before the call to start and conduct their own private duel along the 100m course while a man in spectacles runs alongside them on the bank yelling, 'Stop it! Get out at once! You are *not* members of this club, and therefore unable to be in this race. Please get out now, you are ruining the race.'

They do get out, but only after crossing the finishing line. They try to brazen it out as they emerge from the water in goose bumps and wide-eyed wonder, spreading their hands in innocent gestures and saying 'Sorry' rather sheepishly as the bespectacled official continues to berate them. I hadn't even noticed the official contenders start leaping in down the other end when a middle-aged woman erratically thrashes her way across the finishing line, more in a panicky attempt not to drown than a serious swim. As half of the competition has still to get the signal to start, I'm guessing she's had a generous handicap.

She emerges from the water to be presented with a glass of something warm and alcoholic but continues to shiver and look totally baffled. 'You won! Well done!' I tell her but she's shaking too much to answer. Her name is Emi Hunt and she tells me she's originally from Germany and has been swimming this Christmas Day race for the last couple of years, but still hasn't quite got to grips with what this whole thing is all about.

Her daughter arrived yesterday from the West Indies to spend Christmas with her so she's on a bit of a roll, though there is some controversy when they start dishing out gongs. Emi is the winner of the race yet doesn't receive the Peter Pan Cup because she's, well, a woman. She gets the Wendy Cup, which always goes to the winner of the women's event. And it's much smaller than the Peter Pan Cup, which is presented to the bloke in third place.

There's consternation in the crowd as it compares sizes and reckons Emi has had a raw deal ... not that Emi minds. She didn't get where she is today by worrying about cup sizes. She's thrilled, and there is a delicious mixed-up irony in a middle-aged German woman winning such an eccentrically English event ... and then only being give a tiddly cup for her efforts. Bravo England! Bravo Emi! Bravo Serpentine! I'm not sure why, but it makes me proud.

A few days later, I bump into my mate Dave. 'By the way,' he says, 'did you ever finish that book you were talking about writing?'

The one about England that you told me was a bad idea?

'Yeah, that one.'

Well ...

'See, I told you it was a bad idea.'

Yeah, you did.

'Bet you couldn't find anything interesting about England, right?'

Well ...

'See, I *told* you ... nobody is interested; nobody would buy a book about England. *Nobody*. I bet you're glad you didn't agree to do it now.'

Oh yeah, Dave. *Ecstatic* ...

'Mind you,' he says, 'it's not so bad.'

'No, Dave,' I say, it's not so bad.

He gets the pints in and we drink to a place called England.

Bibliography

Ken Ambler, *A Coalfield in Chaos* (Ken Ambler)

Richard Armstrong, *Grace Darling, Maid and Myth* (J. M. Dent & Sons)

Keith Chandler, *Francis Shergold ...* (Musical Traditions internet mag)

Forster Charlton, Colin Ross, *Billy Pigg, the Border Minstrel* (Leader)

Donald Clarke, *The Penguin Encyclopedia of Popular Music* (Viking)

Muriel Furbank, Helen Cromarty, Glyn McDonald, *William Penny Brookes and the Olympic Connection* (Wenlock Olympian Society)

Dr Reg Hall, *The Voice of the People* (Topic)

Christina Hole, *British Folk Customs* (Book Club Associates)

John Large, *Stories of the Lake District* (John Large)

Benedict Le Vay, *Eccentric Britain* (Bradt)

A. L. Lloyd, *Tommy Armstrong of Tyneside* (Topic)

Bob Pegg, *Folk* (Wildwood House)

——, *Rites and Riots, Folk Customs of Britain and Europe*

Steve Roud, Eddie Upton, Malcolm Taylor, *Still Growing* (English Folk Dance and Song Society)

Brian Shuel, *The National Trust Guide to Traditional Customs of Britain* (Webb & Bower)

Michael Williams, *Curious Cornwall* (Bossiney Books)

Folklore Myths and Legends (Reader's Digest)

The Book of British Villages (AA)

The Rough Guide to England (Rough Guides)

The Shell Guide to England (Book Club Associates)

The Tolpuddle Martyrs (National Union of Teachers)